The Lives, Loves, and Art
of Arthur B. Davies

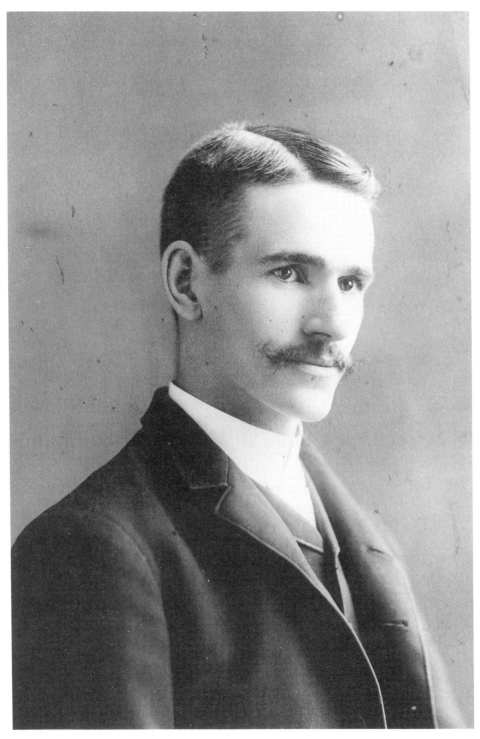

Arthur B. Davies at age twenty-five, 1887. Photograph. Collection of Mr. and Mrs. Niles Meriwether Davies, Jr. Photographer: Max Platz.

The Lives, Loves, and Art of Arthur B. Davies

by
Bennard B. Perlman

STATE UNIVERSITY OF NEW YORK PRESS

Cover: *Figures Synchromy,* 1913. Oil on wood panel, $7^3/_4$ x $9^3/_4$ inches. Collection of Dr. and Mrs. Bernard H. Wittenberg. Reprinted with permission.

Published by
State University of New York Press, Albany

For information, address State University of New York Press,
State University Plaza, Albany, N.Y. 12246

Production by Marilyn P. Semerad
Marketing by Fran Keneston

Library of Congress Cataloging-in-Publication Data

Perlman, Bennard B.
 The lives, loves, and art of Arthur B. Davies / by Bennard B.
Perlman.
 p. cm.
 Includes bibliographical references and index.
 ISBN 0-7914-3835-X (hc : alk. paper). — ISBN 0-7914-3836-8 (pbk.
: alk. paper)
 1. Davies, Arthur B. (Arthur Bowen), 1862–1928. 2. Painters–
–United States—Biography. I. Davies, Arthur B. (Arthur Bowen),
1862–1928. II. Title.
ND237.D3P45 1998
759.13—dc21
[B] 98-5205
 CIP

10 9 8 7 6 5 4 3 2 1

Praise for Arthur B. Davies (1862–1928) from Art Critics and Historians

"It is not too much to say that Mr. Davies is already one of the foremost artists in this country."

—Samuel Swift, 1901

"The romantic painter *par excellence* is Davies, and his work is as personal and as interesting as any done in the country to-day."

—Samuel Isham, 1905

"One does not hesitate to adjudge him the most original of American painters and the peer of those living European artists who are dominated by ideas and not by the brush."

—James Gibbons Huneker, 1908

"Since the death of Albert P. Ryder, Mr. Davies has been recognized, by persons abroad who are familiar with art in America, as the leading living painter on this side of the Atlantic."

—Frederick James Gregg, 1919

"A man of genius . . . a sure-footed artist if ever there was one . . . a boon to American painting."

—Royal Cortissoz, 1924

"Arthur B. Davies is already recognized, not only in this country but in Europe, as one of the few men of original and authentic genius among the painters of our contemporary world."

—Duncan Phillips, 1924

"One of the most personal artists, certainly the most inventive poet in paint this country has yet produced."

—Virgil Barker, 1924

"I found, in America, some exceptional water-colors by Arthur B. Davies. . . . [whose] themes [and] manner of seeing belong to Europe. This artist is unusually many-sided in his expression. His [Lizzie Bliss] decorations [and] his renovated Gobelins [tapestries] in Paris stand out very favorably from most modern attempts of Parisian manufacture . . . There are few Europeans as able in Europe to-day."

—Julius Meier-Graefe, 1928

"It is simpler comprehensively now to appraise him—not alone one of America's greatest artists, but one of the greatest artists as well of our time."

—Edward Alden Jewell, 1928

" . . . with art fashions once more in a state of flux, Davies' poetic landscapes and his figure-strewn canvases will appeal to many who are growing weary of artists who can see nothing but misery and ugliness in the world. Davies saw beauty where it must still exist, in the mind and imagination of man."

—Forbes Watson, 1939

"He beat his own path, and it led up the mountain. He gained an eminence that few artists reach in their lifetime. . . . He was that remarkable phenomenon, an artist who enjoyed an immense success and at the same time was respected by other artists."

—Forbes Watson, 1952

"He was a fastidious and sensitive craftsman, enamored of the emotional quality of color, and with a mind intensely alive, if not profound."

—Milton W. Brown, 1955

"At a time when we are bombarded by the bold and noisy experiments of one direction or another of contemporary art, this [Arthur B. Davies] exhibition provides us with an opportunity to enjoy the work of a rare and gentle romantic visionary. His tranquil and nostalgic statements . . . are an oasis in twentieth-century art."

—John Gordon, 1962

"Davies is one of the most interesting, original, and underestimated figures in the history of early twentieth century American art."

—William Innes Homer, 1977

"I was taken to see Duncan Phillips and his collection. I thought Arthur B. Davies, to whom an entire room was at the time dedicated, a remarkable painter, and I think this still."

—Sir John Pope-Hennessy, 1991

❧ List of Illustrations ❧

(All illustrations reprinted with permission.)

Color Plates

Black-and-White Illustrations

❧ Contents ❧

✤ Acknowledgments ✤

*T*his biography is the result of a chance meeting between the author and Niles Meriwether Davies, Jr., grandson of Arthur B. Davies, which occurred at New York's Whitney Museum of American Art on January 12, 1983. The occasion: A preview reception of "The Seventy-Fifth Anniversary of The Eight" exhibition attended by relatives and descendants of The Eight. My role was guest curator of the exhibit.

Niles Davies, Jr., extended an invitation to visit him at his home north of Manhattan where his artist grandfather had worked and lived. When that occurred the following fall, I was immediately smitten by the notion and challenge of producing the first full-length biography of Arthur B. Davies, an artist much heralded during his lifetime and a tastemaker who advanced the cause and course of modern American art during the early years of the twentieth century.

My deepest heartful thanks go to Niles M. Davies, Jr., and his wife, Jan, for their unending cooperation during my decade of research and writing. I am also indebted to Davies' four other grandchildren: Alan Davies, Arthur Bowen Davies II, and especially Margaret Davies Marder and Dr. Sylvia Davies Diehl.

Contributions by others to the success of this publication range from continually responding to my unending requests for data to providing a single yet critical morsel of information. These individuals shall always be remembered by me for their willingness to offer their assistance and expertise: Ella Abney, Medical Society of the State of New York; Lawrence Austin; Dr. Joseph A. Baird, Jr.; Wendy Baker, Enoch Pratt Free Library, Baltimore; Pamela Baldwin, Yale University Art Gallery; Cynthia Barth, Museum of Art, Munson-Williams-Proctor Institute; Elizabeth Ives Bartholet; Debra Basham, Department of Culture and History, State of West Virginia; Bert Baum,

Walter Baum Galleries; Paula A. Baxter, The Museum of Modern Art; Sidney E. Berger, University of California, Riverside; Laura J. Berk, Illinois State Historical Society Library; Avis Berman; Jennifer Booth, Tate Gallery, London; JoAnne Bowie; Barbara Bowman, The Oakland Museum; Marietta Boyer, The Pennsylvania Academy of the Fine Arts; Arthur Breton, Archives of American Art, Washington; Herbert Baer Brill; Doreen Buckingham; Laurene Buckley, Spanierman Gallery; Zoltan Buki, New Jersey State Museum; M. Leigh Bullard, The Phillips Collection; Marcia Bysart, Enoch Pratt Free Library; Lawrence Campbell, The Art Students League of New York; Jay Cantor, Christie's New York; Martha Carey, The Phillips Collection; Mary Carey, The New-York Historical Society; Sam Carini, The Art Institute of Chicago; Becky Cawley, Enoch Pratt Free Library; Carol Clark, Maurice and Charles Prendergast Project, Williams College Museum of Art; Kim Clark, National Museum of American Art Library; Eliza Bliss Parkinson Cobb; Kenneth R. Cobb, Municipal Archives, New York City Department of Records and Information Services; Ester Coen; Gould P. Colman, Cornell University; Bonnie L. Conway, Museum of Art, Munson-Williams-Proctor Institute; Valerie A. Cramblitt, Enoch Pratt Free Library; Eva Crider, Archives of American Art; Kathleen Bassano Curran, The Metropolitan Museum of Art; Gertrude Dahlberg; Lisa Davis, Yale University Art Gallery; Paul P. Davis; Amy DeBusk, The Baltimore Museum of Art Library; Gertrude Dennis; Carol Derby, Williams College Museum of Art; Deborah Duke, Enoch Pratt Free Library; Anita Duquette, Whitney Museum of American Art; Charles C. Eldredge, National Museum of American Art; Peter Hastings Falk; Sandra Kuntz Ficker; Johnnie A. Fields, Enoch Pratt Free Library; Barbara W. File, The Metropolitan Museum of Art; Lawrence A. Fleischman, Kennedy Galleries, Inc.; Jill Frankel, Graham Gallery; Annewhite Fuller, Huntsville Public Library; Godfrey O. Gaston; Abigail Booth Gerdts, National Academy of Design; Roger Gilmore, The School of the Art Institute of Chicago; Howard Gorelick, The Walters Art Gallery; Shirley J. Gorton, The Rockwell Kent Legacies; Christopher Gray, Office of Metropolitan History, New York; Darrell Green, The Art Institute of Chicago; Russell A. Grills, New York State Office of Parks, Recreation and Historic Preservation; Alan Gussow; Paul Hampden; Nancy Harper, The Theosophical Society in America; Diane Heith, Cornell University Library; Prudence Hubbard;

Richard Hubbard; Althea H. Huber, The Art Institute of Chicago; Fred Hunter, American Medical Association; Stephen B. Jareckie, Worcester Art Museum; Elizabeth Joffrion, Archives of American Art, Washington; Sona Johnston, The Baltimore Museum of Art; William R. Johnston, The Walters Art Gallery; Cathy Keen, Archives of American Art, Washington; Marisa Keller, The Corcoran Gallery of Art; William Keller, Eisenhower Library, Johns Hopkins University; Jane A. Kenamore, The Art Institute of Chicago; Dr. M. Sue Kendall; Leah McVicker Kerns; Reuben Kramer; Betty Krulik, Spanierman Gallery; Brenda Kuhn; Sandra Kuntz; Dr. Erika Langmuir, The National Gallery, London; Patricia M. LaPointe, Memphis Shelby County Public Library and Information Center; Preston Lawing, Mint Museum; Janet J. LeClair; Robert S. Lee; David Levy, Enoch Pratt Free Library; Cheryl Leibold, The Pennsylvania Academy of the Fine Arts; Geoffrey Michael Lemmer; C. Clinton Lindley, Jr.; Reverend James Elliott Lindsley, Diocese of New York of the Protestant Episcopal Church; Nancy C. Little, M. Knoedler & Co.; Sue Davidson Lowe; Ann Lowen, Friends Seminary, New York; Ellen Luchinksy, Enoch Pratt Free Library; Pat Lynagh, National Museum of American Art Library; Phoebe C. Macbeth; Roberta Mahon; Jerry Mallick, National Gallery of Art; Elizabeth Marsh, Yale University Art Gallery; Andrew Martinez, The Art Institute of Chicago; Nancy Mowll Mathews, Williams College Museum of Art; Garnett McCoy, Archives of American Art, Washington; Paul McCutcheon, Enoch Pratt Free Library; Wreath McIntyre; Mary McIsaac, The School of the Art Institute of Chicago; Julie Mellby, Whitney Museum of American Art; Connie Menninger, Santa Fe Railway Project, Kansas State Historical Society; Susan Metcalf, The Achison, Topeka and Santa Fe Railway Company; Charles Mo, Mint Museum; Blanche Nankivell Mougel; Sandy Mowbray-Clarke; John Murdoch, Victoria and Albert Museum; Gary Myer, George Peabody Library; Margaret Nankivell; M. P. Naud, Hirschl and Adler Galleries, Inc.; Nancy Oakman; Annette Ohnikian, Condé Nast Publications, Inc.; Gwendolyn Owens, Canadian Center for Architecture, Montreal; Erika D. Passantino, The Phillips Collection; Meg Perlman, Mrs. John D. Rockefeller III Collection; Carole M. Pesner, Kraushaar Galleries; Daria Phair, Enoch Pratt Free Library; Herb Pierson, The *Washington Post* Information Resources; Gabriele Popp, Royal Academy, London.

Liz Pryor, Wadsworth Atheneum; Jan S. Ramirez, Museum of the City of New York; Julianne Ramos, Rockland Center for the Arts; Susan Raposa, Inventory of American Sculpture, National Museum of American Art; Glenis R. Ratcliff, The New York State Library; Cynthia D. Recouso, Harbor Gallery; Dr. Ellen Reeder, The Walters Art Gallery; Hedley Howell Rhys; Martha Richardson, Sotheby's; John R. Rinaldi, The University of New Mexico; Susan L. Roberts, The New York State Education Department; Elizabeth R. Rogen, The Art Institute of Chicago; Emily Romero, The Art Institute of Chicago; Cathy Ronconi, Multnomah County Library; Myra Rosen, Virginia Museum of Fine Arts; Delanie Ross-Plant, Memphis State University; Wendy Rubin, Sotheby's; Christa Sammons, The Beinecke Rare Book and Manuscript Library, Yale University; Lynda Sanford, The Chicago Public Library; Jane Satkowski, Minneapolis Institute of Art; Isabelle K. Savell, The Historical Society of Rockland County; Ellen Schall, The Maier Museum of Art of Randolph-Macon Woman's College; Dorothy Schneiderman, Harbor Gallery; Ellen Schwarzbek, Hickory Museum of Art; Paul D. Schweizer, Museum of Art, Munson-Williams-Proctor Institute; John Scott, The Historical Society of Rockland County; Patricia L. Serafini, Museum of Art, Munson-Williams-Proctor Institute; Patricia Sheridan; Judith W. Short, Archives of American Art, Washington; Mark J. J. Simmons, Newport Art Museum; Marc Simpson, The Fine Arts Museums of San Francisco; Helen (Mrs. John) Sloan; John W. Smith, The Art Institute of Chicago; Melissa A. Smith, Rockefeller Archive Center of Rockefeller University; R. A. H. Smith, The British Library, London; Will South, Utah Museum of Fine Arts; Joan Stahl, Peter A. Juley and Son Collection, National Museum of American Art; Anne Steinfeldt, Chicago Historical Society; Lisa Stigelman, The Carnegie Museum of Art; Diana Strazdes, The Carnegie Museum of Art; Ruth Sundermeyer, Enoch Pratt Free Library; Elizabeth Tebow, The Phillips Collection; James D. Tingen, Chattanooga-Hamilton County Library; Adeline R. Tintner; Laurie A. Trate, The Carnegie Museum of Art; Cindy Tripoulas, The Baltimore Museum of Art Library; John Verso, Columbia University Oral History Research Office; Gary Vikan, The Walters Art Gallery; Gilbert Vincent, Fenimore House Museum; Frank Walker, Fales Library, New York University; Ian J. Warrell, Tate Gallery, London; Jane C. Weaver; William C. Weber, Jr.; John A. Wells, International

House; Susan Wheeler, Enoch Pratt Free Library; Patricia C. Willis, The Beinecke Rare Book and Manuscript Library, Yale University; Simon Wilson, Tate Gallery, London; Debora Winderl, Museum of Art, Munson-Williams-Proctor Institute; Kay Wisnia, Denver Public Library; L. Woodyatt, National Academy of Design; Brooks Wright; Nancy Hubbard Yeide, National Museum of American Art; Richard York, Richard York Gallery; Linda Ziemer, Chicago Historical Society; and Judith Zilczer, Hirshhorn Museum and Sculpture Garden.

Finally, a very special note of thanks to my late wife, Miriam, whose initial encouragement and continuing enthusiasm for the project has made it a most enjoyable undertaking from beginning to end.

✧ Introduction ✧

The only artists who will survive are those who have a higher ambition than merely to follow contemporary fashion, and who can show that they have their own inevitable and individual style, their own original vision of the material and spiritual worlds.

—Claude Roger-Marx (1888–1977)

*A*lthough these words by the French art critic and playwright may not have been intended to include Arthur B. Davies, the description fits him to a tee: Davies was his own man, one who disregarded the current trends in order to forge an individual direction. Best known as a member of "The Eight," he has often been considered an aesthetic misfit in a group whose subject matter and technique was dominated by Robert Henri, John Sloan, William Glackens, Everett Shinn, and George Luks. While they painted the life of the city with gusto, often focusing on the seamy side of it, Davies was obsessed with the figure. Even Maurice Prendergast and Ernest Lawson produced cityscapes. Davies, on the other hand, employed the same model for fourteen years (this surely qualifies as some sort of a record) and depicted her in an unending number of poses and themes that encompass twenty different mediums of painting, drawing, printmaking, sculpture, and textiles.

It was A. B. Davies, not Henri, Sloan, or any of the others, whom the art critics labeled "one of the foremost artists in this country," "the most original of American painters," and "the leading living painter on this side of the Atlantic."

Davies' studio was located in midtown Manhattan, yet his art reflects a world far removed, one stressing symbolism and the

supernatural, the imagination and erotic dreams. His canvases are replete with idyllic visions of ethereal young women who appear to be twenty-something and never grow older. Little wonder that his oils appealed to a new generation of American art collectors consisting primarily of married, single, and widowed society women, some of whom were attracted by his personal magnetism as well.

Chief among the Davies circle were Lizzie Bliss, Abby Aldrich Rockefeller, and Mary Quinn Sullivan, the founding trio of the Museum of Modern Art. They credited him with developing the avant-garde nature of their collective tastes in art, which led to that action.

In addition to collectors and patrons, Davies encouraged many of the more modern artists of his day at a critical point in their careers. He would purchase frames, pay to rent a studio, or finance a trip to Europe for them, and bought the paintings of Marsden Hartley, Alfred Maurer, Max Weber, Manierre Dawson, and Rockwell Kent, among others. An inveterate buyer of art and artifacts from numerous centuries and cultures, his holdings eventually numbered in the hundreds, and included sixteen Picassos, fourteen Derains, and examples by Braque, Cézanne, Matisse, and Brancusi.

There was also a dark side to Arthur B. Davies, which involved a succession of female conquests, some occurring after his marriage. There was an intense romance with his art school instructor, a love affair with a fellow art student, and a marriage to another woman who was pregnant with his child. Davies seemed bent on modernizing Victorian morality. The liaison that most affected his life and art was with a model with whom he took up housekeeping while still married; ultimately he fathered her child. For twenty-five years Davies led a double life, existing simultaneously under his real and an assumed name. The deception and fear of exposure resulted in his becoming aloof, secretive, and withdrawn.

Only once did Davies abandon his very private existence: he emerged from his self-imposed isolation to mastermind the 1913 Armory Show, the event which brought modern art to these shores on a grand scale. Many of the country's finest collections of late-nineteenth- and early-twentieth-century art resulted from that show. Virtually all American artists were affected by the momentous event, and even today their art is regularly characterized as having been created either before or after the Armory Show. (Davies believed so

strongly in the value of bringing the show's modern European art to the United States that he secretly offered his own home and farm as collateral against any financial loss.)

Following Davies' death in 1928 under mysterious circumstances, *New York Times* art critic Edward Alden Jewell apparently got wind of certain aspects of Davies' lives, intrigues, and cover-ups. He wrote: "It is doubtful whether any exhaustive 'life' of Arthur B. Davies ever will be compiled." Now, after more than a half-century, he has been proven wrong. It is my hope that this biography will not only offer a complete picture of Arthur B. Davies, but provide a missing chapter in the history of American art as well.

❧ 1 ❧

Youthful Years in Utica
(1862–1879)

None of the other boys noticed the small set of paints that Arthur had packed with his gear as they embarked on a camping trip by horse and wagon. They were all too preoccupied, ecstatic at the thought of being allowed to go off for a week of camping and fishing on their own.

One day, toward evening, a large pair of pickerel was caught and hung from the branch of a tree like a big game trophy. While the youngsters celebrated their good fortune, Arthur dove into a tent and reappeared with palette, palette knife, and tubes of oils. His buddies were surprised at the sight of the art supplies but overjoyed at the prospect of a painting being done of their catch. At least they inquired if that was the intent. "No," replied Arthur B. Davies, "I only want to see if I can mix colors like those in that sunset."[1] Only then were their eyes drawn to the exceptional beauty of the radiant sky, and from that day on their chum's nickname, "Art," took on an added meaning.

Arthur Bowen Davies was born on September 26, 1862, in Utica, New York, the fourth of five children of David Thomas Davies and Phoebe Loakes Davies. His paternal grandparents were Welsh and grew up on adjoining farms; Arthur's father hailed from Tynewydd, Carmarthenshire, Wales, his mother from Bluntisham, Huntingtonshire,

England. Soon after their marriage in London on March 29, 1856, David Thomas Davies and his bride emigrated to the United States, where their offspring were born between 1857 and 1866, and named Eliza (Lizzie), Thomas, David, Arthur, and Emma.[2]

At the time of Arthur's birth the family lived at 14 Hotel Street near the Erie Canal, and when he was five they resided at 43 Court Street. By then his penchant for art was already apparent to family members. According to Lizzie: "At the age of five he used his little [watercolor] paints to color pictures—would sit on the floor and copy from the big dictionary."[3]

By the time he was six, Arthur was attracted to the woodcut illustrations in a second-grade reader an older friend was about to discard, and asked that the reader be given to him. A few days later the donor visited Arthur "and there I found the Second Reader with the woodcuts showing what, to my mind, was the most marvelous combination of brilliant colors possible to look upon."[4] The child artist had painted each of the black-and-white illustrations.

Soon Arthur's artistic bent was demonstrated beyond the confines of his home. Below the Davies' abode there stood a high board fence which he began to embellish by sketching pictures upon it with a lump of coal. Neighborhood children would line up on the curb to watch and applaud his efforts. At one point "they dug into their pockets and produced a few stray pennies, with which they purchased a collection of some colored chalks for him so the entertainment could proceed at a higher level."[5]

Arthur's youthful artistry was not limited to two-dimensional surfaces. At age twelve he produced his first triumph with a pocket-knife in the form of a miniature sailboat, which he then fully rigged. It caught the eye of a local merchant who placed it in his window display and sold it for $25. A childhood friend named Bob Adams once recalled how Arthur built a waterwheel, a fortress, and a working fountain composed of a rain barrel with connecting shafts from the seed stalks of onions.[6]

It appears that Arthur readily accepted any challenge of an artistic or mechanical nature. When his brother David, two years his senior, expressed an interest in constructing a small rowboat for trips along the Mohawk River, it was Arthur who volunteered to build it. And build it he did. The youngster regularly tagged along with his brothers, playing a role in their mischief. Once the trio went to the

circus where they were awed by the acrobatics of a performing gymnast. Determined to duplicate his feat, they returned home and anchored one end of a makeshift horizontal bar by drilling a hole through an antique mahogany bureau.

Arthur's initial effort at oil painting occurred at the age of ten on a tiny 6-by-6-inch piece of canvas tacked to a homemade stretcher. The subject is an elderly woman dressed in black and wearing a bright red shawl. She is seated in a high-back chair drinking tea; a black cat perched on her shoulder is poised to sip from the saucer the woman holds in her hand. Adjacent to them is a still-life arrangement of a teacup, a pewter teapot, and a loaf of bread, the latter so

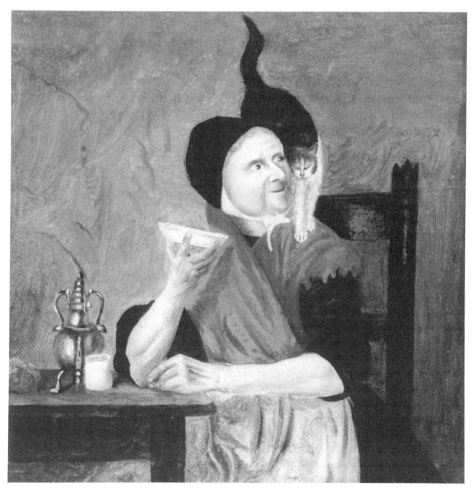

Figure 2. *Woman with Cat,* 1872. Oil on canvas, 7 x 7¹⁄₂ inches. Collection of Mr. and Mrs. Niles Meriwether Davies, Jr. Photographer: Jeoffrey Michael Lemmer.

close in hue to the burnt sienna background that it appears to dissolve into the color surrounding it. The composition was inspired by a black-and-white magazine illustration or a chromolithograph. However, it reveals a degree of technical proficiency unusual for a child of that age.

Davies' skill at paint handling and copying was demonstrated again during the winter of 1873–74. He produced a replica of Winslow Homer's composition *Dad's Coming!* after it appeared as a wood engraving in the November 1, 1873, issue of *Harper's Weekly*. The twelve year old transformed the linear reproduction into the tonal medium of watercolor, carefully duplicating the proportions of two children on the seashore among beached dories, and their mother, who looks seaward for the first indication of the father's return.

Arthur had access to the finest art and literary magazines of the day, and he would sit in the parlor for long periods of time studying the subject matter and techniques of some of the country's finest illustrators. The youngster's parents encouraged his art activities, proudly covering the walls of their home with his pictures. Promotion of art and music among the children was largely credited to their mother, whom Arthur described as having "a keen sense of the beautiful." Though she was lame, this handicap did not prevent her from being "efficient and practical in the home management," as he put it, and "broadminded in her outlook."[7]

Arthur's father was a practical and successful businessman, a clothier by profession and a lay preacher on Sundays. He had learned the tailor's trade before leaving Wales, and in Utica was co-owner of a wholesale and retail men's clothing firm. David Davies' religious calling stemmed from the fact that *his* father had been a Methodist minister in Wales. Arthur's dad was licensed to preach in Wales, and in Utica joined the Welsh Methodist Episcopal Church where he enjoyed delivering as many as three sermons on a given Sunday.

Arthur once described his father as "a man of high ideals, of an intensely religious nature, generous, hospitable, a leader in the temperance movement, devoted to his family, highly conscientious and of indomitable energy."[8] Because of his deep religious convictions, the entire household was reared to fear God. "Father was *such* a religious man," Arthur once recalled, then added, "but mother swore like a trooper."[9]

In order to advance Arthur's propensity for art, his parents decided upon private drawing lessons, choosing as his instructor the son of a fellow Methodist minister, Dwight Williams. Williams was just six years older than Arthur, which makes implausible the oft-repeated claim that Arthur was seven when he began studying with Williams. In actuality the individual instruction commenced in 1876, when Davies was fourteen and just a year after Williams had established himself as an artist and began teaching at a local school of design.

The mentor recalled his initial impression upon viewing Arthur's work:

> My first introduction to him was, from my point of view, largely casual . . . [As I frequently called upon Arthur's] father in the early days at his office on Genesee Street in Utica, New York, he one day spoke to me of his son, who, he said, seemed to have a strong inclination for drawing and invited me to accompany him home to luncheon and give my opinion concerning his son's efforts. . . . Upon entering the home the lad's sketches and drawings were everywhere in evidence, some tucked in picture frames and others pinned to the walls. Instantly I discerned that his work had merit and that he had a fine and delicate sense of the value of line and form.[10]

Dwight Williams maintained his studio in the village of Cazenovia, some thirty miles from Utica. Although he sometimes taught Arthur at the Davies home, on other occasions the youngster rode by horse and buggy to his teacher's studio, a small lean-to built against the side of a barn. Williams' instruction included practice in drawing two- and three-dimensional objects, pencil shading, and combining or contrasting straight and curved lines. "These first principles were stimulating to the boy," Williams remembered:

> In explaining problems in drawing his intuition often ran ahead of the teacher and it was rarely necessary to explain anything twice, for his active mind anticipated my suggestions. . . . there was abundant evidence of marked talent which needed only opportunity, and work would do the rest.[11]

Student and instructor regularly sketched together among the fields and hills north of Utica, and along the banks of Cazenovia Lake. They would usually amble partway to such locations, even though this represented a physical hardship for Williams, who was unable to walk without the aid of two canes. The result of their numerous field trips was the teacher's realization that

> here was a young genius of a high order. He had a wonderful appreciation of nature and all its beauties and very great capacity for selecting, combining and eliminating. . . . Naturally it was an inspiration to his teacher to have for a pupil one so quick to see and to acquire.[12]

Thanks to Dwight Williams, Arthur learned to use pastels, his mentor's preferred medium, to record the sylvan scenes of the Mohawk Valley.

Following nearly two years' tutelage, the youngster amassed a collection of pencil drawings, pen-and-inks, watercolors, and pastels—many accomplished on his own. There is a carefully rendered horse's head complete with bridle and reins dangling rhythmically around an unkempt mane, dated July 15, 1878. Many of the sketches are quite small, with the largest measuring only $2^1/_2$ by 8 inches. The subjects are varied, from an incredibly beautiful head of a cat to rosebuds, a carnation, and sailboats. The teenager now considered his role as an artist with sufficient seriousness to take a page from *Harper's Weekly* and practice various ways of signing his initials "ABD" around the margins, incorporating ascending and descending curlicues with block letters to create artistic monograms.

In 1878 Davies witnessed a major art event, one which would have a lasting effect upon him. That year the Utica Art Association sponsored an exhibit of nearly 250 works by contemporary artists whose canvases were brought there from New York City. The display was held at Carton Hall on Genesee Street, just a block from his father's place of business, and the show served to fire Arthur's imagination. There were the glories of the Hudson River School painters, spelled out in such compositions as Jasper Cropsey's *On the Hudson* and Sanford R. Gifford's *Autumn Woods,* and the near-exotic scenery of L. M. Wiles' *A Foothill of the Sierra Nevadas,* Albert

Bierstadt's *On the Pacific Coast,* and Frederic E. Church's *Scene in the Andes.* And Davies was surely impressed by four works in the exhibition by his own teacher, all of Cazenovia Lake or its environs in sun or snow. Yet it was two oils by George Inness simply titled *Landscape,* with their special qualities of warm earth tones, blurred edges, and a seemingly mysterious light, which would have the most lasting effect upon the youngster as evidenced in his later work.

Inness' influence upon the impressionable youth was double-barreled, for during the run of the show an article concerning the artist's theories on painting appeared in *Harper's New Monthly Magazine,* a publication which was received at the Davies household. There Inness wrote that a work of art is

> simply to reproduce in other minds the impression which a scene has made upon [the artist]. . . . Its aim is not to instruct, not to edify, but to awaken an emotion. The highest art is where has been perfectly breathed the sentiment of humanity. Rivers, streams, the rippling brook, the hill-side, the sky, clouds—all things that we see—can convey that sentiment if we are in love of God and the desire of truth.[13]

Inness' spirituality had been strengthened when it came under the influence of the preacher Henry Ward Beecher. Initially Arthur was likewise strengthened by his father's influence. Yet Reverend Davies' strong, fundamentalist beliefs were something his son would eventually turn against and abandon.

Inness had further been moved by the philosophy of Emanuel Swedenborg, who was to influence Davies as well. The eighteenth-century Swedish mystic believed that God communicated through nature, resulting in a spiritual significance within everything on earth. If nature served as an extension of God's spiritual realm, it logically followed that the artist should strive to produce paintings emphasizing this unity, the harmony of the universe that signified God's presence. The dark, old master appearance of Inness' oils, with their indefinite silhouettes of hills and trees, seemed to capture this ideal. It appealed likewise to Davies.

During the winter of 1878–79, sixteen-year-old Arthur B. Davies was beginning to think about selecting a college in further pursuit

of his art career. However, early in the new year his father suffered business reverses so plans for Arthur's further education had to be abandoned. His two older brothers were sent to Chicago to contact friends and obtain employment prior to a possible move there by the entire family. Their sister Lizzie wrote them on February 6, 1879, asking "the result of your conference over pa's letter" about whether to go ahead with the move:

> ...pa has come to the opinion that we ought to go [to] C[Chicago] anyway. And really boys it does seem the best ... Never mind if we cannot have as nice a house or live as well as you would like, still we will all be together ... if we do not go this spring, I do not think we will ever come. For pa is very anxious to go in business for himself if we stay here [in Utica] and that will involve new perplexities for both him and us.[14]

Why Chicago? Job opportunities seemed more promising there as the city recovered from the Great Fire of a few years before, when one-third of it had been destroyed. There was a great rebuilding effort and Arthur's father imagined this as an appropriate site for his own fresh start as well.

On March 25, 1879, eighteen Utica businessmen signed a letter recommending David Thomas Davies "to the favorable reception and confidence of all those who may form his acquaintance in his new & future home" of Chicago. The testimonial indicates that he, "of the late firm of Davies & Jones," had been a manufacturer and dealer in men's clothes in Utica for fifteen years, "the reverses of Business & fortune having recently overtaken him."[15] For Arthur, the move would mean an opportunity to further his art studies and to experience his first real love affair.

❧ 2 ❧
Chicago and the Southwest
(1880–1885)

By the late spring of 1879 the Davies family was in Chicago, and soon after settling in, Arthur obtained a job as a bookkeeper with Alexander Geddes and Co., a firm that held a seat on the Chicago Board of Trade. Although he excelled in mathematics and had an analytical mind, recording bids on grain and pork bellies did little to satisfy his creative bent. He soon enrolled in a class at the Chicago Academy of Fine Arts, where his fellow students included Albert Sterner and George Gray Barnard.

Yet most of his art activities were carried out on weekends at home or at the Chicago zoo. He filled one sketchbook with numerous drawings of a lion, an ostrich, and deer. There is a pencil rendering of his thirteen-year-old sister Emma reading, and another of her sweeping the floor; his older sister Lizzie also posed for him, playing the piano and sitting casually in a chair.

Some of these drawings appear in outline only while others contain careful shading, evidence of keen observation and a sure hand. A sense of humor is also occasionally revealed in the sketchbooks, as in the drawing of a bird perched atop a sign reading "Keep off the Grass." Other subjects include a dilapidated pier, with flotsam and jetsam floating over the water and the silhouetted skyline of Chicago in the distance.

Toward the end of 1881 Arthur's father fell ill, the hardships of the new environment having apparently taken their toll, and an old friend from Utica provided him with the funds necessary for a trip to Colorado to regain his health. At about the same time, Arthur was diagnosed as being threatened with tuberculosis, so after he had endured two Chicago winters, a change to a warmer, drier climate was suggested for him as well. Upon learning that the Atchison, Topeka and Santa Fe Railway was seeking draftsmen and surveyors in the Southwest, he obtained a job and set out for his post. Although the nation had been united by a ribbon of rails a dozen years earlier, the Santa Fe had sought a second, more southerly route to the California coast. These tracks were completed in March 1881 when they linked up with the Southern Pacific Railroad at Deming, New Mexico. During 1881 and 1882, however, fully two-thirds of the Santa Fe's iron rails were slated for replacement with steel ones, their deterioration due to the increased weight of the company's locomotives. Additionally, sections of track between Lamy, south of Santa Fe, and Las Vegas, New Mexico, had washed away during the preceding rainy season. Now surveyors and draftsmen such as Davies would initiate the construction.

Legend has it that Davies traveled by horseback, taking three months to reach New Mexico via the Rockies. The vision of a sickly nineteen year old braving freezing weather, wild animals, and unfriendly Indians and cowpokes does provide an adventurous touch; however, it is much more likely that he made the trip on the Rock Island Railroad from Chicago to Kansas City, then over the recently laid tracks of the Santa Fe to his station in the northeast corner of New Mexico Territory. Sketches by Davies indicate that he was compelled to stay overnight in Dodge City, and it was there that he experienced his first taste of the West—of longhorn cattle being driven through the town to the railroad's holding pens and of streets lined with dance halls and saloons. Yet when it came to recording scenes of this Wild West outpost in his sketch pad, he preferred drawing a pair of prospectors with picks and burros, a horse tied to a hitching post, and a farmer plowing his field behind a team of mules.

Arthur met up with the men who would comprise the surveying team for the railroad; most of them were Civil War veterans, older men who packed pistols and donned well-worn cowboy hats.

Arthur's job was to serve as draftsman for the team; they would drive stakes to mark the route, he then drew a plat plan. His first work was along a nine-mile stretch from Las Vegas to Hot Springs, producing drawings there and at Glorieta Pass atop a seventy-five-hundred-foot mountain. From that spot the railroad began its gradual descent over what was once the Santa Fe Trail, soon paralleling the Rio Grande River.

In his spare time Davies sketched the towns of Lamy, Cerrillos, Bernalillo, and Laguna, New Mexico, all of which had grown up along the single track right-of-way.

The surveying team traveled in mule-drawn wagons and, like the track gangs that would follow, their shelter consisted of tents outfitted with wood-burning stoves. Davies and the others existed on a diet of beans, pork, bread, sorghum, and sometimes buffalo meat. Gamblers and prostitutes were attracted to the railroad gangs, recognizing the ready market among men who sought entertainment after a hard day's work and had the ready cash to pay for it.

On Saturdays the railroaders would ride into the nearest town and drink away much of their pay. Cerrillos, New Mexico, for example, was also home to hundreds of lead, zinc, and silver miners, and there were twenty-one saloons located there. It was in such places that Arthur, probably wishing to be considered the equal of the older men and beyond the reach of his father's call for abstinence, became a steady drinker.

Davies arrived in New Mexico just three months after Billy the Kid was killed there, and the threat of bodily harm from other outlaws, professional gunslingers, and poachers was ever present. Yet for Arthur and his team, the most ominous threat came from the rival gangs of the Denver and Rio Grande Railroad who sought to halt further construction of the Santa Fe. They stood accused of dynamiting the roadbed and tearing up sections of Santa Fe track under cover of darkness. Sidearms and carbines were always at the ready for just such occasions.

During the evenings, Arthur captured the likenesses of his companions as they erected a tent, peeled potatoes, or mended clothes, some still wearing their guns and holsters. Each figure drawn and shaded in pencil is identified by name: Long Barney, Crazy Jack, Shorty, and Tooley. And the artist/draftsman interspersed his likenesses of this

imposing lot with those of animals, including two horses and his dog Major whom he had brought along from home.

Davies was also drawn to the changing landscape. The route of the surveying team paralleled the Continental Divide, and he never tired of making sketches of Ponderosa pines, Douglas firs,

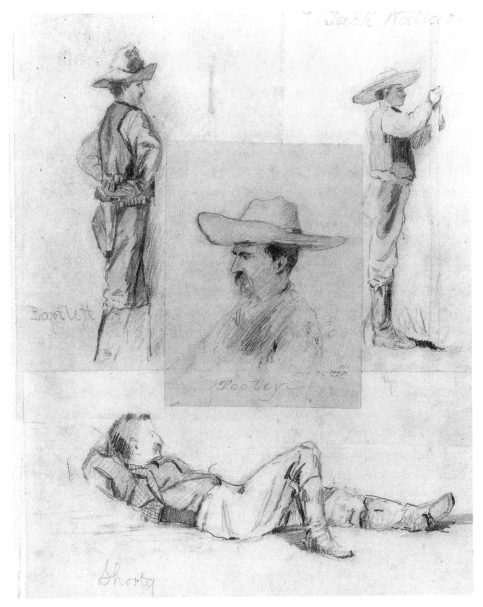

Figure 3. Fellow members of Davies' Santa Fe Railway surveying team, 1881. Pencil on paper, 8¼ x 6½ inches. Collection of Sylvia Davies Diehl and Kenneth R. Diehl.

spruce, and cottonwood trees, and the overlapping silhouettes of mountain ranges. At the lower elevations there gradually appeared a semi-desert terrain with scrub brush hardly sufficient to sustain their horses. In the summer, temperatures sometimes soared to near one hundred degrees; in winter they could dip to below zero, just as cold as Chicago.

Out of curiosity and family tradition, Davies visited the mission churches located in pueblos along the rail line. It was there that he saw, according to Dwight Williams, European-style religious paintings, their images influencing his future artistic style. In the Church of San Felipe de Neri in Albuquerque he gazed upon a sizable canvas of *Jesus Crucified*. In this painting the figure is placed upon a simplified background of earth, distant hills, and sky all painted in Venetian red. Sixteen miles south, in Isletta's Church of St. Augustine, he viewed an oval composition of the Madonna enthroned, including fourteen angels and religious figures in red and blue, based on an earlier Italian original. Another, of the Madonna with St. Anne, possessed the poses and subtle shading of Renaissance painting. But it was in the adobe Church of Santa Domingo that Davies was most impressed by what he saw. There, through flickering candlelight, he viewed fourteen oils representing the Stations of the Cross and stylistically similar to medieval Italian painting. They were destined to influence his own painting style in the future.

In the ensuing months and most of 1882, Davies viewed additional examples of Gothic religious art when he and his team worked in Mexico, for the Santa Fe's directors had decided to construct a railroad all the way to Mexico City. Now, as a result of Davies' extensive field experience, his title was upgraded from that of draftsman to civil engineer.

His initial sketchbook entry as he headed south was a meticulously detailed pen-and-ink drawing of a customs officer with a sword and pistol hanging from his waist, his face partially shaded by a sombrero as he sits astride his gleaming black mount.

Davies and the surveyors began work at Paso del Norte (now Ciudad Juárez) across the border from El Paso, then headed for Guadalupe and Chihuahua. At midyear they were called to Mexico City to help with the track being laid to the north. Now the subject matter of Arthur's art became increasingly varied: At Chihuahua he

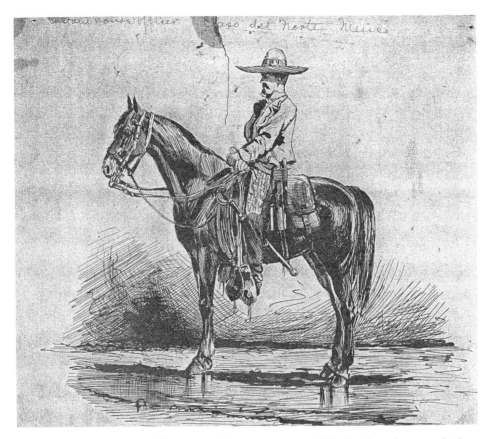

Figure 4. *Custom House Officer, Paso del Norte, Mexico,* 1882. Brush and pen-and-ink on paper, 9 x 11³/₄ inches. Collection of Joan Dye Gussow, Piermont, New York.

drew eight oxen pulling a cart; near Mexico City, a woman making tortillas and another kneeling in prayer; at Palmillas, a blacksmith and a young Mexican boy. And where most of his earlier drawings had been limited to pencil, he now expanded his media to include brush and ink, watercolor, gouache, and pastel.

Adobe architecture fascinated him, from small, whitewashed homes, to churches where a cast shadow from the bell tower could serve to interrupt the otherwise gleaming white facade. And there were always the ranges of hills and mountains silhouetted against a clear blue sky. Because some of his sketch pads contained alternating pages of gray and tan paper, the resultant tempera paintings are especially impressive, with white walls and clouds sparkling against the darker sheets (Plate 1).

At one point Arthur wrote to his family: "Wish you would send me a full pan of Winsor & Newton's moist water color 'Cobalt Blue.' " He noted that there was a large coliseum in Chihuahua "like the one in Rome" and also observed: "Some awful pretty girls here ('dark-eyed Senoritas') but they are bold as brass. . . . "[1] No other letters survive from the year in Mexico admitting to a fascination or even a passing interest in women.

One of Davies' last jobs for the railroad involved drawing up specifications for the route near Zacatecas in the summer of 1883. The city was dominated by an imposing cathedral, its tall twin towers piercing the sky. Davies was intrigued by its baroque facade replete with stone carvings of cherubs, shells, leaves, and branches abundant with fruit; such decorative elements would one day find their way into his art.

When the railroad work was completed, Davies' employment was terminated, and he retraced the route through El Paso, New Mexico, and Dodge City on the trip back to Chicago—producing a continuous stream of sketches along the way. Some were of single figures—a surveyor beside his transit, a woman washing clothes—while others were more complete compositions, such as a group of pueblos labeled *Ruins at Santa Domingo* and a camp in the Sierras. Color notations indicate that several of the drawings were intended as the basis for future paintings.

His return to Chicago after a two-year absence should have made for a festive homecoming, but he was met with sadness instead. A month earlier, on September 5, 1883, his father had died of consumption in Colorado. The change in air and environment had come too late to benefit him, and toward the end of his life he complained of "hard spells of cough" and confessed to extreme weakness and a loss of his voice.[2]

Arthur had, of course, missed the internment of his father in Chicago's Oakwood Cemetery, as well as a memorial service held in his former church in Utica. As a pall continued to hang over the Davies household, Arthur took his leave. This time he accepted employment painting Bull Durham Tobacco advertising signs which graced the sides of barns, houses, and fences. Some locations were in the Chicago area while others took him farther afield.

This period of hack commercial work was one he preferred to forget, speaking only briefly of it years later, when he took Marsden Hartley to his first baseball game. As the two of them sat in the stands and Davies glanced out at the high board fence that surrounded the playing field, he pointed to an Adams Chewing Gum sign and told Hartley, "That's the way I used to earn my living."[3]

After a year the wanderer returned home, carrying with him his trophy: A pair of overalls so caked with pigment that they could stand up by themselves. Examining his collection of drawings from the Southwest, he chose two compositions from which to produce a pair of etchings: *Herding Towards Noon* and *Two Burros*. *Herding Towards Noon* is of a shepherd looking out over his grazing flock, and *Two Burros* shows only the animals' heads in a darkened, stable-like enclosure. Although the crosshatch shading appears a bit crude, when they were transferred onto copper plates, these represent his initial foray into a print medium. Then, using his sister Lizzie as a model, he produced several more etchings, the image for one measuring less than 2 by 3 inches.

The Davies family subscribed to a dozen art and literary publications, including *Frank Leslie's Illustrated Newspaper, Munsey's Magazine, Commercial Advertiser and Graphics, Country Life in America, Harper's Monthly,* and *Harper's Weekly.* Arthur would pore over the illustrations, using watercolor washes to enliven the black-and-white wood engravings. In the February, 1885, issue of *The Century Magazine,* for instance, he chose a picture of two women reading in a garden and bestowed upon one a pale yellow dress; in the June number he tinted a woman's hair and gown red and her necklace and bracelet a golden yellow. Such focus on the female figure was a precursor of his own art's future direction.

Another influence from the magazines came in the form of an article in *The Art Union* titled "What Makes an Artist":

> . . . when it comes to studying Art seriously as a life pursuit . . . in no other vocation is a man required to be at the same time two things so different as the artist must be. He must be at once a poet and a mechanic. His imagination must set before him an ideal, and his hand must have the cunning to execute the shapes and colors which will ex-

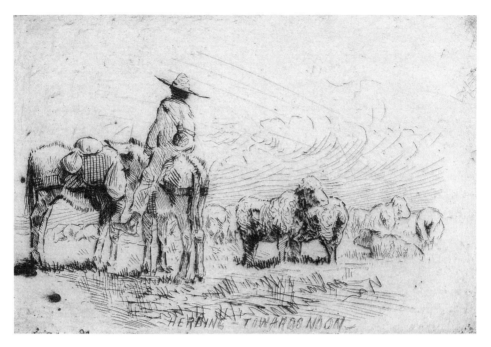

Figure 5. *Herding Towards Noon,* 1884. Etching, $3^1/_4$ x $4^{15}/_{16}$ inches. The Metropolitan Museum of Art, Gift of Mrs. A. B. Davies, 1930. (30.6.11).

press that ideal. . . . the imagination of a great artist must . . . be lofty . . . To become an artist the student must have these qualifications.[4]

Taking the statement about being a mechanic seriously, Davies practiced drawings, producing pen-and-ink studies of women and pencil compositions of landscapes. Many of the latter were created in the summer and fall of 1885 in and around Rowlesburg, West Virginia. One of them, titled *The Causland Mountain Project,* may explain the reason for his being in the East: perhaps he was a draftsman for another railroad job, since Rowlesburg was on the main line of the B&O between Chicago and Washington. Davies created these rural landscapes in soft graphite, most of them views of the Cheat River grade and Grafton, West Virginia. Whereas his pen-and-inks were usually on white paper, these subtly shaded renderings of tree-clad mountains and rushing water were on tinted sheets, allowing for the addition of highlights in opaque white.

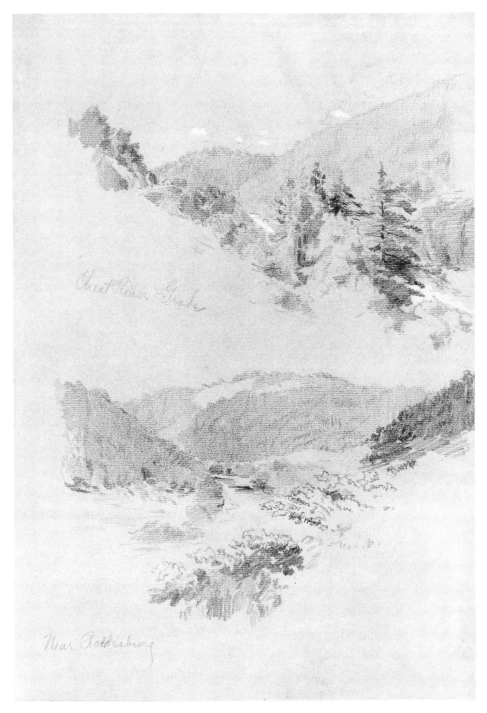

Figure 6. *Cheat River Grade and Rowlesburg* [West Virginia], 1885. Pencil and Chinese white on tan paper, 12⁵/₁₆ x 9 inches. Collection of Mr. and Mrs. Niles Meriwether Davies, Jr. Photographer: Duane Suter.

The combination of pencil and gouache on tan or gray paper was a popular blend, the middle-value background providing a contrast for pencil tones ranging all the way to black and white paint adding the lightest shade. Such a medium was utilized by Winslow Homer and second-generation Hudson River School artists, including Frederic Church, Jasper Francis Cropsey, and William Hart. Davies' beautifully controlled landscapes appear technically the equal of theirs.

Back in Chicago in 1886, Davies and a partner established the firm of Lederer and Davies, specialists in graphic arts reproductions and produced as a sample "Specimen of Typogravure," a sepia halftone of one of Davies' West Virginia compositions titled *Twixt Grafton and Newberg*. However, when the undertaking turned out to be unprofitable, Arthur, for the first time in his life, became a regular art student, one anxious to compensate for the formal training he had missed earlier.

❧ 3 ❧

First Love
(1886–1889)

On October 4, 1886, a week after Arthur B. Davies turned twenty-four, he entered the School of the Art Institute of Chicago. He signed up for the Morning Antique Class and the Costumed Life Class which met daily from 9 A.M. to noon and from 1 to 4. The latter course was taught by Charles Abel Corwin, a young Munich-trained artist who had worked under Frank Duveneck. Many of the drawings Davies produced in the class still exist—sketches of a male model who posed leaning on a rake or wearing a Civil War uniform, and a woman outfitted in a Spanish dress or a cloak and bonnet. Here Arthur sought to master the multitude of media he had already tested on his own.

Yet it was the Antique Class that caught his fancy, in part because of its content—plaster casts of classical European sculpture had just arrived at the school the previous year—but to an even greater extent because of the teacher, Alice Kellogg. The same age as Arthur, she was diminutive—only a half-inch over five feet tall and in marked contrast to Arthur's nearly six-foot height. He was attracted to her from the start, to her beautiful face, round cheeks, classical nose, full lips, and well-endowed figure. Arthur himself was handsome, as evidenced by his image in a sepia photograph he gave Alice: Piercing, deep-set eyes, a strong nose and chin, flawless complexion, and dark hair carefully combed and parted.

21

Figure 7. Alice Kellogg, ca. 1890. Photograph. Courtesy JoAnne Wiemers Bowie.

Their student-teacher relationship quickly became something much more. Sometimes he accompanied Alice to the Rock Island Railroad where she entrained for her home in Washington Heights southwest of the city; on other occasions he visited her studio, where he watched her paint and they made drawings of each other. His 1887 etching titled *Gold of Youth* is a portrait of Alice. Arthur soon confided to a friend in Utica that he had found his love, and she wrote to one of her sisters about the possibility of marrying him.

Alice Kellogg, a cousin of the Kelloggs of Battle Creek, Michigan, came from a family with strong ideas about the mysterious links between body and soul. Alice was concerned with certain metaphysical notions. Her bookshelves included volumes by Swedenborg and it was probably she who introduced Davies to Theosophical thought. As she wrote on two occasions to a family member:

> I have been reading . . . "Karma" by [Alfred Percy] Sinnett. What an odd book it is . . . I am gradually being harmonized to the Order of Things. . . . It is a shame to inflict so much incoherent metaphysics upon you, but there are none to whom I can talk [about] them beside you, and Arthur . . .
> The Christian Science-Theosophy and all that, which seemed so real so true to me, still seem real, seem true . . . [1]

Early in 1887, Charles Corwin informed Davies that artists were needed to paint a new cyclorama being built as a tourist attraction adjacent to the B&O passenger depot on Chicago's Michigan Avenue. Invented a century earlier, cycloramas were panoramic views painted on the walls of enormous circular rooms and calculated to appear real by filling the viewer's entire field of vision. In 1808 John Trumbull planned a panorama of Niagara Falls; six years later John Vanderlyn began one of the palace and gardens of Versailles that measured 12 by 165 feet when it was erected in New York's City Hall Park. The country's most successful cyclorama—and the one that inspired the Chicago undertaking—was completed in 1884 at Gettysburg. It graphically depicted the great Civil War combat scene of Pickett's Charge, in which Confederate soldiers broke through the Union lines.

When the Chicago entrepreneur H. H. Gross had his three-story high, circular shell constructed—being certain that, at 365 feet in diameter, it would exceed the dimensions of the Gettysburg structure by nine feet and could thus be advertised as the largest—he had the exterior emblazoned with a sign proclaiming "Battle of Shiloh." Here was a Civil War encounter that represented a true victory for the Union troops under the command of General U. S. Grant, the recently deceased president.

Gross engaged six artists to carry out the project: Davies; John H. Twachtman, also known to Corwin; Warren Davis, a classmate and friend of Davies; Joseph P. Birren, who had assisted in painting the Gettysburg cyclorama; Oliver Dennett Grover; and Frank C. Peyraud. Davies' expertise at drawing animals won him the job of painting the horses. Twachtman, already on his way to becoming an impressionist, produced the sky. Birren, who had the reputation of being the only artist among the Gettysburg muralists capable of making a dead soldier appear dead, was given responsibility for most of the figures. According to Davies, one of the other artists felt compelled to bring rocks, grass, and earth into the workplace in order to achieve more realistic renditions in what he considered the dullest areas of the composition.[2]

Employment on the project marked a turning point in the careers of at least two of the participants: Twachtman, who had returned from Europe penniless the year before, could now go home to Connecticut and afford to pursue his art, and Arthur used the funds to fulfill his long-time desire to head for New York City. Davies also later produced a small, near-impressionistic canvas titled *Landscape,* evidently another ramification of working on this project with John Twachtman. Its muted palette, vague foreground, and misty row of trees appear to be influenced by equal parts of Twachtman, Inness, and Thomas Dewing.

Davies' decision to leave Chicago coincided with Alice Kellogg's plan to embark on two years of art studies in Paris. Though physically separated, the two remained close through correspondence. Alice, in the French capital by Thanksgiving, 1887, wrote to her sister Peggy: "If you see Emma or Lizzie Davies—please give them my love. I had a lovely letter from Arthur . . . "[3]

Figure 8. *Landscape*, 1887. Oil on canvas, 8¼ x 12 inches. Sheldon Memorial Art Gallery, University of Nebraska-Lincoln, Howard S. Wilson Memorial Collection, 1966.

This was followed by a steady flow of correspondence from both sides of the Atlantic, Alice acknowledging that "I get such good letters every week from him and write him—just as often." Her letters indicate other items he sent her: "I had such a good one from Arthur with a birthday book ... selections from George Eliot ... "; "One of my Xmas gifts came from New York—Arthur, of course, a lovely copy of The Sower [by Millet] ...," and "Yesterday that dear Arthur sent me—as he always does, a fine book, 'Emerson in Concord' and in it I read this which breathes so universal a spirit ..."[4]

Alice wrote to her family on August 12, 1888:

> Arthur sent me a copy of St. Nicholas which had some illustrations by him in it. They were very good, by far the best in the book, and full of that something, that sympathy and understanding that is in his work almost more than in any one's I know. The story was a sweet one with a good deal of boating and sea water in it as well as much sweet human feeling. ...[5]

The article that caught her eye was "The Bell-Buoy's Story" by Lucy G. Morse, which appeared in the August number accompanied by four Davies illustrations. In addition to those of a woman standing at the end of a wharf, a sailboat plowing through high seas, and a man swimming to rescue a maiden clinging to a buoy, there was a drawing of a young couple picnicking on a hilltop. It was the latter which illustrated the portion of the story that Arthur must have found particularly fitting to his situation:

> "You are *sure* to be a great poet," said Margaret ...
> "Ah no, little Peggy!" sighed Russell, "that is an impossible dream of yours. I must work for bread and butter, not for fame."

It could have been Alice Kellogg who suggested that he seek work as an illustrator, for she had produced the drawings for Lydia Avery Cooley's book *Singing Verses for Children*. On the other hand, Davies was aware of the number of artists for whom illustration was

a stepping stone to a painting career, beginning with Winslow Homer. Frederic Remington's scenes of the Wild West had been a familiar fixture of *Harper's Weekly* for six years, and illustrations by Willard Metcalf in *Harper's New Monthly Magazine* included views of the Rio Grande and El Paso. When Davies began contributing to *Saint Nicholas Magazine* in May, 1888, Remington's art was appearing on its pages, too, together with that of a dozen other artists, including Edwin Blashfield and Joseph Pennell.

Davies' initial illustration was reproduced the previous March in *Century Magazine,* owned by the same company. For an article entitled "Some Pupils of Liszt" he had been provided with a photograph of the composer and assigned the task of transforming its halftones into a pen-and-ink rendering, from which a wood engraving would be made and used in the printing process. Although the Liszt portrait was unsigned, for it was only a copy, subsequent illustrations can be identified by his initials. And because one of his fellow students in Chicago was named Arthur Dawson, Davies always signed his work "ABD" to avoid confusion.

Liszt was an appealing subject to Davies because he advocated the new musical concept of Richard Wagner, who had already become Davies' favorite. Davies was in regular attendance at concerts featuring Wagner's works. When the Abbey Opera Company appeared in Chicago several years earlier to present *Lohengrin,* he was there, and he was also on hand when Walter Damrosch brought his German Opera Company to Chicago to stage *Tannhäuser.* It would not have escaped Davies' notice that Franz Liszt had died while attending a Wagner festival.

During the remainder of 1888 and for the next few years, Davies' illustrations appeared intermittently in publications of the Century Company. For *Century Magazine* his drawings—sometimes simple, individual subjects, at other times, ambitious compositions—accompanied such articles as Charles De Kay's "Pagan Ireland" and John Muir's "Treasures of the Yosemite and Features of the Proposed Yosemite National Park." One three-part series was jointly illustrated by Davies and J. Alden Weir; another, "Life in California Before the Gold Discovery," by Davies, Frederic Remington, and Charles Dana Gibson.

Simultaneously, Davies produced more frivolous drawings for *Saint Nicholas: An Illustrated Magazine for Young Folks.* Over a

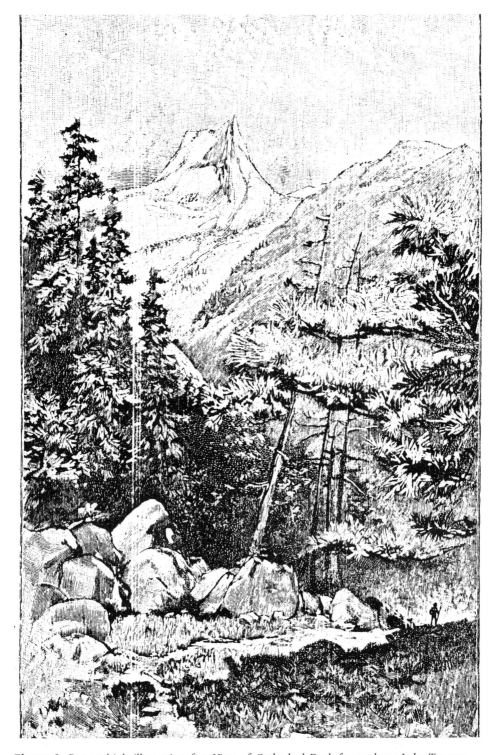

Figure 9. Pen-and-ink illustration for *View of Cathedral Peak from above Lake Tenaya,* in John Muir's "Treasures of Yosemite and Features of the Proposed Yosemite National Park," *The Century Magazine 40* (September 1890), page 658.

Figure 10. Pen-and-ink illustration for Eudora S. Bumstead's "Waiting for Santa Claus," *Saint Nicholas Magazine,* 16 (December 1888), page 225.

four-year span he contributed thirty-five illustrations for a dozen stories and poems. Typical were four pen-and-inks of costumed boys and girls to accompany a play titled "Waiting for Santa Claus." The children's figures are convincing, well-rendered, and appealing.

During the fall of 1888, ABD enrolled in an evening Costume Sketch Class at the Art Students League. It was taught by Kenyon Cox, who also drew for *Century.* Cox had become an advocate for Puvis de Chavannes, the French muralist, and it was probably he who initiated Davies' interest in Puvis when an exhibit of his allegorical paintings was held at the National Academy of Design that year.

The league was located at the time on East Twenty-third Street in an old piano factory. Davies counted among his fellow

students Edith Cooper, who was sufficiently enamored of him and his art that she produced an engraving of one of his compositions; and Mary Helena Horgan, who in later years would say that she was Arthur's first love. There were a sufficient number of locations in the league building for the two of them to take refuge, including an isolated, top-floor studio where someone had written in chalk across a ceiling beam these words by Emerson: "Congratulate yourselves: if you have done something strange and extravagant and broken the monotony of a decorous age."[6] With Arthur having recently turned twenty-six and Mary nearly a decade younger, it was he who must have assumed the role of teacher.

Meanwhile, Alice Kellogg was studying and painting in Paris, making a name for herself as one of only a handful of American women artists represented in both the Exposition Universelle of 1889 and the Paris Salon. She maintained her weekly correspondence with Arthur, sending him her best compositions and a copy of the Salon catalogue. Everything in Paris seemed to remind her of him. The artist who critiqued her evening class, she wrote her sister Kate, "with deep intense dark eyes, a nervously sensitive face and a very low quick way of speaking" was likened to Arthur; on another occasion she saw some pictures, "really wonderfully true and inspiring renditions of many phases of Nature. They made me think all the time of Arthur . . . "[7]

After two years abroad, Alice planned her reunion with ABD. "Even if I were to marry . . . ," she confided to her sister, "if Arthur and I find that we two . . . are necessary to each other, I hope I may marry. And if we are not, pray heaven that I may be brave."[8]

In order to increase his income, perhaps in anticipation of Alice's return, ABD sought additional illustration work and succeeded in obtaining it. Seven of his pen-and-ink drawings on the subject of the Oklahoma Land Rush of April, 1889, appeared in the May 4 and 18 issues of *Harper's Weekly*. He wrote of his anticipated triumph in a letter to his sister Emma in Chicago:

> I have been very busy since I came to Newtown [a section of New York City]. I did a lot of work about the celebration time and now have a number of pen drawings on hand for Harper's Weekly. As soon as they are finished, I shall com-

mence some color work again. I think this month will foot
up in the neighborhood of 300.00. But I really do not like
to think about money when working. The results are not so
good artistically nor am I as happy as when I do the work
simply because *I like to do it.* Then it is play—I do more
work & better [work] that way. Harper's are always limiting
a man so by their business rules—I hate to work for them.
But I guess I shall be able to do as I please after a while.
As yet I am a new man and they watch me pretty close . . .[9]

But Davies' hope of financial stability from turning out illustrations
did not materialize, and these drawings became his sole contribution
to the pages of *Harper's Weekly.*

He had already gained a reputation at *Century* and *Saint
Nicholas* as one who reluctantly changed his drawings to suit the art
editor's taste, and as a result he was assigned a decreasing amount
of work. During one six-month period only three of his drawings
appeared in *Century:* One of Sutter's Fort in California copied from
an old print, an adobe house, and a Civil War view of the Johnson's
Island prison (more architecturally descriptive than aesthetically pleas-
ing) drawn from a soldier's sketch. How envious he must have been
of Frederic Remington, only a year his senior, who was regularly
represented in the magazine by a dozen drawings per issue.

On one occasion when an editor rejected an illustration Davies
had submitted because he considered it art, not illustration, ABD
found himself lacking the anticipated rent money. He announced to
his landlady that because he was now an artist "she could worry about
his room rent."[10] Yet he worried as well about living in poverty.

Alice Kellogg conspired to leave Paris for Chicago in August,
1889, via New York. "I want to stay two or three days there to see
Arthur . . . ," she informed her sister.[11] But when the meeting took
place, ABD turned her away, stating that he simply did not wish to
get married at that moment. The real reason was most likely profes-
sional jealousy at her accomplishments, his crush on Mary Horgan, or
his financial plight. At the time, Davies was so strapped for funds he
was forced to share a single room on Twelfth Street with Bob Adams,
his boyhood chum from Utica who was now a medical student.

Thus rebuffed, Alice left to resume her career as a painter and
teacher in Chicago. Several months later, Alice's longing for Arthur

got the better of her and she tried again. Closing her Chicago studio, she moved to New York in order to be near him. Then, rejected a second time, she departed for good to an art colony in upstate New York.

Davies had succeeded in extricating himself from one love affair but would soon find himself involved in another.

❧ 4 ❧

Marriage and Murder
(1890–1892)

During the summer of 1890, Arthur and Bob Adams were on a ferry boat when they met two women whose destination was the same as theirs—a concert on Staten Island. The men's new-found companions, it turned out, were both medical doctors at the New York Infant Asylum: Lucy Virginia Meriwether Davis, the chief resident physician; and Angenette Parry, her associate.

Arthur was immediately smitten by Dr. Davis' looks: she was angelic, with a round face, fair complexion, a slightly upturned nose, blue eyes, strawberry blond hair, and a height of five foot one. For her part, she found Arthur quite a gentleman, a charmer, and an impeccable dresser.

Though Virginia spoke in a soft voice with a slight Southern accent, Arthur quickly learned that she was anything but demure, this independent woman who challenged him with her intelligence and her ability as a good conversationalist. They began to spend time together, but not in her flat on Rutherford Place or his on Forsyth Street on the Lower East Side's tenement district. "My room is horridly papered in a dirty yellow, with a large noisy pattern," he confided to her. "I don't want to see the paper—all of my sketches are seen with an effort. I must kill the paper, and the way to do the deed is with more yellow,—sunsets, yellow draperies, bright colors &c."[1]

Figure 11. Lucy Virginia Meriwether Davis Davies, about age twenty-eight, ca. 1890. Photograph. Collection of Mr. and Mrs. Niles Meriwether Davies, Jr. Photographers: Moreno and López.

On her days off from the hospital, Virginia and Arthur would retreat to the country, taking a West Side ferry to the Palisades across the Hudson. There they strolled along the footpaths or sat at the water's edge, gazing hypnotically at the river. On such afternoons and evenings Arthur learned more about Virginia: She had been born in Huntsville, Alabama, and raised in Memphis; her earliest memory was of seeing defeated Confederate soldiers straggling home from the Civil War; and one of her childhood friends had been Jefferson Davis' daughter when the families were neighbors in Memphis.

Lucy Virginia Meriwether Davis was a direct descendant of Meriwether Lewis, of the Lewis and Clark team that had explored the western reaches of the continent. Her father Niles had begun his career in a manner similar to Arthur's—as a surveyor's assistant for the Nashville and Chattanooga Railroad—and eventually became the city engineer of Memphis. Virginia's mother, Lide Smith Meriwether, was an individualist who announced her independence at age seventeen when she set out for the Southwest to earn her own living as a teacher. During the Civil War she had smuggled morphine from the Union side into the Confederacy, taking two-year-old Virginia along in order to dissuade Union troops from searching her buggy.

Virginia followed in her mother's footsteps as a pioneering free spirit by becoming one of the few females to study medicine in New York City. She enrolled at the Woman's Medical College of the New York Infirmary for Women and Children, which had been founded by Dr. Elizabeth Blackwell (the first woman physician in the country) and her sister Emily. Dr. Emily Blackwell served as Virginia's professor of general medicine. "Most of the city's population was so hostile to the thought of women doctors that they shouted and jeered at us as we walked along the street," Virginia recalled. "However, I had little time to fret over such intolerance."[2]

Arthur and Virginia quickly learned of their common interests in art, music, and literature, and that first dreamy, moonlit night on Staten Island was the start of a courtship that had the ring of an increasingly torrid romance. Unable to be with Virginia as often as he wished—"I don't like to feel that I must storm the parapets of the 'enfant terrible' Asylum, to see you when I most want to . . . "[3]

—Arthur resorted to a continuous stream of letters. His initial salutation of "My dear friend" gradually became "My darling," "My sweetheart," and finally "My beloved."

At first he waxed poetic by quoting the words of others, such as Dante Gabriel Rosetti's poem *The Blessed Damozel* or Caliban's speech from act 2, scene 2 of *The Tempest*. When he wooed her with such a sentence as "The lark at heaven's gate sings not sweeter than your kisses," he was modifying a line from Shakespeare's song in *Cymbeline* that goes, "Hark, hark the lark at heaven's gate sings." Soon such literary references were discarded in favor of his own romantic outpourings: " . . . The muses became didactic last night, how they swung in majestic strides over the chords of our being, showing us an ideal, that our city life seemed only an irritation when placed in juxtaposition . . ."[4]

When Virginia was unable to see Arthur because of her work schedule or a date with another suitor, he took her associate, Dr. Parry, or another of Virginia's friends, Lucile du Pré, out instead. After writing Virginia "I think of you constantly," he informed her that

> Saturday evening I spent pleasantly with Miss Parry at the first Symphony concert of the Season, Walter Damrosch is the director you know. I prefer Nickish [sic; Arthur Nikisch, the recently appointed conductor of the Boston Symphony Orchestra]. . . . I shall see Lucile this week and look forward to a good time. . . .[5]

Three weeks later he wrote Virginia:

> I wanted to go to hear Lohengrin this week and perhaps get Miss du Pré to go with me. She is an extremely unique person, Miss D-P. I enjoyed an evening last week with her and wish to know her more. I'm to have a sketch in exchange for one of mine!!![6]

Having planted the seed of jealousy concerning Lucile du Pré, a violinist, music teacher, and amateur artist, Arthur inquired of Virginia: "Why not make life exquisite in the flame of ideal feeling? . . . as the happiness of roses greeting the sun's joy of giving light, the wave's laughing response to the wind's whistle."[7]

Davies' letters to Virginia represent one of the few significant collections of his correspondence, and they contain valuable insight into his art activities, knowledge of artists, and other interests. When she mailed him a pressed yellow leaf, for example, he wrote that it was "strangely expressive—of yourself and of a strange mysterious sweetness like a life that I might have lived three or four centuries ago. Or like some old Italian or Byzantine painting." Then he reciprocated by enclosing violets in his letter to her, asking: "Does Rosetti write about the violet? I know he paints them with beautiful intention . . ."[8]

Referring to a portrait he was drawing of a "sweet faced Madonna," Arthur concluded, "I am likely to turn a Pre-Raphaelite! I have been drawing drapery all the evening & see in Manet, the 'arch' impressionist, more of the old masters than in any of the so called realistic school. Degas another great man—is definitely a classic."[9] Of Charles François Daubigny he wrote: "His work is delicious poetry. Daubigny and Corot are likely to have more admirers than [Theodore] Rousseau—and I think, *I* could live longer with Rousseau."[10]

When Arthur traveled to Taberg, New York, near Utica, to visit his cousin Libby and her husband on their farm, his letters became a virtual diary. He described the train ride from Manhattan, delighting in

the immense oak trees & then [proceeding] along the 'raging canawl' [a reference to the Erie Canal as pronounced in a then-popular song] for about 12 miles. At Oneida I got a genuine whiff of city life & it made me sad. I like the hills of Taberg better than the wide valley of Oneida . . .

The trees about here are immense, on the bare hillsides, these big fellows represent what seems to me, the life of the people—these trees have a magnetic effect on me . . .[11]

Their grandeur inspired him to paint his first large oil, an 18-by-40-inch canvas titled *Along the Erie Canal* (Plate 2). The center of the composition is completely dominated by three large trees situated along the banks of the placid waterway.

In the immediate foreground of this painting, a single female figure faces the observer. The woman's perceived loneliness symbolizes that of the artist himself, as evidenced in his letters to Virginia. During those periods when Arthur was far removed from her, his

letters became increasingly amorous, culminating in a burst of erotic outpourings: "I want to press your soft breasts against mine and kiss your neck, catch the perfume of your hair, see your eyes and curving mouth. Oh, all the sweetest treasures you possess for me."[12] Even after his return to New York City, he would chronicle in his letters to Virginia the sadness of his solitude: "Last Sunday I took a long walk alone, around High Bridge and down by the river . . . " or "To-day . . . I dropped everything and went Palisading—alone."[13] Such melancholy notes were interspersed with those of his planned art activities:

> I must up to Central Park early this morning to sketch tigers, & will try to go again tomorrow. I love animals, one of my earliest ideals was to become an animal painter, & I found the old instinct today revived.[14]

There is also occasional mention of his illustration work, such as "Will try to go into the Century Office today & make further inquiry into the job for Mr. Seamans [the editor]" or "I worked hard yesterday & today—tomorrow I hope to have the other drawing finished for the Century Co."[15]

During all of 1891 the assignment editor gave Davies very few articles to illustrate for either *Century* or *Saint Nicholas*. For the September issue of the latter he was reduced to producing a pair of decorations of tall grasses and a farm boy standing by a fence for a single-page poem. He did not even bother to sign them. Arthur desperately sought other avenues: He produced an elaborate cover design for *The National Cyclopedia of American Biography* and tried teaming up with another artist in a short-lived venture to produce theatrical posters. Then he designed the cover for a new children's magazine to be financed by "two ladies and Mr. George Howes Whittle, of The Century Company, [but] the project's financing disappeared when the two women left for California and Mr. Whittle left the Century Company."[16]

At one point ABD turned to the Lithographic and Illustrative Agency in hopes that it might "cook up trade" for his work, but though he provided a group of art samples, including one of a women's tennis match and a set of the four seasons, the results brought nothing but disappointment.

Figure 12. *A Good Return*, 1891. Ink, wash, Chinese white, and pencil on board, $10^{13}/_{16}$ x $18^{1}/_{2}$ inches. Collection of Mr. and Mrs. Niles Meriwether Davies, Jr. Photographer: Duane Suter.

Amid such gloomy prospects, Arthur looked more and more upon Virginia as both his future wife and immediate financial savior. This became more of a reality during the summer of 1891 when they learned that a company was promoting real estate in Rockland County, about an hour north of New York City, by providing free transportation to the hamlet of Congers. The two of them took the trip, then separated from the rest of the group as soon as the prospective buyers were ushered into carriages that were to take them to the planned subdivision. Instead the couple traipsed through woods and fields bordering the northern edge of a lake, Rockland Lake, and along the hills overlooking the Hudson River. They discovered that a property there, located beside the old stagecoach road that stretched from Manhattan to Albany, was for sale: It consisted of thirty-eight acres, a two-story farmhouse, a barn, and other outbuildings.

For them the farm was love at first sight. Like a pair of schoolchildren, Arthur and Virginia—they were then both twenty-nine years old, she five months older than he—visualized the transformation of a dream into reality. Arthur would abandon his career in art and Virginia hers in medicine. They could quit Manhattan and move to this idyllic site.

Once back in the city, Arthur advised Virginia about the possible purchase of the farm:

> If you gave him [the real estate agent, a Mr. Van Gilder] your check for $100 or $200,—with a receipt & written bargain price from him I do not know of anything more satisfactory until you have the title examined.[17]

Unbeknownst to Arthur, Virginia and Lucile du Pré were planning to buy the property, each having already placed a $100 deposit on it, as this letter from Lucile to Virginia reveals:

> Darling:
>
> On returning home I discovered that only part of my letter has been mailed. As it is a matter of vital importance that we should know how the matter stands with Mr. Van Gilder and the Congers real estate I will mail this remnant today. If you have his receipt for the $100 I already paid, will you

send it? I *used* to possess his receipt for $15, paid down that first day . . . Did I ever have the $100 receipt from him? I only remember yours which I promptly lost.[18]

It is also unlikely that ABD ever knew the true feelings that Lucile harbored for his fiancée, as expressed in excerpts from her letters to Virginia:

> Please devise some plan to be here & stay with me soon as you can—long as you can—whenever you can. So often I dream of you—think of you—wonder about you! . . .
> I can't write frankly about your real problems. I'm pulled between two forces: our absolute love & faith in each other impells me to plain speech— . . .
>
> Beloved,
>
> Oh, Lutie [Lucile du Pré's nickname for Lucy Virginia], how I love you and how I wish I could see your face. . . . I am going to run away to you tonight . . . Write to me when you can, my darling, your letters mean everything to me. . . . Come to me to Palisade Sunday.
> I loved you first because you caressed me, and afterwards from habit, & for your intellectual supremacy. Lately, for your lovely patience with my wiggles of misery . . . I never told of your engagement, though even you thought that I did, until you gave permission to tell Mrs. Moore, when she chided me for dreading your marriage . . . I am what I most abhor, it seems.
>
> Your loving Lucile[19]

In the final analysis, it was Virginia's parents who paid for the farm. By coincidence, they had been summering for several years at one of the resort hotels on Rockland Lake to escape the oppressive heat of Memphis. The sum paid for the farm was $6,500, with the purchase consummated on September 12, 1891.

By this time Arthur and Virginia were engaged, and he agreed to visit his Uncle Joseph Davies and his Aunt Hetty Bowen Davies— they were half-brother and sister— on their farm in Holland Patent, near Utica, in order to learn the business of farming. That fall Arthur wrote Virginia on a regular basis to report his progress:

Figure 13. Lucile du Pré, ca. 1898. Photograph. Collection of Mr. and Mrs. Niles Meriwether Davies, Jr.

Have been making a great many inquiries about farm work & products & realize more daily that a practical work is the thing I need to order to learn . . . the grape vines at Rockland must be trimmed this fall. I also got a course of instruction in grafting apple-trees—planting vegetables, raising chickens, &c. Apple trees should be grafted in the spring before they bud . . .

. . . if I can remember all the instructions I have had this morning we shall have good fruit I can assure you. His apples are the finest I ever ate.

. . . [we should] buy the manure but not the horses—the cows are high price for fall, they say here—a cow should be at least $15 less in fall than spring.[20]

Arthur's crash course in farming did not prevent him from producing some art in his spare time. In one letter he mentions: "I have painted twenty-two studies since I came up here & think you had better have the best of them before someone gets stuck on them."[21] He also filled a sketchbook with drawings of horses, cows, roosters, frogs, and squirrels, each sketch revealing his keen sense of observation and knowledge of animal anatomy.

Virginia apparently sought some changes in Arthur's physical appearance and drinking habits, for in one letter he acknowledged: "I am happy to announce my present weight as 135 lbs., an increase of 6 lbs. in 5 days."[22] In another: "I expect to join a gymnasium this week—go through a regular drill about three times a week. Later on shall do some sparring and fencing . . ."[23] And in still another: "I have decided not to drink any more beer or whisky—I can trace all my 'cussedness' to that. Forgive me."[24]

Arthur's engagement to Virginia could have been a prolonged affair, except that by the beginning of July, 1892, she realized she was pregnant with his child. No shotgun wedding was necessary to convince him to utter the marriage vows, for, as he wrote her:

My darling—your letter came this morning and it made me wish more & more to be a husband to you and that you might have the supreme joy of hope & confidence of your own love & your own motherhood . . .[25]

Before the marriage ceremony could be performed, Virginia's parents insisted on a pre-nuptial agreement "in contemplation of a marriage soon to be performed and solemnized between the parties," in which Arthur

> releases . . . all right . . . as the husband . . . or as father of any possible future child or children . . . to or over the real estate . . . now owned by the second party [Virginia] . . . and . . . all the personal property of whatsoever nature, money, bonds, stocks, bank accounts . . . and over all the earnings and gains which the second party may at any time make by her professional labors as a physician. . . . "[26]

Such a pre-marital arrangement was essential in the minds of Virginia's parents; after all, their future son-in-law was an artist without a visible means of income, and it was Meriwether money that would pay for the farm and provide, at least initially, for his support. Besides, they were from Memphis, and what did they really know about this northerner whose family they had not yet met? Mr. and Mrs. Meriwether must have hoped and prayed that this union would not end in a manner similar to that of Virginia and her first husband, Lowe Davis.

The wedding of Arthur and Virginia took place in the parlor of the farmhouse, with Virginia's parents, her older sister Mattie, and her nieces, Mattie, Lucy, and Rostan, in attendance. In a symbolic gesture, the bride's bouquet closely resembled the one carried by Ophelia in Act IV of *Hamlet:* "There's rosemary, that's for remembrance; pray, love, remember, and there's pansies, that's for thought . . . There's fennel for you and columbines; there's rue for you and here's some for me; we may call it herb of grace on Sundays . . . "[27]

The date of the ceremony is in dispute, having been held either on May 20, 1892 (according to *The National Cyclopedia of American Biography*), July 12 (as listed in the *Lineage of the Meriwethers and the Minors*), or July 8 or late August (dates advanced by various family members). The marriage is not on record in the office of the State of New York, Rockland County, or any of the surrounding subdivisions.

Virginia never sought to hide from Arthur the fact that she had been married before to a Mr. Davis, perhaps explaining it away as an early annulment. But what she probably did not reveal before the marriage—and maybe *never* felt disposed to tell him—was that she had shot and killed her first husband. The whole horrible incident occurred a decade before, and was recounted on the front page of the *(Chattanooga, Tennessee) Daily Times* on September 14, 1882, with a story headlined:

KILLED BY HIS BRIDE

THE TERRIBLE TRAGEDY
AT RHEA SPRINGS

The Full Particulars
of the Most Remarkable
Killing of the Age

"Two months ago two of the most dashing belles of Huntsville [Alabama] were Misses [Virginia and Mattie] Meriwether, daughters of Col. [Niles] Meriwether, a prominent citizen," the article began, "and . . . their most ardent admirers were Capt. Betts and Lon. [Lowe] Davis, son of Col. [Nicholas] Davis . . . and nephew of Zeb. Davis, who was Mayor of Huntsville for many years."

Although Virginia's mother had objected to the attention Lowe Davis paid to her, "the girl appeared to love him, and finally an elopement was agreed on, and one night, when the young couple had engagements to attend a concert, they instead boarded a train for this city where they were married. [Also on the train was sister Mattie, who was eloping with *her* beau, Rostan Betts.]

"The honeymoon passed happily but soon Davis' character began to assert itself, and his wife discovered the awful fact that he was addicted to the use of opium, and was in incessant gambler." After having endured the situation for a time, Virginia finally left him and returned to her home, but "the excitement incident to this brought on brain fever, and for a while her life was despaired of, and when she recovered her mind was partially deranged."

The family doctor had recommended that Virginia be taken to Rhea Springs, a Tennessee spa where the well-to-do came to drink mineral water, rest, and play. Her husband had been advised "to keep aloof from her for some months," and had agreed "not to annoy her by his presence until he was sent for."

Virginia had arrived at the spa accompanied by her mother in late June, 1882, where she had rapidly recuperated "and her intellect was soon restored." Without permission having been granted, Lowe Davis had journeyed to the resort but was prevented from seeing Virginia; however, on a second visit they had met. She had refused "to return to him until he reformed."

The article continues:

Last week he again visited the Springs, but was denied seeing her. Several stormy interviews passed between [Virginia's] mother and him, and for several days he was seen hanging about his wife's room, but was denied admittance.

Sunday he procured a pistol and demanded admittance, or threatened to kill the mother. He was finally quieted and gave the pistol to her. Monday he was heard to say that his wife should return to him or a murder would follow. Tuesday night [Virginia] stepped from her room to go to a toilet room. He was near at hand, and followed. They met some distance from the hotel; and he pointing to a pistol he carried in his hand, demanded that she return to him. She had the pistol he gave her mother in her pocket at the time and quietly slipped it from her pocket [and] placed it against his body, the ball passing through his bowels.

She then walked deliberately to the hotel, informed the proprietor of what she had done as coldly as if she were relating some trivial incident, and left for her room. She exhibited not the least excitement Tuesday night, although many ladies were in hysterics from excitement . . . Yesterday Mr. Davis was found to be rapidly failing. He stated that his wife shot him in self-defense, and he deserved it; that he had brought it on himself, and no one but himself was to blame. . . . at 9 P.M. Mr. Davis was thought to be dying . . . The physicians pronounced Mr. Davis' case as hopeless, and say he cannot live until morning. He is having internal hemorrage. His wife visited him to-night. She exhibited no emotion whatsoever . . . [28]

He had died two days later and his parents had accompanied the body back to Huntsville, where he had been buried.[29]

Virginia had graduated from the Augusta Female Seminary (now Mary Baldwin College) in Stanton, Virginia, in May, 1882, prior to her elopement. Now, just three months later, the scandal had made it uncomfortable for her to return to the family home in Memphis. As a result she left within days of the shooting for New York City to pursue the study of medicine.

❧ 5 ❧

The Golden Bough
(1893)

*F*ollowing the wedding, Arthur and Virginia found their newly acquired home constantly crowded with family—her family. Virginia's parents, her sister Mattie—she was thirty-two and had been recently widowed—and Mattie's three daughters, ages nine, seven, and five, stayed on for the remainder of the summer. It was the beginning of an annual ritual that Arthur came to deplore.

Since Virginia's father had paid for the farm, he and his wife had no qualms about moving in for several months at a time, while Mattie also found the place a wonderful vacation spot for her children as soon as school was out. Initially Arthur delighted in having the young girls around and made sketches of them in watercolor and pastel (Plate 3). But the joy of drawing was more than offset by the negatives of commotion and communal living.

When the newlyweds first moved into their dream house, the land was referred to as "Meadow Sweet" by Virginia. ABD officially dubbed it "The Golden Bough," a name he adopted from the title of Sir James G. Frazer's volume on mythology, primitive culture, and magic. The book had already had a profound effect upon Arthur, who read on its opening page: "Who does not know Turner's picture of the Golden Bough? The scene [is] suffused with the golden glow of imagination . . . a dream-like vision of the little woodland lake of Nemi."[1] Frazer further described the Englishman's painting as

49

Figure 14. The Golden Bough, undated. Farmhouse (on right), barns, and silo (on left). Photograph. Collection of Mr. and Mrs. Niles Meriwether Davies, Jr.

including a palace and terraced gardens which descend to the lake, an image that had its New World counterpart for the newlyweds on the land overlooking the waters of Rockland Lake.

Yet for ABD, the gold of the Golden Bough was already beginning to wear thin. At times the noise level and activities forced him to leave the house, at which point he would gather up a handful of art supplies, often only paper and pencil, and walk the land, sketching a cluster of trees or a figure sitting atop the Palisades gazing out over the Hudson. Maybe such a drawing was intended to represent him pondering his future.

Arthur's resolve to abstain from an art career was short-lived, if he ever really meant it at all. By October, 1892, with Virginia entering her fifth month of pregnancy, he announced his intention of returning to New York City to enroll at the Art Students League. He agreed to visit his wife on weekends, beginning a pattern that was to mark most of the rest of their lives. His situation appears to have been referred to in a letter he wrote to John P. Davis, who had transformed ABD's illustrations into wood engravings for the Century Company:

> . . . the dogwood & laurel are in full feather, otherwise the world is very green and awaiting someone to pursue it as a new bride who knows not that she is pregnant and feels the voluptuousness of life and is full of soup while the happy hopeful husbandman ever widens his sphere . . .[2]

The Art Students League had just moved into the new building of the American Fine Arts Society on West Fifty-seventh Street when Davies enrolled in the Sculpture and Men's Modeling Class under Augustus Saint-Gaudens. His teacher was working at the time on a nude figure of Diana, shown poised on one foot with bow and arrow in hand, which, when cast in bronze, would grace the top of Madison Square Garden. Davies had no way of knowing that the model for the sculpture was Saint-Gaudens' mistress who had recently given birth to his illegitimate child. Nor could Arthur have guessed that he would follow a similar path in years to come.

Inspired by Saint-Gaudens, ABD purchased six plaster casts of European sculptures for his personal use, half of them copies of ancient Roman heads. He also enrolled in a Morning Antique Class,

and, beginning in January, 1893, added a session in sketching as well. One of his fellow students was Edith Cooper, who began her career as a wood engraver by copying an ABD composition of grazing sheep. Another classmate, by coincidence or design, was Mary Horgan.

Virginia gave birth to a boy on or about March 24, 1893, and named him Niles, after her father. It is unknown whether Arthur was on hand for the blessed event, the actual date of which is uncertain since it is not found in any of the family records nor those of New York State. Davies archives indicate that on the day Niles was born, ABD sold his first painting, *Ducks and Turkeys,* at the National Academy of Design. However, a work of his by that title was not shown there until February 5, 1894, further complicating the birth date of the child.

Once again the in-laws descended on the Golden Bough and once again Arthur drew Virginia's nieces. This time he produced a series of studies of Mattie, the oldest child, and a pastel of the two younger ones, Rostan and Lucy, sitting on the ground with a baby lamb. The pastel became the basis for an oil ABD entitled *Little lamb, who made thee? Dost thou know who made thee?,* words known to him as the first two lines of William Blake's poem *The Lamb.*

The small pastel shows a formal composition with the lamb centered and the children, one in profile, the other a back view, in frilly dresses to either side. The foreground is peppered with tiny flowers, the background with tall grasses. Here the figures of Rostan and Lucy appear to be younger than their then-current ages of eight and six, but in the resultant oil their bodies are lengthened. Lucy, on the left, is extended to the point where one foot reaches the bottom edge of the 14-by-12-inch canvas; with the foreground thus all but eliminated, the background becomes a network of dabbed leaves dancing over the otherwise dark surface.

The girls' dresses are simplified in the painting as well. The back of Rostan is devoid of the pastel's predominant folds to such an extent that a line of five light buttons, in a vertical row from neck to waist, assume greater importance against her darkened clothing. It is as though Davies sought to transform her frock into a dark tunic with a row of brass buttons like the one worn by the figure in Manet's *Fifer.* Such a likely artistic influence is combined here with the symbolic, for while the lamb in Blake's poem represents the Christ Child, in ABD's oil it stands for his own newborn son.

Figure 15. *Little lamb, who made thee? Dost thou know who made thee?*, 1893. Oil on canvas, 14 x 12 inches. Private collection. Photograph courtesy Peter A. Juley and Son Collection, National Museum of American Art, Smithsonian Institution.

An opportunity to escape the family's annual summer visit occurred in May, 1893, when the World's Columbian Exposition opened in Chicago. Arthur lost no time in going there. Chicago resident Alice Kellogg already knew of his betrothal, for she had noted in her diary the previous fall:

> Arthur Davies is married to a Miss Winifred *[sic]* Davis—
> formerly—I understand, a nurse in a N.Y. hospital—They are
> living on a farm on the Hudson near New York—Que la Vie
> est un enigma—! [Life is an enigma] And him and I—![3]

Realizing that it was fruitless to continue to carry the torch for him,
she had married a Chicagoan earlier in the year.

Arthur was cognizant of Alice's inclusion in the World's Fair
display, where she was represented by two portraits, one of her
sister and the other titled *The Mother;* in fact, he had viewed the
latter work when it was exhibited in New York and reproduced in
Century Magazine. In addition, she had created an ambitious, clas-
sically inspired decoration for the Women's Section of the Illinois
State Building at the fair. In it, Instruction is personified as a woman
with an open book in her arms facing two children, the younger of
whom is sprawled on the ground and reaching for the apple of
Knowledge.

ABD may have pondered the direction his life and art may
have taken had he chosen to marry Alice. When she died of diabetes
just seven years later, after first having wasted away and gone blind,
he treated the tragedy as if she had been a member of the family
and pasted her obituary in a scrapbook beside his father's.

When he returned from Chicago, Arthur took up residence at 116
East Twenty-eighth Street in New York City, informing Virginia that

> I am back at my old boarding place now—where the food
> tastes like something . . . I know I am fortunate to get in
> here & shall stay all summer in the city. The many little
> resorts I can go to very cheaply & then the country has
> disagreeable features as I found last summer.[4]

Over the past several years, a few of Arthur's drawings and
paintings had found their way into annual exhibitions. His very first
accepted work, *Strawberry Time,* had been included in the American
Water Color Society show of 1888. It was small, priced at sixty
dollars, and placed in a corridor gallery where viewing conditions
were less than ideal. This was a modest beginning, to be sure, but
Davies must have been proud to be exhibiting among some already

well-established artists, including Winslow Homer, Frederic Remington, and John La Farge.

During the next few years, works bearing such titles as *Dawn, An Evening in Spring, Cattle,* and *A Twilight Procession* were included in the Water Color Society's 1892 and 1893 annuals and at the National Academy of Design in 1891 and 1893. Wishing to expand his exhibition opportunities, he wrote to the Pennsylvania Academy of the Fine Arts in Philadelphia:

N.Y. Oct. 6, 1893

Dear Sirs

I have exhibited my work in the past at the N. [National] Academy, Water Color Society here & wish to have an introduction to the Philadelphia art lovers. Will you have the kindness to send me a blank for your coming exhibition that I may submit to your judgement one or two paintings.

Very respty yours

Arthur B. Davies[5]

The effort quickly bore fruit, for two months later a pair of his paintings was accepted in the Pennsylvania Academy's sixty-third annual exhibition. One of them, titled *Mother and Child,* shows Virginia holding their year-old son upright against her torso. Their adjacent heads, the child's body, and a sliver of sky comprise the only areas of light against the mother's black dress and a darkened landscape. The figures' poses appear to be a variation of several Madonna and Child compositions by Giovanni Bellini; at some point Davies even retitled his canvas *Madonna,* furthering the idea of such a source. Despite this, however, the arrangement of the two figures is actually closer to some by Mary Cassatt.

Davies strove for an Old Master appearance in the paint surface as well, seeking to learn how the colors of Renaissance artists had remained so pure, intense, and alive. Yet his early oils, like those of many other nineteenth-century Americans, gradually turned dark with age, losing their luster and in some cases their details. One cause of this was the widespread use of van dyck

brown, a combination of clay, iron oxide, humus, and bitumen. It was not unusual for ABD to cover his canvas with a thin coat of it, perhaps with the notion that it would simulate the Gothic and Renaissance practice of painting on wood panels. But unbeknownst to him and others, this color has a tendency to grow dark, causing some details to disappear. The problem was compounded when, in order to hasten the drying process, bitumen was glazed on top. If a particular work had to be dried quickly so that it could be submitted to an exhibition, the still-moist canvas would be placed in front of a fireplace in an attempt to hasten the process.

Still other difficulties were encountered when ABD mixed a soft resin with his oil paints so the medium would be easier to handle; in addition, certain pigments, such as Paris Green, turned dark when exposed to the sulfurous compounds contained in the then highly polluted urban air.

One of Davies' idols, Albert Pinkham Ryder, was a less than ideal model to emulate when it came to technique. Ryder's pigment could be dry to the touch but remain moist between the outer crust and a wood panel or canvas support. As a result, an occasional seascape's thick pigment would drift ever so slowly downward of its own weight, lapping over the edge of the frame and displaying a wavy horizon line due to the paint drying unevenly over a long period of time. At least this effect was not experienced by Davies.

In ABD's *Mother and Child,* both figures gaze out of the 12-by-6-inch picture as though the composition were inspired by a larger one where another focal point existed. This painting was subsequently bought by a portrait photographer named Alice Boughton. Later Boughton took an unposed photo of Henry James gazing intently at it in the entranceway of her studio. "At the time, my latest acquisition was [this] small painting . . . by Arthur Davies," she would recall.

> This was hanging near the door, and on his way out Mr. James [having already posed for a formal portrait photograph] stopped before it and looked at it a long time, bending forward, in his top hat, his stick behind him. 'Just one more, please—I must do this, for you look like a Daumier!' He seemed really amused, but remained in the same position until I photographed him again. Then we shook hands and he departed . . .

Figure 16. *Mother and Child* (retitled *Madonna*), 1893. Oil on canvas, 11¹/₂ x 5¹/₂ inches. Utica Public Library, Gift of Lizzie P. Bliss. Photograph courtesy Peter A. Juley and Son Collection, National Museum of American Art, Smithsonian Institution.

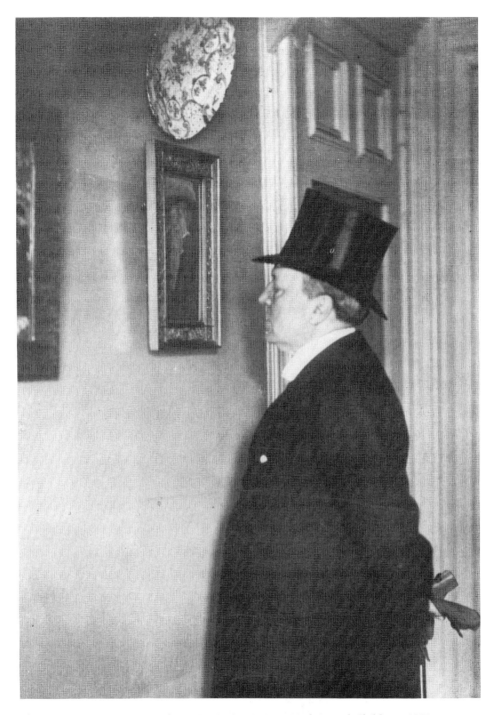

Figure 17. Henry James studying Davies' painting, *Mother and Child,* ca. 1903. Photographer: Alice Boughton. From *Photographing the Famous,* by A. Boughton (N.Y.: 1928).

Not more than five or ten minutes after he had gone, Mr. Davies came in, and I told him about Mr. James . . . examining the painting, and how he looked so like a Daumier picture. To which Mr. Davies replied, "Very tactful of you to tell him that!" "Why tactful?" "Because Mr. James has always been a great admirer of Daumier and years ago wrote an article about him for Harper's."[6]

Arthur utilized Virginia and baby Niles as subjects in other paintings as well. One unusual composition, *Mother and Children,* shows a child about to be breastfed behind a thicket while Virginia's three curious nieces look on. Another, of Virginia nursing Niles, is titled *Golden Stream.*

Toward the end of 1893, Davies succeeded in having some of his recent lithographs exhibited by Frederick Keppel, a print dealer and gallery director who ran the American branch of Frederick A. Keppel and Son, a London firm. One of the prints shown was *Monarch,* made from a drawing of a recumbent lion he had sketched at the zoo. The animal and background surfaces are shaded in the rich grays and black attainable with a lithographic crayon, while some of the highlights were created by scratching into the grease-crayon surfaces with the point of a knife. *Duck Pond,* a farm scene, shows an equal degree of technical proficiency, but its overall pattern of chiaroscuro lacks the drama of a bold dominant form. And a print of Mattie and Rostan standing beside a seated sheep, titled *Golden Age,* was exhibited in an unfinished state, with portions of the girls' bodies and their feet existing only in outline.

Davies' lithographs were the subject of his initial art review, published in the *New York Times* on October 9, 1893:

Lithography, as a means of artistic expression, is almost unused nowadays, but Whistler has been trying it of late. His "Songs on Stone" are soon to appear in London. A young New-York artist, Mr. Arthur B. Davies, has been experimenting for some time in this direction. Some of his prints . . . are at the Keppel Gallery. One of his later essays is a lithograph of a big lion in Central Park reclining in majesty in a savage landscape—rocks on the left, a clump

Figure 18. *Monarch*, 1891. Lithograph, 7^{11}/$_{16}$ x 11^{1}/$_{8}$ inches. Collection of the Library of Congress.

of trees against a distant sea. Lithography, as a rule, is produced by painting the smooth surface of the stone with a special preparation, but Mr. Davies sometimes goes back to the earlier methods, and in parts of the picture uses the knife to scratch or shave the stone, in order to produce particular effects. He is best known as an illustrator, but shows no little skill in water colors and oils....[7]

Within two weeks of the article's appearance, Arthur was called back to the farm, for Virginia found it necessary to return to work at the hospital in New York in order to raise some much-needed cash. She traded places with him, indicating his chores in a letter written on October 22:

It is inexpressibly strange to be going about this old place and the old ghost-like work . . . I shall try to see the Columbian exhibition and the Monets at Durand-Ruel's, and tend to a little business downtown. . . . I forgot to say anything to you of the goose-berries—I should think they might be put at the end of the row designed for currants down by the hickory tree end—they need much shade and coolness. If you can I should like to have the chicken house floor finished so that I can set about hen gathering as soon as I come back . . .[8]

Arthur did the best he could, but when she returned the floor of the chicken coop was still unfinished. Instead he had completed a number of sketches of the fowl. During her absence, Arthur received the sad news that his sixty-three-year-old mother had died. Unable to leave the farm unattended, he was prevented from going to the funeral; thus, unintentionally, Arthur had succeeded in being absent for both of his parents' burials.

For more than six months, Virginia had been caring for their son and managing the farm virtually on her own. "At the start we raised forage and grain crops, some vegetables and some small fruits," she recalled, adding:

. . . we had from 20 to 30 crates of strawberries each day during the season . . . I sold them to local stores and to wholesalers . . . I learned to do, and did do, most farm work except plowing, cultivating and heavy team work . . .[9]

Yet on a page of her private journal dated November 13, 1893, Virginia confided: "What is it I cling to in turning away from medicine . . . "[10]

As fate would have it, all of that was about to change. The Davies farm was located near several large stone quarries, only a few miles from the Haverstraw brickyard, and less than a mile from the headquarters of the Knickerbocker Ice Company. Hundreds of workers for the ice company cut ice each winter on nearby Rockland Lake, then loaded it onto barges and shipped it down the Hudson to Manhattan. Accidents at all of these sites were commonplace, caused by the stone crusher or a mistimed explosion at the stone quarry or a clay cave-in near the brickyard. As word began to circulate that Virginia Davies was a physician, she was quickly pressed into service.

Taking up the medical profession she had earlier vowed to abandon, Virginia became a bona fide country doctor, transforming the first floor of the farmhouse into an office and operating room. The hordes of workmen who labored to cut three-hundred-pound cakes of ice on the lake during the winter toiled at the stone quarry in summer. Whenever a mishap occurred, Dr. Davies rushed to the scene in her horse and buggy and ministered to the maimed or dying. If injured and bleeding workers were transported up the narrow road to the farmhouse, the porch, living room, or kitchen table were pressed into service for emergency operations. Sometimes wounds were even sewed up at the dinner table during a meal.

As more of Virginia's time was consumed by the practice of medicine, Arthur's lovely, well-dressed bride allowed herself to be transformed by her profession into a sweaty, unkempt individual whose simple cotton dresses were often stained with dirt and dried blood. The sight proved repulsive to him, this man of manners who continued to be an immaculate dresser.

For her part, Virginia was beginning to have second thoughts about being married. Her journal entry for Christmas Day, 1893, reads:

> Marriage is like the old punishment of linking a murderer to his victim—a device by which you are held to one individual pressed close up to him, cannot get away from him till you accept human nature for what it is—see your-

self in this light of the universal—have no more twisting
aside and dreaming of other, better, imaginary beings, among
whom you would include yourself.[11]

Virginia apparently came to realize early on that her marriage
to Arthur would never develop into the idyllic, loving union they
had both envisioned. Instead she became resigned to the option of
accepting freedom for herself and for him. Already convinced of his
artistic talent, she simply sought to play some role in its further
development.

There were still occasions when the two of them shared some
of the interests that had initially drawn them together: During his
weekend visits they would hike over the Palisades, Arthur with his
sketchbook and Virginia with Niles papoose-style on her back; or
the two of them would sit in the parlor while Virginia played her
favorite piano piece, Mendelssohn's *Songs without Words*. In a letter
to Virginia, Lucile du Pré referred to another pleasurable activity they
enjoyed: "Wish I could hear you and Arthur read together,"[12] for all
three of them were lovers of Shakespeare. Both ABD and Virginia
were inveterate bookworms, his taste including everything from
Aeschylus to Tennyson.

Lucile's letter was in response to a note from Virginia concern-
ing her depressed state over being married, and Lucile continued:

> How I appreciated that first Mother-letter—short and sweet.
> I had been very anxious because your condition that July
> was not what it should have been. . . . To my mind marriage
> vows are binding til death—and if people will be so silly
> as to expect to live [with] the same one all their life-time,
> why they ought to bear anything. I hope this poor man will
> behave better . . . You have proved you can manage a farm—
> why not prove that it cannot dominate you?[13]

Lucile would visit the Golden Bough from time to time, sleep-
ing over after Virginia cooked a late-night meal for her. When Arthur
was present, they often discussed Theosophy, to which Lucile was
a recent convert. On the other hand, ABD was a long-time believer;
though not a card-carrying member of the Theosophical Society, he

had once met Helena P. Blavatsky, the movement's founder, and placed a picture of her in the back of his pocket watch for good luck.

Arthur had read Madame Blavatsky's *The Collected Writings,* published two years before her death in 1889, and he pursued its primary tenet: To enhance awareness of the relationships between nature and spirit, enabling the individual to achieve direct, intuitive knowledge and personal experience of the spiritual. Other artists were likewise influenced by the theories of Theosophy, especially some among the European avant-garde. These included Paul Gauguin, who was acquainted with Theosophy by 1889; Piet Mondrian, a member of the Theosophical Society beginning in 1902; and Wassily Kandinsky, whose reading of Madame Blavatsky's *The Key to Theosophy* prompted him to quote from it in his *Concerning the Spiritual in Art* of 1911.

In *The Collected Writings,* Blavatsky discusses dreams and how memory stores them without order or sequence: "On waking these impressions gradually fade out . . . The retentive faculty of the brain, however, may register and preserve them if they are only impressed strongly enough."[14] Davies came up with his own system for retaining the essence of dreams—he jotted them down immediately upon waking. Sometimes, if he awoke in the middle of the night, he scribbled them on the wallpaper behind his bed or even scratched them into the headboard. As a result, both the wall and headboard took on the appearance of graffiti-decorated surfaces.

On occasion, when Lucile du Pré visited the farm on weekends and Arthur was there, she would serve as his model. Once when she brought along her cello to entertain, he seized upon the opportunity to escape the family hubbub by persuading her to pose for him on a mountain trail. They hiked a short distance, Arthur toting the unwieldy instrument while Lucile carried his Kodak camera. Then, as she played for him amid evergreens and wild underbrush, he took her picture from various angles. The resultant painting is titled *Cellist.* In it Lucile's head and torso and half of the instrument are compressed into a 10-by-8-inch canvas. The figure and cello are limited to hues of pink and brown, and a solid dark tone replaces the illogical background of rocks, trees, and sky.

Another time Arthur utilized a professionally made studio photograph of Lucile standing in an interior setting, her violin and

bow in hand. It was a picture she had given to Virginia, but ABD was sufficiently taken by the composition to create a painting from it. He adopted the pose, substituted an open door for a massive credenza, added a cat in one corner, and called the painting *Aspiration*. The figure and wall surface are bathed in a warm yellow glow, with pigment applied in such thin washes that the weave of the canvas is clearly visible.

During a portion of 1893 and 1894, Arthur appropriated a room on the first floor of the farmhouse for his studio. While the workspace was small, it was adequate for his paintings which, at the time, seldom measured more than a foot in either dimension. A pair of windows provided north light, but this meant little to ABD, for like so many other artists who began their careers as illustrators, he still thought essentially in terms of black and white, with color playing a minor role. As a result, his oils, like those of Daumier, were conceived of as strong dark and light patterns dominated by a limited palette of warm hues.

Davies continued to work from sketches and photographs produced the previous summer. One painting, *Girl at Pool,* shows a youngster, perhaps Virginia's oldest niece, at the water's edge in a woodland setting. Her nude body is seemingly poised in mid-motion while she rises from a seated position. Below, the white glow of her legs is reflected in the clear pool, transforming what might have been the nakedness of innocent childhood into that of a young, sensuous temptress.

The pose could have been inspired by that of the woman of lost virtue arising from her lover's lap in *The Awakening Conscience* by William Holman Hunt, one of Davies' Pre-Raphaelite favorites. However, ABD retitled his work *Nixie,* thus associating his figure with the water sprite in Germanic folklore and, more specifically, one of Richard Wagner's Rhine maidens. The painting measures only 6 by 4 inches, making it appear all the more precious and jewel-like.

Arthur produced other canvases of principals from Wagner's music-dramas: Hagen, who killed Siegfried; Brangäne, Isolde's confidante; and a half-length nude of Isolde herself. The Metropolitan Opera House reopened in November, 1893, after having been destroyed by fire the previous year, and it is likely that Davies was

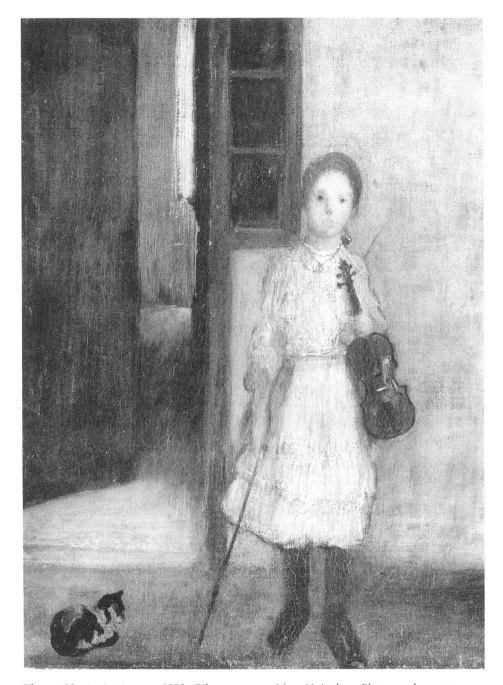

Figure 19. *Aspiration,* ca. 1892. Oil on canvas, 14 x 11 inches. Photograph courtesy Kraushaar Galleries, New York.

Figure 20. Lucile du Pré, ca. 1886. Photograph. Collection of Mr. and Mrs. Niles Meriwether Davies, Jr.

Figure 21. *Siegfried's Death,* ca. 1893. Oil on canvas, 16 x 20¹/₂ inches. Photograph courtesy Sotheby's, Inc.

moved to create these subjects following his attendance at performances of *The Ring Cycle.* In one canvas ABD depicted the scene of Siegfried's death in *Die Götterdämmerung,* in which Siegfried's body is transported by the vassals while Hagen stands, unseen by them, behind a massive tree trunk. The painting is only slightly smaller than Albert Pinkham Ryder's *Siegfried and the Rhine Maidens.* Ryder recounts that he produced his painting after *he* had attended the opera, then returned home about midnight and "worked for forty-eight hours without sleep or food."[15]

As far as Davies was concerned, Ryder served as the ideal role model to which he aspired. Davies visited him in his West Fifteenth Street studio, a tiny, ground-floor room with a solitary window, and viewed his paintings firsthand. At some point he even purchased one of Ryder's canvases, a long, horizontal work titled *Oriental Landscape.* It was an imagined scene containing a line of

hills, a meandering river, a castle, a bridge, and a sampan. When ABD set about organizing the Armory Show in 1913, he determined that Ryder should be the only American artist whose works would hang in the prestigious center galleries with those of van Gogh, Gauguin, and Cézanne. The admiration of Davies for Ryder was apparently mutual, for by that time the older artist referred to Davies as one of his "two boys,"[16] the other being J. Alden Weir.

Davies first became enamored with Ryder when he read a lengthy article about him in the June, 1890, issue of *Century*. Titled "A Modern Colorist: Albert Pinkham Ryder," it characterized him as "a poet in paint" whose "pictures glow with an inner radiance," an artist who moves "on higher planes of thought and emotion," whose completed pictures could be likened to "a strain of lovely music which refuses analysis."[17] Davies was particularly taken by the parallel drawn between art and music, one which would become the basis for much of his own future painting. When it came to interpreting nature, ABD, on at least one occasion, sensed the superiority of music, as revealed in an 1891 letter to Virginia:

> Wish you could have been with me yesterday in a walk over the high hills after a flock of sheep that I wished to sketch. The wind was blowing fresh & scurry clouds. An orchestra of sounds from the forests, with quieter touches of sunlight. Have an idea that wind-wave, sunlight—proportion &c, represent the different instruments of the orchestra better than the primary colors—as it has been applied . . . [18]

The idea was codified for him in 1893 when he read the following lines in George Moore's *Modern Painting:*

> . . . just as the musician obtains richness and novelty of expression by means of a distribution of sound through the instruments of the orchestra, so does the painter obtain depth and richness through a judicious distribution of values. . . . The colour is the melody, the values are the orchestration of the melody; and as the orchestra serves to enrich the melody, so do the values enrich the colour.[19]

Two years later Davies was quoted in an article as stating that "painting is like music, with contrast of harmony and syncopated time; it can no more tell a story nor be translated into words than can music at its highest."[20]

The *Century Magazine* article about Ryder also included an example of his poetry, its lines especially appealing to ABD at the time when he had begun courting Virginia:

> I am the wind, the wind, the wind.
> I'll away, I'll away to where maidens
> Are sighing for fond lovers,
> And softly coo and woo and whisper in their ears,
> With sigh answering sighs,
> Making their hearts to throb,
> Their bosoms rise
> Till I seem hardly from without—
> Almost within the voice
> Of their soul's illusion![21]

Davies found multi-talented artists especially to his liking, which is one of the reasons he was drawn to the work of other painter-poets such as Blake and Rosetti and, in later years, Max Weber.

The Ryder article also contained what must have sounded like a clarion call to an artist such as Davies, poised as he was on the threshold of his career:

> . . . critics are often fond of denying any originality or other worth to American art, and by unreasonable pessimism do much to discourage native art and artists, thereby keeping matters as unfortunate as possible. But perhaps American art, like American mechanics, literature, politics, has a mission of its own. Perhaps it may teach the great lesson in the fine arts which the United States is teaching in many other fields—individuality, freedom, rejection of the authority of any one school.[22]

❖ 6 ❖
A Call to Art
(1894–1895)

*T*he year 1894 opened on an encouraging note for Davies when an article about him appeared in the January issue of the *Art Critic,* a publication "devoted to the advancement of the interests of American Art." It began:

> How often do we not hear the following plaint in reference to some neglected genius, uttered in more or less indignant manner, "It is really a shame that he had to starve all his life and was only recognized in his old age!" And yet, whenever a new individuality appears on the horizon of art, how few are able to recognize its merits at a first glance?
>
> New York possesses a young painter at present, entirely unknown even to the profession, who is making, or trying to make, his debut at various exhibitions, and whose efforts unmistakably bear the traces of a remarkable talent, if not genius.

The write-up concluded:

> Davies is a dreamer as well as a painter, and the thought which underlies all his work is to render childhood (the conventional emblem of purity) more sensuous, and to

> chasten the temptative qualities of womanhood, which are
> considered sensual in this hypocritical world of ours.
>
> Whether Mr. Davies will be allowed to exhibit all he
> paints is another question.[1]

Perhaps this piece can be credited with Davies making his first sale,
of the painting, *Ducks and Turkey,* at the American Water Color
Society annual the following month.

The *Art Critic* article was written by Sadakichi Hartmann, the
publication's founder and editor, whose career in art and drama was
as unusual as his heritage, which was half-Japanese, half-German.
Just a month earlier he had been jailed for publishing what was
deemed obscene literature, his own play titled *Christ.* Hartmann's
statement regarding the motivation for ABD's art—that its underlying
thought was to depict childhood in more sensuous terms and re-
strain the tempting nature of womanhood, thereby reversing the
usual characteristics of such portrayals—is difficult to verify, since no
inventory exists of Davies' paintings prior to January, 1894, and the
whereabouts of many of them is unknown. However, his *Girl at Pool*
does match Hartmann's description, and it is likely that there were
many other compositions featuring one or more of Virginia's nieces
who, at nearly eleven, nine and seven years of age, could have been
provided with grown-up attributes and poses. Also, ABD's pre-1894
oil titled *Arethusa,* of the adult wood nymph with whom the river
god Alpheus fell madly in love, depicts the nude female figure from
the back as she faces the water, rather than from a more suggestive
frontal view.

Hartmann apparently met Davies soon after the writer moved
from Boston to New York in 1889, for the following year Hartmann
penned a poem called "Hours of Midnight" which was dedicated "To
A. B. Davies." It contains eleven stanzas and incorporates elements
of symbolism and eroticism. A portion of it reads:

> The fires of day have vanished to the magic flames of night,
> and half mankind lies dreaming in calm and subdued light.
> The lines of passion glimmer in the mysterious book of life,
> and luscious songs are flowing from the body of the husband
> to the body of the wife . . .

> The gates of virginity are yielding to the nervous longing of youth,
> and the halls of womanhood are widening with nature's
> trenchant truth.[2]

After a series of minor modifications, the poem was printed in an unknown journal.

During February and March, 1894, Davies exhibited *Ducks and Turkeys* at the American Water Color Society annual in the National Academy of Design galleries, at the Boston Art Club, and with the Independents. Hartmann heralded his inclusion in the latter show in the same January issue of the *Art Critic:*

> The society of Independents will hold their first exhibition at Leavitt's Art Gallery, 12th street and Broadway, New York, February 1 to March 15. Davies will exhibit with them.[3]

In the March number, which proved to be the final issue of the short-lived journal, ABD was singled out again in a review of the Independents exhibition:

> . . . Arthur B. Davies, in a number of . . . oils and pastels, shows a decided talent for composition, a good eye for color and an agreeable sentiment, but is careless about drawing. His best things are a small "Madonna," in oils, and a sketch of "Three Boys in a Boat," in pastels. . . .[4]

As a result of this generally favorable press notice plus his exhibit of lithographs at the Keppel Gallery the previous fall, Davies was invited to participate in a group show at the Macbeth Gallery in March. Located at 237 Fifth Avenue, the gallery occupied a single back room on the ground floor, with a frame shop and a small exhibition area in the front. Macbeth's could only accommodate about twenty average-size canvases, plus another one or two placed in the front window.

William Macbeth had previously sold prints for Frederick Keppel and Company, rising from stock boy to partner before deciding to

Figure 22. *Arethusa,* ca. 1893. Oil on canvas, 27 x 22 inches. The Butler Institute of American Art, Youngstown, Ohio.

establish his own gallery. He signed a lease with Benjamin Altman, who owned the Fifth Avenue building, then prepared an announcement proclaiming that the Macbeth Gallery would feature

> . . . the permanent exhibition and sale of American pictures. The work of American artists has never received the

full share of appreciation it deserves and the time has come when an effort should be made to gain for it the favor of those who have hitherto purchased foreign pictures exclusively. I hope to make this establishment *the* place where may be procured the very best our artists can produce.[5]

The inaugural exhibit in April, 1892, had included the work of H. M. Rosenberg, an artist who had recently moved to Manhattan from Chicago, where he had known Davies. Having renewed their friendship, Rosenberg spoke of ABD favorably to Macbeth.

At some point Macbeth must have questioned the wisdom of his timing in establishing this gallery, for he opened during the economic panic of 1892, and sales were so marginal throughout the first season that he was forced to pawn his wife's jewelry in order to remain afloat. Now, two years later, he was showing *Figure Subjects by Seven American Artists,* including Walter Shirlaw, Will H. Low, Rosenberg, and Davies. ABD exhibited:

> *"Little lamb, who made thee?"*
> *Dost thou know who made thee?"*
> *"Where'er you turn your eyes*
> *The blushing flowrs will rise."*
> *Young Musicians*
> *A Pastoral*
> *Mother and Child* (watercolor)

Macbeth framed Davies' five paintings and some others, in exchange for which he received *"Little lamb, who made thee?"*

A review of the exhibit in the *New York Sun* stated:

> Arthur B. Davies is a young farmer-painter of whom his friends plausibly promise better things. . . . He has an unmistakably fine sense of color . . . But he is a dreamer in whom the sense of form and the forms of sense are deficient . . . but there is always a redeeming something, call it feeling or color, or what you please.[6]

The *New York Tribune* critic referred to several compositions

> in which he has crystallized his striking conceptions of childish grace and sweetness. The picture called "The

Lamb" . . . is an enchanting study of infantile types. There are technical defects in Mr. Davies' art; his execution is naive—almost. But he feels the spirit of his pretty subjects keenly, and it passes into his work.[7]

A Pastoral and *Mother and Child* were purchased after the show closed, and by year's end the gallery had sold a total of fifteen works by Davies. The nearly eight hundred dollars in sales represented his first continuous income from painting and a big boost for Macbeth as well. Two decades later Macbeth would reminisce: "I have always looked back to 1894 as one of my red letter years in that it saw the beginning of a long, unbroken friendship with Mr. Davies and my acquaintance with his unique, personal art."[8]

During the first week of April, 1894, a pair of artists, Robert Henri and William Glackens, journeyed over from Philadelphia to view the exhibit. Henri had learned of Davies from the pages of the *Art Critic,* to which he subscribed, and after seeing the show, wrote to a friend:

Glackens and I were together (in N.Y.) Outside of the Metropolitan and a little private ex[hibit] on 5 ave in which there were a number of Davies (known to us through S. Hartmann) we were not greatly enthused. . . . [9]

Henri and Glackens would have the opportunity to see more of Davies' work the following month in Philadelphia, when it was included in an exhibition of proposed courtroom decorations at the Pennsylvania Academy.

As a result of the Chicago World's Fair, where an extensive program of commissioning murals had been implemented to complement the white, imperial structures at the fair, a mural craze was sweeping the country. A competition had been held for wall embellishments to the New York Circuit Court Building just being completed, and now there was talk of holding a similar contest to decorate the Council Chambers in the Philadelphia City Hall. Preliminary sketches for the New York project were submitted by twenty-five artists, including D. Maitland Armstrong, Leslie Bush-Brown, Will

H. Low, Walter Shirlaw, and Davies, and following their display in Manhattan the art was shown in Philadelphia. Although ABD's designs were not chosen, the experience served as a training ground for relating decorative schemes to architectural interiors which would prove helpful on future occasions.

Arthur continued to live in New York and return to the farm on weekends, even after Virginia informed him that she was again pregnant. He moved into a studio at 152 West Fifty-fifth Street, only a short walk from the Art Students League, where he would occasionally visit former friends and make some new ones. Sophia Antoinette Walker was enrolled there for the first three months of 1895; she had attended Davies' opening at Macbeth's and they previously rented studios in the same building. Now she was busy gathering material for an article about him which would appear in the *Independent* later that year. In the article she quoted ABD as saying:

> I painted a long time just as well as I could, being just as much a hypocrite as anybody else, trying to paint just like everybody else; and it wasn't a success. Nothing that I did was liked, and if I did anything expressing myself, that was the worst of the lot. Then I went home one day and gave it all up. I said, "I have tried to be good and paint as people think I ought. Now I will be just as bad as I can. I will be myself. I will do painting to please myself and nobody else." Then I began to improve and made great leaps. . . . After the things are done I don't care whether anyone likes them or not; they may take them or leave them.[10]

Another student at the league during the first few months of 1895 was Edna P. Potter, a tall, seventeen-year-old redhead. Theirs may have been a mere passing acquaintance at the time, though one day she would become Davies' model, then the mistress who would eventually bear him an illegitimate child.

Davies hired his first model at about this time, a long-legged, auburn-haired beauty named Mary Allis. She posed for him for several works, including the painting *Two Figures by the Sea*. In this oil her nude body, centered in the composition, is seen from the side with arms flared. An unclothed male figure, added sometime

later and possibly from memory, stands behind her, his hand placed just below her breast. The addition of the man and his suggestive gesture transforms the subject matter of the painting into an erotic fantasy.

Davies' art was included in several important exhibitions early in 1895, among which were the National Academy of Design, Pennsylvania Academy, and American Water Color Society annuals. Reviewing the latter exhibition in *Harper's Weekly,* Royal Cortissoz observed:

> ...Mr. A. B. Davies...has put into these...two or three pictures of children....as he puts into all of his paintings, a wonderful amount of new and sensitive feeling...the spirit is poetic, the sentiment is really tender, the tone is that of a new man developing a new art...[11]

His entry in a Boston Art Club exhibit drew critical praise in the *Springfield (Massachusetts) Republican:*

> Arthur B. Davies...is a new man; he is also an original man, and paints things according to his own imagination; in his technic [sic] and his conception he is equally original. His "Children of Music" [described as of a young girl holding a violin, another fingering the keys of a harpsichord, with children grouped around them in the shadows of trees] is pure fancy...a singular and fascinating poem in pigments.[12]

The *Boston Evening Transcript* referred to the same canvas as among "the figure pictures in the Art Club exhibition which are most likely to be remarked [upon]."[13]

Back at the farm, Virginia had made known her strong belief that children should be born at home. That is exactly where the Davies' second son, named Arthur David for his father and paternal grandfather, was brought into the world on March 22, 1895. Davies may have missed the birth, however, for he left his wife at some time during the day to deliver a group of recently completed pastels to Macbeth for shipment to Chicago and then attended Varnishing Day at the National Academy, when artists could retouch their can-

vases prior to an exhibition opening. (Two of the pastels he sent, *The Red Schoolhouse* and *Portrait Sketch—Miss S.,* were accepted in the seventh annual *Exhibition of Water Colors and Pastels by American Artists* at the Chicago Art Institute.)

Soon after his son's birth, Arthur sought to be closer to Virginia and the boys. He abandoned his Manhattan studio and rented an empty ice house on Rockland Lake for that purpose. With the advent of spring, much of his time was spent outdoors, creating pastels of nearby subjects, such as a pair of budding birch trees titled *Spring Beauties.* In another, *The Red Barn,* the trees are in full foliage, with the farm building placed in the distance and the foreground left as an unembellished area. Both compositions had been initially sketched in pencil on buff paper, with the pastel applied directly, showing only occasional evidence of colors having been blended with his finger.

But the new studio arrangement did not last. With summer fast approaching, shallow-draft swan boats were put out on the lake and the verandas of a large hotel and group of boarding houses began to fill with guests. With activity and the noise level increasing, ABD relinquished the workspace after a two-month trial.

Davies left Congers briefly in April to attend the opening of his first one-man show, taking place at a branch of Frederick Keppel and Company in Chicago. One critic observed that ABD's collection of panel paintings was

> attracting a good bit of attention. . . . All of the pictures shown are . . . abounding in peculiarities odd enough to make an advocate or enemy almost instantaneously out of every beholder . . . [14]

Returning to the farm, he looked in on Virginia and remained for only a short while, just long enough to produce some pencil, pastel, and wash drawings of the boys while they ate and slept. Never comfortable around newborn children, ABD gathered up his collection of figure sketches and once again headed for a studio in New York City.

During the next few weeks he created a series of lithographs, incorporating figures from earlier drawings. Of these, his

Figure 23. *Every Saturday,* 1895. Oil on canvas, 18 x 30 inches. The Brooklyn Museum of Art, Gift of William A. Putnam. (12.92).

most ambitious composition, titled *Concert,* shows Virginia standing beside Lucile du Pré playing the violin, with a group of children placed in the foreground. It is a variation of the painting praised in the Boston show. Two of the youngsters resemble Mattie and Lucy Betts, drawn on the lithographic stone from a sketch he had made the summer of the wedding.

Arthur also continued to paint, informing William Macbeth on May 15: "I have started some new oils of a slightly larger size and think in that way we will be better able to adjust a scale of suitable prices."[15] The most impressive of these was *Every Saturday,* a depiction of three figures in profile walking along the edge of a pond peppered with ducks. One of the women, shown holding an umbrella over her head as protection from the sun, bears a striking resemblance to Georges Seurat's crayon drawing of *Young Girl with Parasol,* a work Davies would one day own. ABD confined his subject matter to the lower third of an 18-by-30-inch horizontal canvas, with the figures hugging the rim of the pond as if they were precariously placed in a flattened world. These aspects of the composition are reminiscent of the nineteenth-century Italian artist Giovanni Costa, whose work Davies may have seen.

Davies continued painting through July, when a fortuitous combination of circumstances enabled him to fulfill his dream of viewing European art treasures firsthand. On July 13, 1895, he left on a two-month, all-expense paid trip arranged for by William Macbeth and Benjamin Altman. For his art dealer, Davies agreed to search out nineteenth-century European paintings for possible purchase, and to return with frame designs that could be produced in Macbeth's shop.

Altman had made his initial art purchases a dozen years before and had visited Europe twice, but he now left it to Macbeth to recommend certain acquisitions. Since the merchant prince had loaned the art dealer twenty thousand dollars for his gallery operation, Altman agreed that a portion of this amount could be applied as a credit for the purchase of art from Macbeth.

Had circumstances been different, Macbeth might have made the trip himself. But a few years earlier while he was away on a business trip, his three children had come down with diphtheria. The two younger ones had died. Macbeth refused any lengthy travel thereafter.

Altman sent Macbeth three hundred dollars for Davies' expenses, in partial exchange for which he acquired ABD's oil titled *Young Artist*. *Young Artist* was destined to become the only self-portrait Davies would ever paint. There was a bit of symbolism in Altman's choosing a self-portrait, as though the individual depicted would be forever tied to the patron who financed this initial European experience.

Just prior to Davies' departure, he wrote Macbeth:

> The arrangements about money for expenses and return passage, you know best what to do . . . Mrs. Davies and all of my people here recognize the situation fully, but thought it was a fairy story . . . [16]

Arthur did as well.

Arthur's sense of expectation in visiting Europe was heightened by having previously read about such an adventure. *The Sketch-Book of Geoffrey Crayon, Gent,* by Washington Irving, whose home was directly across the Hudson from the Golden Bough, contains the observation that

> None but those who have experienced it can form an idea of the delicious throng of sensations which rush into an American's bosom when he first comes in sight of Europe. . . . It is the land of promise, teeming with everything of which his childhood has heard, or on which his studious years have pondered.[17]

Davies began his tour in the Netherlands. Macbeth had provided him with letters of introduction to several Dutch painters and collectors, including Adolph Artz, an artist "whose paintings Macbeth has had in N.Y." and Hendrik William Mesdag, a popular painter of romantic pictures who Davies characterized as "one of Holland's wealthiest & most able artists."[18]

In a letter to Virginia, ABD was quick to identify his own taste in art, among which were the Rembrandts in the Rijksmuseum and paintings by Pieter de Hooch, classified as one who "paints the intelligent middle class in a most poetic way." Arthur ob-

served that "we have no one who paints with that feeling today—except possibly the early work of Matthew Maris."[19] (The latter artist was already a Davies favorite and likewise revered by Albert Pinkham Ryder.)

Davies reported to Macbeth that he had viewed works by Millet and Daubigny among "the *modern* pictures of the Steengracht Collection, which is to be sold on Sept 10th . . . " and the Kuyper Collection, containing a work by Hobbema, "undoubtedly genuine . . . half the size of the largest Hobbema in the Rijks Museum and in quality very much like it and better than the other two there . . . " Davies added: "But $10,000 is a very large figure for so small a canvas."[20] Davies also referred to "a number of very fine landscapes by Rosseau [sic], Corot, Jules Dupré"[21] and sometimes supplemented his descriptions and notes with tiny shaded pencil sketches.

Then it was on to Paris, where he reported his impressions to Virginia:

> . . . Paris is like New York with differences which are very slight. I really expected a glowing sort of world, like a Claude [Lorrain] or Turner—but it is a thrifty village—or commune, nothing new. I arrived here night before last [August 6] met some American art students who are helping me out with my French . . . I went to the Louvre—& was paralysed artistically—by Leonardo—he is great. Rafael [sic] marvelous. Claude, Van Eyck, Corregio [sic], Titian, Giorgione, but most of all I think I like Botticelli best. The frescoes [Botticelli's *Lorenzo Tournabuoni and the Liberal Arts and Giovanni Tornabuoni* and *Venus and the Graces*] are not unlike my decorations—Simplified. The St. John Virgin [*The Virgin, the Child and Saint John the Baptist*] is exquisite. Mantegna—is a big man. . . . Am going to the Luxembourg Museum of modern pictures this morning & to see the private collection of Durand Ruel this afternoon, by special privilege . . . [22]

It was also in the French capital that Davies first met Robert Henri, who had sailed for Europe five weeks before him. As ABD would inform Sadakichi Hartmann: "I met Henri in Paris and we were quite chummy. I liked him immensely . . . "[23]

By mid-August, ABD was in London, and wrote his wife:

... my quarters here are in the best neighborhood to see
pictures—about two minutes walk from the National gal-
lery ... like the Turners better than ever. The Italian work
there is delicious. I think my friend Piero della Francesca
one of the greatest, his color is very charming, grey with
fine rich color in places—I like his color better than I do
Botticelli. Fra [Fi]lippo (Lippi) has good color. His "Annun-
ciation" you remember [from] the engraving I have—is su-
perb in color. Titian rather wearies me. Several of the Bellinis
are fine in color. Vermeer has a very beautiful "Interior"
with a woman in his usual fine manner. Among the old
English school Crome & Barker are surprisingly good—
strong and rich, simple, very sweet in sentiment. Constable
is disappointing—though I saw a very good thing by him
in the Louvre. Gainsborough's landscapes are beautiful ...

Went today into an exhibition of Connoisseurs Treasures
on Regent St. saw three Burne-Jones, an Albert Moore, two
Whistlers, Watts, Rossetti, many other very beautiful things,
the Albert Moore was exquisite, like a Tanagra figurine, a
marine by Whistler very fine ... Went to the [British] Mu-
seum, which is simply grand. The Greek antiques ... the
Elgin marbles were very impressive.[24]

At the Elgin Salon, Davies could view the Parthenon's bas-relief run-
ning frieze where one section held a special appeal for him: A cow
raising its head to bellow was thought to have inspired Keats to write
of "that heifer lowing at the skies" in his *Ode on a Grecian Urn.*

Before the month was out, Macbeth briefly joined Davies in
London; they visited with a collector named Forbes who showed
them "a hundred or more choice watercolors by [Anton] Mauve—
another fifty by [Joseph] Israels. Maris—fifty ... Then best of all a
lot of choice Richard Wilson's—15 or 20 Constables ... and the
lovliest of all 'Old' [John] Crome."[25] Then, just as suddenly as Macbeth
had arrived, he departed.

Arthur complained to Virginia: "While Mr. M was here I
found little time for work as we went together everywhere. Now
he has gone I shall get at it again— ... shall try to go to Greenwich
where I can [sketch] some more shipping ... "[26] Using pastels, he

produced a pair of small compositions titled *Mysterious Barges I* and *II* which echo Whistler's nocturnes in their atmospheric, undetailed, twilight mood. One of these compositions vaguely resembles *Nocturne—Blue and Gold—Old Battersea Bridge*, with Davies' barge heading between two piers of a darkened span while reflected lights dance on the river. In contrast to his earlier pastels, so crisp and direct, these are intentionally vague, with the edges of barges, river banks, and bridge abutments blended and blurred until their shapes appear to be dissolving in a diminishing light.

Before departing for New York in September, Davies also sketched along the English coast, creating additional drawings of the countryside and views out to sea. Macbeth was sufficiently impressed to offer him a one-man show the following March. Arthur lost little time in painting oils from some of his pastels: *Barges on the Thames* was inspired by *Mysterious Barges; Landscape, Dorset* and *Weymouth, England* were modeled after drawings made there; and *Ocean Symphony* was rooted in a series of rhythmic rising and falling waves in his sketch titled *Ocean Swells.*

In addition, he painted compositions that echo the influences of Italian painting so recently viewed, including an oil he named *The Throne,* of Virginia nursing David, in which background figures are reminiscent of two of the Three Graces in Botticelli's Louvre fresco; and *Rose to Rose,* where Virginia and Rostan are silhouetted against a darkened landscape in a manner similar to Botticelli's Virgin, Christ Child, and Saint John juxtaposed before rosebushes and trees.

These works and others produced as a result of his European travels reveal a new direction in Davies' art. No longer does Albert Pinkham Ryder appear to be the dominant influence upon his style, for the trip had the immediate effect of expanding ABD's creative horizons to a greater number of subjects and techniques. By January, 1896, ABD could report to Macbeth that "The work here [Congers] goes on rapidly and successfully I think," adding: "As I know your tendency to idealize I shall not mention any titles as I thought I should . . . "[27]

A few weeks prior to the opening, Sadakichi Hartmann offered to write an introduction to the Davies exhibition catalogue, but the artist informed him that

... I had not thought of having a preface in the catalogue and now am somewhat modest about having any. I believe I don't want any catalogue but presume I must, shall give as little besides numbering as I possibly can (avoid). If I get through, the exhibition will be on deck after the 9th of March. My health has been wretched all winter and I have really done but little actual work, mostly thoughts and have not expressed them as I hope to soon. I look forward to doing as you have so often advised, three or four important good things. Will send you an invitation in due time. I am sorry not to be present at your readings. With kindest regards to Mrs. Hartmann and the little ones and thanking you heartily, I am

<div align="right">

Very sincerely yours
Arthur B. Davies[28]

</div>

Macbeth did provide a catalogue, a simple, single-fold sheet measuring just $6^{1}/_{2}$ by $4^{3}/_{8}$ inches. When the size was set, Davies produced four small lithographs, the tiniest barely two inches square, which were placed inside, intended as souvenirs of the show. The subjects in each case were the artist's family: A portrait of Niles; David being held by his cousin Rostan; Virginia and Niles; and the two brothers together. All four were sketchy, pale, and devoid of the rich, dark values so prevalent in his lithograph, *Concert,* from the year before.

Because the majority of Arthur's paintings were still relatively small, there was room to hang forty-two of them in the gallery, including *Aspiration, Every Saturday,* and *Sisters Three,* the latter an oil version of the 1891 watercolor of Virginia's nieces.

Invitations to the opening were prepared, and among those Davies designated to receive them were Albert Pinkham Ryder, Henri, Hartmann and Walter Damrosch, whom he may have met following a concert by the philharmonic. Everything stood in readiness on Monday, March 9, 1896, when Macbeth opened the gallery door.

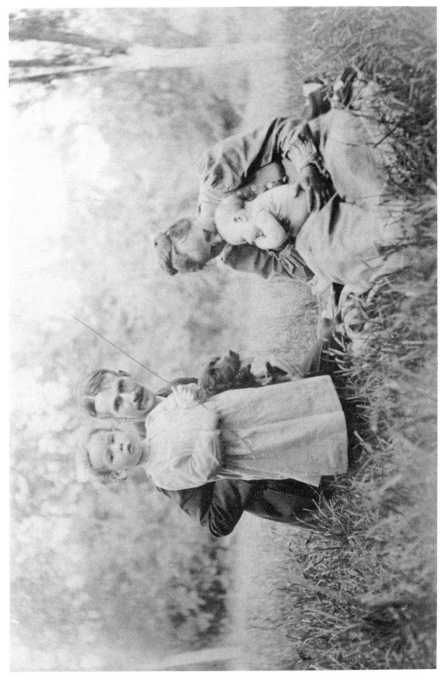

Figure 24. The Davies family, 1896. Arthur and Niles (on left), Virginia and David. Photograph. Collection of Mr. and Mrs. Niles Meriwether Davies, Jr.

❧ 7 ❧
The Dealer and the Double-Dealer (1896–1898)

*D*avies made a special effort to appear elegantly clothed and well-mannered on the first day of his exhibition, but an incident occurred that served to spoil it for him:

> I was walking up the steps to the gallery when I saw a beautifully-dressed woman standing at the door, about to go in. I bowed to her and held the door open for her to pass, and as I did so she brushed me aside and sailed haughtily in without so much as a thank you. I felt so chagrined and hurt that all my happiness left me, and I walked around my own exhibition like a total stranger. Well, the exhibit was a success and many people congratulated me, but when *she* came over and gushed "Oh, Mr. Davies, aren't you *wonderful!* Oh, you *must*—" I just turned my back on her and walked away.[1]

Such was the artist's sense of propriety when it came to a normal courtesy and the common words of gratitude expected in exchange.

William Macbeth, the consummate art dealer, had written a candid yet enticing introduction for the catalogue:

> . . . Mr. Davies, for a few years past, has given much trouble to juries, critics and hanging committees. None has seemed

to know exactly what to do with him or where to put him, but, somehow, none seemed willing to let him alone. And yet his timidly made offerings to the current exhibitions were never of an aggressive sort, but rather sober, quiet little scraps, only a few square inches of surface. . . . Among the newspaper critics a discriminating few, while not hesitating to call attention to what they considered shortcomings, have expressed frequent and cordial appreciation, but others have been all at sea in attempting to review his exhibits. . . .

Yet, in spite of all this hesitancy and uncertainty, seldom has an artist had a more loyal circle of friends than Mr. Davies, and many a collector among them has showed substantial appreciation by welcoming to collections, where only great masters are admitted, more than one ripe example from his easel. . . .

To the jury capable of deciding, and its number is rapidly increasing in this country, is submitted the question: To what class do these paintings by Mr. Davies belong? Can they be hung in harmonious relation with the pictures that have stood the test of time? It would not be in order here to anticipate or suggest the public verdict. On the gallery walls full evidence is presented, and a careful consideration of it is cordially invited.

W. M.[2]

As Macbeth predicted, the critics offered mixed reviews. Referring to the entire collection of work, the *New York Times* reported: "Together they form quite one of the most unique exhibitions of the season . . . ," though the writer was quick to add that

Judged by all known rules of drawing, composition, and the traditions of picture making, Mr. Davies is singularly lacking. . . . [Nevertheless,] fertile in ideas, dreaming away ideal scenes full of mysticism, romance, poetry, and the supernatural, the artist has woven out vague, unreal fancies, suggesting the early Italians in the simpleness of motive, [while the works] at first startle, then amuse, interest, and finally become absorbing, in the serious intent one feels behind it all.[3]

According to the *New York Post,* "Barring a tendency towards affectation, there is much to admire in the two score of paintings by Arthur B. Davies now at William Macbeth's gallery . . . "—despite

references made to "the often childish drawing and composition as naiveté." After pointing out the reliance upon Italian painting in a work titled *Demeter,* which was "reminisicent of Puvis de Chavannes," the reviewer concluded that "no one who wishes to be thought *au courant* with things artistic can afford to miss [the exhibit]."[4]

The *New York Sun* critic opined:

> With so much that is commonplace in art it is an especial distinction for Mr. Arthur B. Davies even to have raised the question as to his place as a painter. . . . Mr. Davies has never done anything better than the lovely painting of "Two Welsh Girls and Harp" in the show. It is charming in tone and in what is called fat color, a veritable little poem indeed.[5]

After praise for such other works as *Weymouth, England; Landscape, Dorset;* and *The Burning Spring,* which were cited as "among his most poetic expressions," the writer singled out four other efforts as being "absurd symbolisms."[6]

The *New York Mail and Express* devoted half a column to a review of the show, labeling Davies "an artist whose individuality asserts itself quietly and forcibly in all his productions."[7]

Sadakichi Hartmann's voice was conspicuously absent from the chorus commenting on the Davies exhibition, but that was due to his having temporarily abandoned writing to work in the library of the architectural firm of McKim, Mead, and White. Yet eight months after the fact, an article by him appeared in the *Daily Tatler,* in which Davies was characterized as being one of the forerunners of the modern movement:

> . . . Students and lovers of art apparently have come to the conclusion that these suggestive sketches [by Davies] represent a higher art than finished pictures . . .
>
> All of A. B. Davies work manifests a highstrung talent, even in the smallest trifles although in many cases they reveal a remarkable amount of insolence, and it is no excuse whatever that Whistler, Manet, Courbet, etc., have also slapped the public's face with their debuts. . . .
>
> If art continues in the Davies style it will soon be reduced to slips of differently colored paper, with a few disconnected, partly visible figures, sometimes only with certain

parts of the body, like a knee or nose, appearing on the edge, or even merely with a few lines and dots and some crosshatching that have some hidden symbolical meaning which one has to guess from the shape and the tone of the paper, the color and the suggestiveness of the drawing. . . .

All this is highly fascinating, but it is at the same time insipid, vainglorious, morbid, badly nourished, and absolutely unworthy of what occidental mankind has hitherto called art. And yet men like Davies are the indispensable pathfinders and roadbuilders of our new American art.[8]

As was his practice, Davies offered neither a rebuttal nor response.

Hartmann described the colors in ABD's oils as "nearly always muddy."[9] This was, in fact, the result of Davies' method of painting at the time. Many of his early oils, including those in the exhibit, were produced on wood panels—the same kind of surface employed by Robert Henri when the two of them met in Paris. But while Henri used the Whistler "soup" method—covering the wood with a heavy, linseed oil–saturated coat of paint and working the subject matter into it—Davies began by coating the panel with a thin turpentine wash, then sketched his subject over it with graphite. Because he apparently failed to spray the penciled outlines with fixative, they dissolved into the pigment as he painted, adding a grayness to all of the colors.

The Macbeth exhibition was a financial success, with two works sold prior to the opening, five sold during the show, and two more immediately after it closed.[10]

The next month, April, 1896, forty of Davies' paintings were sent to the Keppel Gallery in Chicago, where that city's *Tribune* identified them as "mostly small studies of children at play in the meadow or woods." The artist was labeled "an idyllist pure and simple, yet by his strength and refinement he keeps his art from lapsing into sentimentality."[11]

The *Times Herald* critic wrote of him: "The more Mr. Davies is studied the more interesting he becomes."[12] And a third newspaper identified ABD as "a former resident of Chicago who has made a name in the Eastern cities as 'one of the strongest and sanest idyllists American art has known.' "[13]

1896 was also proving a good year for Davies' acceptance into group shows: His painting in the Boston Art Club annual was reproduced in *Modern Art* magazine; two oils were selected for the *First Annual Exhibition* at the Carnegie Institute in Pittsburgh, where they were hung among the canvases of Whistler, Cassatt, Eakins, and Winslow Homer; and four were chosen for the Pennsylvania Academy of the Fine Arts annual in Philadelphia.

Meanwhile, William Macbeth was proving to be the ideal promoter of Davies' art. In the November-December issue of *Art Notes,* his gallery publication distributed to a growing list of American art collectors, the dealer wrote:

> Since completion by Mr. Davies of the two large important pictures to which attention was called in October Art Notes, he has been busy on new canvases that will be ready for exhibition early in December.
> As four of them have already found purchasers, they will be visible here for a few days only.[14]

Thus enticed, Macbeth's patrons purchased an additional four paintings by ABD before the month was out.

Now Arthur began enjoying the role of weekend father to his sons. Each Saturday he boarded the Weehauken Ferry for the trip across the Hudson, then the West Shore Railroad to Congers, where he devoted himself to the boys. He carved a fleet of toy boats for their entertainment, and made box kites for them as well. And after reading a newspaper article about mounting a sail on a sled for added speed, he fashioned a mast and spinnaker so that the three of them could cruise the frozen surface of Rockland Lake. Davies knew precisely the thickness of ice necessary to support a person, and the additional depth required for a horse and sleigh. Soon, however, Niles and little David came to dread Sunday afternoons, for that was when their father caught the 4:49 train back to the city. Yet even as a weekend parent, Arthur did not always focus attention on his sons when he visited them. On various occasions he would take Niles along to a spot not far from the farm where he planned to paint or sketch; he would then instruct the youngster not to talk while his father was working.

By the end of 1896, Virginia surprised Arthur with news that she was pregnant again, at which point he quickly lined up a one-man show at Macbeth's for the following spring. He turned his attention to producing a new group of paintings.

The exhibit opened on April 24, 1897, with thirty-eight oils, none of which had been previously shown. Macbeth did his part to promote it, announcing in *Art Notes:*

> To many friends who have requested the privilege of a first look at the new work, I can only promise that for the day before the formal opening to the public, they will be given an opportunity to see it. The invitations for that day will all be mailed at the same time.[15]

Referring in the catalogue to Davies' exhibit of the previous year, Macbeth recalled that it had "excited more interest and comment than any of my previous exhibitions and made for the artist many new friends."[16] The writer for the *Critic* stated that ABD's show "should secure for him a place in the front rank of American artists. . . . "[17] Despite these efforts, however, only two works were sold.

On July 1, 1897, Davies wrote to his dealer: "The 'stork' arrived this morning at 2.10 and brought a little girl with a caul over her face, which signifies many things to the superstitious. She is a sweet dainty little thing and is to be called Silvia." Arthur selected the name from Bulfinch's *Mythology,* where Silvia is identified as the daughter of King Turnus' herdsman. It was the senseless killing of her favorite stag by the trojan Iulus that provoked the war with Aeneas, son of Venus.

Davies added in another letter written later the same day: "I am awfully tired from last night & the past month's strain. I feel like starting many canvases and getting right down to work Monday next [July 5]."[18]

The "past month's strain" referred to more than Virginia's ninth month of pregnancy and the birth of Silvia. It concerned a devastating review of his one-man show by Sadakichi Hartmann in the June issue of *Art News,* another one of the critic's publishing ventures. It was of little consolation to Davies that the June number was the publication's fourth and final issue.

In the unsigned diatribe, titled "The Echo," Hartmann stated:

> I have known Mr. A. B. Davies for some time. I was even
> one of the very first who attracted attention to him . . .
> Well, the Echo had another exhibition at Macbeth['s], April
> 24th to May 8th, and revealed once more his marvelous
> capacity of appropriating other men's work. . . .
> His pictures are merely a patchwork of other men's ideas
> and technical characteristics. For instance, a Pre-Raphaelite
> figure under a Ruysdael tree with an Inness light effect and
> a Steinlen background, representing a Walter Pater idea. . . .

Hartmann's accusation is not entirely without merit, as seen
in one of Davies' most joyous and skillful paintings of 1896, *Orchard
Idyl* (Plate 4) (though this is not necessarily the work to which Hartmann
referred). It depicts Virginia with son David hoisted on one shoulder
in front of an apple tree on the farm. Two of the Betts girls, their frilly
frocks flying, hold hands and dance in the foreground.

The darkened tree in the middleground bears some resem-
blance to a Jacob van Ruisdael, although it appears closer to those
painted by Ryder. The figure of Virginia is somewhat Pre-Raphaelite
in pose, with cast shadows across her face and on David's body
suggesting the dramatic chiaroscuro found in a Tintoretto. The girls'
dresses, painted in masterly, broad brushstrokes, come as close as
ABD ever did to the style of Sargent; the background trees, their
edges dissolved by the setting sun, are indeed Inness-like. And the
artist would surely have been a kindred spirit with Walter Pater, the
nineteenth-century British Neo-Platonist who wrote about Renais-
sance literature and art from a quasi-mystical point of view.

One direct result of Hartmann's scathing attack was Davies'
failure to create any further paintings in this vein, for he never again
produced a work that would embody so many rich and varied
sources. Furthermore, he sought to hide the influence of others upon
his subject matter, composition, and technique from that time on,
and made it a rule to never give interviews to the press.

Hartmann's article concluded:

> In the whole history of art I do not know of another man
> who is such an expert plagiarist as Mr. A. B. Davies. . . .

Nothing and nobody is safe from him. . . .
Nothing is original with him . . .
And one drop, however muddy it may be, that rises from the depth of your soul, Mr. Davies, would be more valuable than [a] hundred bucketsful of crystal water flowing from other sources!

Then, remarkably, Hartmann added: "P.S.—Nevertheless, if I had money, I would buy several of his pictures."[19]

The reason for the critic's abrupt change of heart toward Davies' art is unknown. Perhaps the rift developed after Hartmann offered to write the catalogue introduction for his 1897 exhibit and was rebuffed a second time; maybe he had become jealous of ABD's new friendships with others. Whatever the reason, their relationship was never amicable again. In a display of pique that went beyond the bounds of professionalism, Hartmann rededicated his poem "Hours of Midnight" to Edmund Russell, a banker and vice-president of the Otis Elevator Company.

Davies' plans for painting after the baby's arrival were short-lived. He was uncomfortable around his newborn and unhappy with his extra chores and the presence of Virginia's family. Just as he had done following David's birth, ABD now planned another trip overseas, this time embarking on a three-month tour when Silvia was but five weeks old.

While once again assigned to evaluate nineteenth-century paintings and sketch frame designs for Macbeth, this journey would provide Davies the opportunity to view art in countries not previously visited, including Ireland, Belgium, Germany, Italy, and Spain. In addition, he hoped to regain his physical and mental well-being. As he informed Macbeth in August, 1897: "I believe my mental rest has had the effect of increasing my weight . . . "[20]

Davies' discoveries are outlined in a series of letters written to his dealer, letters which represent a rare insight into his early taste in art:

[August 14, Dublin.] I went to-day to see the Gallery of paintings, and I can assure you they are not excelled in many pictures. A fine Mantegna, Botticelli, Bellini, Vandycke

[sic], Fra Angelico . . . They have many things in the gallery falsely attributed and they are constantly changing them . . .

[August 23, Oxford.] Two days . . . among the delightful old buildings, cathedral & chapels. Burne-Jones fine windows, & Reynolds—tapestries and a wonderful collection of Italian drawings at Christ Church Library, some fine old paintings, a grand Mantegna, a superb Piero della Francesca . . . [London.] I saw in the [British] Museum six or eight drawings in crayon & color by [Jan] Lievens, landscape & portraits . . . The portrait in the National Gallery, of which you have a photograph, of a woman & open book . . . Went up to the Tate . . . I went to the Nat. Portrait Gallery this afternoon, and also to the Sloane [Soane] Museum, a private collection . . . Saw a rip-snorting Sir Joshua [Reynolds] "Snake in the Grass," about the best. A wonderful Watteau . . .

[August 29, The Hague.] Went to the Maurithaus Museum as soon as it was open.
 . . . then to the Steengracht collection. The mother and child there attributed to Rembrandt is by Lievens. [Amsterdam.] . . . saw a very important Lievens at the Rijks Museum a large portrait of an admiral, a stunning thing equal to any Rembrandt. Another important one of Samson & his wife & her lover.

[September 5, Munich.] I visited several galleries, the New Pinakothek . . . At the Exposition I saw a number of Am. pictures Childe Hassam has several & 2d medal. Alex[ander] Harrison, [Gari] Melchers . . . By the way saw a George Inness Sr. sunset in his best vein on the line in the New Pinakothek, looked well. Arnold Boecklin is the biggest man of Modern Germany (a Swiss, who now lives at Florence). I may need a little more money by telegraph . . .

[September 10, Milan.] This afternoon I went to see The Last Supper by Leonardo, at an old barracks, formerly a monastery. It is the most fascinating thing but in a dreadful condition . . . saw several heads of old men by Titian at the Brera [Museum] . . . there are several very fine old Italian pictures, a superb Andrea Mantegna—one of my Gods? The Ambrosian Library with its several Leonardos about twenty of his drawings . . . the most beautiful Botticelli I have seen so far. . . .

[September 28, Assisi.] I left . . . (for Rome) . . . after seeing the fine frescos [sic] in the San Francescan Monastery by Giotto, Memmi & others.

[October 10, Naples.] The Museum here has a number of very good things Giorgione, Titian, Correggio, Claude [Lorrain] &c but the Greek collections from Pompeii, Rome, Herculaneum &c are unsurpassed. The bronzes, marbles and frescoes are very beautiful & instructive. I shall probably go down to Pompeii tomorrow and as quietly as possible contain my feelings until I reach the starry shore.[21]

During his visit to the Naples Museum, Davies viewed a group of frescoes originally created for a large villa near Boscoreale, where they had been buried for centuries by the eruption of Mount Vesuvius. Viewing these ancient Roman wall paintings reinforced his growing taste for the classical. Several of them were acquired a few years later by the Metropolitan Museum in New York.

Davies was occasionally able to devote some time to his own art, and even consummated at least one sale while in Venice:

I was in this little place, on the top floor, and I was at the window working on the drawing when it flew out the window. It was all finished. I needed the money and there it was somewhere down below. I wanted to kill myself.[22]

He dashed outside, retrieved it and the sale took place as planned.

Unfortunately, no record exists of any drawings or paintings he produced during the three-month trip. However, one direct result of Davies' exposure to ancient Roman art is *Antique Scene: Woman with a Horse,* in which he combined his own love of the female figure, animals, and landscape. The circular tower may well have been inspired by one he viewed in the Naples Museum in a fresco from the vicinity of Herculaneum. Davies introduced an element of trompe l'oeil into this work by creating faux cracking, in imitation of that which he had observed in the Roman wall paintings.

Davies arrived in Gibraltar on October 18, 1897, and wrote to Virginia: "Tomorrow go to Tangiers for two days then to Cadiz and Seville, Cordova and Madrid. The Moorish stuff here is simply stunning . . ."[23]

Macbeth felt compelled to concoct a story to explain Davies' three-month absence from New York and his inability to exhibit any

Figure 25. *Antique Scene: Woman with a Horse,* ca. 1898. Oil on canvas, 9½ x 13½ inches. Babcock Galleries, New York.

new paintings in the gallery. He included the following notice in the October *Art Notes* while the artist was still overseas:

> Mr. Arthur B. Davies has spent a very busy summer as usual, taking little rest except in the variety of his work. The favored few who have been allowed to see his pictures grow from month to month speak with great enthusiasm of his new work. They find him far past the experimenting stage and with growing confidence more than fulfilling the promise of his early work.
>
> For the pleasure of a few friends who have taken a deep interest in Mr. Davies' work, I hope shortly to arrange for a private view of three large important works, now nearing completion, before they are forwarded to the destination for which they are intended.[24]

Shortly after ABD arrived back in New York on November 8, he renewed acquaintances with Robert Henri, who had also recently returned from Europe. Henri was living in Philadelphia and during November his first one-man show was mounted at the Pennsylvania Academy. Although no sales resulted, Henri was invited by William Merritt Chase to exhibit ten of the paintings at the Chase School in New York.

In anticipation of the show, William Glackens, who was now residing in Manhattan and working on the art staff of the *New York Herald,* provided Henri with a report of the New York art scene: "The exhibitions over here are atrocious . . . Davies no longer sends to the Society [of American Artists] notwithstanding invitations . . . He had a remarkably fine exhibition here this spring, he gets better each year."[25]

On December 1, 1897, Henri traveled to New York to see his exhibit, calling on Davies to take him along. Davies succeeded in interesting Macbeth in Henri's work, and within a week a group of Henri paintings was displayed in Macbeth's gallery. Although none of the canvases was sold, when Davies saw Henri in Philadelphia the following month he informed him that "Macbeth had in no way weakened about [your] work and is confident he can find buyers."[26] Henri showed his appreciation of ABD's efforts by painting a small portrait of him.

At this point in their careers, Davies and Henri had a good deal in common. Both men were drawn to the works of Rembrandt, Van Dyck, Manet, and Puvis de Chavannes, among others, and both had made copies of Spanish paintings when they visited the Prado, ABD reproducing a Goya; Henri, several canvases by Velasquez while also purchasing some Goya aquatints. Three years later, Davis would be credited with helping Henri obtain his first teaching position when the latter moved to New York.

The year 1898 opened on an optimistic note for ABD, with work being accepted during January and February for exhibits at the Pennsylvania Academy, the Society of Washington Artists, and the Artists' Club of Denver. There was the encouragement of occasional sales at Macbeth's as well, and he had his final fling with magazine illustration, producing five pen-and-ink drawings "after old prints" for an article in *Harper's* titled "University Life in the Middle Ages."

Seeking additional income to help support his growing family, ABD requested and received Macbeth's approval for another exhibit, this one to feature his drawings. The arrangement was agreed upon with some reluctance on Davies' part. He preferred to retain all of his sketches since they were often utilized as starting points for paintings and prints.

The show evoked a comment in the *Art Collector* a year after the event:

> His [Davies'] sketches of the human figure show him as one of the draughtsmen of the age. This was revealed when last winter [1897–98] a hundred and fifty of his drawings were gathered up and exhibited, much against his will...Mr. Davies in his drawings, of colored crayon on colored paper, is the Degas of America. No other man is trying to put all of life into a picture.[27]

Davies' painting output in the early months of 1898 was minimal because he was consumed by a mural project, a proposed decoration for the new Appellate Division of the State Supreme Court Building on Madison Square. Over two hundred thousand dollars of the structure's budget had been allocated for art; one-quarter of this was for paintings.

Davies obtained a set of blueprints showing areas designated for mural designs, then did his homework by studying photographs of Puvis de Chavannes' recently installed murals in the Boston Public Library and Royal Cortissoz's *Century Magazine* article, "Mural Decoration in America." The space chosen by ABD for his submission was the imposing wall before which the judge's bench was to be placed. His ambitious oil sketch, measuring five feet in length, involved three dozen figures, including personifications of "Industry," "Doubt," and "Summer" along the lower border. Davies' depiction of "Justice" is similar in pose to the goddess Flora in Botticelli's *Spring*. But whereas Flora is clothed in a flower-covered gown as she issues forth flowers from its folds, ABD's figure is of a young girl who utilizes the upper portion of her dress, discreetly removed, to hold her collection of blossoms.

The mural design includes seemingly incongruous elements: Figures bearing musical instruments, naked children, and a pair of cows. Yet it is "Justice" that appears the most untraditional. In place of the majestic symbol he painted a mortal woman—she bears a striking resemblance to Virginia—whose sword is held higher than her scales, thereby reversing the symbolism. And while there is a certain rhythmic flow among the groups of figures, it would likely have been difficult for courtroom spectators to distinguish such a multitude.

The May, 1898, issue of *Harper's Weekly* contained the names of the nine artists chosen to carry out the decorations, and Davies' was not among them. All but one of the group were National Academicians, including ABD's former teacher Kenyon Cox, and they also held membership in the recently organized National Society of Mural Painters. The winning design for the space ABD had sought to fill was by Henry Oliver Walker and titled "Wisdom Attended by Learning, Experience, Humility and Love, and by Faith, Patience, Doubt and Inspiration."

Years later two art critics wrote articles concerning that decision. According to Frank Jewett Mather, Jr.:

> For the Appellate Court of New York he [Davies] sent in an admirable design . . . Its merits were not ignored even in the promiscuity of a general competition. But it was feared, as

⁂ 103

Figure 26. Mural design for the new Appellate Division, New York State Supreme Court Building, 1898. Oil on canvas, 22 x 60½ inches. Art Museum, Munson-Williams-Proctor Institute, Utica, New York, Gift of Mr. and Mrs. Niles Davies, Sr.

naturally as mistakenly, that so young an artist would be unable to execute the design acceptably. . . . As it stands, the Court House . . . contains nothing which has at once the graciousness of design and depth of color of Mr. Davies' rejected project.[28]

Elisabeth Luther Cary stated in the *New York Times*:

Here is the sketch of a court room decoration which was not used. If the jury or committee declined it, they probably made a mistake for certainly the originality of design and the beauty of its color, place it far above the average level of such decoration.[29]

Davies had not yet recovered from the disappointment of losing the mural competition when he experienced a more tragic loss: His daughter Silvia fell victim to spinal meningitis. Just as he had happily reported the occasion of her birth to William Macbeth, so he now sent him a telegram dated June 4, 1898: "Silvia died this morning eight twenty." She was only eleven months old. The devastating blow was still paramount in Virginia's mind five months later when she wrote in her journal: "The brown chestnut leaves lie close over my darling's little grave—curled like a scroll . . . "[30]

Although there was no known treatment at the time for the often-fatal disease, it would have been normal for Arthur to feel that his wife, a doctor, should have been able to initiate a recovery. Sadly no one in the family ministered to Arthur's pain or his needs. Speaking about it to his model more than a dozen years later, he still remembered the loss with a tinge of bitterness toward his spouse: "I was heartbroken, and I didn't get very much sympathy," he said.[31] And the scenario would be repeated three years later.

❧ 8 ❧

Forging Friendships (1898–1900)

\mathcal{A}rthur B. Davies' morose mood continued throughout the summer of 1898. The death of his daughter hung like a weight tugging at his heart. His painting hand seemed incapable of lifting a brush; canvases remained untouched. Compounding his sorrow was the outbreak of the Spanish-American War, which turned people's attention away from art; Davies' sales ceased.

Davies followed the pattern set on previous occasions when personal problems overwhelmed him: He left Congers and New York City. This time he headed for Jonathan, North Carolina, a town in that state's remote southwest corner situated in the shadow of the Great Smoky Mountains. Virginia's nieces had chosen to attend a nearby camp in place of their usual visit to the farm.

The change was a tonic for Arthur, as he duly reported to Macbeth:

> ...on my return from one of the most enjoyable trips I have made, that to the top of Junaluska mountain ... I have been much surprised at variety in these many peaks and I feel it is like a new language which I must become familiar with. I have been making innumerable notes ... I have several good motifs ...
>
> I hope to get Mrs. D[avies] & the children down here ... I have never seen so many & such beautiful swiftly running

streams, beautiful verdure and big primeval trees, not all firs by any means, but the mountains are an inspiration.[1]

Another inspiration was surely Lucy and Rostan Betts, for they were now thirteen and eleven years old and, as Arthur observed, "more charming than ever."[2] When Davies first began sketching them several years before, his motive was to engage them in a quiet activity—anything to eliminate the childish behavior that proved so disruptive to his work. But as they reached puberty and their slender bodies began to blossom into womanhood, he saw them in a different light.

On the other hand, always wishing for a daughter himself, then finally fathering one only to have her die in infancy, the artist looked increasingly upon the girls as his surrogate offspring. He was especially drawn to Rostan, whose beautiful face and lovely red hair brought to mind images of Elizabeth Siddal. Siddal was one of the Pre-Raphaelite Brotherhood's favorite models, who posed for many works by Dante Gabriel Rosetti as well as John Everett Millais' *Ophelia*.

Davies produced few paintings on the trip. One was *Foot-log on Jonathan Creek, North Carolina,* where several figures stand atop a log at the water's edge. His summer masterpiece, however, was *Cherokee Pinks,* for which the girls were the models. As Rostan reaches toward the ground for the low-growing flowers, her pose is like a profile view of a Millet gleaner. Lucy, also painted in profile, is placed behind her, arm extended along her sister's back. The title of the painting combines the name of the crinkled-edged flowers Rostan is poised to pluck with that of the North Carolina town of Cherokee where the canvas was created.

Compositionally this is one of Davies' most successful early works, and indicates that he had learned the lessons of Degas and Japanese prints. (He already owned one or more of the latter.) The girls' legs, like those of a pair of dancers, echo each other, introducing two sets of verticals and diagonals. The standing figure's body continues an upright thrust which reaches to the very top of the canvas, visually reinforced by a lone tree trunk. That linear movement appears to intersect the body of the bending figure and lead directly into her upright leg. Rostan's outstretched arm repeats the verticals while the back of Lucy's dress echoes the diagonals. In addition, the visual extension of Lucy's arm continues directly along

Figure 27. *Cherokee Pinks*, 1898. Oil on canvas, 14¹/₈ x 12¹/₈ inches. Private collection. Photograph courtesy Peter A. Juley and Son Collection, National Museum of American Art, Smithsonian Institution.

Rostan's forehead, and that diagonal is repeated by the hemline of the girls' dresses.

Back in New York, Macbeth's clients were kept appraised of ABD's art activities in *Art Notes:*

> Mr. Davies has been hard at work since last season, part of
> the time in the mountains of North Carolina, and has some

subjects partly finished that will confer high distinction on him some day. There are fine examples by him in my gallery now.[3]

The art dealer always kept a supply of Davies' work discreetly hidden behind curtained painting racks which stood wainscot high in the gallery. As soon as a visitor showed the slightest interest in a work on exhibit, he would reach beneath the curtains and bring forth one canvas after another.

On December 15, 1898, an article highly complimentary of ABD appeared in the *Art Collector*. Coming as it did just days after the signing of the peace treaty ending the Spanish-American War, it appeared to symbolically signal a new beginning:

> Mr. Davies is so full of America that he tries to paint her song . . . to express music with color and flat form—in other words, to entwine the arts and try to project the whole of life at one clip on a piece of canvas . . .
>
> Just at present he has a distinct place in American art. No other man is trying to put all of life into a picture. And this remains as his chief ineffectiveness—that some of his subjects are too large and of the impossible.
>
> But if there are many more tall, thin, dark young men like Arthur Davies and Stephen Crane up the State around Rockland and Sullivan Counties, we would like to have them "handed down"—as Mr. Dooley would say,—any time.[4]

Shortly after the article appeared, four of his oils were sold by Macbeth. These represented Davies' first sales in over a year.

Before the final days of 1898, ABD also sought a fresh start by moving his studio from 1140 Broadway to 237 Fifth Avenue, where he established himself on the top floor of the building that housed the Macbeth Gallery. Now he and his dealer would no longer find it necessary to communicate by letter. They made a practice of having lunch together almost daily, enjoying a simple meal prepared by the janitor's wife. Sometimes Davies even brought along one of his still-wet canvases for Macbeth to peruse.

By now Davies and Macbeth had become intimate friends. The dealer entertained the artist at his home on Prospect Place in

Brooklyn, a large structure with a spacious yard in what still resembled farm country, while ABD invited him to visit the Golden Bough. And Macbeth continued to promote Davies' career above all others. In the April, 1899, *Art Notes,* he wrote:

> To the many inquiries as to what Mr. Arthur B. Davies is doing I can only say that he is working incessantly but spending so much time on his pictures that a finished one has rarely been seen in the past two years.
>
> I had hoped to have the pleasure of making an exhibition of his work this Spring, but the few of the new ones that have not already gone into private collections are not enough for that purpose. They, however, may be enjoyed by any who care to see them, and it is hoped that additions may soon be made.[5]

Macbeth furthered Davies' reputation with new exhibition opportunities as well. For instance, during the summer of 1899 four of his works were submitted by the dealer and accepted in the *Second Exhibition of the International Society of Sculptors, Painters and Gravers* in London. Davies showed there alongside an impressive array of artists: Whistler (who served as president of the society), Monet, Renoir, Pissarro, Sisley, Vuillard, and Rodin among them.

The November issue of *Art Notes* contained a small but enticing notice:

> I am hoping very soon to be able to show the pictures by Mr. Davies which represented him in the recent International Exhibition in London. I understand that all four of them were splendidly placed.[6]

One of the paintings, *The Waterfall,* of a roaring cascade with a nude figure on a ledge silhouetted against it, was sold even before the announcement appeared; another, titled *Lucia and Silvia,* was acquired by Stanford White.

There is hidden symbolism in the title of the White acquisition. "Lucia" represents Virginia—she was sometimes referred to by her first name, Lucy—and "Silvia" refers to the couple's daughter

whose untimely death Arthur still likely blamed on his wife's medical failing. Additionally, in the tragic opera *Lucia di Lammermoor,* Lucia kills her husband on their wedding day.

The two female figures, both depicted nude, appear in the lower portion of the painting, their poses similar to those contained in Bronzino's (Agnolo di Cosimo's) celebrated sixteenth-century composition titled *Allegory of Venus and Cupid.* A pigtailed Silvia kneeling on the ground resembles the position of Bronzino's Venus, and Lucia's outstretched arm touches Silvia's hand in the same gesture as that of the Italian mannerist's Father Time. Yet it is probably one or more of the other personifications in Bronzino's oil, those of Folly, Inconstancy, Jealousy, and Hatred, which ABD would have attributed to Virginia.

Seated alone in the background of Davies' painting along an unsettling diagonal horizon and amid wind-swept trees, is a static, silhouetted male figure, here representing the powerless artist himself.

Employing symbolism had a liberating effect on Davies. It freed him of the need to depict what he saw around him and allowed him to express spiritual, subjective, or repressed thoughts. One of the symbolist writers to whom he was exposed earlier in his career was Stuart Merrill, who heralded the cause to American artists in the late 1880s, at the time ABD was enrolled at the Art Students League. France's leading symbolist poet, Stéphane Mallarmé, hit a responsive chord as well, for his *The Afternoon of a Faun* could be appreciated on several levels: Its mythological setting, the faun's uncertainty about encountering real or imagined nymphs, and whether the faun merely experienced an erotic dream or had actually raped the nymphs. It is understandable, then, that ABD entitled another painting, of his seven- and five-year-old sons, *Little Fauns on the Bank of the Arethusa.* It was those waters that resulted when the goddess Diana transformed the wood nymph Arethusa into a fountain.

In February, 1900, Davies was touched by another tragedy when he learned of Alice Kellogg's death in Chicago. She had died on Valentine's Day, a fact capable of being interpreted as a sign by Arthur, who must have once again pondered a series of "what ifs."

The following month the Macbeth Gallery was the setting for Maurice Prendergast's initial New York exhibit, the display being paired with a selection of Davies oils hung in the outer gallery. The

arrangement was a logical one, for when the Boston artist wrote Macbeth to inquire about exhibiting there, Davies would have been consulted on the subject; in fact, it may have been ABD who suggested that Prendergast make the inquiry.

Davies was already familiar with Prendergast's art, for the paintings of both men had been included on a regular basis in the same annual shows in Boston, New York, and Philadelphia. At Macbeth's their work appeared in marked contrast. Davies was represented by a group of dark oils including those inspired by Wagnerian operas, and Prendergast by watercolors and monotypes of Venetian scenes and circus subjects.

When Prendergast visited Manhattan that spring, Davies took him to the farm in Congers and they painted together on the banks of Rockland Lake. The area had changed somewhat during the few previous years; the Grand Rockland Hotel, destroyed by fire, had not been rebuilt, and a number of windmills that had once circled the lake had been brought down by a fierce snowstorm two winters before. Prendergast failed to bring his art supplies to the Golden Bough, so Davies supplied him with wood panels, paints, and brushes, and the two of them produced small oils near the water's edge. Davies' subject was an overall view of the far shore with a marked contrast between the dark hillside and light sky, while Prendergast's consisted of a row of foreground trees with sailboats placed in the spaces between.

On his subsequent trips from Boston, Prendergast continued to meet with Davies, and on one of these visits probably inspired ABD to experiment with monotypes. Prendergast had been producing them for a decade, initially in Paris under the influence of Whistler and Japanese prints. Like Prendergast, Davies painted his subject matter with oils on a small sheet of copper, applying mixed colors directly with a brush. After the areas meant to remain white were wiped clean with a rag, the print process consisted of merely placing a piece of paper on the copper plate and rubbing the back of it with a spoon. As the term "monotype" implies, only one print is meant to result from each composition, though it is possible to pull a second impression which will, by its nature, consist of paler colors.

While Prendergast's works in this medium display a careful, studied attention to detail, Davies' are more spontaneous and freely

Figure 28. *Figure of a Girl in a Landscape,* ca. 1901. Monotype in oils, 5$^{1}/_{2}$ x 9$^{3}/_{8}$ inches. The Metropolitan Museum of Art, Gift of A. W. Bahr, 1958. (58.21.5).

brushed. Examples of this are his *Figure of a Girl in a Landscape,* with its frenzy of blue-green dabbings and staccato brushstrokes; and *Two Nude Bathers,* in which there is only the most general definition of the figures and a rocky terrain.

On another of Prendergast's visits to New York, he and Davies dined at Mouquin's, where they happened upon Henri and Glackens. It was in this way that the visitor was brought into the fold of what would soon become a coterie of like-minded artists.

Davies and Henri had engaged in a long-distance friendship during the past several years. Davies had invited him to his 1896 and 1897 one-man shows at the Macbeth Gallery but Henri was in Europe on both occasions. After arranging for Henri's initial exhibit at Macbeth's, Davies, three years his senior, began sending him articles from the New York newspapers in order, as ABD pointed out,

> . . . to give you an indication of the situation here . . . Fitzgerald the Evening Sun man is the best we have, and is somewhat alive—or dreaming—all of the others suffer from insomnia—Have not seen the [National] Academy Ex[hibit] yet. The ten scions [The American Ten] of the Society of Am[erican] A[rtists] ex. opens next week. If you come to N.Y. after Mch. 30 you can look over the ground—very little to be seen. Hoping to see you soon anyway.[7]

Henri was married in June, 1898, then left for Paris on a honeymoon that lasted two years. Upon his return to the United States in mid-1900, he expressed an interest in moving to Manhattan. He needed, however, to find a teaching position to replace the private classes he had organized overseas. In September, Davies learned of an opening at the Veltin School, a finishing school for girls, and he quickly sent a telegram to Henri who was in New York the next day. Davies offered the use of his studio so Henri could arrange a display of his paintings as an appropriate backdrop for the required interview with school officials.

When Henri learned later that month that he had been hired for the job, he wrote Davies to that effect, prompting this response:

My Dear Henri, September 27, 1900

Naturally I have been wondering how the "affair" with Mrs.
S. S. [Isabelle Sprague-Smith, vice-principal at the school]
had settled, and your note received last evening gave me
great satisfaction. I believe better things will follow for you.
Let me know when you will be in town again. I can give
you night's lodging on a couch if that would be a
convenience. . . . With best wishes,

I am, Very Sincerely,
Arthur B. Davies[8]

The previous month, ABD had left abruptly for Newport,
Rhode Island, a trip taken ostensibly to seek out new subject matter.
In actuality it served as an escape from responsibilities associated
with the birth of his fourth child, a boy he named Alan.

Davies had reported to Macbeth on August 20 from Newport:

I have made a great many small sketches and hope to get
a wack at a big storm on the rocky coast this week, if it
should come . . . There [is] a lot of beauty of all sorts lying
around on this luxuriant Isle . . .[9]

His desire to witness "a big storm" sprung from his trip to New-
foundland the previous year. There he captured on canvas such
subjects as *Storm over Placentia Bay,* featuring an ominously dark-
ened sky contrasted with the whitecaps of a raging surf; and *Wrecks,
Newfoundland,* where two schooners are shown foundering after
being battered by the continual pounding of a surging sea. In New-
port, however, nature did not cooperate; the few oils he did produce
were along the lines of a procession of sailing vessels floating by on
a becalmed sea, a work he titled simply *Coast Scene with Ships.*

Davies had no plans to exhibit his Newfoundland or Newport
paintings until an article appeared in a Brooklyn newspaper on
October 14, 1900:

Arthur B. Davies is an artist who is a tireless worker, yet
who will not consent to exhibit more than a small propor-
tion of his canvases. For this reason he has not made a
special exhibition of his work for two years . . .[10]

Figure 29. *Wrecks, Newfoundland,* 1899. Oil on canvas, 9⅜ x 14 inches. Photograph courtesy Peter A. Juley and Son Collection, National Museum of American Art, Smithsonian Institution.

As a result of the charge, a half-dozen of his paintings were shown at Macbeth's in December. A review in the *New York Evening Mail and Express* by Samuel Swift characterized Davies in this manner:

> Here is a man of intense feeling and wholesome imagination . . . to be taken with the utmost seriousness, artistically speaking. No more expert technician, perhaps, is at work, among American artists; and, what is far better, none uses his powers with more imaginative force, or more earnest and successful effort to express high and admirable ideas.[11]

Among the oils on display were several of yachts and steamships. Although Swift referred to these and the other canvases as "new works," the group included *Aspiration,* produced from the photograph of Lucile du Pré and shown in Davies' first solo exhibit at Macbeth's four years earlier.

By 1900 Lucile had removed herself from Virginia's and Arthur's presence, having taken up residence in Denver due to a tubercular condition. Her letters to Virginia, though fewer in number than before, were still perfumed with unrelenting passion:

> My dear One, write when you can. I dream of you every night. Always, that I am flying across spaces . . . and I reach your home breathless—I dream you are so ill—so ill! and Arthur will not let me enter. Very mean of him, too, when I come so far! . . . Come . . . , Madonna [to] Colorado . . . and be near enough to make my life glorious.[12]

When her worsening condition thwarted Lucile's career as a concert violinist, she turned to writing poetry, expressing the thoughts she had written to Virginia over the years:

> Forever we were but a breath,
> But a word or a look apart;
> You waited too late, well-beloved.
> Death knocked at my heart.[13]

Lucile du Pré eventually made her peace with ABD, writing to Virginia that "I think Arthur is a genius, working among earth's most subtle spiritual forces . . . I'm at last, a genuine friend of his."[14] Responding to his request for sayings from the *Tao Te Ching,* Taoism's sacred book, she sent him a list including: "All things spring forth from within, into activity . . ." and "Quiescence underlies motion. Therefore the wise man never loses his quiet from day to day."[15]

These were well-suited to Arthur's expanding interest in symbolism, mysticism, and the occult. Although his Welsh heritage always received credit for making allegory and symbolism a natural language to him, these concerns dominated his very existence. They became the world of his art, his dreams, his fantasies, a silent domain in contrast to the cacophony of the urban world that swirled around him when he worked in his New York studio.

Less than a decade before, Arthur had conceived of the Golden Bough as an ideal romantic retreat. It had become instead the center for crying babies, family responsibilities, and manual labor. Now his sanctuary from the external world was the top floor at 237 Fifth Avenue, "my dark hole" as he came to call it, where the temple of his mind held sway. In contrast to the art of Henri and his associates John Sloan, William Glackens, and George Luks, whose focus was on life in the streets of the city—its everyday dramas, noisy crowds, and animated activities—Davies' art was tranquil and almost silent. It was less a shout than a whisper. It is not surprising that ABD produced only one known cityscape, an early oil showing a subway entrance near Cooper Union at night, with people cramming the park under the glare of street lights and the elevated railway cutting across the scene. This was not for him.

Davies' reason for avoiding what would become known as Ashcan School subject matter was many faceted. Subjects that included trash-strewn gutters, peddlers, livery wagons, and manure-covered streets did not appeal to him. He sought instead to fashion landscapes emanating from the imagination which combined the symbolic with reverie. Davies looked upon the creation of art as a contemplative process, not one requiring quick, on-the-spot sketches as preliminaries to the final canvas. So private a person as ABD felt conspicuous and uncomfortable positioning himself to paint in a public place, where anyone and everyone could gather around to gawk, and usually did.

And as one who had suffered respiratory illnesses early in life and was prone, even now, to catching bad colds, he was not enamored by the practice of drawing or painting outdoors amid soot-ladened air in near-freezing temperatures. As he once wrote to his brother David:

> I have been "laid up" for a month with the "flu" and in getting rid of the weakness I have not been very able to get around, and with our street car traffic paralyzed by the heavy snows New York has not been as agreeable as might be. . . .[16]

After all, even someone like Robert Henri would soon abandon painting cityscapes out-of-doors because one mid-winter art excursion into the streets led to his contracting a miserable cold that nearly turned into pneumonia.

Davies found inspiration in the art and themes of Inness and Ryder, Blake and the Pre-Raphaelites, the Greeks and Romans, Piero di Cosimo and Botticelli, Böcklin and Hodler, Puvis de Chavannes and Matthew Maris, Titian and Giorgione. Matthew Maris appealed to ABD because his tiny rural scenes, soft-edged and subjective, were akin to those of Ryder, who had once met Maris in London. It is likely that Davies read E. B. Greenshields' *Landscape Painting and Modern Dutch Artists,* which devoted a chapter to Maris and linked Ryder's view of nature to the late-nineteenth-century Dutch movement. Ferdinand Hodler was considered the most prominent Swiss artist at the turn of the century, heralded as one of the fathers of modern art beyond the French school. Davies was attracted to his paintings of women, ill or convalescing, which embody the same symbolist elements of melancholy, anxiety, introversion, and a preoccupation with death as are found in the art of Edvard Munch.

It was the mythological themes of Arnold Böcklin that caused Davies to consider him a kindred spirit. Böcklin forsook the realm of gods and goddesses, however, focusing instead on satyrs, nymphs, and centaurs, whose erotic desires and cavorting love-making held a special appeal for ABD. Böcklin's disquieting oil, *The Isle of the Dead,* in which a coffin is transported in a rowboat to an island replete with ominous mountains and tiered burial sites, was soon

proclaimed the most widely known German painting executed since the sixteenth century. Davies owned a framed copy of it, as did his future friend, Alfred Stieglitz. And it would not have escaped Davies' attention that when Sergei Rachmaninoff made his first American tour several years later, one of his compositions on the program was *The Isle of the Dead (A Symphonic Poem after Böcklin)*.

Davies maintained an extensive collection of picture postcards which further reveals the scope of his artistic taste. The sepia reproductions illustrate works by Goya, Velasquez, Puvis, Giorgione, Mantegna, and Parmigiano, plus early Christian relief panels and Tanagra sculpture. However, interest in the subject matter and styles of others eventually proved less important in guiding Davies' mind and hand than his own imagination, thoughts, and visions. There are occasions, for instance, when he claimed that the solution to a painting was arrived at when a pair of Old Masters visited him in a dream. First Giorgione came by and drew the answer to the problem, then Titian arrived and concurred. When ABD awoke the next morning he was thus inspired to complete his picture.

By the turn of the century, art critics acknowledged the unusual source of his art, for as Samuel Swift concluded in his December review: "The key to it all . . . is that Mr. Davies' inspiration comes from within . . ."[17]

❧ 9 ❧
A Model Liaison
(1901–1902)

*W*hile many artists eagerly sought the opportunity to serve on the juries of major annual exhibitions, reveling in the camaraderie and prestige, Davies regularly declined such invitations. He did so in January, 1901. when he wrote his regrets to the Pennsylvania Academy at not becoming a member of the New York committee for its coming exhibit. He felt compelled to add: "I am sure you will find someone more competent than myself from among the hundreds of artists living here."[1] This statement was written more because of ABD's desire to remain uninvolved with art world politics than because of any sense of inferiority. He was well aware of the fact that personal friendships and animosities sometimes had much to do with whose work was accepted or rejected.

Furthermore, even accepted entries could be shunned by the Hanging Committee, in essence a second jury. This group of artists determined where each work was to be located on the gallery walls. Placement in a small gallery or hallway diminished a painting's importance in the public mind. Similarly, since exhibition rooms were still largely lit by daylight, the only canvases guaranteed a proper viewing were those situated "on the line," at eye level. Others were "skied," a term used to denote placement closest to the ceiling, atop a row of three or four pictures.

Robert Henri, who was also tuned in to the system, organized a small exhibition at the Allan Gallery on a more democratic note. There each artist would be represented by the same number of works, "equally arranged half in light and half in dark."[2] Henri and Davies met on February 20, 1901, then went to visit George Luks. When the show opened at the West Forty-fifth Street gallery on April 4, neither Davies nor Luks were among the seven exhibitors, which group included Henri, John Sloan, William Glackens, Ernest Fuhr, Alfred Maurer, Van D. Perrine, and Willard Price. Davies' failure to be represented stemmed from the fact that he was hard at work preparing thirty-four canvases for another one-man show at Macbeth's slated to open the following month.

Critical reviews of ABD's exhibit at Macbeth's heaped the usual amount of praise. One writer labeled him "a personality that stands secure in the front rank of American artists to-day . . . One of the very few to whom we can look with confidence in considering the future of art in this country." The critic concluded: "Mr. Davies's art is intensely emotional, and the more sensuous element may safely be enjoyed even by those who are blind to its deeper significance."[3] Another reviewer was sufficiently impressed by four of the Newfoundland subjects in the exhibit to recall them years later as "bleak landscapes . . . a new note in my estimate of the artist, which seemed to me . . . as very personal expressions."[4]

Still another critic observed: "Without laying too much stress on a matter of minor importance, attention may be drawn to the titles that Mr. Davies has given to his pictures. . . . In an effort to find expression through words, he . . . suggest[s] the thoughts that motivated the several paintings. Sometimes the outcome is inspired . . . "[5]

A portion of the growing mystery and appeal of Davies' canvases *was* the unusual nature of the titles he bestowed upon them. Although the majority of his earlier works were given merely descriptive names, he now increasingly scoured the writings of Shakespeare, Ben Jonson, Rossetti, Swinburne, Tennyson, and Ryder, and Frazer's volume of *The Golden Bough* and Bulfinch's *Mythology* for titles with a poetic meter or captivating lilt to highlight symbolic content. Included in the exhibit were paintings bearing such captions as *The Night Passes,* a personification of Dawn rising from a cave to view the morning sky; *A Golden Link,* where the form of a nude figure rising from a lake suggests the link between earth and

sky; and *Enter These Enchanted Woods, You Who Dare,* of three female nudes screened from the outside world by dense foliage. Sometimes, as in the latter example, the title is titillating, carrying with it varied messages, both romantic and erotic. One of the marine scenes, of craft bobbing up and down in rough seas, was titled *Giggling Boats.* Other titles included *Time—Old Mystery; The Wind, the Changer;* and *Dance, Tone and Speech.*

Samuel Swift outdid himself in his enthusiastic review of the show:

> At the very end of the art season comes unexpectedly one of the really stimulating and significant exhibitions of the year . . . by Arthur B. Davies at the Macbeth gallery. . . . It is not too much to say that Mr. Davies is already one of the foremost artists in this country—and there was nothing new shown at London or Paris last summer in which could be discerned more promise or more achievement. . . . [6]

Henri, after visiting Davies' exhibit, noted succinctly in his diary: "fine show."[7]

Less than two months later ABD left on a four-week trip to London, leaving behind his wife and three sons, now ages eight, six, and one. Macbeth joined him so they could jointly view certain works for possible purchase, for even though the gallery was now heralded as specializing in American art, the dealer still found it necessary to handle some European paintings in order to keep his operation profitable.

After Macbeth returned home, ABD wrote to Virginia:

> I took some of my things up to show Frank Short—he liked the color very much—and we had a very nice talk on art generally—also he gave me a letter of introduction to another artist in Chelsea who has some good work by a man named Potter whose work Short says is like mine. . . . I went also to Murhmann's with my things & he also liked them & is going to speak to a dealer here who he thinks will buy one or two. . . . Murhmann introduced me to another American artist here named [F. Luis] Mora whose studio I intend to visit tomorrow. I have the Yellow Book editor to see tomorrow also & if I can will try to dispose of a watercolor if he wants one . . .

Arthur closed his letter with these words: "My dear one, I shall be so glad to get back to you again and love you better than ever . . . want to be home and at work in the quiet of my studio—and most of all to caress & kiss my sweetheart . . . I can hardly wait.

Arthur"[8]

But the joyous reunion was spoiled by tragedy, as Henri noted in his diary for August 21, 1901: "Davies came, returned from Europe . . . on Davies return found that his little baby had died while he was coming over. [V]ery sad."[9] The terrible irony was that Alan, like Silvia, had died of spinal meningitis.

The distraught father was left with unspoken accusations, and memories made poignant by his pencil drawings of Virginia cuddling the infant and three head studies of the baby asleep in his high chair. During the following months Davies became even closer to Henri, especially when he learned that Henri's wife had lost a child through a miscarriage two years before. Now the artists exchanged studio visits several times a week, dined together often, and when they discovered their tastes in music were similar, attended a Boston Symphony concert at Carnegie Hall. On another occasion, Davies provided tickets for Henri and George Luks to accompany him to a program of Indian folk music, Negro folk songs, and an address by Booker T. Washington.

Both ABD and Henri submitted work to the Pan-American Exposition opening in Buffalo in September, and both won silver medals, the first prizes they had won. Davies' award was for his painting *Full-Orbed Moon,* a haunting night scene featuring a nude woman standing near one fully clothed and partially cut off by the left-hand side of the composition.

The title was inspired by an Albert Pinkham Ryder poem which begins:

> In splendor rare, the moon,
> In full-orbed splendor,
>
>
>
> a lover's boat,
> In quiet beauty, did float
> Upon the scene . . .[10]

Figure 30. *Alan,* March 30, 1901. Graphite on pink paper, 10½ x 8 inches. Collection of Sylvia Davies Diehl and Kenneth R. Diehl.

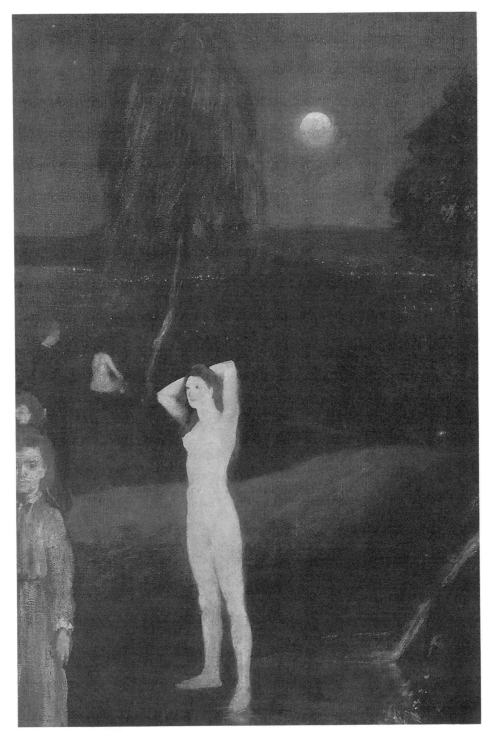

Figure 31. *Full-Orbed Moon,* 1901. Oil on canvas, 23 x 15³/₄ inches. The Art Institute of Chicago, Mr. and Mrs. Martin A. Ryerson Collection, 1933.1191. Photograph ©1997, The Art Institute of Chicago. All rights reserved.

Ryder's verse accompanied his painting *The Lovers' Boat* when it was exhibited in an early Society of American Artists annual, and ABD's *Full-Orbed Moon* bears some resemblance to the oil, especially in the location of a lake, willowy trees, and the moon. However, in place of Ryder's sailing vessel, Davies' composition is dominated by the female nude, her brightly lit body made all the more prominent by its being silhouetted against the darkness. With arms clasped behind her head, she appears like a land-locked siren of the sea.

Davies' technique, which in previous years had possessed the heavy paint quality of a Ryder, is now less impasto, with most areas of the composition revealing the weave of the canvas. Perhaps the most surprising element is the fact that, though the work was singled out for Davies' first painting award, he neither repeated its mood nor its subject matter in subsequent canvases.

Davies was also represented in the exposition by three additional oils: *At Evening (Viola Obligato), The Source,* and *Place of the Mothers,* the latter a barnyard scene with a dozen pigs, including a group of four young, suckling their mother. This most un-Davies-like subject was inspired by several photographs taken by the artist.

Attempting to diminish the impact of his son's death through renewed art activities, ABD scheduled a one-man show of fourteen drawings and paintings for Brooklyn's Pratt Institute in November, 1901; he then arranged for Henri to exhibit there the following January. Henri reciprocated by mounting a small show of Davies' work at the Veltin School in February.

The two men were constantly viewing each other's new work as well as the art of others; one day Davies would show Henri his latest acquisition of Japanese prints, another time they would go to the Durand-Ruel Galleries to view a Monet exhibit.

The day after Henri's second one-man show opened at Macbeth's on April 1, 1902, he paid a visit to Davies. The next afternoon he met with Glackens and Luks to "talk of [an] exhibit of four of us."[11] Exactly a year earlier Henri had organized the Allan Gallery show. Now the proposed exhibition of "The Four" failed to materialize because Davies would be displaying twenty of his works at Macbeth's following Henri's exhibit there, and Luks was preparing to embark on a trip to Europe in May.

The friendship between Davies and Henri also resulted in their sharing of models. Toward the end of 1901 Davies hired a woman named Sidna Nouvelle, then directed her to Henri who proceeded to have her pose for three oils. Beginning in 1902 they both painted Jesseca Penn, a ravishing redhead with green eyes, a tiny waist, and long, slim legs who danced in the Ziegfeld Follies. Henri chose to paint her dressed in a flowing black gown or to have her pose nude, while Davies preferred that she dance, then hold certain positions sufficiently long for him to capture the attitude in pastels. "She was particularly ecstatic in her appreciation of Davies," a friend of hers recalled.[12]

When Henri began employing Jesseca Penn with increasing frequency, referring to her as one of the finest nudes he had ever seen, Davies was moved to seek a replacement, finally settling on another dancer named Edna Potter. Similar in proportion and stature to Jesseca Penn, she was five feet nine inches tall, just the sort of elongated figure ABD liked. Miss Potter had a dancer's grace, carrying her head high and appearing to float rather than walk.

Davies gradually became enamored of her, and their relationship began to stray beyond the bounds of a working artist and model. She became his Beatrice, the ideal love of Dante, and ultimately assumed the role of Rossetti's Elizabeth Siddal—his model, mistress, and eventual wife. Edna's features not only bore a passing resemblance to those of Siddal, but both women possessed striking auburn hair, the edges of which became a gleaming red when touched by the sun.

Davies was additionally intrigued and challenged by Edna Potter's intellect—the same attraction that had originally drawn him to Virginia—the fact that she had studied dance in Paris after a stint at the Art Students League, and knew both French and German. "My alliance with him was not an ordinary liaison," Edna would later confess. "I never sought him but he pursued me for [a] full five years."[13]

One can imagine Arthur's sense of guilt as the affair progressed, this son of a Methodist minister. Perhaps the affair was the result of a mid-life crisis, of his having turned forty in 1902 (Edna was twenty-five). Maybe it was prompted by Virginia's weekly absence from his life, plus her abrupt departures from the farm for two and three days at a time when she was regularly requested to deliver

babies at the expectant mothers' homes. And then there was Virginia's unkempt appearance, this once well-dressed doctor whose clothes were often blood-stained from tending to the newborn, the injured or dying. In all probability it was a combination of several of these factors that seemed to justify the transgression in his mind.

Had Davies known of the love affair between Charles Dickens and the actress Nelly Ternan he may have used it as a model for his future life with Edna. Though Dickens was separated from his wife, he was unable to reveal the affair with his mistress, given the strict moral code of Victorian England. Davies was not only driven by a similar fear of scandal and humiliation, but by the fear of losing the patronage of his growing number of socially prominent women as well.

There were always whisperings and wonderings about artists and their possible studio seductions of women who came to pose—especially when they were actresses and dancers, professions still looked upon at the time as unladylike and risqué. Davies could probably have cited any number of examples of such relationships, including the two successive mistresses of Joseph M. W. Turner, Richard Wagner and Mathilde Wesendonck, and Augustus Saint-Gaudens and Davida Clark.

For the first several years, Arthur and Edna had extended "modeling" sessions in his studio and living quarters atop the Macbeth Gallery, and though they could continue after the gallery and other businesses in the building had closed, discretion dictated that she not be seen leaving in the early morning hours. When he finally convinced her, by 1905, that they should live together, a second apartment and another identity were required.

So it was that the couple moved into 314 East Fifty-second Street as Mr. and Mrs. David A. Owen. His selection of the assumed name was really quite simple, yet no one associated it with him during his lifetime:

Arthur Bowen Davies ➜ Davies, Arthur Bowen ➜ David A. Owen

His step-grandfather's name was David Bowen, the first name having also been bestowed upon ABD's father, his oldest brother, and one of Arthur's sons. And in Welsh, "Bowen" means "son of Owen."

Because Arthur could not pose as an artist, he required a bogus occupation as well. Reaching back into his past, he professed to being a civil engineer whenever someone who knew him only as Mr. Owen made inquiry.

His decision that he and Edna live as husband and wife in Manhattan while he still maintained weekend ties with his real family required careful planning on a daily basis. It also caused him a great deal of anxiety. He and Edna could not be seen in public places such as the theater for fear that his secret would be discovered. New friendships could not be encouraged and no invitations were ever extended to visit the two of them in their apartment. Even his studio became a secret lair where entrance was gained only by those who knew the special knock; others simply left when no one answered. A glass panel in the door was covered with cardboard from within to prevent anyone from seeing if Davies was there.

To many it appeared as though ABD had had a personality change overnight. He became secretive and aloof. Former close associates such as Henri were now discouraged from dropping by. When Davies had a telephone installed in his studio, the number was unlisted. He failed to provide it to more than a handful of people, explaining that a phone call would interrupt his train of thought.

Now Arthur began having Edna pose clothed and nude in various dance positions and attitudes, first sketching her in pastel or chalk on colored paper, then incorporating her likenesses into oils that were given such titles as *Diana* and *Adam and Eve*. The former painting contains two Dianas, one clothed and positioned beside her symbolic deer as goddess of the forest and the hunt; the other, nude, a sensuous siren representing her mythological associations with love and childbirth. Both light bodies and clothing are in striking contrast to the darker woodland scene beyond, and Davies applied the paint thinly on the faces and figures, reserving heavier pigment for the background.

Compositionally the figures lean away from each other and gaze in opposite directions, just as ABD's feelings toward Edna encompassed her dual roles as model and lover. The picture brings to mind the theme and double depiction of clothed and unclothed figures in Titian's *Sacred and Profane Love*, though Davies used discretion in avoiding a frontal view of the unclothed Edna.

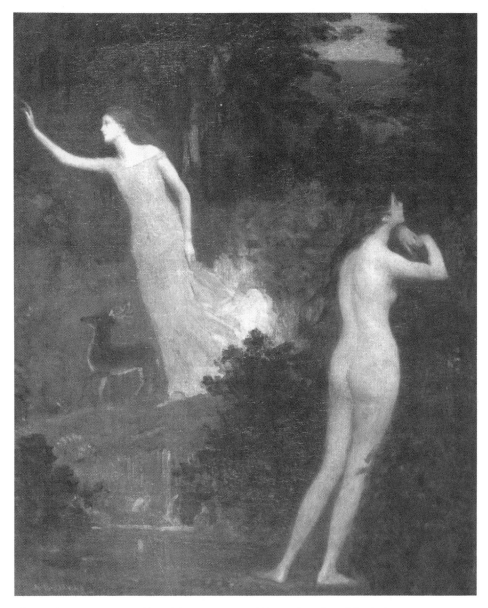

Figure 32. *Diana,* ca. 1902. Oil on canvas, 20¹/₈ x 16 inches. The Baltimore Museum of Art, Gift of Dr. and Mrs. Herbert Friedenwald, 1937. (1937.68).

Adam and Eve also avoids a traditional interpretation of the subject, for this naked Adam, symbolizing ABD, is astride a horse, representing flight and freedom, while a nude Edna/Eve, like a seductive Salome, entertains him by assuming a dancer's *cinquieme en haut,* the fifth position in which arms form a graceful circle above

the head. In Davies' version there is no apple tree in sight, no reminder of the fruit he associated with the Golden Bough. This imagined Eden was his and Edna's.

It was an idyllic existence from Arthur's point of view, but he was forced to fabricate a continuous stream of stories in order to forestall any thought of marriage on her part. If he sought a separation, he contended, Virginia threatened to take the boys to the south; a divorce and she would kill them. Then, to seemingly justify the continuing affair, he told Edna that the two children who had died were fathered by other men. This not only served to elicit her sympathy and understanding but helped explain the retaliatory adultery on his part.

One can only surmise the pangs of remorse Davies may have felt over the years regarding his real wife and sons. The boys longed for a full-time father, yet he was there for them only on weekends. The effect of his life of deceit and near-abandonment had a profound impact on the members of his immediate family. Virginia knew the warmth of true love for less than a decade after the utterance of their marriage vows. Niles and David essentially grew to manhood without a father's daily love, guidance, and camaraderie. And what of Edna, who was coerced into an existence of secrecy and loneliness, prevented from entertaining or developing a circle of close friends, and forced to abandon her career as a dancer?

Arthur never expressed any of his own repressed emotions in writing, and those that might have been spoken to a confidant such as William Macbeth have been lost for all time. But there exists a single drawing by Davies showing a woman at her dressing table, head turned toward a man who stands a few feet away. Though the faces are in silhouette and were too quickly sketched to indicate their identities, across the top of the sheet Arthur wrote in clear, capital letters the words "THE ADULTERER."

❧ 10 ❧

New Alliances
(1902–1905)

*I*n 1902, while Arthur was in the early throes of his affair with Edna, Virginia's oldest niece, Lucy, died at the age of seventeen. Though he continued to sketch and paint his new live-in model, he also produced several canvases of the Betts girls as a sort of memorial to the deceased.

Two years earlier ABD had drawn a happy foursome titled *Cherubian Children,* a pastel of his two boys and Virginia's two older nieces walking, arms around waists, toward the woods. The angelic cousins are shown in three-quarter views from the back, the boys nude, the girls in ankle-length, diaphanous dresses. With trees in full bloom and the teenage girls blossoming, it appears to be the boys whose youthful innocence is about to be tested.

Now Davies painted *Dancing Children,* and though the title implies a festive subject, the participants appear less than joyous. Attention is focused upon a group of three young girls in summer frocks, two of whom appear isolated and deep in thought, though they assume dance positions beside one another. The third, seen from behind, touches hands with a mirror image of her pose, the latter placed in shadow before a deeply darkened bower. This third youngster, representing Lucy, is being ushered by Death into the world beyond. A bridge leading out of the picture has been included in the background for just that purpose. A lone, clothed female sits

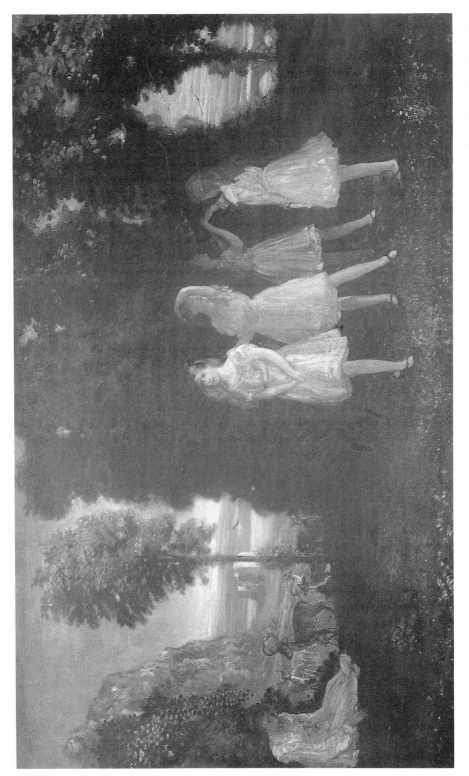

Figure 33. *Dancing Children*, 1902. Oil on canvas, 26 x 42 inches. The Brooklyn Museum of Art, Bequest of Lillie [Lizzie] P. Bliss. (31.274).

far off to the left, her head bowed as several deer roam aimlessly about her. She represents Virginia, a sad and fallen Diana who no longer typifies the love goddess in Arthur's eyes.

Following the death of baby Alan and the partial break-up of the Davies' marriage, ABD focused on activities with Niles and David during weekend visits to the farm. He enjoyed teaching them to create with their hands as he had done in *his* youth: to carve or construct swords, baseball bats, and hockey sticks. Davies took numerous photographs of the boys as well, clicking the shutter as they ran nude around the farm or posed for him in a particular stance, just as Thomas Eakins' art students had done for their mentor. On his return to the city, ABD would take along the photos, plus several landscape sketches in watercolor or pastel he had produced, for incorporation into future oils.

Arthur's obligation to visit his sons on weekends normally precluded all other demands on his time, so it was not unusual for him to inform Henri, for example, that they could meet "any afternoon (excepting Saturday)...when I go home to play with my boys."[1] Virginia would sometimes absent herself from the farm during his visits, usually for professional reasons involving ministering to the sick. She demonstrated no interest in cooking, aside from routinely preparing a large pot of oatmeal when she arose at 6 A.M. The children would eat it cold when they came down for breakfast. When Arthur was there she might leave something for dinner, though it could consist of as little as potatoes fried in lard.

Davies began to come under increasing emotional strain, attempting to maintain the weekend schedule along with his existence in Manhattan. The strain was exacerbated by the added financial burden of a mistress and an apartment. Macbeth tried to ease his plight by having his paintings on almost continuous display; for instance, after twenty of them were shown during April, 1902, four more were placed on view the following month in conjunction with another artist's one-man show.

Yet despite the fact that the critics responded favorably—one wrote of the latter exhibit that "The oldest sceptics, if capable of feeling at all, ought to be convinced of this artist's [Davies] rare gifts..."[2] —William Macbeth sold only three of his oils during the first nine months of the year. Depressed, ABD left abruptly for New England

in October, subsequently informing Macbeth that "I feel better & will get over my nervousness in this bracing air."[3]

When he returned to Manhattan, Davies visited Henri, who showed him a group of four etchings by John Sloan that Sloan had just sent him. "Nothing better has ever been done,"[4] was Davies response. Sloan, who was still living in Philadelphia, reported seeing a couple of works by Davies at the American Item Art Company exhibition that had opened there earlier in the month. It was an attempt by ABD to supplement his income at a time when he depended on Macbeth to advance him monies against future sales of his work.

Henri was beginning to teach his first classes at the New York School of Art, and almost from the start he was directing his students to "go to see Arthur B. Davies," as one former pupil recalls. "He would tell us to see certain paintings from time to time."[5] In April, 1903, another pupil noted in his diary:

> Henri brought over a little picture of two children by Arthur B. Davies. It was presented to him by the artist. It was a beautiful picture of sympathetic child life, being surrounded by a fairy-land atmosphere, and handled with exquisite delicacy.[6]

The work became a focal point for classroom discussions before such students as Edward Hopper, Guy Pène du Bois, Glenn Coleman, and Rockwell Kent.

In April, 1903, an exhibit was held at the Colonial Club titled *Exhibition of Paintings Mainly by New Men,* which included twenty artists, among them Henri, Sloan, Glackens, Luks, and Ernest Lawson. Although Davies was too well-known to be considered a "New Man," at least one critic made reference to his absence, noting: "It is regretted that such an exhibition as this has nothing from Arthur Davies and Everett Shinn, two men in their different ways that have got the shackles off. . . ."[7]

When a group of ABD's oils was exhibited at Macbeth's later that month, Samuel Swift wrote in the *Mail and Express:*

> Several new landscapes by Arthur Davies, without figures, represent this painter at his best. When historians of some

future date examine the work that Americans were doing at the beginning of the twentieth century, they will find no point of view more completely contemporary in spirit than that of Mr. Davies . . . "[8]

What Swift had in mind were paintings such as *Autumn Landscape,* an oil of animals grazing in a foreground cast into shadow with sunny fields and hills beyond. Though Davies created it with one foot firmly planted in the tradition of rural scenes of nineteenth-century art, the other foot was placed forward in the execution of free brushwork, a reaction against turn-of-the-century academicism.

Among ABD's canvases created at this time are several in which nature and its moods dominate. In *The Flood* he offers the viewer a rare example of unleashed emotion and impending disaster. Here the wind whips trees and water into a frenzy while two nude people cower in the corner, striving to escape the mighty onslaught. In technique, the dabbed roughness of the raging water is similar to that found in his earlier painting of *Wrecks, Newfoundland.* Although Davies' subjects were rarely based upon the day's news, it is likely that *The Flood* was his response to the year's midwest disaster in which overflowing rivers caused hundreds to perish.

Such landscapes reveal a level of originality not evident in ABD's earlier compositions, for virtually gone are the noticeable influences of Ryder, Botticelli, Puvis de Chavannes, and others. In addition, the emphasis upon painting children has ended; they have been replaced by adults, often depicted in the nude. The change was surely encouraged by his relocation to a studio close to his gallery. While ABD had previously avoided the display of human emotion as part of his artistic vocabulary, now paintings begin to appear in which such feelings seem paramount.

Davies' studio above the Macbeth Gallery served as both a work space and a repository for the countless paintings and drawings that could not be accommodated in the gallery. Bryson Burroughs, an artist and Metropolitan Museum curator, described Davies' quarters:

> . . . Pictures in all stages of progress, wherever one looked! Canvases, literally hundreds of them, leaning face to back against the wall, arranged according to sizes, in rows which

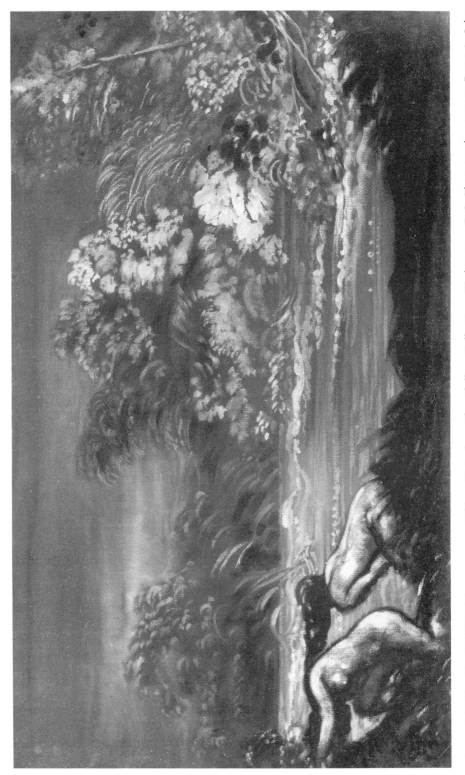

Figure 34. *The Flood*, 1903. Oil on canvas, 18¹/₈ x 30 inches. The Phillips Collection, Washington, D.C. Photograph courtesy Peter A. Juley and Son Collection, National Museum of American Art, Smithsonian Institution.

extended well out towards the centre of the room; on the tops of these, other rows of smaller canvases and panels! How could he find any particular work without endangering the balance of these lofty heaps!

All the furniture was littered with drawings; there were piles of drawings left anywhere on the floor—in moving about one had to watch one's step. Chairs were cleared for us; what was on them was dumped helter-skelter on the floor. . . . he showed me his drawings . . . His way of showing them was significant of his attitude towards his work. Like an ashman handling his cans he would lug out a great pile of drawings from some corner and chuck them down into the open space about the easel. A cloud of pastel dust would arise as the pile thudded against the floor . . . But Davies showed no concern. "A work of art," he said at one time, "has no value until it is sold."[9]

In September, 1903, just at the beginning of the exhibition season, a fire broke out in the five-story building housing Davies' studio and the Macbeth Gallery. For a brief moment the artist must have envisioned his life's work vanishing before his eyes, for it was he, a newspaper reported, who "smelled smoke and notified Patrolman O'Flaherty, who turned in the alarm . . . Davies carried several of his most valuable paintings with him"[10] as he scurried across the roof to the Reform Club next door, followed by some of the other tenants. After the flames were extinguished it was determined that defective wiring had ignited the blaze. According to one account, Macbeth's inventory suffered the most, totaling some one thousand dollars in damages.

A few weeks later the *New York Evening Post* reported that Old Master paintings were no longer on display at the gallery. One can only assume that because the art dealer's insurance premium would rise dramatically after the fire, he could no longer afford to carry European paintings, their value being considerably greater than the native offerings. At this point, William Macbeth began placing even greater emphasis on the sale of American art.

The newspaper article also revealed that "There will be no one-man shows this year [the 1903–1904 season] at the Macbeth galleries" because the owner had determined "there are too many of them in our art season, and [he] believes that people interested in

art prefer to find dealers' galleries hung always with the works of a number of artists."[11] It was reported that among the paintings Macbeth was prepared to place on exhibition were those of Davies, Henri, and Inness. Though ABD may have been apprehensive about the policy change, it appeared to work to his advantage, for Macbeth succeeded in selling eleven of his canvases during the following six months.

In the meantime, Henri began searching elsewhere for exhibition opportunities. He found success at the National Arts Club, which offered its gallery for a group show of Henri's choosing. The space was considerably larger there than at Macbeth's; he estimated that their two rooms could accommodate about sixty works. Each time Henri had invited Davies to exhibit with him in the past he had always declined due to a conflicting one-man show. Now ABD readily joined Henri, Sloan, Glackens, Luks, and Prendergast in the exhibition. Together they represented six of the future group of "The Eight."

The National Arts Club on West Thirty-fourth Street had been founded six years before by Charles De Kay, art and music critic for the *New York Times,* who still served as its gallery director. Although club shows did not normally receive the same degree of attention from newspaper reviewers as did public gallery offerings, De Kay's involvement guaranteed coverage from his fellow critics. A flood of articles followed the January 19, 1904, opening. Arthur Hoeber's piece in the *New York Commercial Advertiser* was headlined "A Most Lugubrious Show," categorizing the exhibition as one "where joyousness never enters . . . where unhealthiness prevails to an alarming extent."[12] De Kay's critique appeared under a *Times* banner: "Startling Works by Red-Hot American Painters." He observed that "Discussions are violent. . . . if the end of the month is reached without duels the club is in luck."[13]

Many of the adverse remarks were aimed at George Luks' canvas *Whiskey Bill*. Luks' subject was seen as a melancholy alcoholic rather than a jovial drinker in the tradition of Frans Hals. Davies generally remained above the fray, especially whenever seamy subject matter was discussed. Here he was represented by seven compositions: *In the Valley, L'Allegro, Wanderers, A Supplication, Wildwood Mysteries,* one simply titled *Nude,* and another of boys swimming.

Samuel Swift wrote that the other men showed such influences as Manet, Degas, Whistler, Courbet, and Velasquez, yet

> in the case of Arthur B. Davies the artist's originality has created a style of his own . . . there is abundant power and much charm in the group of boys bathing in a rain-swept lake, and the primitive figure under a feathery tree.[14]

The following fall, ABD made a trip to Utica, feeling the need to return to his roots and visit old friends. He informed Macbeth:

> Much has gone but much of the old has remained and [I] took a more comprehensive interest in the "scenes of my childhood, the fond recollections &c" glorified by the larger vision, and feel this trip has already begun to pay in the purple plums of culture—Cazenovia is perfectly ideal, such people, gardens, old houses, grand hills and trees, I have never realized except in my pictures and dreams, and I can see how much I have owed to these very conditions, through my dear friend Dwight Williams . . .[15]

Davies dropped in on his former mentor and presented him with a pastel, for ABD traced his proficiency in the medium back to Williams' instruction. As might be expected of Davies, the choice of this particular drawing was both sentimental and symbolic, for it was one of his first pastels to have been included in a major exhibit, in this case the 1894 National Academy of Design annual.

Early in 1905, Macbeth decided to modify his policy of not scheduling one-man shows in order to allow for one by Davies; however, the works were first displayed at the Doll and Richards Gallery in Boston. The collection of thirty-six paintings on view at the February 23 opening elicited favorable comments from the critic for the *Boston Sunday Globe,* who wrote that

> Mr. Davies' . . . pictures are of a visionary cast, and are memories rather than direct representations of nature. The best of them have a singular charm of color, composition and poetical sentiment.[16]

The *Boston Herald* reported:

> Arthur B. Davies of New York . . . is a powerful painter, not
> because he neglects certain of the facts of the visible world—
> as he does—but because he puts qualities of life, enthusi-
> asm and good taste into the doing of the things he has to
> do. Above all, he is not afraid . . .[17]

Maurice Prendergast viewed the exhibit, then wrote to a friend in
Boston that "it is the first time I have seen them [Davies' paintings]
in a collective exhibition and they interest me . . . "[18]

The show closed in Boston on March 8, 1905, and opened the
following month in New York. The *Evening Sun* art critic Charles
FitzGerald opined:

> The exhibition at the Macbeth gallery should win over many
> of the puritans who have hitherto stubbornly refused to
> enjoy what they could not explain . . . Creative art of this
> order is so rare that distrust and misgivings are hardly to be
> wondered at . . . Let it be understood that this introduction
> is intended not as an attempt to establish dogmatically the
> place of Arthur Davies, but as a plea for the liberty of
> genius in the profession of a great art, almost unknown in
> our day.[19]

Charles De Kay applauded the show in the *New York Times,* referring
to it as

> a very uncommon exhibit . . . The drawings of some of the
> figures will cause acute pain to some, but the strong vein
> of poetry shown in many pictures will be savored by those
> who find too much dryness and academical coldness in our
> exhibitions.[20]

Yet it was Samuel Swift of the *Mail and Express* who once
again sang the loudest praises under the headline "New Paintings by
Arthur B. Davies: Striking and Unforgettable Work by This Imagina-
tive Genius at the Macbeth Gallery":

... Mr. Macbeth has placed on exhibition nearly thirty more canvases, which prompted many visitors to declare Arthur B. Davies (for it is he, of course) the creator of the most enthralling and the most precious art works now being produced in this country.... No other such original force, save that of Albert P. Ryder, who is narrow in sympathy where Davies is broad, and whose accomplishment as a master of his medium cannot be compared with that of the younger man, has manifested itself in the whole course of American art.

The visitor that misses this Davies show is neglecting a striking, an epoch-making development in American art.[21]

Because seven of the canvases in the Boston exhibition had been previously sold and were merely loaned for the occasion, substitutes for them were added at Macbeth's. These included *Cucuhullin and the Birds,* a representation of an Irish war hero from the oldest epic poem in western Europe; *Invocation, October,* of a male trio playing French horns against a landscape; and *To Hesperus,* which symbolized the appearance of the planet Venus as an evening star. The subjects were unusual even for Davies.

These canvases contained figures depicted with dark skin tones, prompting the *New York Times* critic to reason that the artist was adopting "the prehistoric methods of the Etruscan wall painters and early Greek decorators of vases when he paints his nude young men a reddish brown."[22] While such influences upon ABD could not be denied, it is more likely that the model he had employed was a full-blooded Algonquin Indian named Tahamet, an individual with a magnificent physique who had been a model at the Art Students League. At the time of Davies' one-man show in 1901, one reviewer included the statement that "Mr. Davies is now absorbed in painting the American Indian."[23] In fact, a Davies composition in the exhibit was similar to *Cucuhullin and the Birds.* Showing the figure lying on his back with birds perched on both hands, it was titled *Tahamet Playing with Birds.*

Davies' exhibitions at Doll and Richards in Boston and at Macbeth's in New York were overwhelming financial successes. Between February and May, 1905, seventeen of the works were sold for a total of over eight thousand dollars. Among the purchasers

were such previous collectors of his art as Gertrude Käsebier and H.
H. Benedict; among first-time buyers was George Eastman, manufac-
turer of the Kodak camera. One may assume correctly that the
glowing nature of the art reviews had helped encourage sales, but
there was yet another contributing factor: Not long before Davies'
show opened, the Macbeth Gallery was raided for exhibiting an
example of what was termed "obscene" art. The censor was none
other than Anthony Comstock, New York's self-proclaimed protector
of morals who descended upon the gallery in his role as head of the
Society for the Suppression of Vice.

Comstock's ire was raised by Bryson Burroughs' painting of
The Explorers, which was hung in the front window. The moralist
was offended by the composition of five nude children—two boys
and three girls—wading in a stream with carefree abandon. He
ordered that it be removed at once "on the ground that the work
was not a proper subject for display,"[24] according to one newspaper
account. Comstock cited the picture as being "wicked and illegal."[25]
This champion of purity and decency instilled such fear in Macbeth's
young office boy that, in the owner's absence, he was intimidated
into taking down the picture. Comstock permitted it to be rehung in
the gallery's back room.

While the resultant notoriety was not as widespread as that
following the banning of *September Morn* in Chicago a few years
later, it was sufficient to draw a crowd of the curious to Macbeth's
for a reasoned or titillating look, since this was one of Comstock's
earliest actions. (It was not until the following year that he confis-
cated all copies of an Art Students League publication because it
contained reproductions of undraped females.)

Thanks to the several sales, Davies lost no time in determin-
ing what to do with his new-found wealth. The answer was a trip
west. Ever since illustrating John Muir's article, "Features of the
Proposed Yosemite National Park" for *Century Magazine,* he had
longed to visit there, and the journey to Utica and Cazenovia in the
fall of 1904 had served to whet his appetite for travel. The clincher
was a full-page advertisement in the January, 1905, issue of *Sunset
Magazine* headlined "California: Land of Recreation." Davies clipped
the ad and the following June, after bidding goodbye to his wife,
children, and mistress, embarked on a four-month-long adventure.

❦ 11 ❧
Reaching the Heights
(1905–1907)

\mathcal{D}avies' western adventure began in Denver, where he started filling the first of a succession of sketchbooks with line and shaded drawings, some accompanied by color notations for future paintings. Other details were recorded with his Kodak camera, such as those of Glen Park at Palmer Lake. This photograph shows a dramatic view of hills hidden by evergreens with clouds hugging the crests, the whole back-lighted by a setting sun. Such wondrous scenes were a prelude to the breathtaking vistas he was about to encounter in California, Oregon, Washington, and parts of Canada.

The experience of trekking among lofty peaks, cascading waterfalls, and mammoth redwoods and sequoias was about to forever alter the size, subject matter, and color of Davies' art. As art critic Frank Jewett Mather, Jr., would one day point out: "The little Arcadia of the early pastorals had become gigantic, cosmic."[1] And Marsden Hartley would remark that "[ABD's] redwoods of the West become columns of Doric eloquence and simplicity."[2]

The paintings ABD later produced from his sketches and photos were almost uniformly 15 by 40 inches, a large horizontal format suited to capture the panoramic grandeur of nature. Although he had once advised a friend "not to paint anything you can't carry under your arm because that's where the painting is most of the artist's life,"[3] the scope of his new subjects moved him to contradict his own words of wisdom.

Davies' feelings of exhilaration and reverence were revealed in his letters to William Macbeth:

> [June 18, Leadville, Colorado.] They say this town is built of shanties but is a builder of palaces. On a bleak hillside, dusty, the smoke from the smelters & fierce cold wind from the snowy mountains sweeping everything high before it . . . my week just finished at Twin Lakes, fishing & sketching!!! I caught a few trout . . . Twin Lakes lies between Mount Elber[t]'s 14,300 ft. & near Mount Massive 14,4000 ft. a most beautiful place. I doubt if I shall find anything better. The ride over from there this morning in the stimulating air was something to spiritualize in paint. I leave for the San Juan country this afternoon, will be in Ouray tomorrow. Hope to reach Salt Lake City at or about July 1st. Can assure you I am feeling tip-top too.[4]

It would not have been lost on Davies that his journey from Leadville to Durango, Colorado, took him along the route of the Denver and Rio Grande Railroad, the rival line of the Achison, Topeka, and Santa Fe when he was working in New Mexico twenty-five years earlier. The job as draftsman had stood him in good stead, for as he later observed: "That training made me see and feel not the surface only of those mountains, but their construction, as one feels the anatomical structure of the human figure when expressing its exterior forms."[5]

Despite ABD's goal of reaching Salt Lake City "at or about July 1st," he arrived more than two weeks later, which caused him to change his itinerary:

> [July 18, Salt Lake City]. I shall give up the Yellowstone trip which will consume seven days, my Lake Tahoe would be cut out practically for sketching purposes. I have seen enough already to satisfy any ordinary man . . . The great Pacific calls now, and it's off to Lake Tahoe tomorrow, arrive in Truckee [California] on Thurs. morning, shall remain there for a week and will probably reach San Francisco about 27th or 30th July. The box I found at Wells Fargo Ex[press] for which I was thankful as I needed the paints.[6]

Davies produced oil sketches on small wood panels measuring less than 12 inches in width. It was an easy size to transport, and they

would serve as artistic shorthand notations for some of the larger canvases he planned to tackle upon his return.

This just-concluded segment of his trip featured Yosemite National Park, one of his most anticipated destinations. Here ABD found spectacular natural wonders, including cascading waterfalls, one of which plunged nearly twenty-five hundred feet to the valley below.

Davies captured the latter in *Canyon Undertones, Merced River* (Plate 5), in which one senses the thunderous sound emanating from the numerous waterfalls that interrupt a wall of rock, and from rivulets rushing over boulders in the foreground. Above has been painted a small expanse of intense blue sky, where diagonally placed stratus clouds act as a compositional foil against the verticals and constitute the only areas of pure white.

Many Waters further showcases those narrow Niagaras, enlarged in number by spring run-offs from the mountains, as they become less real than symbolic, less descriptive than dream-like, their sprays and meandering shapes resembling nature's dancers. These two canvases are distinctly Davies, unlike any of the works by Albert Bierstadt or Thomas Moran in their two-dimensional perception and ominous mood.

One painting, *View of Cathedral Peak from the West, above Lake Tahoe,* includes a solitary figure in the lower righthand corner. The figure is dwarfed by the enormity of the landscape. This could well represent the artist himself and his feeling for man's insignificance when placed upon the background of this soaring setting.

"California is Davies's favorite region," art critic James Gibbons Huneker wrote three years later:

> He gives us the living panorama of glorious California. He has discovered the soul of California. Men have been painting there for a lifetime and they have seen her beauties through the eyes of the Barbizon tradition. Not so Davies. . . . those majestic, sweeping landscapes with luminous washes of sun and cloud, trees that loom up grave and giantlike to the sky . . . are the result of much pondering. Davies creates beauty.[7]

On his way north, ABD stopped in Portland just long enough to view the Lewis and Clark Centennial Exposition which had been

Figure 35. *Many Waters,* 1905. Oil on paper mounted on canvas, 17 x 22 inches. The Phillips Collection, Washington, D.C. © 1990 The Phillips Collection. Photographer: Edward Owen.

opened in June by President Theodore Roosevelt. The visit was not a sentimental journey on ABD's part, even though his wife was a direct descendant of Meriwether Lewis; rather, it was motivated by a desire to view the Department of Fine Arts exhibition in which he was represented by seven paintings.

After leaving the city, he traveled by stagecoach to the foot of Mount Hood:

> [September 21, Seattle]. I leave here tomorrow noon for Glacier . . . the remaining time at Lake Louise, then direct to Montreal & home by night of Oct. 4th . . . Three days on Mt. Hood with an unsuccessful expedition to the top, bad weather, soaked through by rain one day and heavy snow Sunday with the opening of big crevasses above the 10,000 ft. snow fields. However a most exhilerating experience,

one of my choicest. This morning I sent "collect" a package of the panels, about 70, via Wells Fargo Co. Express. As I have been packing them so long many are quite dry but others are freshly painted. I wish Henry [the janitor] would spread them out on the floor upstairs so they will not get permanently stuck together. I shall not be able to make many more I fear as the rainy season has set in . . . [8]

When Davies arrived back in New York, he plunged directly into painting, tackling a series of 40-inch-long canvases. Upon these paintings he bestowed such titles as *Emerald Bay, Colorado; A Lake in the Sierras; Pacific Parnassus, Mt. Tamalpais;* and *Mt. St. Helens.* In some of the works, such as *A Mighty Forest, Maenads,* he incorporated several sketches of Edna to form a group of gesturing nudes participating in a Dionysian revel. The dancers are arranged in the foreground like dancers on a huge stage against a backdrop of giant trees which serve to echo their shapes.

It is at this point in his career that ABD began to depict certain female figures in a unique, elongated fashion, as if to recall the soaring trunks of California's majestic trees. When such nudes appear before the dark, textured surfaces of redwoods and sequoias, the trees stand like symbols of protective, earthbound sentinels watching over the playful, cavorting women.

Another new aspect of Davies' art, characteristic of many of his large California canvases, is the use of the Golden Section. This concept was written about by Vetruvius, could be found in Euclid's textbook on elementary geometry, was taken up again during the Italian Renaissance, and was used in most American schools until just after the turn of the twentieth century. The Golden Section was considered the ideal proportion, a ratio of sizes employed by the planners of such architectural triumphs as the Parthenon and the west portal of the Cathedral at Chartres.

The ratio formula involves dividing a space into two unequal parts in which the smaller one is to the larger as the larger one is to the whole (3:5::5:8). One example of this, 15:25::25:40, is the size of most of ABD's paintings of California (measuring about 15 by 40 inches); it also explains why a dominant mountain peak or tree has often been placed fifteen inches from one side of the composition.

It was upon Davies' return to Manhattan in October, 1905, that he and Edna decided to live together on a permanent basis as husband and wife, answering to the name Mr. and Mrs. David A. Owen.

As ABD continued to work on his California canvases, he was gratified to learn of his inclusion in Samuel Isham's just-published book, *The History of American Painting*. Under the heading "Recent Figure Painting in America," Isham wrote:

> The romantic painter *par excellence* is Davies, and his work is as personal and as interesting as any done in the country to-day. Never once does he wander from his dream, his vision. His enchanted garden is not visited at rare intervals; it is not one of many resorts, it is his home, his retreat from which he never departs.[9]

The author, just a few years older than Davies, was also an artist who was listed on the book's title page as holding membership in both the National Academy of Design (NAD) and the Society of American Artists (SAA). Davies, on the other hand, had not been invited to join either organization, having stopped submitting paintings to their annual exhibitions. He felt he had become successful in the exhibition game on his own. Despite his refusal to show in the two New York annuals, his canvases were included in many other prestigious exhibits during 1905 and 1906: The inaugural show at the Albright Art Gallery in Buffalo, as well as the Pennsylvania Academy, Philadelphia Art Club, and Worcester (Massachusetts) Art Museum annuals.

Robert Henri had once sought to rectify this situation by having ABD's work admitted jury-free. Henri had been an SAA member for two years when he was chosen chairman of the Committee of Invitation for its 1905 exhibit. On a page in his diary he wrote: "Accepted with idea that I might get them to invite pictures of A B Davies who has not been sending to SAA because of previous bad treatment. . . . "[10] But Henri's plan was thwarted. The SSA rule stated no artist residing in New York City could be so invited; otherwise, Henri recorded, "others would kick or hold out for the same honor."[11]

Henri's role as activist in the Society of American Artists and National Academy shows stemmed from the fact that for several years he had been teaching a coterie of promising students at the New York School of Art and felt that their paintings should be seen by the public. He harbored the same feeling toward his associates' canvases, and at the society's exhibit Henri was sufficiently persuasive as a jury member to elicit votes of acceptance for works by Sloan, Glackens, Luks, and Shinn, among others.

By 1905, however, membership in the society and academy overlapped to such an extent that the one organization's annual show was virtually a mirror image of the other's. As a result, a committee was formed to consider an amalgamation of the two groups; the society was voted out of existence following its 1906 exhibit, and its former members were welcomed into the ranks of the academy. Individuals such as Henri who had previously held associate membership in the NAD automatically became full-fledged academicians.

This series of events led to Henri's being named to the jury for the academy's eighty-second annual in the spring of 1907. Henri was one of thirty jurors who assembled on March 1, 2, and 3 to determine the fate of nearly fifteen hundred entries. During the initial day's determinations many of Henri's associates and students fared well, this despite the fact that their canvases were largely spontaneously painted realistic scenes of everyday city life, while the vast majority of the other entries were either carefully crafted landscapes of rural tranquillity, staged academic compositions of medieval or classical themes, or sentimental genre.

As each of the decisions was subsequently reviewed, the votes of approval for the Henri group diminished, however. Some paintings slipped into a lower category of acceptance while others now received so few votes that they were rejected. Henri was irked that his powers to sway the jury vote—which had worked so well in the past—could no longer carry the day. To add insult to injury, the reconsideration of all entries resulted in two of his own three oils receiving less than unanimous approval from his peers. The personal affront was too much for him to bear; he announced the withdrawal of the two canvases in question.

The entire incident would have been relegated to studio gossip had not one of the other jurors gone to a newspaper with the story,

whereupon Henri was contacted for his comments. An article in the *New York Evening Post* on March 9, 1907, was the first to alert the public:

> It was expected that Mr. Robert Henri's election to the Academy would prove an opening wedge for the representation of the younger element in our art . . . The violent denunciations of the Academy's juries . . . can be remedied by the painters themselves. . . . Let the younger faction start a new organization. The time is ripe. . . . [12]

A course of action had already been set by Henri and Davies, the latter having agreed to speak with Macbeth about the availability of his gallery for an independent group exhibit the following winter. The Macbeth Gallery had moved the previous year to 450 Fifth Avenue, a space that provided an additional exhibition room. On the very day the *Post* article appeared, Davies gave Henri the answer:

> I have just had a talk with Mr. Macbeth regarding our exhibition and he said he did not feel able to give a reply *now,* but that he felt very favorably toward the exhibition & would let us know what he would do. I think we can with certainty count on his two galleries for two weeks next Feby [1908]. [13]

The controversy was now playing out in the press, with "Letters to the Editor" appearing in the dailies and art publications as well as such normally removed magazines as *Collier's* and *Putnam's Monthly*. On April 4 a meeting was attended by Henri, Davies, Sloan, Glackens, Luks, and Lawson where enthusiasm for such an exhibit was unanimous. Everett Shinn and Maurice Prendergast were suggested additions, with ABD volunteering to contact the latter.

The following day Davies wrote to Henri:

> I have just been in Clausen's [Art Galleries] to see [Rockwell] Kent's paintings and I think they are really *great:* poetic, sincere, and beautifully painted. I wish we might include

him in our group. Nos. 5, 10, 11, 12 are masterpieces, and he seems likely to fulfill my expectations of the younger men. . . .[14]

The works cited by Davies were: 5. *Afternoon on the Sea;* 10. *The Shadows of Evening;* 11. *Late Afternoon;* and 12. *Toiling on the Sea.* Reviews of Kent's show were similarly enthusiastic. Huneker wrote in *The Sun:* "If you long for a thrill, go . . . and look at the new pictures . . . of Rockwell Kent . . . he knocks you off your pins before you can sit down . . . ,"[15] while Guy Pène du Bois, who had been a classmate of Kent's when they studied with Henri, proclaimed: "At last we have another American painter. . . . They [the canvases] have economy, precision, dignity and force."[16]

All of Kent's compositions had been painted on Monhegan Island, Maine, a remote location he had decided to visit because of Henri's enthusiasm for it. Kent had even purchased a piece of land there adjacent to one bought by his teacher, yet Henri still rejected the notion that this up-and-comer, seventeen years his junior, should be added to the group. Davies, determined to aid and encourage the struggling artist, suggested to Macbeth that he select several of Kent's oils on consignment; this his dealer did by fall, with the choices including at least one of ABD's favorites, *Toiling on the Sea* (later renamed *Toilers of the Sea*).

Having decided upon the eight artists who would show at the Macbeth Gallery, Henri invited four of them—Davies, Lawson, Luks, and Sloan—to exhibit at the New York School of Art Gallery beginning on April 8, 1907. Of greater significance to ABD, however, was the inauguration of art exhibits at the Colony Club commencing the following day. The initial show there was comprised of thirteen artists, including Whistler, Sargent, Lawson, Maxfield Parrish, the late John Twachtman, and himself.

Davies wrote to the organizer of the exhibition, sculptor and socialite Gertrude Vanderbilt Whitney, commending her for insisting "on a more vital movement in those Armerican artistic qualities as yet not sufficiently perceived elsewhere."[17] Not long thereafter Mrs. Whitney would purchase a Davies painting to serve as part of the nucleus for what would one day become the Whitney Museum of American Art.

The next evening, April 10, the National Academy of Design held its annual meeting. Henri determined to stay away in order to avoid any further friction, but a vengeful tenor was quickly set nonetheless. Academy president Frederick Dielman lashed out at the open hostility of certain individuals toward the institution, labeling their criticism of the recent jury decisions as "unblushing impudence" and merely "grist for their own mill."[18] His speech set the tone for the night's main order of business, the election of new associate members. Davies, one of the nominees, had been represented just the previous month in the Corcoran Gallery of Art's initial *Biennial Exhibition of Contemporary American Painting*, which should have strengthened his cause. But from a list of thirty-three names, each with the required number of endorsements by academy members, all but three were systematically blackballed. The three accepted were the expatriate etcher Joseph Pennell and painters Robert Brandegee and Frederick Ballard Williams; among those rejected, in addition to Davies, were Ernest Lawson, Jerome Myers, Willard Metcalf, Hugh Breckenridge, and Charles Hawthorne.

"Doors Slammed on Painters" screamed a headline in the *New York Sun*. "Academy Bars Noted Artists" proclaimed the *Evening Sun*. "National Academy Elects Three Out of Thirty-six" announced a more sedate *New York Times*. The *Times* article quoted Henri as saying: "A splendid painter like Arthur B. Davies has been so badly treated that for years he has refused even to submit pictures to the jury," adding that "Some of those who failed of election would not have accepted if the Academy had voted to make them associates." Davies was certainly among that group. Then Henri mused:

> It's hard to foretell just what will be the result of the Academy's rejection of painters. What the outsiders ought to do is to hold small or large group exhibitions so that the people may know what the artists who have something important to say are doing.[19]

By the time the *Times* story appeared on April 12, 1907, the men had already begun an exhibition fund of fifty dollars apiece—Davies' check was the first to be received by treasurer John Sloan—and, not completely certain that Macbeth would allow the use of his

gallery, they began investigating alternative spaces: A vacant store on West Twenty-third Street, an empty auctioneer's gallery on Fifth Avenue. Another meeting was held on April 15 and Everett Shinn, playing the role of an antagonist, arrived toting a bucket of cold water to throw symbolically on the exhibition scheme. However, three days later Davies informed Henri that the Macbeth Gallery was theirs for two weeks in February. Davies had already written Prendergast inviting him to participate in an exhibition. When an enthusiastic acceptance was received, the final make-up of the group was set: Henri, Davies, Sloan, Glackens, Luks, Shinn, Lawson, and Prendergast. They had the artists, and they had the place.

On May 14 Guy Pène du Bois was allowed to scoop the other papers with an article "predicting" an exhibition the following winter. The following day the story was provided to the rest of the press. James Huneker is credited with being the first writer to refer to the artists as "The Eight" in his story in the *Sun,* and it was his article that contained their collective raison d'être:

> We've come together because we're so unlike. We don't propose to be the only American painters by any means, but we do say that our body includes men who think, who are not academic . . . and who believe above all that art of any kind is an expression of individual ideas and life.[20]

In the months preceding the show of The Eight, Davies experienced both triumph and despair. He was elated at being included in an "Exhibition of Works by Living Artists," held in Amsterdam in the fall of 1907; he was also disrupted and embarrassed by being evicted from his studio. After only a brief occupancy of the workshop at 25 West Thirty-fourth Street, ABD was not only forced to leave but was also involved in a court case of an unspecified nature.

As he wrote to a collector and the future editor of *Arts* magazine:

> . . . all my plans for the visit to Maine have been completely upset by a cantankerous landlord. I have had to give up a later plan for an outing on Mt. Washington, returning by way of Portland [Maine] & Ogunquit, this has fallen through

too as my case goes to court this week with likely postpone-
ments to make ready. I must be in town for emergencies. The
new studio [at 53 West Thirty-ninth Street] now I'm in it (be-
ginning Aug. 1st) I like exceedingly well and would not be
evicted. The summer's work has been much interrupted by
these nasty house troubles, they have been a waste of good
time & energy, naturally I am anxious for a clearing . . .[21]

During the weeks when Davies was without a studio, the
only art he could produce had to be done outdoors. Despite the fact
that the forthcoming exhibition of The Eight would likely be domi-
nated by paintings of realistic city life, ABD continued to shun
scenes of the immediate mid-town neighborhood where he lived,
and headed instead for High Bridge across the Harlem River. He
recorded it several times in carbon and Wolff pencil, then in pastel.
The resultant sketches of the lofty, multiple arches of this engineer-
ing marvel record a rural subject related more closely to an aqueduct
in Ancient Rome than to the pulsating life of Manhattan. When an
oil was eventually produced from one of the drawings, it was ap-
propriately titled *An Idyll of Harlem*.

In preparation for publicity at the time of The Eight show,
each of the artists visited the Fifth Avenue studio of photographer
Gertrude Käsebier to sit for his portrait. Käsebier's pictures avoided
the formal, stilted poses of run-of-the-mill commercial photogra-
phers, being characterized instead as more natural, and including the
utilization of items belonging to the sitters.

Henri, for example, was captured with a felt hat and an
umbrella he just happened to carry along with him; Glackens' gloved
hands clutch his walking stick; and Shinn's fingers hold a cigarette.
Of the various pictures she took of Davies, several show him with
a book, a logical prop for this well-read individual. The photo
chosen, however, has him staring out at the viewer empty-handed,
his black suit blending into the darkened background.

Davies may well have been the one to suggest Käsebier for
the job, having sat for her in 1904 prior to his one-man show in
Boston. She already owned two paintings of his and now acquired
a pastel, possibly in exchange for his photos.

Davies was active in other preparations for the show as well,
serving as a liaison between Macbeth and the artists. He had earlier

Figure 36. *High Bridge*, 1907. Carbon and Wolff pencil on paper, 5 x 14 inches. Collection of Mr. and Mrs. Niles Meriwether Davies, Jr.

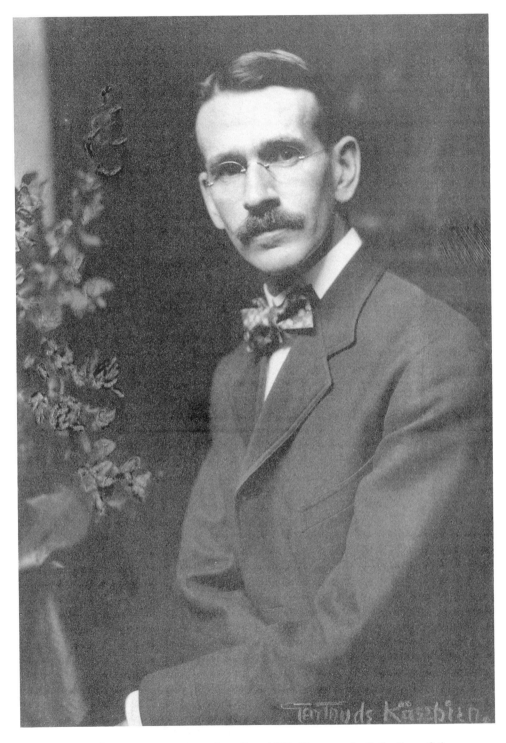

Figure 37. Arthur B. Davies at age forty-five, 1907. Photograph. Collection of the author. Photographer: Gertrude Käsebier.

revealed that the dealer would require a guarantee of five hundred dollars from the exhibitors: the amount they had already collected, plus twenty-five percent of the sales. ABD was also busy designing the exhibition catalogue, allocating a double-page spread for each artist; however, when it was learned that this would cost two hundred dollars and involve an additional assessment, Sloan offered to visit the artists' studios to photograph a work by each exhibitor as a money-saving gesture. Davies easily avoided such an invasion of his privacy by having Macbeth deliver one of his paintings to Sloan for photographing. He then changed his mind and provided a photo of his own. Ironically, the Davies composition illustrated in the catalogue, *The Flood,* was not among the paintings he exhibited.

Because Henri was out of town on a portrait commission for much of the month preceding the February 3, 1908, opening, it fell to Davies and Sloan to carry out many of the menial tasks. These included checking the printer's proofs, purchasing twenty-five hundred envelopes in which the catalogues would be mailed, and prodding the other artists to supply mailing lists to Macbeth. Henri wrote that "I feel that I am missing some of the fun of our exhibition by being away,"[22] but he was obviously missing the work as well. Then, when he finally did return just three days prior to the opening, he was quick to voice disappointment over the quality of the reproduction of his painting in the catalogue. "It is not very good," Sloan readily admitted in the confines of his diary, then added on those hidden pages: "But as usual in these affairs, one or two do the work and the rest criticize."[23]

The previous warmth of the Davies-Henri friendship began a gradual cooling off at this time. Davies resented being saddled with so much of the time-consuming dirty work involving the exhibit, and he was still irked by Henri's summary rejection of Rockwell Kent as an exhibitor. On Saturday evening, February 1, The Eight met at Macbeth's to hang the show. Davies was noticeably absent. Whether he was suffering from pleurisy, as he informed Sloan, or was simply fed up at having already devoted a disproportionate amount of time, we will never know.

The initial announcement of the exhibit indicated that each participant would be represented by five pictures, but because of the

Figure 38. *Autumn Bower*, 1907. Oil on canvas, 18$\frac{1}{8}$ x 30$\frac{1}{8}$ inches. Photograph courtesy Peter A. Juley and Son Collection, National Museum of American Art, Smithsonian Institution.

varying sizes of their paintings this approach was abandoned in favor of another: a single wall of twenty running feet was allocated to each artist in the two identical galleries. As a result, Davies, Glackens, and Luks showed six works apiece, Sloan seven, Shinn eight, and Henri nine. Lawson had only four, and Prendergast seventeen, the latter's selections involving mostly small panel paintings.

Davies, Henri, and Sloan had once discussed the advisability of hanging the display in a single row, at eye level, in obvious opposition to the crowded and discriminatory tier arrangement at the academy; this was done except in a few cases, most notably the large number of Prendergasts, which were double-hung.

A day before the opening, the Sunday *New York Times* filled an entire page of its Rotogravure Section with the Käsebier photographs of The Eight, while page one of the *New York World* Sunday magazine featured pictures of each artist and one of his paintings (Davies' was *Autumn Bower*). The *Herald* published pictures of five of the group. All that remained now was to await the gallery doors being thrown open at 9 A.M. the following morning.

❧ 12 ❧
The Eight
(1908–1909)

On Monday, February 3, an elevator began transporting a continuous crowd of the curious to the fifth level, the top floor at 450 Fifth Avenue, just south of Fortieth Street where the public library was under construction. William Macbeth was on hand to welcome the visitors, who sometimes numbered as many as three hundred an hour. Neither a snowstorm nor a week of slush kept them away.

Davies' six paintings were hung in the second gallery adjacent to those of Glackens and across from Henri's and Luks': *Many Waters* (1905–1906), *Autumn Bower* (1907), *Across the Bay* (1908), *Seawind and Sea* (1905), *A Mighty Forest—Maenads* (1905), and *Girdle of Ares* (1907).

The title of the last-named canvas, which depicts dozens of male nudes engaged in hand-to-hand combat, refers to the Greek God of War and may have been Davies' subtle way of indicating that the exhibit was a symbolic declaration of war against the National Academy. (The painting was actually exhibited in an unfinished state; it was returned to the artist following the 1908–1909 season and completed sometime prior to its acquisition by the Metropolitan Museum of Art in 1914.)

In contrast to this battle scene in which so many small figures are arrayed in an almost frieze-like manner, *Across the Bay* is a close-up of five young women whose bodies are shown half-length, cut

163

off by the bottom of the canvas. They appear in the immediate foreground, thrust against the picture plane. A sense of design is established through their extended arms and a light, arching shore-line in the distance. Countering the prevalence of dark background tones on the righthand side of the composition, the left is dominated by a schooner with gleaming white sails.

These two canvases plus *Many Waters, Seawind and Sea,* and *A Mighty Forest—Maenads* reveal just how far ABD had progressed in ridding his art of earlier influences. While their styles are not indicative of a singular approach nor concern a solitary subject—after all, they had been created over a three-year period—the totality nonetheless presents Davies as his own man.

The press was divided in its reviews of the show. Leading a hostile opposition was the critic for *Town Topics:*

> Vulgarity smites one in the face at this exhibition, and I defy you to find anyone in a healthy frame of mind who for instance wants to hang Luks' posteriors of pigs or Glackens' "At Mouquin's" or John Sloan's "Hairdresser's Window" in his living room or gallery and not get disgusted two days later. Is it fine art to exhibit our sores?
>
> As for Prendergast, his work is unadulterated artistic slop, and Shinn's only several degrees better. . . . Arthur B. Davies is on a slightly different plane, that plane that leaves you in doubt between genius and insanity. Henri, too, has a streak of coarseness. . . . Bah! the whole thing creates a distinct feeling of nausea.[1]

The *Philadelphia Press* critic opined that "When fairly within the Macbeth Galleries you are appalled by the clashing dissonances. . . . " The solution, advised a *New York Tribune* writer, was for The Eight to enroll in an art course before continuing to paint their pictures. Charles De Kay's *Evening Post* review was less demeaning:

> . . . there is no going to sleep over the sallies and whimsies of the Eight painters . . . Join the throngs that fill the elevator to the Macbethan sky parlors, and if you do not remain to pray, you will surely learn not to curse.[2]

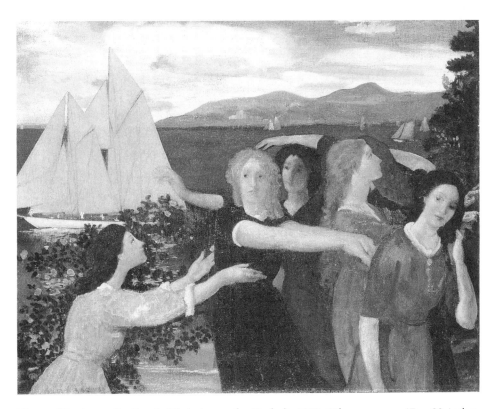

Figure 39. *Across the Bay* (retitled *Across the Harbor*), 1908. Oil on canvas, 17 x 22 inches. Indianapolis Museum of Art, James E. Roberts Fund.

The reliable Guy Pène du Bois wrote enthusiastically in the *New York American,* as did Frederick James Gregg in the *Evening Sun.* Mary Fanton Roberts, employing the pseudonym Giles Edgerton in the *Craftsman,* labeled The Eight "so excellent a group [whose paintings] escaped the blight of imitation," and the *Sun*'s James Huneker commended the artists for having "new ideas to communicate."[3]

Despite Davies' less radical subject matter, the critics' responses to his work echoed those leveled at his fellow exhibitors: John B. Townsend of *Art News* referred to his *Seawind and Sea* as "weird" while the *Independent*'s writer called Davies "a poet whose like does not elsewhere exist." But it was Huneker who praised ABD beyond all of the others, labeling him a "seer of visions, this poet who would penetrate the earthly envelope and surprise the secret fervers [sic] of the soul."[4]

In a follow-up article devoted solely to Davies, Huneker wrote:

We do not hesitate to adjudge him the most original of American painters and the peer of those living European artists who are dominated by ideas and not by the brush. Imagination, then, is the master trait of Arthur B. Davies.[5]

Unfortunately this review appeared four months after the exhibit closed, so it played no part in sales at the time. Nonetheless, two Davies paintings were sold: *Autumn Bower* to Mrs. Henry Hardon for six hundred dollars and *A Mighty Forest—Maenads* for sixteen hundred dollars to Mrs. I. E. Cowdin (who had already acquired two works by ABD from his initial show at Macbeth's in 1894). Gertrude Vanderbilt Whitney purchased four canvases from the exhibit of The Eight as well, but none of them by Davies.

Total sales amounted to four thousand dollars, a sum Macbeth quickly labeled a "remarkable success"[6] in view of the poor financial climate lingering since the previous October's financial panic. Yet he confessed that "a loud chorus of disapproval—mostly honest—on the part of many artists and laymen, was heard every day . . . ,"[7] further explaining the relatively few purchases.

For his part, Davies felt "the show looked quite well but a little crowded in some places. . . ." He called it "an *epoch*" and said "its success should bring about more 'group' exhibitions and in that way destroy the prestiage of the National Academy."[8]

Ironically, Davies, Henri, Lawson, Glackens, and Sloan gave the appearance of having capitulated to the National Academy of Design when their paintings were included in the academy's spring annual which opened on March 14. They, together with Rockwell Kent, George Bellows, and another former Henri student, W. T. Benda, were provided a wall to themselves, "the freak wall" as some of the die-hard academicians referred to it. Davies' contribution was a canvas listed in the catalogue as #286, *Legend, Sea Calm,* a painting that would eventually be retitled *Unicorns: Legend, Sea Calm* (Plate 6) and become his best-known masterwork.

Virtually all visual representations of the mythological unicorn place it either grazing among plants and trees or in juxtaposition with a clothed female. This is true of Raphael's *Lady with a Unicorn,*

Giorgione's *An Allegory of Chastity,* the six fifteenth-century Gothic tapestries titled *The Hunt of the Unicorn,* and compositions by Piero di Cosimo and Arnold Böcklin. Davies could have found inspiration from any one of these sources. However, his unique version features four unicorns rather than one and shows his mythological creatures considerably diminished in size and therefore dominated by the landscape. Pliny the Elder, whom Davies had read, told the tale of the unicorn which could be caught only by a virgin. This beautiful beast dipped its horn into the water of eternal life to neutralize its poisonous content, allowing all other animals to drink. The unicorn sought a better world, not unlike Davies, who strove for his in the imagination.

The word "legend" in the original title refers to the story of Creation, in which the unicorn is the first animal named by Adam. In ABD's painting, the Garden of Eden is limited to a lush sliver of land in the foreground which contains the only trees full of foliage. By contrast, foreboding mountains loom across the becalmed sea, representing the barren region beyond Eden. Though he probably intended the background to resemble that bordering the Mediterranean or Adriatic, areas he had once visited, it is likely the artist was influenced by a stretch of terrain bordering the wide expanse of the Hudson a few miles north of Congers.

Davies positioned his unicorns beside a snake, two apples, and a seated nude woman. Another female figure, this one clothed, stands apart, her back toward the viewer, her head facing the unicorns and the nude. It is Edna who is shown as the naked charmer, the virgin credited with catching the unicorn; the unicorn is a personification of the artist himself. Virginia, isolated and distant, is reduced to mere observer status, an individual who no longer plays an active role in his life.

Davies, however, was never one to discuss such symbolism in his art, so the painting, like most of his works, continues to possess a mysterious aura far deeper than the subject matter or title initially suggest. Of course, no one could have imagined such a personalized interpretation when the canvas was displayed in the National Academy's 1908 annual.

Meanwhile, the exhibition of The Eight was more than just a memory. A week prior to the academy opening on March 14, the

Macbeth Gallery exhibit had its own reception at the Pennsylvania Academy, the Philadelphia institution having requested the show. The Pennsylvania Academy was proud to sponsor the well-publicized offerings since five of the group had been students there during the preceding decade.

Substitutions were made for works sold at Macbeth's, resulting in Davies replacing *A Mighty Forest—Maenads* and *Autumn Bower* with *The Flood,* the painting which had been illustrated in the Macbeth Gallery catalogue but not shown there; and *A Double Realm,* a panorama of hills and mountains inspired by the California trip of 1905. The latter is typical of his paintings with symbolist implications. The composition initially appears to be a straightforward landscape with the title referring to the kingdoms of heaven and earth. But Davies has placed a man on horseback in the middleground, a representation of himself gazing at the distant grandeur. This equestrian appears oblivious to several foreground figures, one of whom resembles Virginia, another, Edna, the latter reclining on the ground in a submissive pose. For ABD the double realm consisted of the two women in his life, a secretive and tortured tale that could be shared only through his art.

The two galleries allocated for the Philadelphia show were considerably larger than those at Macbeth's, thus affording a better presentation of the paintings. Yet the exhibit closed on March 29, 1908, without benefit of a single sale. At Davies' suggestion, Sloan contacted the Art Institute of Chicago about the prospect of having the exhibition sent there, but no dates were available at the institute until mid-July.

Davies was "enthusiastic about a travelling exhibition in the fall with some of the new fellows who are good in it, such men as [Julius] Golz, [Jr.], [Laurence T.] Dresser, etc."[9] His knowledge of their paintings had been gained from an exhibition held during the month of March in the old Harmonie Club facing Bryant Park, around the corner from the Macbeth Gallery. Golz and Dresser exhibited along with thirteen others, all former Henri students, including Bellows, Hopper, Rockwell Kent, Glenn Coleman, and Arnold Friedman. They labeled it *Exhibition of Paintings and Drawings by Contemporary Americans,* though in the minds of these aspiring artists the exhibit "assumed the proportions of a warrant, a death warrant to the Academy, no less," as Friedman expressed it.[10]

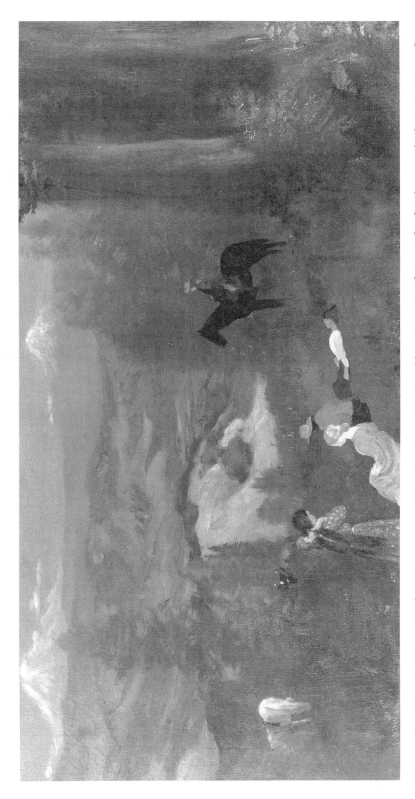

Figure 40. *A Double Realm*, 1906. Oil on canvas, 15 x 29 inches. The Brooklyn Museum of Art, Gift of Robert Macbeth in memory of William Macbeth. (22.85).

Just a month before, Davies had stated that he hoped the success of The Eight would bring about more group shows and undermine the National Academy's prestige. What better way to accomplish this than to include some of these younger talents in a traveling show in the fall? But once again Henri rejected the idea. The number of exhibitors remained the same when The Eight exhibit opened at the Art Institute of Chicago on September 7.

Davies was obviously anxious to have his work on view there, where it could be seen by proud family members and friends. For the occasion he added several oils: His unicorn painting *Legend, Sea Calm; Moonbeam,* of a young girl whose dress sparkles in the moon's glow; and *The Golden Stream,* a decade-old canvas of Virginia nursing one of the children. A review in one Chicago paper singled out the hometown artist, referring to him as "Possibly the most original yet sincere of the group. . . . "[11] The show of The Eight continued on to seven additional cities—Toledo, Detroit, Indianapolis, Cincinnati, Pittsburgh, and Bridgeport—before concluding in Newark nine months later.

It was inevitable that other artists would seek to join The Eight both before and after its exhibition. Albert Sterner, who wrote several letters of support which were published in New York newspapers, had requested inclusion when the formation of the group was announced:

> I have read in the Sun of the banding together of the men for the purpose of being able to show untrammeled their work. You know my sympathies are all with you and I want to know if you won't let me call myself one of you. If you do I shall be happy in the knowledge that I may work and show after my own fashion with men of my own way of thinking. . . .[12]

He was informed that limited gallery space made such an addition impossible.

Marsden Hartley traveled from New England to Manhattan in order to inquire about joining The Eight, bringing with him a selection of recent canvases painted in Maine with a stitch-like brushwork. Prior to viewing them, John Sloan wondered: "Why would a big man come

to New York and dangle around waiting for us to say 'come in to the "eight" show' supposing there was such a thing this year [1909]."[13] When the works were displayed in Glackens' studio for the group to see, Sloan was unenthusiastic, liking two or three but concluding that "Some of them seem affectations—the clouds especially like tinted buckwheat cakes."[14] Shinn rejected the lot but Davies showed an immediate appreciation for the canvases, though his favorable reaction was in the minority. Hartley would later acknowledge ABD's insight into his work by stating that "the essence which is in me is American mysticism just as Davies declared it when he saw those first landscapes . . . "[15]

Following rejection by The Eight, Hartley was introduced to Alfred Stieglitz, who arranged for his first one-man show to be held in May, 1909, at Stieglitz's 291 Gallery. When the artist explained that he lacked funds for frames, Stieglitz agreed to assist him; then Davies learned of Hartley's plight and purchased frames for his four largest works. Hartley, it turned out, had been an admirer of Davies' since viewing his one-man show at Macbeth's in the spring of 1901, when the New Englander was a first-year student at the National Academy of Design. Now Davies took him to the Montross Gallery, where they viewed paintings by Albert Pinkham Ryder. Hartley's enthusiasm prompted Davies to take him to Ryder's studio for a visit.

Ryder's influence upon Hartley is evident in his so-called "dark landscapes" of 1909, which were painted "solely from memory and the imagination . . . as close to Ryder as possible."[16] Hartley's reference to a Ryder marine scene as having in it "the stupendous solemnity of a Blake mystical picture . . . "[17] indicates Davies' introduction of the Englishman's art to Hartley as well.

Marsden Hartley was not the only artist among Stieglitz's "American Moderns" who was aided by Davies at this time. From March 30 to April 17, 1909, the 291 Gallery held the first one-man show of oils by Alfred Maurer. While ABD had observed the gradual evolution of Hartley's art toward freer brushwork and stylized forms, his interest in Maurer was piqued just the previous year, when a story appeared in the Sunday New York Times concerning the annual salon of the Société Nationale des Beaux Arts. Headlined "American Pictures Admired in Paris," the article cited Maurer's "two striking portraits in his new impressionistic style, both of which have received much praise from Paris critics."[18]

Reporting on Maurer's exhibit in New York, Stieglitz noted:

> Henri, Glackens, Sloan, Prendergast, Lawson, Luks—all of
> that crowd, members of The Eight—came and nudged one
> another. They could not make out what they saw. Real
> revolution! Arthur B. Davies also appeared. He bought three
> Maurers [of the fifteen on exhibit]. They were each thirty
> dollars—a hundred and fifty francs—which meant quite a
> bit of money in Paris . . . [19]

Davies wrote Stieglitz of the acquisitions: "I hope you will have a
great success with Maurer's new venture and . . . with many to come
with newer messages."[20]

Davies' support of the two younger artists is an early inkling
of his sympathy for the avant-garde, undoubtedly encouraged in part
by his growing awareness of European modernism through illustra-
tions he observed in various foreign language magazines. It may also
have been prompted by the announcement in the January, 1909,
issue of *Camera Work* that the new function of both the 291 Gallery
and the periodical would be to "Champion modern tendencies."

Davies' ability to purchase frames for Hartley and paintings by
Maurer was the result of a sudden flush of funds, for during a two-
week period in February and early March, 1909, Macbeth sold over
seven thousand dollars worth of his art. Arthur no longer found it
necessary to count on Virginia for financial support as he had during
the first years of their marriage. Yet by the same token he did not
feel compelled to contribute to her upkeep, since, he reasoned, she
retained all of the income from the farm and from her medical
practice as well. While Davies' philanthropic gestures toward the
younger artists are noteworthy, they were coupled with the mon-
etary neglect of his own family—not just his wife but also the
children—and eventually his mistress as well.

A few weeks after The Eight Travelling Show had opened in
Chicago on September 7, 1908, George Luks wrote to Sloan inquiring
about a second New York exhibition: "Are The Eight going to have
a show [at Macbeth's] this season? I think we should as there natu-
rally will be anxiety on the part of our admirers what we'll spring
on 'em—."[21] Sloan was the wrong person to ask, for having just

completed the task of preparing the entire exhibition for the Art Institute, he was willing to let the subject ride. But six weeks later Henri entertained the same thought and noted in his diary:

> Talked with Glack and Sloan about an 8 show at Macbeth's. Want to know what the desire is so that if there is not to be an 8 show, then I may make other arrangements for exhibits. Glack for it. Sloan ditto. To call a meeting at my studio Thursday [December 16, 1908].[22]

But they had waited too long, for Macbeth's exhibits were already booked through the following May. And it was Davies who was scheduled for the gallery from February 19 to March 4, 1909, the first anniversary of The Eight exhibit. This would represent ABD's first one-man show in four years.

James Huneker's review of it in the *Sun* consumed an entire column and a half: "Never has the Davies harvest been so abundant . . . At his best he is a stumbling block for most of us, at his—he has no worst . . ." The critic sought to clarify: "There are several pictures at Macbeth's which may have been Hoboken once, though so transfigured by this dreamer that they are seemingly of No Man's Land"; to question: "What does 'Avatar' mean? . . . is 'A Measure of Dreams' any clearer?"; and to applaud: "He is unsurpassed in the delineation of pure atmospheric effects." In the final analysis, Huneker advised: "The best way to approach Arthur B. Davies is with an open mind."[23]

Apparently many art aficionados did just that because when the show closed, ten of the thirty-eight paintings were marked "Sold." Gertrude Vanderbilt Whitney purchased *Crescendo,* a large composition of seven female nudes arranged in rhythmic, frieze-like fashion against the flat plane of a mountain range; her sister-in-law, Helen Hay Whitney, acquired *Artemis,* showing the Roman equivalent of the Greek goddess Diana clothed in diaphanous drapery and petting a deer. George A. Hearn bought *A Measure of Dreams* (later retitled simply *Dream*), then promptly donated it to the Metropolitan Museum of Art. It was the first of what would ultimately amount to more than one hundred works by Davies to become part of the museum's collection.

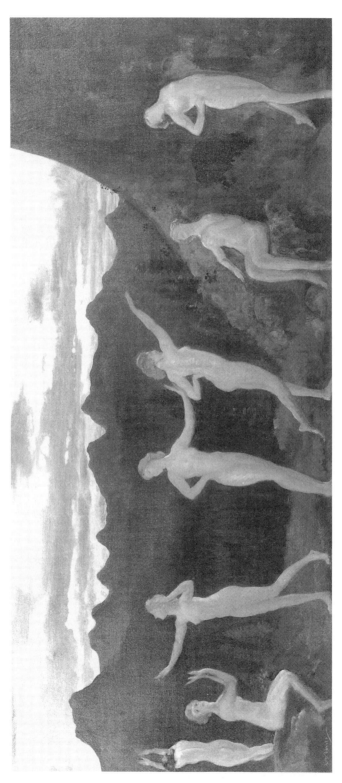

Figure 41. *Crescendo,* 1908. Oil on canvas, 18 x 40 inches. Collection of Whitney Museum of American Art, New York, Gift of Gertrude Vanderbilt Whitney, 31.166. Photographer: Geoffrey Clements. Photograph Copyright ©1997: Whitney Museum of American Art.

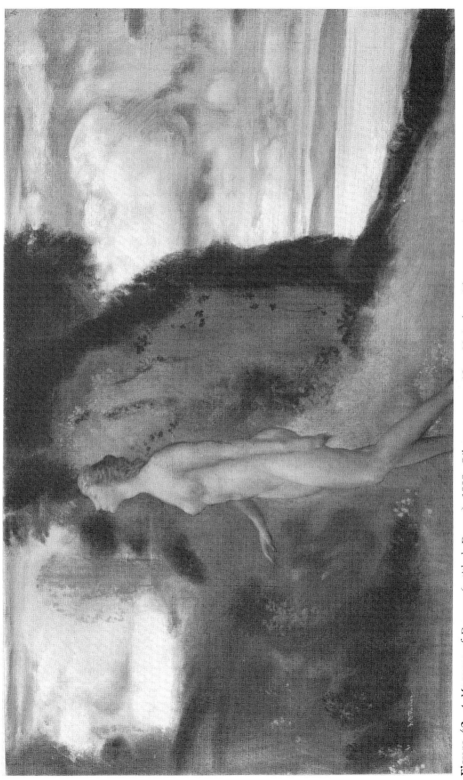

Figure 42. *A Measure of Dreams* (retitled *Dream*), 1908. Oil on canvas, 18 x 30 inches. The Metropolitan Museum of Art, Gift of George A. Hearn, 1909. (09.72.4).

Like some of his other canvases, *A Measure of Dreams* was inspired by poetry, in this case a sonnet written by George Meredith in 1903:

> She, the white wild cherry, a tree,
> Earth-rooted, tangibly wood,
> Yet a presence throbbing alive;
> A spirit born of a tree;
> Because earth-rooted alive:
> Huntress of things worth pursuit
> Of souls; in our naming, dreams.[24]

The painting contains the centered, silhouetted figure of a woman, her head uplifted with eyes closed, placed in almost bas-relief against the darkened forms of trees symbolizing the night. On either side are light, cloud-filled skies as though she is stepping or floating from one world into another. There is the suggestion of something transitory here, either the daylight hours of reality or the dream world of sleep, of hypnotic music, of the spirit set free. The artist has cast a spell from which there is no desire to escape. This canvas marks an important advance in ABD's work, one that at once unites symbolism with the world of the subconscious mind.

One of the sales from Davies' 1909 one-man show would prove to be of greater significance to him than any of the others: It was the initial purchase by a woman named Lizzie Bliss.[25] She immediately became so mesmerized by ABD and his art that she soon evolved into his most avid collector.

Lizzie Plummer Bliss came from an affluent family. Her father Cornelius had amassed a fortune as a textile manufacturer and had been Secretary of the Interior in President McKinley's Cabinet. (McKinley had asked him to serve as vice-president but he had refused, so Theodore Roosevelt was chosen; had Bliss accepted, he would have become president when McKinley was assassinated six months into his second term.) Lizzie was shy and modest, a sensitive woman and an accomplished pianist enamored of music; her life was totally family oriented, for her mother was an invalid confined to the first floor of their home on East Thirty-seventh Street near Madison. Lizzie's daily routine consisted of running the house, doing

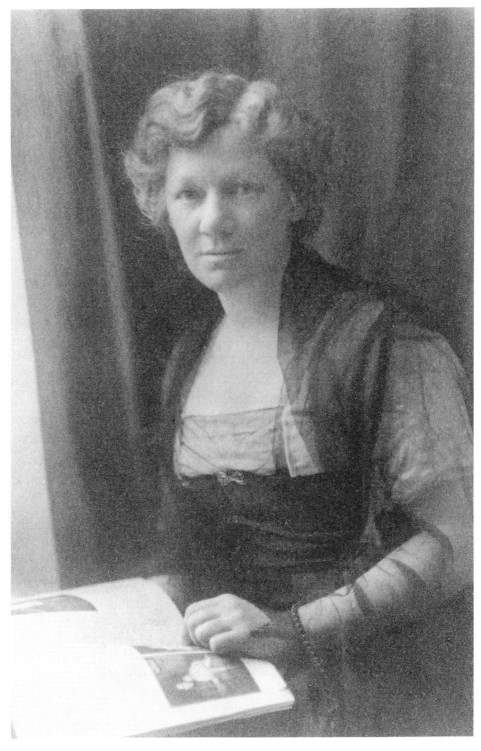

Figure 43. Lizzie P. Bliss, ca. 1904. Photograph. Collection of the author.

the shopping, reading aloud to her mother, and providing entertainment for her through piano playing.

One day in February, 1909, Lizzie, then forty-five, found herself in a deep depression, virtually unable to go ahead with her life. It was at that moment, strolling along Fifth Avenue, that she ascended to the Macbeth Gallery and viewed Davies' exhibition. She purchased an oil for $750 appropriately titled *After Rain*, of a young female nude joyously walking through a stream amid a field of flowers as the skies brightened. Perhaps the buyer saw it as a symbolic image of herself emerging from the dark clouds of melancholy.

Miss Bliss returned to the gallery two or three more times to study the Davies paintings, then finally said to Mr. Macbeth, "You know, I think I have to meet this man."[26] This he arranged, and what began as a beautiful friendship between artist and patron flowered into one of the most legendary associations in the annals of American art. Before long Lizzie Bliss began paying afternoon visits to Davies' studio, that secret retreat just a few blocks from her parents' home. When her mother objected to Lizzie going there for tea, she went anyway. A piano was brought in so that she could play for him. Lizzie was one of the supporters of the Kneisel Quartet, which performed on Sundays at the Havemeyer residence on Fifth Avenue. In 1912, a year after her father died, she inaugurated her own Friday evening soirées, inviting Davies and other artists, actors, and musicians, including Walter Hampden, Ruth Draper, and Ethel Barrymore, to wineless socials featuring the Kneisel playing Brahms.

Years later her good friend Eleanor Belmont, a one-time actress, philanthropist, and widow of the owner of the Belmont Racing Stables, recalled:

> The person who most influenced her life in the field of painting was undoubtedly Arthur B. Davies. Impressed by his genius she purchased first one painting, then several, then almost anything obtainable, from drawing to large canvas, as he finished it. He led the way to exhibitions, talked painting to her, modern methods, plans for future work, and found a willing listener, disciple and patron. She broadened his horizon and revealed to him the rhythm of sound as he unfolded for her the rhythm of color and form. Assisted by Davies' knowledge and inspired by his dreams her delicate intuitive love of beauty developed rapidly.[27]

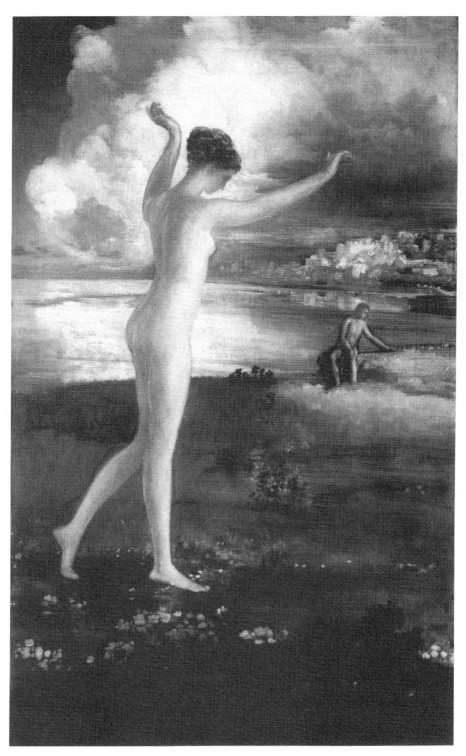

Figure 44. *After Rain* (retitled *After the Rain, After an Evening Rain*), ca. 1897. Oil on canvas, 30$\frac{1}{2}$ x 18$\frac{3}{8}$ inches. Photograph courtesy Peter A. Juley and Son Collection, National Museum of American Art, Smithsonian Institution.

Lizzie Bliss not only purchased Davies' new art from 1909 onward, but many of his earlier examples as well, some dating back to the paintings exhibited in his first one-man show at Macbeth's. One invoice from the art dealer reveals her purchase of five Davies oils for $5,250; six months later she bought thirteen of his sketches. At one point Macbeth listed the titles of all of Davies' works he had sold her: Forty-five paintings, thirty-two drawings, twenty-seven prints, eleven sculptures, and a book of pastel sketches. In the end she owned from seventy to eighty of his oils and between three and four hundred of his watercolors, drawings, and prints.

The purchases came so frequently that Lizzie simply lost track of her accumulated debt and once wrote to Macbeth: "Enclosed please find check for $1550 on account. I have only a vague idea of how much I owe the Macbeth Galleries so I shall continue sending checks when I can until you tell me to stop!"[28]

Lizzie was only two years younger than Arthur, and after their friendship developed "into something very, very deep,"[29] he felt sufficiently comfortable to share with her his innermost secret, that he was living with a mistress under an assumed name. She is reported to have shown sympathy for his plight and then became one of only two individuals who knew the phone number of his and Edna's apartment (the other being William Macbeth).

For nearly two decades Lizzie Bliss was to play a very special role in ABD's life and art, one left unfulfilled by either Virginia or Edna. And, of equal importance, he now could experience a sense of financial independence the likes of which he had never known.

❦ 13 ❦
Two Independents
(1910–1911)

*T*welve days after the close of Davies' 1909 one-man show at Macbeth's another solo exhibit of his opened at the Worcester, Massachusetts, Art Museum. During the remainder of the year his paintings were included in museum annuals in St. Louis, Indianapolis, Cincinnati, Buffalo, and Worcester, as well as the *Eighth Venice International Exhibition,* where his canvases shared the gallery allocated to American art with works by John Singer Sargent and Robert Henri, among others.

Despite his own successes, Davies, like Henri, continued to be concerned about exhibition opportunities for the younger, disenfranchised artists. The show of The Eight had never been planned as an end to the crusade, a fact made clear when a newspaper announced in May, 1907, that "During the next two years they [The Eight] expect to secure a gallery of their own, large enough to display 200 canvases or more."[1] Throughout those two years, sporadic attention was paid to the subject by Davies, Henri, and Sloan, with much of the time devoted to investigating potential gallery locations. In mid-May, 1909, Davies and Henri visited a prospective site on West Thirty-sixth Street. Though the top floor included good illumination from skylights, the annual rent was a prohibitive two thousand dollars.

In the fall, as their focus turned once again to plans for a large exhibit, many New York artists received an announcement of

such a show planned for Baltimore, an exhibition of contemporary American paintings to be held in the city's Fifth Regiment Armory. The previous year the National Sculpture Society exhibit had been viewed by sixty-five thousand people at the same location. "New York had no place, so it was said, large enough and dignified enough to afford an opportunity for showing four hundred and sixty-one sculptures . . . ,"[2] the *Craftsman* reported at the time.

In fact, the National Academy of Design had been petitioning the city for some time to construct a large gallery, arguing that the number of exhibition rooms in the American Fine Arts Society Building on West Fifty-seventh Street, where the academy's exhibits were held, continued to limit their exhibition possibilities. (Of course, the NAD failed to address the question of the nearly uniform conservatism of the art that was shown.) To emphasize the point, academy juries traditionally accepted far more works than could be hung, allowing the Hanging Committee to place on the walls only the safest, most unprogressive examples. This was most noticeable following the jury deliberations for the NAD's winter exhibition in December, 1909. Many artists had paintings pass the judges' scrutiny only to have them eliminated from the exhibit afterward. The ultimate affront occurred to a young artist named Walter Pach who had six of his entries accepted, but none hung.

Davies was represented in the NAD show by a canvas titled *Life-Bringing Sea—South Seas,* but it was the last time he would ever agree to exhibit there. Of far greater significance to him was having two of his large California paintings, *Canyon Undertones, Merced River* and *Lake and Island, Sierra Nevadas,* included in the second Corcoran Gallery annual in Washington, the dates coinciding with those of the National Academy exhibit. Though similar in size, these paintings appear as virtual opposites in composition, color, and mood.

Canyon Undertones is dominated by a wall of rock and a small expanse of intense blue sky, where diagonally placed clouds represent the only areas of pure white in the entire painting. One can sense the thunderous sound emanating from numerous waterfalls and from rivulets rushing over boulders in the foreground. The picture's design is strengthened by three tree trunks at the righthand edge of the canvas; running the entire height of the painting, they

repeat the vertical streams of falling water. Both the subject matter and composition are a variation of *Many Waters* which was exhibited in the show of The Eight.

Lake and Island, on the other hand, is tranquil, the epitome of a utopian retreat. A light but hazy sky consumes fully half of the canvas, with all of the darkest values restricted to the isolated tract of land rising up in the foreground. The waters are still. And while the canyon composition contains an overall brown tonality, excepting the sky, *Lake and Island* is a near-monochromatic green.

The fact that these two canvases that were exhibited during the winter of 1909–10 had been painted four years earlier would have hardly raised an eyebrow among gallery-goers. However, there was good reason for ABD's failure to submit more recent work: He had contracted typhoid fever in the fall and remained ill for months. In December, 1909, Maurice Prendergast expressed his concern in a letter to Walter Pach:

> I wrote Davies after you left and have had no letter
> I sincer[e]ly hope he is coming out all right and [will] be
> himself again it would be a great loss if anything hap-
> pened to him. he is one of the few [of] my sympathetic
> friends I am fortunate to possess.[3]

Davies produced little work during that period, and still appeared weak the following month.

When the Corcoran and NAD shows closed, Davies chose *Life-Bringing Sea—South Seas* and *Mountain Beloved of Spring* to represent him in an exhibition of American art opening in February, 1910, at the Royal Academy in Berlin. This show then traveled on to the Royal Art Society in Munich.

Meanwhile, the idea of holding an exhibition that would be an alternative to the National Academy of Design spring exhibition had been gaining momentum with Davies, Henri, Sloan, and others. Now various fund-raising plans were considered. Henri favored finding twenty patrons who would each contribute one hundred dollars, while Davies preferred having the artists finance the project and expressed readiness to put up his share of the money. Jerome Myers approached the group with a similar idea but sought to make it

184 &

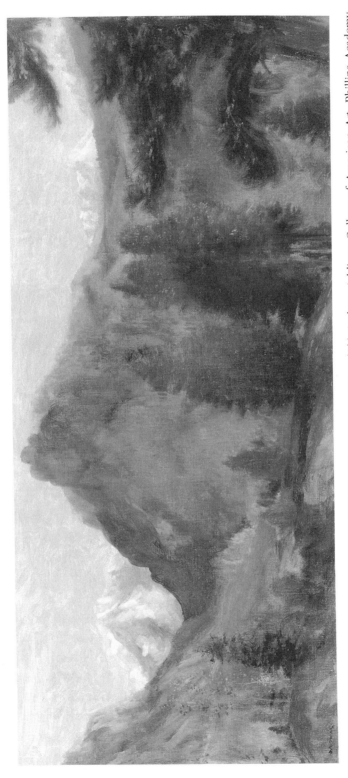

Figure 45. *Mountain Beloved of Spring*, ca. 1906–07. Oil on canvas, 18 x 40⅛ inches. Addison Gallery of American Art, Phillips Academy, Andover, Massachusetts, Gift of Miss Lizzie P. Bliss, 1928. © Addison Gallery of American Art, Phillips Academy, Andover, Massachusetts. (1928.1). All rights reserved.

elitist by not inviting younger artists to exhibit. On March 9, 1910, Walt Kuhn stepped forward to recommend a show backed by four painters each contributing two hundred dollars, with exhibitors charged a fee according to their ability to pay. His timing was perfect, for just the previous day Henri had learned that two of his three entries for the academy's spring annual had been rejected. The insult was compounded by the fact that one of the pictures eliminated was a full-length portrait of his wife.

Now the *Exhibition of Independent Artists'* plan moved quickly forward, and an empty building at 29–31 West Thirty-fifth Street was rented for one thousand dollars for the month of April. Two hundred dollars apiece was contributed by Davies, Henri, Sloan, Walt Kuhn, and Dorothy Rice, a Henri student whose father was editor of the *Forum.* A hundred tungsten lights were purchased with additional two hundred dollar contributions from Gertrude Vanderbilt Whitney and Vera Kuhn, Walt's wife. Invitations were printed and sent to artists, who were informed that their work would be exhibited without benefit of a jury or prizes. An entry fee was established: ten dollars for a single work, eighteen dollars for two, twenty-five dollars for three, and thirty dollars for four. Though this was a considerable price to pay, hundreds of paintings, drawings, and sculptures poured in from disenfranchised artists.

The exhibition was scheduled for April 1 through 27, dates deliberately chosen to overlap the academy annual. Advance newspaper publicity included an article in the *Evening Sun* which announced that it would be "the largest opposition exhibition of paintings that had been held since the union of the National Academy and the Society of American Artists. . . . "[4] Guy Pène du Bois, who together with Davies, Kuhn, and five others comprised the committee to install the show, predicted in his newspaper column that the exhibit would "make art history in New York as the Salon des Refusés did in Paris . . . "[5] And in fact it did.

When the doors were thrown open at 8 P.M. Friday for a public reception, a crush of people quickly filled every room. All of The Eight were represented with the exception of George Luks, who was slated to have his own one-man show (his first) at the Macbeth Gallery just two weeks later. Two of Davies' oils, *Valley's Brim* and *As Movement of Water,* were placed in the first gallery one entered;

two others, titled *Night Magic* and *Withdrawing Rain,* were hung in the next room. Henri's portrait of his wife, the recent academy reject, was given a place of honor in the center of the dominant entrance wall.

The first two floors were filled with two hundred sixty-five paintings, while the third floor housed three hundred forty-four drawings and most of the twenty-two pieces of sculpture, including portraits by Gertrude Whitney. Gutzon Borglum showed a colossal head of Abraham Lincoln. Lincoln's presence was bound to appear symbolic to the perceptive observer, for the organizers of the exhibition were seeking to emancipate American art from the stranglehold of the academy.

By 9 P.M. on opening night it was estimated that a thousand people were crammed inside the building, while another fifteen hundred blocked the sidewalk and street outside as they struggled to enter. Yet despite the overwhelming size of the crowd, by the time the exhibit closed twenty-six days later, only five small drawings had been sold from among the more than six hundred works. There had been a great deal of public exposure to the event but the vast majority of the hundred-plus exhibitors must have felt a sense of disappointment at the outcome. Davies' reaction to it is unknown, but certainly one lasting dividend was his introduction to Walt Kuhn, who would soon become his closest friend and confidant.

Whatever Davies thought of the 1910 Independent, the fact that none of his entries had found buyers was inconsequential. A few months earlier, five paintings had been purchased from Macbeth's in a single week for fifty-six hundred dollars, prompting the dealer to joyfully write his nephew that Davies' work was selling "like hotcakes."[6] Macbeth continued to promote ABD's art. In the December, 1910, issue of his gallery publication, he wrote: "After long waiting we have at last received a few canvases from Mr. Davies. This simple announcement will be sufficient to ensure for them quick attention from discriminating friends."[7] The inevitable sale of several works followed.

Prior to this notice, ABD had left on another trip to Europe, this time to study the art and architecture of Ancient Greece and Rome. At least that was the reason given. But the real purpose may have been to avoid the threat of the forthcoming United States census of 1910 and the possibility that his double life would be revealed. And

so he embarked from New York together with Edna. As a result, the name "Arthur B. Davies" does not appear in the census as either a resident at 53 West Thirty-ninth Street, his studio address, or at the farm in Congers; a listing for "David and Edna Owen" of 314 East Fifty-second Street was likewise omitted. (By 1920 ABD felt sufficiently comfortable with the deception to provide census takers with information at two Manhattan addresses, using his different names.)

Davies' desire to travel to Italy and Greece was due, in part, to his renewed fascination with the art of Puvis de Chavannes. While the attraction dated back many years, it had recently been reinforced by John La Farge's article about the Frenchman in *Scribner's,* which featured the magazine's first full-color illustrations. Davies' exposure to Puvis' paintings was furthered by his having repeatedly viewed *The Sacred Grove* (in a fifteen-foot-long version of the Sorbonne mural at the home of Henry and Louisine Havemeyer) and *The Shepherd's Song* (on exhibit at the Metropolitan Museum of Art since its purchase in 1906).

Maurice Denis had characterized the French tradition in painting as a continuity of classicism that began with Poussin; Puvis de Chavannes was considered by many as the logical heir to this tradition, the principal exponent of tranquil compositions of arcadian subjects. By 1910 Davies' interest in Puvis would have been reinforced by the realization that leading artists among the French moderns shared a similar enthusiasm for his art, most notably van Gogh, Gauguin, Seurat, and Odilon Redon.

Davies' trip overseas included a stop in Constantinople, and though he held its rich Byzantine tradition in high regard, it was clearly the discoveries in Pompeii, Naples, Rome, Paestum, and Athens that made the deepest impression upon him. On December 6 he shared his excitement in a letter to Macbeth:

> I spent two days in the ruins of Pompeii and saw some recent excavations (private) that show paintings which were perfectly thrilling—the very finest things I have ever seen—as fresh as if painted yesterday.[8]

A similar passion for the arts of Greece was contained in a missive several weeks later:

The ruins at Paestum—the Temple of Neptune and the two others are superb in their sheer majesty on the plain. I cannot now tell you how much these things mean to me, as nothing more fortunate could have happened and I shall get hold of even greater things in Athens and Constantinople all along the underlying growth of the human crystal of art. . . . [I] do not feel capable of far greater expression because of my own "entente cordiale" with Greek painters—so archaic—so great—so modern . . . [9]

Writing essentially the same news to Virginia, he added: "Never realized so well how great and how important the paintings by the old Greeks are."[10] (Of course, she was unaware of Arthur's traveling companion.)

Before returning home, ABD penned a final letter to Macbeth on January 26, 1911:

An intoxicating morning in the pagan art of the Vatican. . . . The new Gallery in which are shown the very large collection of primitive Italian small paintings and the Byzantine unknowns and the well known Raffaels [sic] . . . but mostly the primitives with their devoted sincerity and the highly decorative Byz[antines] stirred the cockles of my heart . . . I should have liked to have lingered longer over the ivories—enamels—illuminated parchments and the room with the Greek frescos [sic]—which were . . . probably the very finest in the world and strangely so little known.[11]

Davies did no painting on the trip but produced a group of sketches instead. Frederick James Gregg, the New York *Evening Sun*'s art critic (writing for *Vanity Fair*), was invited to view them, and noted how

[ABD's] intense memory for tone was shown . . . in a striking way after his return from Greece. Turning over the leaves of a small sketchbook that contained the barest outlines in pencil, he was able to describe with the most minute detail the various contrasts of color found in one place after another,

the recollection of which had been stored up in his brain as raw material for future creative use.[12]

During Davies' absence from the United States a one-man show of his paintings was held at the Art Institute of Chicago. Four paintings were sold, including one to the institute for its permanent collection. That canvas, titled *Maya, Mirror of Illusions,* is at once mystical and symbolic, a fascinating Davies concept. Maya, the mother of Siddhartha Gautama (Buddha), is doubly represented on the left as the great Mother of Illusions: In the waters that she is credited with producing there is reflected the long line of mountains while in front of her four nude maidens walk wistfully past her mirror and their own reflections. The composition offers the juxtaposition of reality and illusion, the concrete existing beside abstract thought.

The concept and arrangement are intriguing. Captivated by the work, Macbeth proclaimed in the February, 1911, issue of *Art Notes:*

> If a greater picture, even by Mr. Davies, has been produced in this country, I do not know it. I feel very sure that time will confirm this opinion. I heartily congratulate Chicago on the acquisition of this veritable masterpiece.[13]

Macbeth had submitted ABD's art to several other exhibitions while the artist was traveling in Europe: To Portland, Oregon, for a one-man show entitled *Little Known Figure Drawings;* to the Art Institute of Chicago's *Twenty-third Annual Exhibition of Oil Paintings and Sculpture by American Artists;* and to Columbus, Ohio, for a scaled-down version of the 1910 Independent Exhibition. This latter show had been sought by Julius Golz, a recently appointed teacher at the Columbus School of Art who had participated in the New York exhibition the previous April. When he discovered that the artists would need to be individually invited, Golz asked Henri, his former teacher, to select the participants.

The Columbus exhibit of 135 paintings, drawings, and prints was scheduled for a January 17 opening with Henri slated to deliver a lecture. But an hour before Henri's departure from New York, he learned that two of Davies' paintings had been removed

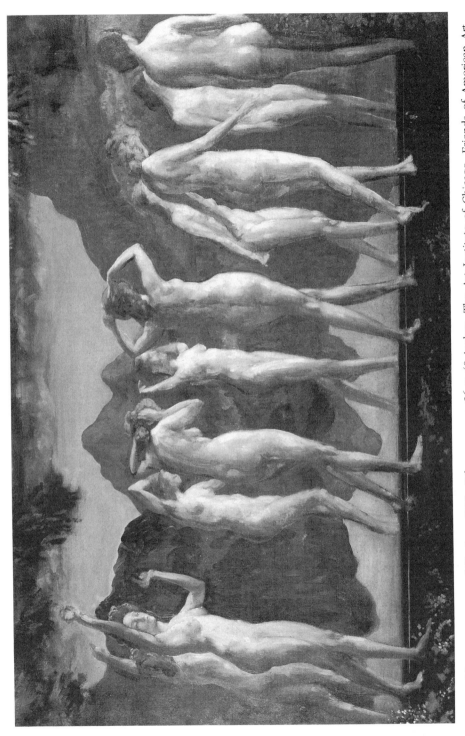

Figure 46. *Maya, Mirror of Illusions*, 1910. Oil on canvas, 26 x 40 inches. The Art Institute of Chicago, Friends of American Art, 1910.318. Photograph © 1997, The Art Institute of Chicago.

by a librarian and a public school art supervisor, who were acting as self-appointed censors. Prior to that action, the art critic for the *Columbus Evening Dispatch* had viewed the show as it was being installed and wrote:

> Perhaps one of the most distinguished of this type of Art [the most progressive and original kind] is Arthur B. Davies of New York, whose pictures show unlimited scope and originality. Two of them especially stand out as very unusual types, "Musidora" and "Day Spring." The artist seems to have drawn away from the smaller minds in his work, and he produced figures of nude women, as he may have dreamed them. . . . there is a charm in the work of Mr. Davies which has placed him in the foremost ranks of New York artists.[14]

Ironically, it was these very paintings that the censors found offensive due to the inclusion and prominence of female nudes. Two figure drawings by ABD, owned and loaned by Macbeth, were left in the show.

Henri notified the Art Association in Columbus that he would cancel his talk unless the Davies canvases were rehung. When he finally entrained for Ohio he did so with the assurance that the works in question had been restored to the exhibit. But while he was en route a new purge took place, including the elimination of the Davies pieces and seven additional works as well: Rockwell Kent's oil *Men and Mountains,* a nude by P. Scott Stafford, four of John Sloan's etchings of inner-city life and George Bellows' drawing, *The Knockout.* In the latter case it was argued that since boxing was illegal in Columbus, even displaying a depiction of it would be regarded as breaking the law.

Kent's objectionable composition shows a pair of nude men against a serene landscape of hills and mountains. It was his intention, he once explained, that the painting be "suggestive of old Greece, of Mt. Olympus; so to enforce that thought, and with the struggle between Hercules and Antaeus in mind, I showed two naked wrestlers in combat on the hilltop."[15] The self-proclaimed censors were oblivious to the artist's intent; perhaps the use of a

classical title would have saved it from being banished. (The subject matter, unusual for Kent, was at least partially influenced by Davies.)

When Henri arrived in Columbus he was furious, and threatened to withdraw the entire show unless the seven compositions were reinstated. This was reluctantly agreed to, but the offensive art was placed in a separate room which was quickly dubbed the "Chamber of Immorality." It was available for viewing by men only.

Upon Davies' return from Italy early in February he was faced with another controversy: The staging of that year's Independent Exhibition. The previous month Rockwell Kent had broached the subject of a 1911 Independent to John Sloan, who lived on the floor above him. When Sloan remarked that he "did not feel disposed to go in to get up another show,"[16] Kent, undaunted, proceeded on his own. He was working at the time as a draftsman for the architectural firm of Ewing and Chappell, whose first commission had been to design a home for Kent's mother. Kent approached his employer, George Chappell, a director of the Society of Beaux-Arts Architects, who obtained the organization's large gallery for his use rent-free.

Kent rushed to share the good news with his former teacher Robert Henri, and in his enthusiasm indicated that a condition for inclusion in the exhibit would be to "force these men to come out and not show their pictures at the Academy." Angered by the restriction, Henri replied: "We never put the screws on anybody," and he immediately refused to be associated with the plan. As the impetuous Kent left in a huff, running down five flights of stairs, Henri came out on the landing of his studio and called after him: "When you have done as much for art as I have, you'll have a right to talk."[17]

In desperation, Kent headed for Davies and revealed what had just transpired. "Good!" Kent reported Davies as saying. "It is time that Henri was put in his place. I'll get you Luks and Prendergast. You see what you can do." And as an elated Kent turned to leave, Davies pressed an uncounted wad of money into his hand. "I'll give you more when you need it,"[18] he promised. The seed money for the show turned out to be more than two hundred dollars.

Davies spoke with Henri, suggesting that Kent was ready to withdraw his demand that the participants boycott the National Academy annual, but Henri, his pride wounded, declared himself

"out of the exhibition entirely unless Kent comes to me and makes a satisfactory explanation."[19]

Davies wrote to Kent on March 6, 1911:

> I think now that the March Squall has passed, we had better get down to work on our canvases and the necessary preliminaries for the exhibition. Henri, Sloan, Bellows and possibly Glackens are out but we can go ahead with the men we have agreed with and I am sure the exhibition will be interesting and keep alive a spirit that should never "die." If you can[,] get others of the Stieglitz crowd—through Stieglitz. Max Weber, Hartley and some others if by invitation only—I would do so . . . "[20]

Davies relished the idea of organizing the exhibition without Henri's domination, yet he had no desire to flaunt his role. He initially considered serving behind the scenes without becoming a participant in the event, and Rockwell Kent indicated in his autobiography that Davies was not included in the show. This would seem to be borne out by the fact that his name did not appear on the catalogue cover and no works by him are listed inside.

However, years later Kent verified that "Davies definitely did show pictures: a large group of chalk figure drawings, which were very fine. . . . I was in error in my book in not listing Davies as one of the exhibitors."[21] In addition to the drawings, ABD also showed four oils: *Sleep Lies Perfect in Them* (later retitled simply *Sleep*), *Free of the Cloud, A Song and a Dream,* and *Refluent Season.*

Sleep (Plate 7), painted in 1908, was the most unusual of the lot, a Davies masterpiece comprised of nightgown-clad women slumbering outdoors in a landscape strewn with flowers. Their recumbent bodies speak tranquillity and an other-worldliness, as evidenced by the fact that the entire scene shows no trace of nightfall or an evening sky, but is bathed in the warm, pink glow of a dream world instead.

Another large oil, painted the same year and titled *A Measure of Dreams,* appears to be *Sleep's* companion piece.

Davies' initial exposure to female figures in similar reclining attitudes was probably in the prints of William Blake, such as his monotype of *Pity,* an illustration inspired by lines from *Macbeth;* or *The Whirlwind of Lovers* and *The Circle of the Traitors,* engravings for

the *Divine Comedy*. Additional, like subjects in oil include those by two other artists he long admired: *Sleep* by Puvis de Chavannes and *Night* by Ferdinand Hodler. Yet both of these compositions display figures in a more dramatic fashion, Puvis' because not all assume a prone position, and Hodler's due to an exaggerated chiaroscuro.

Perhaps Davies was more directly inspired by George Eliot's novel, *Daniel Deronda*, the story of the women of Phocis in Plutarch's *Moralia*, and how the Maenads, those devotees of Bacchus, were watched over by the Delphic women as they slept outdoors before awakening and returning safely to their own borders. Lawrence Alma-Tadema's painting of that subject had been awarded the Gold Medal of Honor at the Paris Exposition of 1889. Regardless of the inspiration, ABD made several figure studies of Edna reclining prior to arranging his unusual composition of slumbering nudes.

Refluent Season was inspired by ABD's recent trip to Greece, and was painted the month following his return. While it focuses on the classical past, the Greek temple that dominates the landscape has been provided with modern proportions, its pencil-thin columns unlike any found in antiquity. A nude Edna is likewise exaggerated in her dimensions, shown as tall and elongated as the columns themselves, her head nearly reaching the capitals.

Among the group of Rockwell Kent paintings shown were *Down to the Sea,* of men and women arranged in frieze-like fashion similar to some ABD compositions; and *Nocturnal Dance,* where Kent ventured even closer to Davies' subject matter and poses, creating thinly clad figures who dance and gesture with arms outstretched.

Other Independent Show exhibitors were Prendergast and Luks from among The Eight; Hartley, Maurer, and Marin from the Stieglitz camp; and Golz, du Bois, Glenn Coleman, Homer Boss, and John McPherson, all former Henri students. The show was called *An Independent Exhibition of the Paintings and Drawings of Twelve Men,* and consisted of 150 works. Each artist was allocated twenty-five running feet of wall space, an arrangement not unlike that utilized for the show of The Eight. The opening reception was held in the Society of Beaux-Arts Architects' gallery, 16 East Twenty-third Street, on March 24, 1911.

Critics referred to the show variously as "The Twelve" or the "Kent Tent." Huneker wrote in the *Sun* that

> The general impression aroused is of dull, muddy paint, blackest of shadows and a depressing absence of reverberating sunlight . . . [Davies], a master draughtsman, . . . makes the rest of the black and white [drawings] too minified for comparison. And this is not fair, as truthfully speaking the drawings are the best part of the exhibition.[22]

Huneker added that Davies was "so absolutely out of place here as to be, artistically speaking, hors concours [with no possible rivals],"[23] while another critic concluded that "The new show is saner and more reasonable than any previous exhibition of the new movement presented here [in New York]."[24]

Attendance the day following the opening and for the remainder of the exhibit was adversely affected by the catastrophic Triangle Shirtwaist Company fire. This tragedy occurred on March 25th and took the lives of 146 garment workers, all women and young girls. It occurred only a mile from the gallery and cast a pall over the city for days. Whether or not this can be blamed for a near-total lack of sales is debatable, but just two works were marked "sold" at the show's conclusion: Davies' *Refluent Season,* purchased by Edward W. Root for two thousand dollars, and an Alfred Maurer still life bought by John Quinn.

A week prior to the opening of the 1911 Independent, Henri had been approached about organizing an exhibit at the Union League. This private club's monthly exhibitions normally ranged from paintings of the Early Italian School to academic artists of the nineteenth century. But the chairman of the league shows, Harry W. Watrous (who also served as secretary of the National Academy of Design) had promised to give the insurgents their day. The exhibit was scheduled for mid-April while the "Kent Tent" was still on display.

Henri invited Davies to serve on the exhibition committee, and at its first meeting Henri suggested that all of The Eight be invited. Davies recommended the inclusion of Kent, Walt Kuhn, and Max Weber. Later that week Davies visited Weber's studio and chose his paintings for the exhibit. The other participants included Bellows, James and May Wilson Preston, and Edith Glackens, William's wife.

Davies wrote to Kent on March 28:

> The committee meeting was unexciting. You are on the list
> canvas & frame about 60 in[ches] in length on line—will
> stop in to see you tomorrow (Wed) evening on my way to
> the Lafarge sale. . . . Ex[hibit] opens April 13. Lists must be
> in April 6th. Try to have figure comp[osition].[25]

The show consisted of twenty-four works by the fifteen art-
ists, with Davies represented by *River and Mountain* and *A Prairie,*
and Kent showing *Burial of a Young Man,* a procession of figures
in a composition over four feet in length. One critic compared it to
Manet's painting of *The Funeral* hanging in the Metropolitan Mu-
seum, but Sloan observed more accurately: "Of course the Kent
picture is done under the influence of Davies."[26]

As was the Union League's custom, the exhibit lasted only
three days, in this case April 13, 14, and 15. When the show opened
on a Thursday afternoon, the gentlemen who strolled from the oak-
paneled dining room into the art gallery were outraged. The *New
York Press* quoted one member as saying, "Well, I call this a joke,"
and another as remarking, "If this is art I guess I'm not up to it."[27]
An academician insisted that "The insurgents' exhibitions should be
closed by the police."[28] On the other hand, the *Herald* referred to
it as "an exhibition in which there is much strength and original-
ity. . . . the finest assemblage of independent art yet seen in this
city."[29]

Rockwell Kent's lack of sales at both shows created a finan-
cial crisis, for his wife had just given birth prematurely and addi-
tional expenses were incurred in keeping the baby alive. Davies
once again came to the rescue, suggesting that Kent take his paint-
ings to Macbeth, then strongly recommending the art to his dealer.
Macbeth purchased a group of thirteen oils, including *Burial of a
Young Man,* for five hundred dollars, allowing Kent to not only pay
the physician, but to purchase a home in Richmond, New Hamp-
shire, as well. It was the start of his northern migration to New-
foundland, where many of his best works would ultimately be
produced.

Kent later recalled:

> I believe that Davies liked me, and I quickly felt a warm
> affection for him . . . That my friendship with him lapsed
> was due mainly to my moving out of New York . . . An
> unforgettable fruit of our friendship was my reading of
> Richard Wagner's autobiography—a voluminous work which
> was lent to me by Davies.[30]

Three days after the Union League exhibit closed, an article
in the *New York Sun* concluded:

> This is the third and last of the series of [Union] League
> exhibitions this season; otherwise there would be nothing
> left but to fetch uptown from Mr. Stieglitz's Little Photo-
> Secession Galleries the appalling Senor Pablo Picasso.[31]

Davies had already viewed the Picasso show as well as
Stieglitz's exhibition of twenty Cézanne watercolors the preceding
month. When ABD's *Refluent Season* was sold from the Independent
Exhibition, he wrote to Stieglitz on April 3, 1911:

> I shall be delighted to own the Cezanne drawing of the
> "Fountain." The $375. will be satisfactory . . . Please let me
> know when you will want the money, I will send a
> check. . . . Your kindly encouragement I appreciate and you
> know I am grateful for the lot of good work you are doing
> for the artistic freedom of all of us.[32]

Alfred Stieglitz made note of ABD's visit: "Arthur B. Davies came in.
He wanted one of the [Cézanne] watercolors. He was the only
buyer."[33]

Davies must have felt an aesthetic kinship with Stieglitz from
the start, for the initial issue of Stieglitz's publication, *Camera Work*,
in January, 1903 had carried a reproduction of Puvis de Chavannes'
Winter, and Botticelli's *Spring* was included in a subsequent number.
And despite Stieglitz's early interest in urban realism, as epitomized

in his own photographs of *Winter—Fifth Avenue* and *The Terminal,* his philosophy appeared akin to Davies' when he said: "There seemed to be something closely related to my deepest feeling in what I saw, and I decided to photograph what was within me."[34]

Davies would soon play a major role in taking the avant-garde art shown by Stieglitz beyond his gallery's confines to a considerably larger audience.

❧ 14 ❧
Assuming the Presidency
(1911–1912)

By the year 1911, Arthur B. Davies and Robert Henri had become the most influential artists associated with the Independent Movement. Henri's ascent to prominence had been heralded in the local and national press with such articles as "New York's Art Anarchists: Here Is the Revolutionary Creed of Robert Henri and His Followers," "The Henri Hurrah," and "Robert Henri: Revolutionary."[1] He was a very public figure; he had fashioned a following of associates and devoted art students and had become most successful in his ability to further young artists' careers. His promotion of the seamy side of city life as respectable subject matter had already become legend.

Davies, on the other hand, never granted interviews and would not discuss the elusive meanings behind his paintings, believing that the art itself should speak to the viewer. As an encourager of young talent he preferred to work unheralded, behind the scenes. Though never a classroom teacher, he welcomed those who searched him out for advice and provided financial aid to individuals he considered worthy. An art dealer once said of him:

> This delicate artist rendered immense service ... by his unfailing sympathy and generosity to younger artists. Wherever he found talent he was quick to purchase the work

of yet unknown artists and to aid and encourage them in every way.[2]

Evidence of such generosity in terms of funds and time are often hidden away in the diaries of those rewarded. For example, Manierre Dawson came to New York from Chicago in 1910 and paid Davies a visit. Dawson recorded the event in his journal:

> He gave me some time in his studio, said he had seen my little sketch for the larger "Terminal" and really gave a good look at my little wood panels and the snapshots of "Flowering Twilight." He was complimentary—wanted to know if a move to New York were possible. His own work is dream-like and very original. After an hour (how I wish I had a studio like his) we visited Albert Ryder—a very exhilerating time there.[3]

In December, 1910, Dawson noted: "Meeting Davies was a great stimulant. I am sketching for projects, thinking much about Rubens and Tintoretto and the Cézannes in Paris. . . . " The following month he wrote, "Davies would be pleased to think that I haven't forgotten his advice to do figure painting."[4]

Sculptor William Zorach recalled how Clara Potter Davidge, owner of the Madison Gallery,

> was always discovering talented young artists, and it seems Arthur B. Davies thought this young man [Canadian-born Arthur Crisp] very unusual, as his work suggested the watercolors of Cézanne, and he [Crisp] had never heard of Cézanne. Davies had interested Lizzie Bliss in sending him out West for a year and paying his expenses [since] they asked him what he would like to do, and he said he'd like to go out West and paint the Indians . . .[5]

Robert Henri's more overt approach to promoting his ideals and himself was bound to antagonize some artists, especially those who had been ignored by him. Jerome Myers, for instance, felt that he was wrongly passed over when Henri chose the members of The

Eight. After all, he had specialized in painting people of the slums long before Henri arrived in New York and began encouraging his pupils to do so. Myers had even exhibited with Henri at Macbeth's as early as 1905 and he lived across the street from Sloan.

Similarly, Walt Kuhn was the artist who suggested the plan to fund the 1910 Independent Show; he had contributed money to make it a reality, oversaw the renovation of the building, and logged in the hundreds of entries as they arrived. Yet when he volunteered to handle the publicity for the exhibit, Henri indicated that the event would not receive proper press unless he was in charge. Kuhn told Sloan that "going into a show with Henri we are all the 'tail to his kite.' "[6]

Such discontent first came to public notice the day before the opening of the Rockwell Kent Independent when a Letter to the Editor appeared in the *Evening Sun*. Though it was signed with the initials "F. J. G.," one could readily deduce from its contents that it was written by the paper's art critic, Frederick James Gregg. The newspaper's general readership was probably puzzled by it, yet artists were immediately aware that all references were to Davies and Henri, the former described in positive terms, the latter negatively:

> ... if there is one thing that your true insurgent objects to it is to giving interviews or having his opinions ... paraded in the public prints. He is always a shrinking hermit who prefers paint ... to vulgar talk. He would rather do things than discourse about them.
>
> Nor does he ever desire to be regarded as responsible for the success of any of his friends ... You will never find him parading as the original discoverer of Genius or Talent. ... Furthermore, such an individualist is never to be seen surrounded by enthusiastic females [a reference to Henri's female students] ... [who find] in the object of their adoration a reincarnation of Manet [Henri's favorite artist], or some other great man of the past ...[7]

After Henri chose to absent himself from the 1911 Independent, he proceeded to arrange with the MacDowell Club, located at 108 West Fifty-fifth Street, to transform a former concert room into a year-round art gallery to be used by self-organized groups. The spacious rooms with 180 running feet of wall space appeared to be

a good solution in the search for a permanent gallery for independent artists. Henri's plan called for two exhibitions per month of between eight and twelve artists, with the cost of each show to be borne by the exhibitors. In May, 1911, he asked Sloan to organize a group for a show to be held the following winter, and Sloan invited Davies, Luks, and Prendergast. Davies replied that he "wished to be free from the 'dreadful thought of an exhibition' so would not go in the MacDowell scheme. . . . "[8] Luks, who indicated he would speak with Davies, eventually declined too, as did Prendergast. Meanwhile, an application was received from an already organized group which included Jerome Myers, Henry Fitch Taylor, and Elmer MacRae, but their request to be the first exhibitors was turned aside. When the premiere show opened in November, 1911, it featured work of the club's art committee, among whom was Henri.

Because of such actions, Myers, Taylor, and MacRae, plus Walt Kuhn, began planning to stage a large independent exhibition of their own, plotting to do so without Henri's involvement. On December 12, Kuhn wrote to his wife Vera:

> Now here's what I've been thinking. We certainly made good this time [a reference to a favorable newspaper article about his just-concluded one-man show at the Madison Gallery], but what we need now is *publicity*. . . . Beginning the first of Jan. I am going to organize a new Society. The plans are still in embryo state but clear enough in my mind's eye to spell positive success—No one is in on it except Gregg [the *Evening Sun* art critic] and he's "mum," and the best advisor I could get. As soon as I have it thoroughly planned we are going to give it to *all* the papers, and they'll jump at it. Of course Henri and the rest will have to be let in—but not until things are chained up so that they can't do any monkey business. He's so wrapped up in the MacDowell Club that he is off guard, and I'll put it over before he knows it, and in such a way that he can't make a single kick.[9]

Three days later he provided further details:

> My idea about the new Society is . . . that it can grow and be as big or bigger than the academy within 2 or 3 years. . . . I

don't want to be the president of the thing . . . Of course I may take a minor office, such as secretary, which although involving labor will pay in publicity. Don't worry, I'll be the real boss—but it will be under cover. . . . I will retain the exclusive privilege of doing the talking to the press— . . . I feel absolutely certain that the thing can be done, and just think of the publicity![10]

The previous day Kuhn, Myers, Taylor, and MacRae had met to discuss the subject, and on December 19, 1911, the first formal meeting of the Association of American Painters and Sculptors was held. Among the other charter members present were Davies, Glackens, Lawson, and Luks. Davies preferred to play an anonymous role, as usual, and it is likely that some of the ideas contained in Walt Kuhn's letters were actually his, for, as Kuhn once confessed: "A.B.D. was the thought behind it all. I was the follower."[11] While the project was certainly near and dear to Davies' heart, he became distracted, his attention focused elsewhere. The reason: His mistress was pregnant.

Edna was in her fifth month when the Association of American Painters and Sculptors was organized, and Arthur was already seized by anxiety. Patience with a crying baby had never been his forte, and there would be no escaping this one. Macbeth sought to help out financially but he found a buyer for only one of Davies' canvases during the final months of 1911. And although an exhibition of ABD's paintings was scheduled for the Women's Cosmopolitan Club for December and January, it was a loan show, with all thirty-seven works scheduled to be borrowed for the occasion from Lizzie Bliss, Gertrude Vanderbilt Whitney, Gertrude Käsebier, and Col. Henry Thomas Chapman. There was no possibility of sales.

Adding to Davies' monetary woes was consideration of his oldest son, who would be entering Cornell University's College of Agriculture in the fall. Further, although his life with Edna was sometimes blissful, there were trials, usually centered on household disputes. She characterized their apartment as an inadequately furnished hovel, much less comfortably appointed than his studio. Friction mounted now because she was feeling sickly during much of her pregnancy.

This series of events in Davies life were destined to alter the course of art in America. Davies shared his plight with Walt Kuhn, whose own financial situation had recently worsened after *his* wife had given birth to a child. Kuhn was a newspaper cartoonist and part-time fine artist at the time. He continued "grinding away at comics praying to the Lord it will soon be over with . . . ,"[12] for his goal was to subsist from the sale of paintings alone. And he considered publicity the key. If only he could engineer Davies' election as president of the newly formed association, both men would benefit from the publicity and enjoy increased prestige and purchases of their art.

At the association's meeting on January 2, 1912, with President J. Alden Weir absent, a statement was read that began: "The National Academy of Design is not expected to lead the public taste. It never did and never will . . . "[13] Although the meeting lasted past midnight, Kuhn, as publicist, had already supplied the morning papers with a news release. Upon reading the statement in the newspaper, Weir, a long-time member of the NAD, shot off a letter to the *New York Times* announcing his resignation from the association. It was the perfect opportunity, thought Kuhn, who approached Davies about assuming the presidency. Davies was already involved in the workings of the organization, having agreed to serve on a three-member committee to fashion its bylaws. He undoubtedly had a hand in articulating the group's clearly stated mission: to develop "a broad interest in American art activites, by holding exhibitions of the best contemporary work that can be secured, representative of American and foreign art."[14]

It looked as though the forthcoming election for president may mean a showdown between Davies and Henri, for the latter, still considered by many the leader of the insurgents, had some loyal backers among association members. But when Henri was contacted as to whether he would agree to be president if elected, he answered "no—would accept presidency of nothing."[15] The following day, Jerome Myers and association treasurer Elmer MacRae called on Davies, who consented to serve. At a January 23, 1912, meeting, Davies was officially put in charge. Henri's response was, "They are in slight prospect of doing anything . . . ,"[16] a statement which would become one of his most imperfect prophecies.

An eight-member board of trustees was elected which included Davies, Kuhn, Myers, MacRae, Taylor, and John Mowbray-

Clarke, with ABD squarely in charge. (Mowbray-Clarke, a sculptor, lived six miles from the Davies farm in Rockland County and coincidentally happened to be married to Mary Horgan, ABD's love from his Art Students League days. The arrangement would allow for convenient meetings at the Mowbray-Clarke home, which was rumored to be a hotbed of free love, supposedly containing several lean-tos outfitted with mattresses.) Committee heads were of Davies' own choosing: Glackens was appointed chairman for domestic exhibits, MacRae for foreign exhibits, with Kuhn in charge of the Catalogue and General Printing Committee. Glackens was chosen based on his knowledge and appreciation of recent styles in painting, for he had just spent a month in Paris purchasing twenty-thousand-dollars worth of art for Dr. Albert C. Barnes, his former high school classmate. His purchases included works by Renoir, Degas, Cézanne, and van Gogh. Glackens was also developing into an outspoken Davies enthusiast: "He is a symbolist, a painter of ideas. He is one of the truest symbolists that ever lived. . . . He aims straighter, perhaps, than any other man here at beauty. . . ."[17]

Davies had precious little time to devote to the association during the next few months because of the approaching birth of his child. Still concerned about Davies' financial situation, Macbeth scheduled a Davies show for March, 1912. Writing in *Art Notes,* he promoted ABD's first solo exhibit at the gallery in three years:

> One of the big treats now in preparation is an exhibition of pictures by Mr. Davies. As yet the public has seen no result of his late trip to Greece, but he has not been idle for a day since his return. His coming show will be one of the real events of the season.[18]

In a subsequent issue, the dealer further enticed the art-buying public by indicating:

> I have seen enough of the new pictures to be assured that he [Davies] will immeasurably strengthen the firm hold he has already made on the esteem of the many who have long recognized his unique and high position in the modern art world.[19]

Though the exhibition was to be held from March 18 to 30, the first sale was recorded ten days before it opened—to Lizzie Bliss. She, too, had been taken into Davies' confidence and told of the impending birth. So convincing was the story he related to her of his marital trials that she became totally sympathetic to his plight. Lizzie Bliss, Macbeth, and Walt Kuhn were the only ones informed that he was fathering a child out of wedlock.

Bliss purchased six canvases from the exhibit for more than five thousand dollars and may have influenced the sale of four more to Mrs. Charles Cary Rumsey, the former Mary Harriman. By the end of the month, twenty-one paintings had been sold for over seventeen thousand dollars, more than enough, even after the gallery commission, to take care of medical bills and associated expenses. Following its New York showing, the exhibition was sent on to Boston's Doll and Richards Gallery for a week, and two more sales resulted.

On April 14, 1912, two days after the show closed in Boston, a daughter was born to Arthur and Edna. Arthur chose the name "Helen" for the infant, since the mythological Helen of Troy had been deemed the most beautiful woman in the world. Years before, during his courtship of Virginia, Arthur had sent her a love letter in which he wrote of "This passionate hunt for Helen who is always in a strange land and eludes me. . . . I still keep the ideal before me."[20] How ironic that, finally having a Helen, she is borne of Edna rather than of his wife. The child was given the middle name of "Ronven," a variation of the Welsh "Rhonwen," which means "slender and fair." The birth certificate lists the father as David A. Owen, fifty, and a civil engineer; the mother's name is given as Edna P. Owen, thirty-five.

Davies, his "wife," and the baby continued to live in the apartment at 314 East Fifty-second Street. As Edna recounted years later in a letter to ABD's younger son David:

> Ronnie was born in [a tenement] and the bed your father provided for her birth was *straw*. In those days my allowance for household expenses was ten dollars a week. When I was sitting on the floor knotting up 35 cent floor covering for the little flat, his 57th Street apartment was three and four deep in costly Oriental rugs. Any comforts which I got little by little came from my own money.[21]

This depiction of Arthur as selfish to the extreme was written seventeen years later, following his death, at a time when Edna was seeking a portion of his estate for their daughter. Nonetheless, there is no doubt that Edna's accusations bear some element of truth. Her cruel treatment and neglect at Arthur's hands appear on par with that experienced by Virginia.

Shortly after Ronnie arrived, Davies moved his studio from West Thirty-ninth Street to larger quarters at 337 East Fifty-seventh Street, which would become the location of his workshop for the next dozen years. Davies was under constant emotional strain, resulting from having a sickly infant in the household, the chore of moving, and the pressures attendant to being president of the association. In a note to Walt Kuhn he admitted: "Moving has upset me physically & other worries so excuse briefness."[22]

The mounting pressures made Davies short-tempered as well. After his initial rejection of Sloan's invitation to exhibit at the MacDowell Club, he was approached again, this time by Henri, who found that they were still one artist short. "[I] will see . . . Davies and will let [him] open the matter . . . ,"[23] Henri informed Sloan. But Henri was never offered the opportunity to broach the subject, as he reported: "One day I called on him at his studio [and] Davies shut the door in my face. I recognized Davies's peculiarities and thought he was entitled to them. . . ."[24]

An additional ramification of ABD's current predicament was the postponement of payment for a second Cézanne purchased from Alfred Stieglitz. As he wrote the dealer a week after Ronnie's birth:

> I regret the unexpected delaying of the payment for the Cezanne drawing. I know you will understand the sluggishness of circumstances we would move more quickly if we could. . . .[25]

By May, Davies began to work on the association exhibit in earnest, finding it a convenient excuse to absent himself from daily chores involving Edna and Ronnie. The organization's members expected a major exhibit of American art, although they anticipated some foreign painting and sculpture being included, as the bylaws allowed. For some, having a smattering of European art was the

expression of a liberal attitude. It echoed the statement made by Henri when membership of The Eight was announced, that consideration was being given to inviting a few European artists to participate.

When it was learned that Henri would be teaching an art class in Spain during the summer of 1912 and then visiting Paris, a delegation from the association approached him with the notion that, while there, he might select some foreign works. His reply was featured on the front page of the *New York American:*

"PROGRESSIVES" IN ART COUNTED OUT
BY REACTIONARIES

———

Great Exhibition of "Standpat" Painting and
Sculpture Is Being Arranged.

———

Robert Henri in Revolt

. . . As he was to be in Paris this summer he was asked if he would consent to help gather foreign works while there. He implied, so the report goes, that he would do nothing unless given full authority. That did not forthcome.[26]

The article included a statement that "The largest exhibition of painting and sculpture and the first international one of its kind ever held in this city will . . . open in the Sixty-ninth Regiment Armory in February."[27] This was the first announcement in the press that a site had been found and a date chosen.

The armory, built in 1906 on Lexington Avenue between Twenty-fifth and Twenty-sixth streets, was an ideal choice for the show. Not only would its drill floor provide a massive space for exhibits, but clusters of lights hanging from the ceiling and a bank of windows along the balcony would allow for adequate illumination. Terms for renting the building were negotiated with the commanding officer of New York's Sixty-ninth Regiment National Guard, and on May 6 an agreement was reached calling for a rental fee of five thousand dollars, with payment of fifteen hundred up front. This was a sizable amount to be committed by a group of twenty-two

artists, virtually all of whom envisioned the exhibit as a moneymaker for themselves. But Davies saw it more as a mission, a way of bringing art by living American and European artists to a large segment of the population which was still unaware of, or looked askance at, any paintings by anyone more recent than Millet. On May 7, 1912, ABD personally consummated the deal with a fifty-dollar check, followed by payment of two-thirds of the fifteen hundred dollar amount.

With the overwhelming financial success of his recent show at Macbeth's, one of the reasons for his assuming the association presidency was no longer as pressing. Yet his personal commitment went far beyond providing start-up funds and a willingness to emerge from his accustomed seclusion long enough to direct the selection, assembling, and financing of so giant an undertaking. Unbeknownst to the other association members or even his wife, ABD and John Mowbray-Clarke offered their homes and farms as collateral against any financial loss from the Armory Show. For Davies, at least, this could have been a most embarrassing situation, since the farm remained in Virginia's name. Yet Davies had great faith in the undertaking, and also faith in Lizzie Bliss to help him out if the show was a terrible failure.

❧ 15 ❧
The Armory Assault
(1912–1913)

\mathcal{B}y the summer of 1912, the proposed list of participants for the Armory Show was still far from avant-garde, for its foreign section at that point was composed of many relatively unknown, not-so-radical Frenchmen. A newspaper article in June gave evidence of this, stating that "Among the foreign exhibitors will be Le Sidaner, Raphaelli, Aman Jean, Felland [sic] Gibb, August Bodin [sic], Albert Besnard, Augustus Solin and the late Cézanne."[1] Of course, only Cézanne, Auguste Rodin, and Phelan Gibb, the latter a British-born painter of architectural subjects living in Paris, would ultimately be included.

Davies transformed this lackluster sampling with the aid of art magazines and catalogues, some of which were translated by Walter Pach, a Paris resident at the time. Davies had become aware of Pach when an article by him, titled "Cézanne—An Introduction," appeared in the December, 1908, issue of *Scribner's*. It was the first appreciation of the artist to appear in an American magazine. When Davies and Pach met the following year, Davies was impressed by Pach's knowledge of both Renaissance and modern art. The admiration became mutual, with Pach purchasing a book of the classic poetry of China, *A Lute of Jade,* "on Arthur B. Davies' recommendation." It contained "things in it that are a revelation—most wonderful," according to Pach.[2] In a 1909 letter to Pach, Davies had written that "I am more delighted than ever with Gauguin and his work . . . I

211

would wish to know more of this true artist, who has the spiritually enlarging vision."[3]

Pach had participated in the 1910 Independent; then, back in Europe, he began receiving from ABD French magazines to translate, plus requests for photographs of works by certain artists. When Pach learned that Davies had been named president of the Association of American Painters and Sculptors, he wrote him offering his assistance.

In July, 1912, John Quinn, the New York lawyer and collector who had purchased one of the two paintings sold from the 1911 Independent, became associated with the Armory Show project by agreeing to file its papers of incorporation. During the same month, Quinn received a letter from Cologne written by Martin Birnbaum, director of the Berlin Photographic Company gallery in New York. Birnbaum expressed enthusiasm for the Sonderbund (Separatist Group) exhibition he had just viewed in the German city:

> There is . . . a great Futurist show here in which I am much interested. I wish I had some modern sympathetic person with money to back me up, and I would give America the exhibition of its life. . . . We are away behind the times in America, and I shall do my best to wake them up.[4]

Davies, who acquired the majority of his foreign publications from Birnbaum's Madison Avenue establishment, obtained a copy of the Sonderbund catalogue from him upon his return. That purchase became the catalyst for the ultimate direction of the Armory Show.

Davies would have loved to have viewed the Cologne exhibit himself, but Edna, who had previously expressed her objection to his accepting the presidency of the association, now vehemently opposed his leaving her and the infant to travel to Germany. It is unclear whether Davies initially approached Elmer MacRae to go in his stead, since he was the group's chairman of foreign exhibitions, but on September 2, 1912, ABD wrote to Walt Kuhn, who was vacationing with his family in Nova Scotia:

> . . . I wish we could have as good a show as the Cologne Sonderbund—I think you would do well to see it before the close on Sept. 30 and talk with that man August Deusser,

maler [painter], who seems to be the main pipe. You could get a heap out of him for many purposes I believe. I don't know whether Hamburg or Bremen would be more convenient for quick connections. However, I think enclosures [of ship sailings] from a good English weekly pretty good. . . . [5]

Then Davies sent a letter to Pach in Paris: "I had expected to go over with him [Kuhn] . . . [but] just now domestic troubles are delaying [my departure]. . . . " He added his assessment of the projected Armory Show: "To those of us and men like yourself the possibilities loom tremendous yet so many can only see another opportunity of showing their work— . . . "[6]

When Kuhn arrived in Cologne he was enthralled by what he saw: Two hundred twenty-four works by van Gogh, Gauguin, Cézanne, Picasso, and Munch. Davies, for his part, continued to direct Kuhn's tour from New York:

> I believe you will see Cezanne at the Pallerin house which is the most desirable of all places for a visit. I am delighted you had a fall to with [Edvard] Munch, don't go too much on his eminence as a success. Pinch him on some less popular phase, but more himself.[7]

On October 1 he wrote: "Don't forget we want a roomful of Futurists and another of Cubists."[8]

Nine days later Davies advised him:

> . . . [Bryson] Burroughs [Curator of Painting at the Metropolitan Museum of Art], said to write to Roger Fry, London. Druet & Bernheim Frer[e]s Paris and he thought they would back us up in the whole matter of advancing the interests of the Post-Impressionist movement & help us in our borrowing . . . [Fry] is to have another show in London immediately you can certainly make use of those fine things he will have in this year's show & those of last year yet obtainable . . . [9]

At this point Kuhn sent ABD an urgent request to join him. As Kuhn later explained to his family: "I just thought this thing was

getting too big for me. Davies came very promptly but reluctantly because Mrs. Potter [Edna] was raising a ruckus because Ronnie was just born."[10] Kuhn's daughter Brenda noted, "My father didn't have the experience or age [he was fifteen years younger than Davies] to deal with this thing."[11]

Davies arrived in Paris on November 6, 1912, and he, Kuhn, and Pach embarked on a whirlwind tour of art galleries, artists' studios, and private collections, seeking out the inspirational and experimental—anything new for the exhibit. "Davies had not been in Paris for years," Pach observed, "and was seeing the moderns for the first time. The depth of his intuitions was therefore astonishing—in my experience, unique."[12] Upon viewing the work of the brothers Marcel Duchamp, Raymond Duchamp-Villon, and Jacques Villon, for example, ABD commented: "That's the strongest expression I've seen yet!"[13]

When the threesome visited Brancusi, Davies

saw that hermit, so intent on his job, so oblivious of all the machinations of the arrivistes [unscrupulous individuals]— the people whose one goal is material success—he said, "That's the kind of man I'm giving the show for." And on the spot he bought for his own collection the exquisite little *Torso of a Woman* . . .[14]

At Odilon Redon's studio, ABD spotted his pastel of *Roger and Angelica* and, in an aside to Pach, said, "That's sold; don't tell him so."[15] The purchaser would turn out to be Lizzie Bliss. And when Davies left the apartment of Gertrude Stein's brother, Michael, after Michael had agreed to lend two Matisse oils to the exhibition, Davies stood outside the closed door, doffed his hat, and bowed low in appreciation.

Davies and Kuhn visited Marsden Hartley there, too, and were among the first to view his new work. Davies chose two oil still lifes which combined the influences of Cézanne and Matisse, a style Davies had encouraged the winter before when he took Hartley to view his first Cézannes at the Havemeyer Collection. Hartley would have chosen differently, as he wrote to Stieglitz, "chiefly because I am so interested at this time in the directly abstract thing but Davies says no American has done this kind of thing—and they

would serve me and the exhibition best at this time."[16] Davies invited the younger artist to be represented by six of his abstract drawings as well.

Pach remained in Paris to arrange for shipping the art to America. He would be bestowed with the title of European Representative of the Armory show and, for this and other services, paid the sum of twelve hundred dollars, becoming one of only two salaried employees. (The other was Frederick James Gregg, who served as Chairman of the Press Committee and received the same amount.) Davies and Kuhn left for London, where they viewed Roger Fry's second post-impressionist show at the Grafton Gallery, arranging for many of the works to be sent to New York. "I could see in the glint in Davies' eye that we had nothing to fear by comparison [with the Fry exhibit]," Kuhn recalled.[17]

Fry's cooperation was assured because he was an admirer of Davies and his art. In 1909 he had written to the English artist Philip Wilson Steer, "I hope you like my American friend A. B. Davies's things at the International [Exhibition in Venice]. He is one of the few men there whose work interests me."[18]

Davies and Kuhn, buoyant over the quality and scope of their selections, sailed for New York on November 21. When they shared their enthusiasm with the association members at a meeting the following month, Davies' control of the forthcoming exhibition had become virtually absolute. Henri, for instance, was assigned to the Committee for Foreign Exhibits, a meaningless gesture since the majority of the European works were already being packed for shipment to Manhattan.

There remained but one major nemesis to deal with: Gutzon Borglum. Davies, Borglum, and John Mowbray-Clarke comprised the selection committee for three-dimensional art and Borglum, whose heroic heads of four United States presidents would one day grace Mount Rushmore, thought in terms of enormous marble statuary of a conservative bent. Davies and others feared that such entries would overpower the European sculptures and diminish the visual impact of the paintings. And there was the added cost of shipping such sizable pieces to the exhibition site.

As a result, ABD insisted on accompanying Borglum on his visits to sculptors' studios. Seated in his car on their first trip out,

Borglum casually mentioned to Davies that if he were a sculptor he, too, could own a car. "I could," ABD is said to have replied, "if I were that kind of a man."[19] The remark led to Borglum's resignation from the Sculpture Committee and subsequently from the organization as well.

As with much of the undertaking, funding for the Armory Show fell upon Davies' shoulders. Only he and Mowbray-Clarke, among all of the artist-members of the association, were listed as contributors; in fact, the initial funds received for the exhibition came from ABD on September 10, 1912, in the amount of $150. Two days later Davies provided another $2,500, but it is most likely that this came from Lizzie Bliss. Although she was the major financial backer of what she considered Davies' project, all of her donations were made anonymously.

In October, 1912, ABD informed Kuhn, "I am gently working a millionaire friend and must say I have big hopes for his help on our show. . . . "[20] But apparently that effort did not bear fruit, for of the more than $10,000 in contributions received by the association, and with the exception of those from Davies and Mowbray-Clarke, all but $500 was given by women. It is estimated that at least twenty-five percent of the total came from Lizzie Bliss, with another twenty percent contributed by Gertrude Vanderbilt Whitney and Dorothy Whitney Straight. Yet these were merely the contributions listed in the organization's ledger. Additional funds must have been channeled directly through Davies for such expenses as renting an office across the street from the armory and a stable nearby for the storage of European works. And the cost of insurance and round-trip transportation for all of the art amounted to $25,000. Just as Lizzie Bliss' name does not appear on the official list of donors, neither does that of another financial backer, Abby Aldrich Rockefeller, (Mrs. John D., Jr.).

The Whitney and Straight monies were channeled through Clara Potter Davidge, who became a virtual one-woman fund raiser for the event. It was, after all, in her Madison Gallery that the initial discussions between Kuhn, Myers, MacRae, and Taylor had taken place, leading to the establishment of the association. And Henry Fitch Taylor, the gallery manager, was her protégé. Mrs. Davidge was responsible for raising or channeling to the organization more than one-third of the donated assets.

Another contributor to the cause was Mabel Dodge, whose arrival in New York late in 1912 coincided with the publicity cam-

paign for the Armory Show. She was already heralded as a liberated woman whose badge of honor among the avant-garde literati was Gertrude Stein's word portrait of her. When she learned details of the forthcoming event from Clara Davidge and Mabell Gregg, wife of the *New York Evening Sun* art critic turned Armory Show publicist, she "felt as though the Exhibition were mine. I really did. It became, over night, my own little Revolution. *I* would upset America . . . "[21]

When she forwarded a check for $500 to Davies, it included a note which began:

> I'll be delighted to help in any way in the exhibition, be-
> cause I think it the most important thing that ever happened
> in America, of its kind. Anything that will extend the
> unawakened consciousness here (or elsewhere) will have
> my support. . . . The majority are content to browse upon
> past achievements. What is needed is more, more and al-
> ways more consciousness, both in art and in life.[22]

Davies, who would have this message printed on cards and distrib-uted among visitors to the Armory Show, complimented her on the "happy augury that you have," then added that "with simplicity we hope to overcome the parasitic disorder of those who rob life of beauty. That great art is a state of the soul and of positive benefit to all who can feel exaltation."[23]

After ABD, Pach, and Kuhn had elicited all of the commit-ments from galleries and collectors overseas, Davies turned his at-tention to seeking additional works in the United States. Between December, 1912, and the opening of the exhibition the following February, he requested that Alfred Stieglitz lend seven drawings and a bronze each by Matisse and Picasso; Gertrude Käsebier, seven watercolors and a bronze by Rodin; and Max Weber, seven oils and ink drawings by Henri Rousseau.

Utilizing his expertise as a draftsman, Davies had drawn a floor plan in October, 1912, and shared it with Walt Kuhn. It divided the vast, open armory floor into twenty-six galleries. There is little doubt about the type of art Davies sought to emphasize at the Armory Show, for exhibition spaces labeled "French," "van Gogh," "Redon," "Matisse," and "Gauguin" were located toward the entrance, while three large

galleries designated "American Paintings" were placed in the rear. At the bottom of his floor plan Davies wrote to Kuhn: "this is to roughly indicate what's doing. Don't show to anyone out side of the family."

Davies' plan called for his favorite artists to be well represented. His own symbolist leanings resulted in Odilon Redon having a display of forty works, by far the largest collection in the exhibit; Puvis de Chavannes had fifteen; Ryder, ten; Munch, eight; and Matthew Maris, four. Davies labeled one gallery in his exhibition layout "Futurists," but when he produced the plan he had no way of knowing that none of the futurists would actually participate. It was his biggest disappointment.

Figure 47. Davies' proposed floor plan for the placement of art in the 69th Regiment Armory Exhibition (The Armory Show), produced in October, 1912 in a letter from Walt Kuhn to his wife Vera dated October 31, 1912. Walt Kuhn Papers, Archives of American Art, Reel D240, Frame 437.

Mapimí [Mexico], June, 1883. Sketchbook. Watercolor and gouache 4 × 6⅞ inches. Collection of Sylvia Davies Diehl and Kenneth R. Diehl.

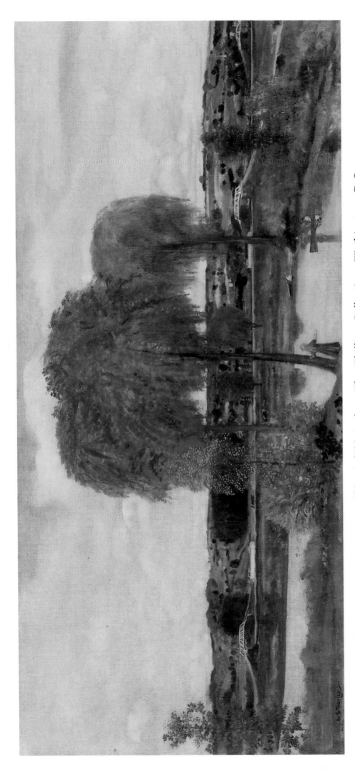

Along the Erie Canal, 1890. Oil on canvas, 18⅛ × 40⅛ inches. The Phillips Collection, Washington, D.C.

Rostan, ca. 1895. Pastel and pencil on gray paper, 14 × 8^{15}/$_{16}$ inches.
Collection of Mr. and Mrs. Niles Neriwether Davies, Jr.

Orchard Idyl, 1896. Oil on canvas, 32½ × 26½ inches. Private Collection.
Photograph courtesy Babcock Galleries, New York.

Canyon Undertones, Merced River, 1905–06. Oil on canvas, 26 × 40 inches.
Photograph courtesy James Graham & Sons, New York.

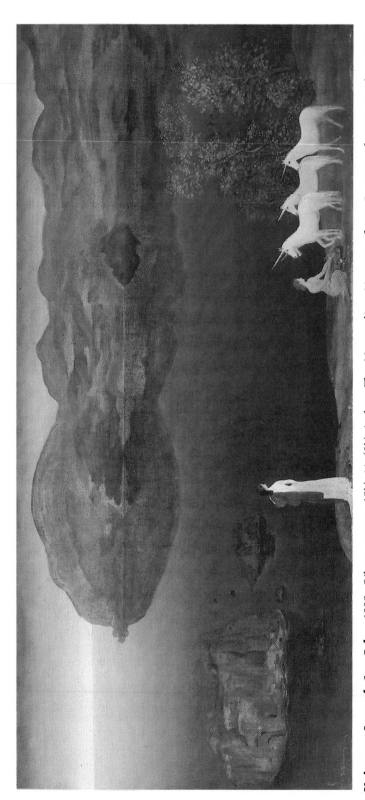

Unicorns: Legend, Sea Calm, 1908. Oil on canvas, 18¼ × 40¼ inches. The Metropolitan Museum of Art, Bequest of Lizzie P. Bliss, 1931.

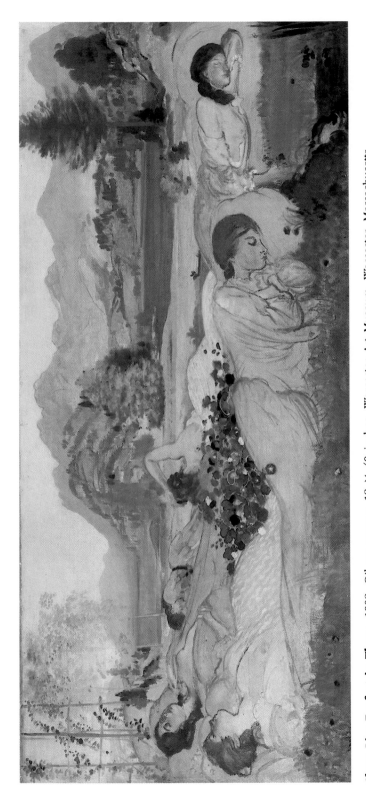

Sleep Lies Perfect in Them, 1908. Oil on canvas, 18 × 40 inches. Worcester Art Museum, Worcester, Massachusetts, Gift of Cornelius N. Bliss, 1941.

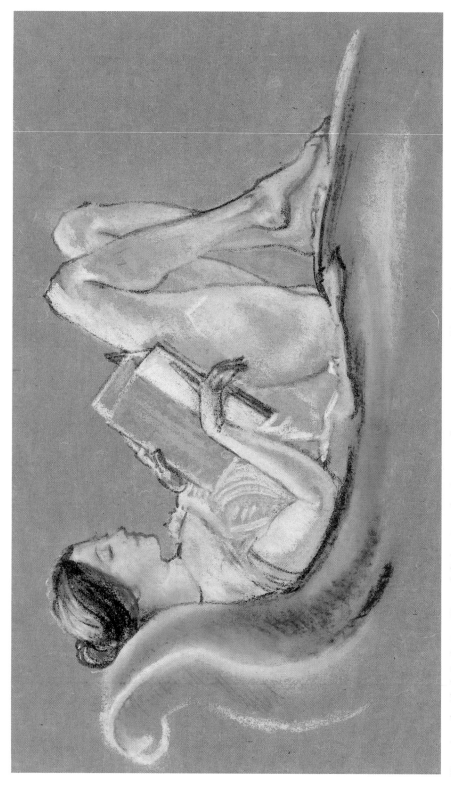

Drawing (retitled *Reclining Woman*) [Edna Potter], 1911. Pastel on gray paper, 8³/₈ × 11¹/₂ inches. The Metropolitan Museum of Art, Alfred Stieglitz Collection, 1949.

Figures Synchromy, 1913. Oil on wood panel, 7³/₄ × 9³/₄ inches. Collection of Dr. and Mrs. Bernard H. Wittenberg.

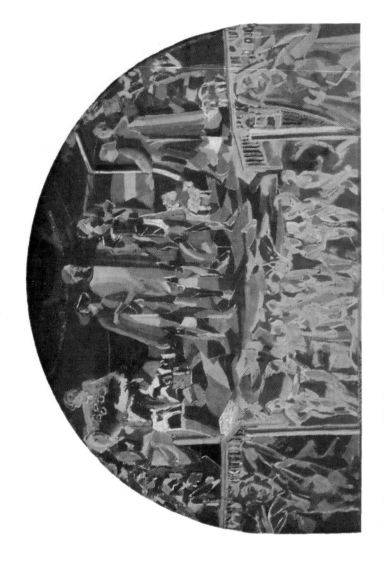

Shepherd Kings, 1913. Pastel on canvas, 20¼ × 29¼ inches.
Collection of Mr. and Mrs. Niles Meriwether Davies, Jr.

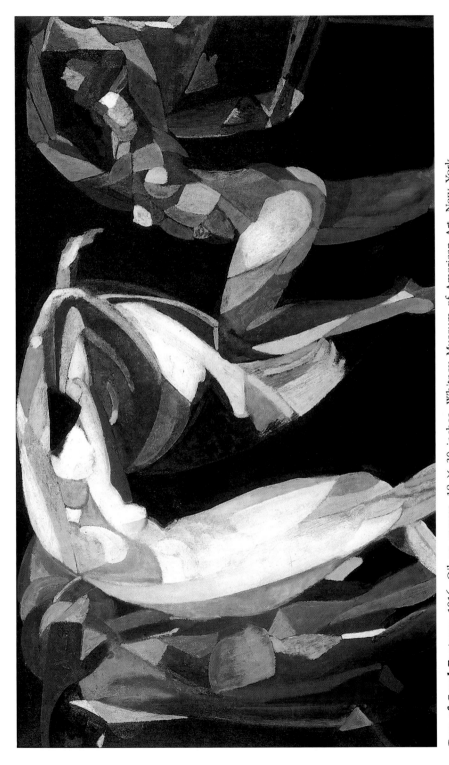

Day of Good Fortune, 1916. Oil on canvas, 18 × 30 inches. Whitney Museum of American Art, New York, Gift of Mr. and Mrs. Arthur G. Altschul. Photographer: Geoffrey Clements.

Athlete, ca. 1915. Wood, 13 × 10¼ inches.
Collection of the late Mr. and Mrs. Arthur David Davies.

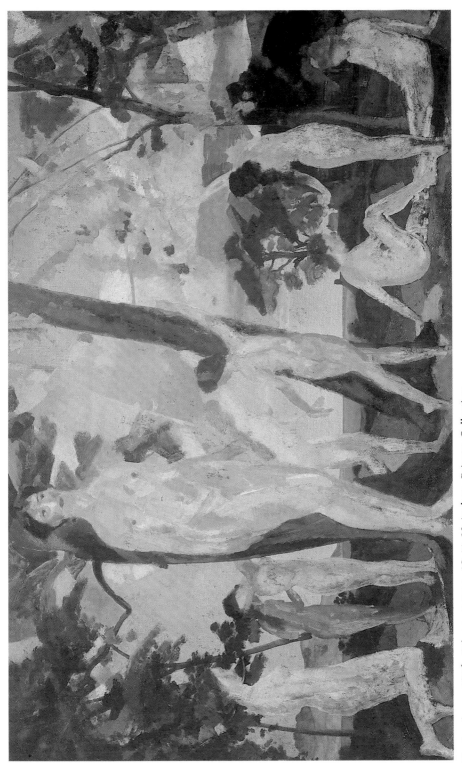

Tartessians, 1916. Oil on canvas, 18 × 30 inches. Private Collection.

St. Aignan, 1924. Watercolor, Chinese white and graphite on gray paper, $9\frac{1}{4} \times 12$ inches. Collection of Arthur Bowen Davies II and Margaret Davies Marder. Photographer: Duane Suter.

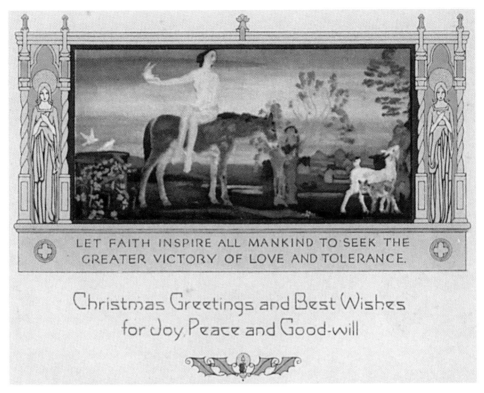

Let Faith Inspire All Mankind to Seek the Greater Victory of Love and Tolerance, 1924. Color reproduction on paper board, $1^9/_{16} \times 3^1/_4$ inches; size of card, $3^7/_8 \times 5$ inches. Collection of Margaret Davies Marder.

A Thousand Flowers, ca. 1928–29. Tapestry, 42 × 70½ inches. The Museum of Modern Art, New York, Gift of Abby Aldrich Rockefeller. Photograph © 1998 The Museum of Modern Art, New York.

He had become aware of the Italian avant-garde in February, 1912, when an exhibit of their work was held in Paris and duly reported in the *New York Sun*. A subsequent article in the *Evening Journal* revealing that "Futurist artists see through mental eyes"[24] naturally aroused ABD's interest. While in Paris that fall, Davies, Pach, and Kuhn had met with futurists Umberto Boccioni and Gino Severini, who were visiting there, and extended an invitation for their coterie to show in New York.

The futurists, however, anticipated being asked to participate in the "First International Roman Secession Exhibition" in Italy, and the prospective dates of the two shows overlapped. Giacomo Balla wrote to Carlo Carrà, two other members of the group, to check whether the invitation to the Italian exhibit had been received. "As soon as you have any news write or wire me . . . All of this because we are invited to show in New York with Picasso, Braque, the Cubists, Cezanne, etc."[25]

On November 15 a reply was sent from Filippo Marinetti, the founder of Futurism, verifying the Italian commitment and adding:

> As for joining in the Armory Show, the Futurist presence there in the company of so many different trends could only increase the confusion already rampant in Europe. . . . We are all absolutely against exhibition with Cubists in New York.[26]

By then Davies had left Paris for London so the news did not reach him.

The focus now turned to the American section of the show. Though Glackens and his Domestic Art Committee, which included Prendergast, made most of the decisions concerning who would be invited to exhibit how many works, Glackens' high regard for Davies allowed the latter to occasionally usurp the committee's authority. "It seems to me," Glackens wrote at the time of the Armory Show, "that Arthur B. Davies stands alone in America or even the world. He is the most important man in this country. . . . "[27]

It was Davies, for instance, who requested that Leon Kroll submit work after viewing his paintings at one of the MacDowell Club exhibitions, and Manierre Dawson similarly noted that "He [Davies] has invited me to send some of my things, what I consider

the most novel, to him . . . "[28] There were also occasional charges of political expediency leveled at ABD. One involved the invitation to exhibit three works by sculptor Charles Cary Rumsey, whose wife, the former Mary Harriman, was a collector of Davies' art. It was she who encouraged two family members to contribute more than one thousand dollars to the show.

In the day-to-day operations, Davies often turned to the more aggressive Walt Kuhn, having been quoted as saying that "Kuhn was my right hand. He did all the fighting."[29] Yet there were times when ABD's more diplomatic approach was required, especially in limiting the number of entries from certain artists. "[Joseph] Stella wanted to put *14* pictures in the show," Kuhn informed his wife. "I called up Davies and he will put the Kibosh on him."[30]

A more vexing problem involved Max Weber. In 1909 Davies had been Weber's first patron, and when he had a show in 1912 ABD encouraged Lizzie Bliss to acquire four of his works. Davies' appreciation of Weber went beyond enjoyment of his fauve-like oils. In a 1910 article in Stieglitz's quarterly publication, *Camera Work,* Weber had written an essay titled "Fourth Dimension from a Plastic Point of View," in which he stated that "In plastic art, I believe, there is a fourth dimension. . . . The stronger or more forceful the form the more intense is the dream or vision. . . . "[31] His "dream or vision" theory was especially appealing to ABD. Once, when a critic labeled Weber's art "brutal, vulgar and unnecessary," Davies countered by referring to him as "the greatest painter of landscapes in America."[32] He obviously planned on Max Weber's inclusion in the Armory Show, but Weber, who had been a student of Matisse's in Paris and considered himself the leading American modern, was not about to be content with playing a minor role. He felt he deserved a sizable display.

Weber had already been offended by not being asked to serve on the Armory Show's Domestic Exhibition Committee and felt that the avant-garde nature of his art entitled him to be represented by eight or ten paintings. Davies made no reference to the number of works in a letter dated January 1, 1913, concerning the loan of his Rousseaus:

> You have probably heard of the growth of our new "movement" and you know better than I can tell you of the surprises

in store for the dear public when they get sight of the work I have secured in Europe for the exhibition of the Painters and Sculptors in February. I expect you will make a good selection of your own work for the show. I have planned a room for paintings by Henri Rousseau, Matthew Maris and Albert Ryder. I wish you to lend me for the group your Rousseaus . . . [33]

When the Domestic Committee met, it invited Weber to submit just two works. He reacted with bitter sarcasm: "I heard they were inviting school girls and boys who'd painted for a little while, with three, four canvases, five canvases. I get an invitation to send two pictures. . . . "[34] He then took an obstinate, all-or-nothing stand, prompting Davies to write him this terse note: "Your ultimatum to the Exhibition Committee is accepted as final and you have queered all my efforts to get you in the show."[35] Alas, Weber would not be among the exhibitors.

Keen interest in the Armory Show had begun to build among artists and the public alike. Newspaper publicity had begun in mid-December: "Show of Advanced Art Promises a Sensation" was the bold headline in the *Sun;* "Works Worth $2,000,000 Will be Seen at Art Show" claimed the *Press;* "Revolution in Art to Sound Its Note Here in February" trumpeted the *Globe and Commercial Advertiser.*[36]

A different type of article intended to promote the event appeared on January 26, 1913, when Alfred Stieglitz leveled a scathing attack at Henri, William Merritt Chase, and John Alexander as the art world's conservatives. Under a blaring, six-column headline in the *New York American* proclaiming "The First Great 'Clinic to Revitalize Art,' " Stieglitz spoke out against what he called the "eternal repetitions" of these old fogies:

> The dry bones of a dead art are rattling as they never rattled before . . . Oh, yes, the Chase School and the Henri Academy and the Alexander Manufactory will go on doing business at the old stands. Sometimes the dead don't know they're dead. . . . What's the use of going on breeding little Chases, little Henris and little Alexanders—and little Alexandrines?[37]

For Stieglitz, the "live ones" were Matisse, Picasso, Braque, Gleizes, and John Marin. He could not resist the opportunity to promote

Marin, whose one-man show was currently on view at his gallery. (Marin would be represented by ten watercolors in the Armory Show.)

Henri was devastated by the attack. On February 15, two days prior to the Armory Show opening, his curiosity got the better of him. Accompanied by one of his students, he entered the armory and found the vast drill floor transformed by burlap-covered partitions into spacious galleries. Some of the paintings were still being hung and the sculptures positioned as they walked past the survey of nineteenth-century French art, past portraits by Ingres, Delacroix, Courbet, and Manet, oblivious to the din reverberating through the great hall. Proceeding along the impressionists' canvases and beyond the still lifes of Redon, Henri came to the Cézannes, then the eighteen works by van Gogh. "Who can see the Whistlers for the Cézannes, Rousseaus and van Goghs?" his pupil asked. Then, turning to his teacher, he inquired, "What do you think of van Gogh?" There was a pause. "If you don't mind, I'd rather reserve my opinion," Henri replied.[38] Further conversation seemed fruitless, and when they reached the areas designated for the fauves and cubists, not a word passed between them.

As Henri rounded the corner of a partition, there, squarely before him, were Arthur B. Davies and Walter Pach. For a brief moment they stood face to face, speechless amid the noise and activity. Finally, Henri said, "Don't you think these pictures are hung a little low?" Davies remained silent. "If they were raised ten, eight or even six inches, the visitors could see them better," Henri added. The suggestion appeared to be directed at ABD, but with a turn of his head Davies ignored it. Henri glanced down at the brilliant colors of some fauve paintings leaning against the partition, then back at Pach. "I hope that for every French picture that is sold, you sell an American one," he asserted. Pach replied to his former teacher, "That's not the proportion of merit."

For a moment Henri remained motionless with his head bowed, then as Davies and Pach began to move away he called after them, "If the Americans find that they've just been working for the French, they won't be prompted to do this again."[39] And they wouldn't.

Davies' activities had accelerated to a furious pace during the final weeks and days preceding the exhibition. He was involved in all sorts of decision-making actions: Choosing works to be illustrated

on postcards, requesting installation of a mailbox inside the armory, channeling newspaper editors' inquiries to Gregg, investigating the possibility of a large electric sign on Broadway heralding the event, arranging for groups of volunteer guides, organizing a cloakroom and attendants, coordinating uniformed patrolmen, and overseeing proper fire precautions.

Because of these and other demands placed upon him, ABD was unable to create any new paintings for the show. In a letter to an artist a month prior to the opening, he lamented:

> As you know the work of organization and of getting things done by other people is taking nearly all of my time and has done so for months. I don't know when I shall have time for my painting again.[40]

The works representing him included three oils (*Hill Wind, Seadrift,* and *Moral Law—Line of Mountains*) and three pastels (*Design, Birth of a Tragedy* and two simply titled *Drawing*).

A Line of Mountains, at 18-by-40 inches, was his largest entry. It was originally titled *Moral Law—Line of Mountains,* and it features, in a frieze-like arrangement along the bottom of the composition, a dozen figures silhouetted against a row of foothills. An example of Davies' symbolism, it includes an old man with white hair and beard, wearing a cloak, who represents Moses, the Law-Giver; and another, holding a staff, standing for Christ the Good Shepherd. Some of the figures lean forward as they search the ground, seeking morality outside of themselves. But the specter of Davies' own immorality and his breaking of the Seventh Commandment ("Thou shalt not commit adultery") appears in the darkened hills looming over the scene, for there, hidden in a series of undulating lines, one can perceive the shape of a larger-than-life reclining female nude. Although the catalogue indicated the canvas was lent by the artist, it had actually been purchased by Lizzie Bliss a month prior to the opening.

Two of ABD's other works involve implied motion through a series of related poses. By including these, he must have assumed that the perceptive viewer would comprehend the relationship between his pastel *Design, Birth of Tragedy,* his oil *Seadrift,* and

Figure 48. *Moral Law—Line of Mountains* (retitled *A Line of Mountains*), ca. 1911. Oil on canvas, 18 x 40⅛ inches. The Virginia Museum of Fine Arts, Richmond, Virginia. Photograph by Taylor and Dull courtesy of the Photographic Archives of the National Gallery of Art, Washington, D.C., from a negative made by Taylor and Dull.

Figure 49. *Design, Birth of Tragedy* (retitled *Birth of Tragedy*), ca. 1912. Pastel on gray paper, 18 x 34½ inches. Colby College Museum of Art, Gift of Mrs. Jacob M. Kaplan.

Duchamp's *Nude Descending a Staircase. Seadrift* features a row of bodies rising up out of the surf until assuming a fully upright position, as if to illustrate the evolution of the human species. In *Design, Birth of Tragedy,* a succession of overlapping male nudes represent a single Adam. Depicted without Eve, he thrusts his arm upward, stretching to pluck the forbidden fruit of Eden; the subsequent depictions show Adam bending, kneeling, and ultimately crawling from the Garden. The birth of tragedy indeed. Though the symbolism may have been lost on the viewing public, ABD's intent is now clear: The pastel's title refers to the unplanned birth of Ronnie, and the impending tragedy he associated with the event should it be discovered by his legion of loyal collectors.

Davies came to refer to his use of multiple images of the figure as "continuous composition," an idea he first encountered in Eadweard Muybridge's photographic studies of *The Human Figure in Motion.* During the next dozen years following *Design, Birth of Tragedy,* as ABD produced variations of this concept with such works as *Suppliant Maids* and *Sweet Tremulous Leaves,* he tended to avoid overlapping figures so that the negative spaces between them could take on added significance.

Davies' third oil, *Hill Wind,* depicts six male and female nudes assuming dance poses, their extended arms serving as compositional devices to visually tie the figures together while simultaneously continuing the rhythmic curves of background hills. Of ABD's other entries, one depicts a solitary, kneeling figure; another, a woman reading. The latter, retitled from *Drawing* to *Reclining Woman* (Plate 8), is a profile view of his model. Clothed only in a nightgown, she is depicted lying on a chaise longue with her legs drawn up, causing her gown to fall back to her thighs. It is a sensuous portrait of Edna, perhaps his only unposed sketch of her. Including it in the show was a thoughtful gesture, acknowledging her decade-long contribution to his life and art.

The Armory Show, officially called the *International Exhibition of Modern Art,* opened on the evening of February 17, 1913, with four thousand invited guests on hand. Uniformed attendants with the words "International Exhibition" emblazoned in gold across their caps stood outside with megaphones at the ready, summoning the limousines and horse-drawn cabs that lined the streets around

Figure 50. *Suppliant Maidens,* ca. 1919. Charcoal and chalk on gray paper, 13 x 18³/₄ inches. Collection of Sylvia Davies Diehl and Kenneth R. Diehl. Photographer: Duane Suter.

the building. A fanfare of trumpets announced the event. Once the elegantly attired first-nighters mounted the armory's exterior stairs and ambled through a forty-foot vestibule, they were confronted by ten large and colorful art nouveau–style screens decorated with Indians, animals, fish, and birds, the work of Robert Chanler.

Davies took refuge behind the screens, peering out like an actor with opening-night jitters who looks over the house from the other side of the curtain just before the show begins. One guest observed:

> Davies would never let himself be recognized at any gallery where his work was being exhibited, or on any public occasion anywhere, except by one who knew his ferocious maintenance of this self-imposed rule, and of whose confidence he could be sure.

Figure 51. *Sweet Tremulous Leaves,* 1922–23. Oil on canvas, 30³/₈ x 18¹/₄ inches. National Gallery of Art, Washington, Chester Dale Collection, 1962. © Board of Trustees, National Gallery of Art, Washington.

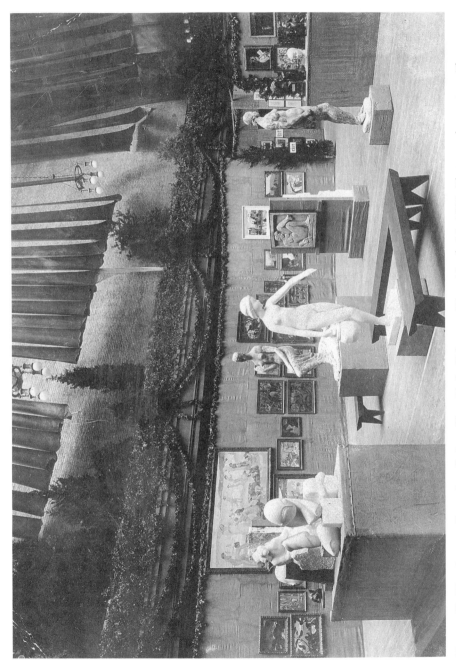

Figure 52. The Armory Show installation, New York, February 17 to March 15, 1913. Photograph courtesy The Museum of Modern Art, New York.

> I entered the Armory Show early on the [day] of its opening. I had not seen Davies for over a year, but through a peek-hole in one of the great Chanler screens near the entrance he saw me enter along with other visitors. He immediately emerged and, approaching me with swiftness and stealth, whispered in my ear, "New York will never be the same again," and with equal swiftness vanished again behind the screen.[41]

Davies' words were prophetic, for the styles of virtually all American artists, as well as the tastes and purchases by its foremost collectors, would henceforth be characterized as "before" or "after" the Armory Show.

The exhibition was packed from 2 to 10 P.M. on Sundays and from 10 to 10 during the remainder of the week as thousands came daily to muse, to marvel, and mainly to mock the modern. A band of ushers guided visitors through the galleries, where the works were arranged in chronological order beginning with the French neo-classicists, to the romantics, realists, impressionists, post-impressionists, and, finally, the fauves and cubists, thereby encouraging the public to gradually reach the most advanced European art at the end of an unbroken historical and stylistic evolution. Yet despite such attempts, the greatest crowds would constantly queue up in galleries H and I, the areas allocated to cubism and fauvism.

Laughter abounded and derisive comments were bantered about. Some referred to the work as a freak show or a circus, likening it to Barnum and Bailey's, whose animals were housed in Broadway Alley a block away. Others labeled the collective drawings and paintings by Matisse, Picasso, and Duchamp a "Chamber of Horrors." To add to the frenzy, there were those individuals who sought to race back and forth in front of Duchamp's *Nude Descending a Staircase,* having heard that by moving quickly before the abstraction, one could perceive the movement of the figure. Walter Pach, as the individual in charge of sales, conversed with many visitors, yet he recalled speaking about the controversial *Nude* "with only two individuals, Arthur B. Davies and Manierre Dawson, who appreciated the genius of the work."[42]

The New York press had a field day, offering generally negative reviews. Royal Cortissoz of the *Tribune* characterized the exhibit

as "some of the most stupidly ugly pictures in the world,"[43] while a *Times* article stated, "The Armory Show is pathological! It is hideous!"[44] The *American's* art critic, Charles H. Caffin, referred to the event as "a circus . . . muddled in the carrying out. . . . To be perfectly frank," he concluded, "there is too much suggestion that the selection mainly reflects the preferences of Arthur B. Davies."[45] A more positive assessment of ABD's role might have been written by James Gibbons Huneker had he not left his position as critic for the *Sun* the previous fall to become a foreign correspondent for the *New York Times*.

Davies sought to counter the exhibition's freak show image by reserving the morning hours for persons who wished to contemplate the works in a quiet, uncrowded atmosphere—the way he preferred to view art. He also saw to it that the association publish and offer for sale four pamphlets, one of which was a translation by Pach of Elie Faure's essay on Cézanne, containing the artist's immortal words about treating nature by means of the cylinder, the sphere, and the cone. "When I read a passage [of it] to Arthur B. Davies [in 1912]," Pach recalled, "he had me translate the whole essay for publication at the Armory Show."[46] Thus did ABD seek to explain the outlook of the father of Cubism to an uninitiated public.

Likewise available for purchase at the exhibit's bookstand was a special issue of *Arts and Decoration* devoted to the show, in which Davies set forth its purpose:

> In getting together the works of the European Moderns . . . [the Association's] sole object is to put the paintings, sculptures and so on, on exhibition so that the intelligent may judge for themselves by themselves.
>
> Of course controversies will arise, just as they have arisen under similar circumstances in France, Italy, Germany and England. But they will not be the result of any stand taken by this Association . . .[47]

The magazine also included a chronological chart made by Davies in which he sought to reveal the growth of modern art by placing all of the major nineteenth- and twentieth-century artists under the headings of classicist, realist, or romantic. Interestingly, Matisse and Picasso appeared among the classicists, the same category in which he would have placed himself.

Davies was on hand at the armory almost daily, showing dignitaries through the exhibition and meeting with artists. Though he did not intend to display a haughty air, some of the visitors mistook his noticeably erect posture for just that.

On March 4 Davies guided Theodore Roosevelt on a tour of the show. It was the day William Howard Taft left the White House and Woodrow Wilson was inaugurated president. When Roosevelt complimented Davies for one of his figure compositions, ABD explained that it was "all built up geometrically, Mr. President, just full of pentagons and triangles on the inside." "I dare say," Roosevelt replied, "and I dare say the Venus de Milo has a skeleton on the inside, and that's the right place to keep it."[48]

Three weeks later an article titled "Roosevelt on Cubism: A Layman's View of an Art Exhibition" appeared in the *Outlook,* containing his famous quote regarding Marcel Duchamp's *Nude:* "There is in my bathroom a really good Navajo rug which, on any proper interpretation of the cubist theory, is a far more satisfactory and decorative picture." He concluded by stating: "To name the pictures one would like to possess . . . I should like to mention the pictures of the president of the Association, Arthur B. Davies . . . and Robert Chanler."[49]

On another occasion ABD escorted Albert Pinkham Ryder around the armory, the sixty-six-year-old recluse appearing unkempt in a ratty Prince Albert coat, his long hair and beard in disarray, his eyes rheumy. Ryder acknowledged the art by simply nodding his head. When he and Davies arrived at the gallery containing ten of his paintings, he merely nodded some more. Virginia, Niles, and David Davies viewed the Armory Show as well, but no record exists of their reactions to it or the sense of pride they felt at ABD's achievement if, indeed, there was any.

Association members bemoaned the fact that American art at the show played second fiddle to the European imports, a response easily anticipated by Davies. William Glackens was quoted in an article in *Arts and Decoration* as admitting, "I am afraid that the American section of this exhibition will seem very tame beside the foreign section."[50] Visitors recognized it at once as a clear statement of fact.

The day after the Armory Show opened, Alfred Stieglitz wrote ABD to congratulate him on his triumph:

A vital blow has been struck. Whether Cézanne, Van Gogh or any other individual is fully represented or not makes but little difference. Whether the pictures can be represented more efficiently or not is also immaterial in view of the actually big Fact established. You have done a great work. . . .[51]

Two days later Stieglitz purchased Davies' pastel drawing of Edna from the show.

Of the 174 works sold, all but 51 were by European artists. Davies bought 8 of the foreign works himself, spending more than seven hundred dollars for paintings by Picasso and Jacques Villon, 2 lithographs by Cézanne, 1 by Gauguin, an etching by Redon, and sculptures by Raymond Duchamp-Villon and Manuel Martinez Manola. The Picasso, a 1907 gouache titled *The Trees,* represented Davies' first acquisition of a work by him. He would ultimately own over two dozen.

Davies' life-long pursuit of collecting resulted in holdings numbering nearly five hundred items, with examples by Blake, Pissarro, Degas, Seurat, Signac, Rodin, Maillol, Braque, Leger, Gris, and Derain, among others. His American purchases included works by Ryder, Homer, Kuhn, Prendergast, Luks, Bellows, Weber, Marin, Maurer, Sheeler, Joseph Stella, Patrick Henry Bruce, and Stanton MacDonald-Wright. There were also selections of Greek and Roman sculpture; Persian and Mesopotamian pottery; and Coptic, Flemish, and English tapestries. Davies developed one of the premier art collections of his day. When space in his studio became scarce for displaying and storing his own art and his acquisitions, ABD made use of the Manhattan Storage Co., finding it a more convenient repository than the farm.

The Armory Show encouraged many others to begin or expand art collections as well. Acting on Davies' advice, Lizzie Bliss purchased twenty modern European works. Among the others who also obtained art from the exhibit were Walter Arensberg, Albert Barnes, Stephen C. Clark, Clara Davidge, Katherine Dreier, Arthur Jerome Eddy, Hamilton Easter Field, Albert Gallatin, John Quinn, Edward W. Root, Mary Rumsey, and Alfred Stieglitz. And on the final day of the exhibition, the Metropolitan Museum of Art acquired its first oil by Cézanne.

Artist Leon Dabo expressed much of the prevailing sentiment about the Armory Show when he stated simply that "This man Davies has started something."[52] And Jerome Myers revealed the depth of the lesson learned by so many American artists when he noted:

> Davies had unlocked the door to foreign art and thrown away the key. Our land of opportunity was thrown wide open to foreign art, unrestricted and triumphant; more than ever before, our great country had become a colony; more than ever before we had become provincials.[53]

Davies' newly acquired role as a molder of public taste, in an arena far more influential than that of his own studio, had catapulted him into the limelight. It was he who had led the charge against America's artistic isolation, against its near-total ignorance of the European avant-garde. With a single event, Arthur B. Davies had redirected the course of American art. It was surely his finest hour.

❧ 16 ❧
Modernism and Models
(1913–1914)

\mathcal{W}hile the Armory Show was still making headlines in New York, there were fourteen other cities in the United States and Canada requesting it. Davies determined the exhibit would tour only Chicago and Boston. The director of the Art Institute of Chicago, William M. R. French, who traveled to Manhattan so he could meet with Davies and view the exhibit, wrote him:

> Of course what we especially want is the more novel part of the exhibition, chiefly the things which come from Europe.
> . . . we might limit the American exhibitors to one work apiece . . . because we are already acquainted [with some of them] . . . and there seems no good reason for going to the expense of transporting their works hither.
> If you would like to send a group of your own work, we shall welcome them, as one of our old students, and the President of the Association.

Then Mr. French added: " . . . it devolves upon you and me to select the works that shall come."[1]

It seems as though ABD's time-consuming tasks connected with the Armory Show were never ending. Letters had to be sent by him to each of the purchasers requesting that their acquisitions be

allowed to remain with the exhibit. Some artists were added, such as Manierre Dawson, who was not represented in New York but did show in his hometown of Chicago. And, of course, there were the whims of individual collectors with which Davies had to contend.

For example, Arthur Jerome Eddy, a Chicago lawyer, wrote him insisting that the American works he had purchased in New York be exhibited in Chicago, along with his other Armory Show acquisitions of foreign art,

> because taken all together they illustrate my attitude in art, which is exceedingly catholic. While if the foreign pictures alone were exhibited, it would naturally give rise to the inference that I had lost interest in the strong and virile American pictures.
>
> Mr. Pach assured me that the English translation of all the titles would appear in the Chicago catalogue. I wish he would be very particular to have all the titles of my pictures translated, even if he is not able to do the same for all others.[2]

The three American paintings were sent on to Chicago and Eddy, making additional purchases there, wound up with twenty-five works from the show.

When four railroad boxcars carrying the exhibit arrived in the Windy City in cold and inclement weather, one newspaper wag reported that the Armory Show was greeted by post-impressionist snow. But when the art was displayed at the Art Institute of Chicago beginning on March 24, 1913, the reception it received was even colder and more hostile than in Manhattan. A Methodist minister insisted that the museum be publicly censured for prostituting its walls with such lewd, vulgar, and obscene pictures. A high school art teacher suggested that school children be barred from viewing the show. And students at the Art Institute's own school conducted a mock trial of an artist they called Hennery O'Hair Mattress (Henri Matisse). The found him guilty of artistic murder, pictorial arson, and total degeneracy of color sense, then burned copies of his three large paintings titled *Luxury, Goldfish,* and *The Blue Nude* on the steps of the building. As a result of newspaper coverage of such overt hostility, attendance in Chicago soured to nearly two hundred thousand.

When the exhibit was installed in Boston's Copley Hall at the end of April, it bore little resemblance to the original show, for no American work was included and less than three hundred of the foreign examples were displayed due to lack of space. In addition, an unseasonable hot spell contributed to a disappointing attendance figure of slightly more than twelve thousand, and only five sales resulted during the three-week tenure.

After the Armory Show closed for good on May 19, Davies anticipated a return to painting and a life of relative seclusion. Despite a lack of creative output during the first half of 1913, collectors continued to seek Davies' art. The result was sales averaging three thousand dollars a month during that period. William Macbeth, ever the opportunist, had opened an exhibit of Davies drawings on March 15, the final day of the Armory Show in New York. During the next two weeks, ten were sold to Lizzie Bliss alone, including the drawing of a kneeling figure that had been on display at the armory.

For the annual Carnegie International held in Pittsburgh the following month, ABD opted to submit his five-year-old oil entitled *Sleep,* which had previously been included in the Rockwell Kent Independent. Despite its hints of Puvis de Chavannes and Ferdinand Hodler, the painting impressed the jury sufficiently for them to award it an honorable mention. Although nothing in that year's Carnegie Institute exhibit echoed the most avant-garde styles of French painting included in the Armory Show, *Sleep* was viewed with alarm by at least one Pittsburgh art critic, who cited it as the last word in Post-Impressionism.

The aura that surrounded Davies and his armory triumph continued to produce fallout. Now he was approached to help organize an exhibition of cubist works to be shown between June and August, 1913, at department stores in Cleveland, Pittsburgh, and Philadelphia. When the display reached Pittsburgh, he arranged for the ten French paintings by Léger, Metzinger, Gleizes, and Jacques Villon to be augmented by a like number of canvases by area artists. This, in turn, led the local art society to seek an exhibit of contemporary paintings by American artists who had been affiliated with the Armory Show. Davies was asked to make these selections as well, and for this exhibit, held at the Carnegie Institute, he chose examples by Kuhn, Glackens, Prendergast, Sheeler,

Stella, Schamberg, Pach, MacRae, Allen Tucker, and George Of, as well as some of his own.

When the exhibition opened on December 1, 1913, it represented the first museum show of modern American art in the country. The following February, the first anniversary of the Armory Show, these same works were displayed at the Montross Gallery in New York. That the heretofore conservative establishment would present such a collection of advanced art caused quite a stir, prompting the owner, Newton Emerson Montross, to state:

> When it is considered that men of such admitted preeminence as Arthur B. Davies and Maurice Prendergast head the list it must be clear to everybody that there can be no suggestion of a desire to startle the public for the sake of making a sensation.[3]

One of ABD's canvases in the Montross exhibit, *Peach Stream Valley,* featured figures cubistically fragmented, the shapes in shades of yellow, red, and green. Though the overall effect represented a marked departure from his lyrical landscapes and lilting ladies, the figures are still discernible because their patterned, multicolored bodies are sufficiently isolated from the background. Critic Henry McBride offered this evaluation:

> . . . If your idea is to be great you may gain a pointer from the position of Arthur B. Davies in the exhibition. The people laugh at Mr. [Joseph] Stella's "[Battle of Lights,] Coney Island" and Mr. [Morton] Schamberg's "Wrestlers" and even at Mr. [Henry Fitch] Taylor's linoleum designs, but to "Potentia" and the "Peach Stream Valley" of Mr. Davies they say "How beautiful." No matter how abstract this artist may be he holds his audience.[4]

By this time Davies had again begun painting in earnest. Prior to resuming work in oils, however, he produced a group of watercolors which can trace their lineage back to Cézanne's *Bathers.* Each of these compositions involves nude figures or bathers in a forest, bearing such titles as *Two Nudes with Tree, Three Nudes in Landscape,* and *By the River.* In the latter example, five women were

Figure 53. *By the River,* 1913. Watercolor and pencil on paper, 12 x 7 inches. Maier Museum of Art, Randolph-Macon Woman's College, Lynchburg, Virginia, Gift of Mrs. C. N. Bliss, 1949. Photographer: Dennis McWaters.

roughly sketched with a broad piece of graphite, then provided with sparse watercolor washes. A sixth bather, standing knee-deep in water to the left of the others, is boldly outlined in cobalt blue, resembling the delineation of Matisse's *Blue Nude*. Lizzie Bliss lost no tine in purchasing six of these works.

Davies' foray into cubist oils was combined with a theory of composition being advanced by Hardesty G. Maratta, a former Chicago artist who had recently moved to New York. After many years of research, Maratta believed he had rediscovered the Greek science of proportion by determining that geometric shapes could be multiplied and divided, "making a basis of absolute harmony upon which a work of art may be built."[5] He sought to prove that Leonardo, Michelangelo, Andrea Mantegna, Veronese, Tintoretto, and others worked with just such a system.

As Maratta explained it:

> I am led to believe that visual objects such as lines, surfaces, solids and colors, may be measured and proportioned scientifically, as in the musical interval, called the *octave* . . . [my discovery] will some day change the whole tenor of modern art.

The theory appealed to ABD, which Hardesty Maratta acknowledged when he added that " . . . Mr. Arthur B. Davies who, most of all our painters, is admired for the harmony and rhythm of his composition, has been most benefited by the Maratta system of proportions and of color."[6] Following Maratta's approach, Davies would place four squares in a horizontal row, subdivide each one into sixteen smaller squares, and then crisscross them with diagonals placed at the intersection of every vertical and horizontal line. Figures, or portions of them, would then be located along this linear network. The Maratta System was adopted for a time by other artists as well, including Henri and Bellows.

A Davies painting was among the first sales at the opening of the Montross Gallery show, where daily attendance surged to between five hundred and twelve hundred for its entire three-week run. From New York the exhibition was sent on to the Detroit Institute of Arts, the Cincinnati Art Museum, and the Peabody Insti-

tute in Baltimore, where the press, at least in the latter city, still appeared hesitant to accept the new. A day prior to the opening there, the *Evening Sun* announced: "A circus has come to town . . . but unless you have a taste for farce comedy and are blessed with a sense of humor, perhaps you had better avoid the gallery for the time being."[7]

Another of ABD's post–Armory show tasks involved the Carroll Gallery, which was brought into existence by John Quinn and Mrs. Charles C. Rumsey. Since both of the owners were already Davies admirers and collectors, Davies was asked to serve on the gallery's board of directors. It was ABD who arranged the exhibitions of contemporary art for the initial season (1913–14), which included a show of works by Stanton MacDonald-Wright and Morgan Russell, the American originators of Synchromism.

Weeks after the Armory Show, Davies was still involved in settling the association's affairs: Works had to be processed and shipped back to their owners, insurance claims negotiated for damage to Manet's *Bull Fight* and Duchamp-Villon's *Portrait of Baudelaire,* the lease for the rented warehouse space terminated, and replies to museum officials and artists who inquired about a follow-up exhibition sent. Albert Barnes, for instance, wrote Davies inquiring about what had become of the Vlaminck he had purchased and how soon he might expect to receive it. When one of Art Young's drawings was not returned to him, it was Davies who had to request a description of the missing work, then contact Mahonri Young on the chance that it was sent to him by mistake. And there were miscellaneous letters to be answered, such as the one from a man in Yonkers who complained that a lady's silk umbrella with a silver handle had been lost in the Armory Show checkroom. The demands on Davies' time continued unabated. In a letter written in August, 1913, he complained that "The infernal drag of the damned Association keeps on me somehow. . . . "[8]

Davies wished desperately to resume working from the model full-time. Edna, however, after having given birth to their daughter and then nursing her, no longer presented a svelt appearance. At age thirty-six her proportions were insufficiently goddess-like to suit his aesthetic taste. Enter Mary Haskell. She and her lover, the Lebanese

writer and artist Kahlil Gibran, had viewed the Armory Show when it was in Boston, then had moved from there to Manhattan. Once in New York, Mary made contact with Davies in an attempt to further Gibran's art career.

In September, Mary went to ABD's studio. "He had said in a note he would like to make a sketch from me," she wrote in her journal, "and now suddenly he asked to do it with me as a regular model. I was surprised, but it never occurred to me to suggest waiting till we were better acquainted. It seemed wholly impersonal. I said Yes."

After posing in the nude, she arranged to bring Gibran to him the following day. When she went home and told him about having modeled, Gibran was noticeably upset. As Mary recalled: "He told me frankly that Davies was thinking me either . . . a fool, or a woman seeking sex experience."[9] The two of them kept the appointment but not before Kahlil insisted that Mary write a letter to ABD stating that, because she knew him to be "an artist of the future . . . whose work is a strange and beautiful gift," this had given her "a strange and beautiful freedom from the narrowness of the world [allowing her to be] for an hour the woman of the future," and she would model no more. In Davies' studio the two men were tense. There was little conversation between them. The host spent two hours showing his pictures, and after the pair departed, Kahlil said to Mary: "I am disappointed in that [later] work. His other work that has been bought is much better. It is all too obscure, too broken up [cubist], too unclear." Davies was helpful, though, arranging for Macbeth to see Gibran's drawings and paintings with an eye toward exhibiting them. By the end of 1914 Kahlil Gibran would acknowledge ABD's help and influence by saying to Mary, "I am a pupil of Rodin, of Davies, of Millet."[10]

The newest Davies paintings which Gibran saw were inspired by a combination of Cubism and Sychromy, separate but related styles which most appealed to him in the months before the Armory Show and for a number of years thereafter. He was aware that the synchromists were all American artists, and although Morgan Russell, Patrick Henry Bruce, and Arthur Burdett Frost, Jr., had been students of Henri's, he would not hold that against them, since he recognized that they had progressed well beyond the style and taste of their teacher.

Davies' initial efforts along synchromist lines were a small, experimental painting titled *Figures Synchromy* (Plate 9), of two nudes before an orange tree, intense blue mountains, and a vigorously brushed yellow sky; and *Synchromy,* a more formalized approach to multicolored figures, with each subdivided into hard-edged shapes of primary and secondary hues against a lavender background.

Lacking a model, Davies had resumed painting by employing old compositions and pastel sketches of Edna made years before. In addition, he did not have to look far for inspiration from abstract art, for hanging on his studio wall were two of his Armory Show purchases, Picasso's cubist landscape and Jacques Villon's *Flowering Trees, Puteaux.*

Davies' first cubist-conceived canvases were among the most avant-garde of any art being produced in America at the time. However, when judged by the standards of the French innovators, they sometimes lacked structural clarity. Davies could appreciate Cubism intellectually, but producing paintings in that style, combined with the added, bright-colored palette of the synchromists, was another matter.

At one point he studied Edna by looking through a crystal prism, believing that this would provide a visual break-up of her anatomical parts. That notion may have been suggested by a cartoon in *Punch* labeled "The Cubist Photographer," which showed a many-faceted crystal sphere placed midway between a studio photographer's camera lens and the sitter; or by Davies' theosophist idol, Helena P. Blavatsky, who expressed the notion that "the prisms through which Occultism appears, to those innocent of the philosophy, are as multi-colored and varied as human fancy can make them."[11] Indeed, Davies painted a gouache titled *Prism Framing,* in which yellow lines crisscross the surface and intersect a pair of two-dimensionally conceived figures.

During 1913 and 1914 his cubist/synchromist compositions progressed from the simple to the complex, and from small, tentative sizes to large, bold formats. *Figure Composition,* for example, is a tempera containing four seated women with cubist lines superimposed over realistically drawn female torsos. *Shepherd Kings* (Plate 10), purchased by John Quinn, is a lunette-shaped pastel divided into two horizontal bands, its upper level occupied by multicolored figures of shepherds with their flocks, while below appears a gathering of women, the whole flanked by a pair of male and female torsos.

Figure 54. *Prism Framing,* 1913. Gouache on paper, 14⁵/₈ x 7⁵/₈ inches. Collection of Mr. and Mrs. Arthur G. Altschul. Photographer: Nathan Rabin.

Figure 55. *Intermezzo,* ca. 1914. Oil on canvas, 28 x 14 inches. Photograph courtesy James Graham and Sons, New York. Photographer: Geoffrey Clements.

In the oil *Intermezzo,* nine figures are arranged along a series of angular lines which crisscross bodies, legs, and outstretched arms. The resulting surface planes are enriched by a pattern of linear crosshatching scratched into the pigment. And the most ambitious painting from drawings of Edna, titled *The Great Mother,* is a $3\frac{1}{2}$-foot-high oil peopled by over two dozen female nudes. A half-length portrait of one of them, full-face and larger than the rest, is centered in the upper portion of the canvas, as if reigning over the assemblage below. Though cubist in concept, the composition is reminiscent of medieval religious paintings which depict the Virgin enthroned.

The logical culmination of his increasingly complex cubist development is *Mountaineers,* of figures visually imprisoned in an overall pattern of fragmented, colorful shapes. In earlier efforts, such as one entitled *Facades,* Davies separated a row of nudes from the background by silhouetting their light-hued bodies against darker values. But *Mountaineers* contains areas of the identical red, orange-yellow, yellow, and yellow-green on each positive and negative shape, with the result that no dominant color is established to capture the viewer's attention.

When Picasso and Braque produced their early cubist paintings beginning in 1907, they were monochromatic, involving a palette of either browns, greens, or blues. This simplified decisions concerning color, allowing near-total concentration on the break-up of shapes. But Davies' idea was to combine fragmentation with varied hues, a challenge, he would come to realize, which resulted in having to resolve too many simultaneous choices during the creative process.

The first abstract canvas ABD exhibited in New York was *Jewel Bearing Tree of Amity,* shown at Macbeth's, which included women bedecked in cubist robes, their jewels encircling a pair of tree trunks which were thereby transformed into spiraling Byzantine columns. Its inclusion in a group show of American artists evoked this unusual response from art critic Henry McBride:

> Well, well, well. It seems that Arthur B. Davies has been and gone and done it. Is everybody going to do it? We knew all along that the Armory Show wasn't the last of it,

Figure 56. *Mountaineers*, 1915. Oil on canvas, 18 x 40 inches. Photograph courtesy Peter A. Juley and Son Collection, National Museum of American Art, Smithsonian Institution.

still we never suspected that Mr. Davies was being inocu-
lated during that month last spring . . . But to have post-
impressionism, cubism, dynamism and even disintegration
suddenly appear all in one picture by Davies is surprising,
to say the least.

Yet the new picture, now to be seen in the exhibition of
American painters at Macbeth's, exhibits all of these symp-
toms and even some new ones as yet undiagnosed. It is, as
the doctors would say, a highly interesting case.

And the patient is doing well too. We hasten to reassure
you. Be not alarmed. The picture is a good one.[12]

Despite such encouragement for his abstract style, adverse
comments began to be heard from a number of friendly critics and
art collectors. In many cases, of course, these individuals still re-
jected cubism in any form and were disappointed that Davies had
abandoned his established style for the new one. Duncan Phillips,
for instance, who ultimately purchased twenty-five of ABD's works,
would refer to his abstractions as "affectations and distortions and
confusions of all kinds," adding that he "lamented his departing from
the charming Italianate romancing of his early period. . . . "[13] And Leo
Stein, Gertrude's brother, concluded:

What happened to Picasso, happened in turn to Davies . . . if
only he can forego the structural elements invented out of
hand to bridge the gap between his sensitive perception
and pictorial geometry.[14]

Writing in *Art in America,* Frederic Fairchild Sherman labeled
such Davies paintings "fruitless experiments in the intricacies of
linear design," though he did acknowledge that they possessed "a
degree of skill . . . that might . . . produce real masterpieces."[15] Guy
Pène du Bois would likewise admit to not being enamored of Davies'
cubist foray "in which the instinctive rhythm of his earlier canvases
has given place to one imposed by his will, by extraneous
intellectual . . . processes."[16] Even Marsden Hartley observed, in an
article entitled "The Poetry of Arthur B. Davies' Art" that

with the arrival of Cubism into the modern aesthetic scene,
there appeared a change in the manner of [his] creation. . . .

The art of Davies is the art of a melodious curved line. Therefore the sudden angularity is abrupt to the appreciative eye.[17]

Among the advocates of ABD's former style, only Henry McBride maintained his praiseworthy tone in seeking to convince others that Davies' current direction was equally valid:

Mr. Davies's cubistic paintings were at first so astonishing to us . . . that in our distraction we never thought to read poetry from his prismatics. The prismatic, abstract, cubistic—call them what you will—new works by this artist are however—it must be seen and admitted by everyone—to be the real Davies.[18]

Although ABD continued to create cubist paintings from old figure sketches during the fall and winter of 1913 and 1914, he did not abandon the search for a new model, so that his current compositions could be developed from the start. The void was finally filled in May, 1914, when a sixteen year old named Wreath McIntyre entered his life. She was destined to be his only female model for the next fourteen years, as well as his companion and confidante. She provided him with opinions and support for his art, and was, as well, an attractive young woman who would accompany him to exhibition openings. (The first time they walked into the Macbeth Gallery on such an occasion, William Macbeth approached Davies and remarked, "Oh, your young daughter?" "No, my young model," came the reply.[19] Wreath would not learn of Davies' second family until after his death.)

Wreath McIntyre did not initially call upon ABD uninvited—nobody ever dropped in on Davies. She was an aspiring singer at the time who had been attending dance sessions at Carnegie Hall when Walt Kuhn spotted her and asked if she would pose for *him*. "I have a class of women who come once a week and they want to draw a nice little Southern girl. Now how would you like to be dressed up in a great big hat and a pretty costume?" Wreath agreed, thinking only of the pay which would help finance more singing lessons. After the first week Kuhn told her, "You know, I have a friend named Arthur B. Davies who has been looking for someone like you all his life."[20]

Figure 57. Wreath McIntyre, ca. 1916.
Photograph. Collection of Roberta T. Mahon.

When she visited Davies' studio for the first time, her mother, a Baptist missionary, insisted on serving as chaperon, having said, "We don't know anything about this man." But when they reached the doorway to the brownstone at 337 East Fifty-seventh Street, Wreath asserted, "Mother, you can't come any further."[21] Mounting the stairs to the top floor, she knocked on the door and entered. Standing immediately inside, amid the seeming disarray of the room, stood the tall, slim, rather elegant-looking artist. She must have appeared to him as a perfectly proportioned and well-endowed Venus whose long and graceful legs were topped by a gorgeous torso and a beautifully sculptured, classical head.

Kuhn had described her as "a small girl developed beyond her years physically but a wonderful mix of woman's finesse and childish naivete."[22] Davies was also attracted by her fair skin, freckles, and green eyes which were sparkling and alive, and the long, auburn hair with glints of red and gold that appeared to glisten beneath the room's only electric light bulb.

Davies inspected the visitor from all sides, then sat her down in one of his lovely antique chairs in order to make a quick sketch of her in her black dress. But the quick sketch turned out to be four or five drawings which consumed an hour and a half. All Wreath could think about was her mother waiting downstairs. The concerned teenager finally told the artist of her embarrassment, and just prior to departing he arranged for her to pose every Monday, Wednesday, and Saturday morning from 8 A.M. to noon, the time when sunlight flooded through the room's three windows that faced east. Wreath retrieved the hat she had unceremoniously placed atop a Matisse bronze and ran downstairs to her mother.

Returning two days later for her initial session, she was shocked when he asked her to disrobe. She moved toward the door but Davies persuaded her to stay by offering a handful of colorful silk scarves as cover. "Just drape them about you and we'll go ahead with our work," he said reassuringly. One of those resulting sketches, titled *Drawing No. 6,* shows Wreath full-face, her feet together and hands upraised in a static pose. Davies used only white chalk to tone her face and figure, making it appear ghost-like against the gray of the paper. Several blue and yellow scarves hang from her shoulders and descend to her knees.

Figure 58. *Drawing No. 6,* 1914. Chalk and pastel on gray paper, 17¹/₂ x 11 inches. Carnegie Museum of Art, Pittsburgh, Museum Purchase, 1918. (18.19).

Wreath posed for the first few weeks swathed in silks, but they were gradually eliminated; Wreath was like a Salome systematically dropping her veils. "I never minded because I felt I knew him so well," she mused, "just as one would know a father."[23] Indeed, Davies would become a father figure to her, since just a few months before they met her own father had died.

The walls of the room where ABD produced his sketches of Wreath were papered in black, causing her nude figure to stand out in sharp contrast. The combination resembled a classical sculpture in bas-relief or the painted decoration on a Greek vase. As she stood, sat, or reclined, his vantage point was seldom more than five feet away, positioned on a low bamboo bench, his legs stretched out in front of him and a stack of drawing paper in his lap. Sometimes he used blue, buff, or gray paper; at other times it would be toned with persimmon juice in the manner of Japanese screen makers. And despite the prevalence of chalk dust from the pastel medium he regularly employed, Davies refused to wear a smock to protect his immaculate attire.

After Wreath left for the day, he would arrange a group of the figure drawings on the floor and use them as the basis for a painting. When she was eventually permitted to view one or more of the completed oils, she occasionally complained about her cubist likeness. "You make me look like a patched quilt,"[24] she told him.

One day Davies began rummaging through the rows of pre-Armory Show canvases stacked against the walls and selected a number of previously completed landscapes, some of which had already been exhibited. He drew one or more nude figures of Wreath in chalk atop the dry pigment, then painted them in in his earlier, more representational style. The scenes of woods, dells, and hillsides now became the backdrop for idealized women. In one work, three nudes were placed in the foreground, where they repeated the rhythm of a boulder; another canvas was altered to include a striding figure with outstretched arms, a horizontal foil against the visual, vertical pull of tree trunks. Wreath suggested a possible explanation for this procedure:

In many of these paintings, just as one dresses a stage by placing this character here and that one there, I think he

Figure 59. *Nude Holding Her Foot,* ca. 1916. Pencil and chalk on brown paper, 17⁷/₁₆ x 11¹⁵/₁₆ inches. Collection of Alan D. Davies. Photographer: Duane Suter.

placed many of the drawings he did of me in his mind, for
he knew exactly where to put this figure and that figure in
a painting.[25]

When ABD produced his pastel drawings of Wreath at their
thrice-weekly sessions, his procedure always remained the same: He
employed long, broad, free strokes, seldom raising the chalk from
the paper, then allowed each completed work to fall gently to the
floor in what became a graceful, almost ritualistic act. The artist
made little effort to speak to his model while he labored, counting
on her to entertain him by singing operatic arias and classical music
in her coloratura voice. The spell was sometimes broken by a loud
bellowing sound or whinny of an animal outside. "Do you hear
that?" Davies would ask. "That's a horse coming in."[26] Then he
would move over to the window to confirm it.

The owner of the building was a veterinarian who could be
seen leading the reluctant creature up a ramp into his animal hos-
pital on the first floor. On occasion barnyard odors filtered up to the
open window of his studio, the reality of city life in marked contrast
to the world he chose to create.

✦ 17 ✦

Murals, Sculptures, and Prints
(1914–1917)

During the week in which Wreath McIntyre began posing for Davies, and nearly one year to the day after the Armory Show closed in Boston, a general meeting was held on May 18, 1914 of the still-intact Association of American Painters and Sculptors. Some of the artists had become openly critical of Davies because no financial statement had ever been issued—the implication being that he may have mishandled association funds. Only ABD, Walt Kuhn, and treasurer Elmer MacRae were aware of the nagging details that had caused the lengthy delay. Beforehand Davies had played host to a select group of the directors in order to map out their strategy. Similarly, the Henri camp met at Bellows' studio for their planning session.

When the general meeting took place, polite conversation must have initially masked true feelings. At the appropriate moment, Henri was nominated for president. Davies, with six proxy votes in hand, was able to thwart that effort, although he chose not to run himself. Prendergast was nominated and elected the new president. (Prendergast had provided ABD with his proxy vote prior to leaving for France the previous month; imagine his surprise upon learning that he had been chosen to head the organization.) The board of directors remained the same, except for the addition of Prendergast.

257

When the treasurer's report was presented, it became painfully clear that no records had been kept of the monies spent in Europe. The final accounting appeared unsatisfactory to many of those in attendance. Now a silent drama unfolded. Guy Pène du Bois examined the incomplete financial report, then wrote his name on a piece of paper with the words "I resign." This gesture was repeated by Henri, Sloan, Luks, Bellows, Myers, Mahonri Young, Leon Dabo, and Jonas Lie, half of those present.[1] The following day ABD sent a note to MacRae, on the back of which he wrote: "I tell you sleep *was sweet* last night—the dread of possible treachery had fled . . ."[2]

Davies began consideration of a second Armory Show–type exhibit of Far Eastern art, and even spoke of traveling to India, China, and Ceylon; however, that plan was canceled because of the outbreak of World War I. The association continued in existence until at least the fall of 1915, at which time ABD received four thousand dollars from MacRae as a trust fund earmarked to settle any lawsuits for damage to artwork exhibited in the Armory Show.

During the summer of 1914 ABD embarked on a new project: the creation of a mural, for which Walt Kuhn offered the use of his studio in Fort Lee, New Jersey. Wreath McIntyre was asked if she were available for daily modeling sessions, and after agreeing to the arrangement, she and Davies began meeting each morning to travel by ferry to the Jersey side of the Hudson. The project was commissioned by Lizzie Bliss for a music room in the home she shared with her mother. The room was not a traditional first-floor salon, for Mrs. Cornelius Bliss, Sr., refused to permit modern art to hang upon her walls. When Lizzie wished to display her contemporary holdings to guests, she had William Macbeth send over his handyman, who would bring a designated example downstairs on a back elevator and place it on an easel in the parlor. He would then return the banished work to its accustomed perch on the third floor and fetch another. The Davies mural was designed to cover the walls of Lizzie's own music room in her upper-floor domain, an area which was adjacent to her bedroom and bath.

Davies and Wreath began work in Kuhn's barn at 8 A.M. each morning, he outfitted in white overalls which appeared incongruous

over a stiff white collar and neat bow tie. The barn was two stories high with a row of windows that flooded the space with light. Before Davies began blocking in the figures on the canvases, he occasionally referred to a collection of drawings of Wreath, then mounted a stepladder and commenced painting. Even after Wreath left about noon to return to New York, ABD often stayed on and worked until late in the day.

Lizzie Bliss' architect had designated nine spaces for murals, the largest of which stretched from floor to ceiling. Davies ultimately produced thirteen panels, all of which contained seated or standing figures cubistically conceived and painted in a monochromatic color scheme of tans and browns. The figures' heads were the most realistic elements, while clothing and background spaces became much more fragmented and abstract. Since the music room contained a marble fireplace and bookcases, ABD sought to consider these shapes in his designs; as an example, he painted the areas directly above the mantel with a series of swirls as a foil against the square geometry of the fireplace. On Davies' recommendation, decorative paneling and silvered woodwork around the room's windows and doors were created by Charles Prendergast, Maurice's brother (the two of them having moved from Boston to New York that fall). Charles had been a partner in a firm that produced just such interior embellishments before he branched out on his own to become a framemaker. Davies had previously purchased frames for some of his paintings from him as well, including those for *Refluent Season* and *Musidora,* feeling that the carving of such decorative elements as rosettes, S-curve chains and repeated linear shapes concentrated in the four corners of the gold frames washed with red or umber, was in keeping with the nature of his art.

When the work was completed, Miss Bliss enjoyed pointing out to friends how Davies' murals were predominantly light in value where the wall surfaces fell into shadow, and darker in areas where light illuminated the walls. She would move a precious art acquisition, perhaps one ABD had chosen for her, from place to place in the room, demonstrating that any segment of the wall proved an ideal setting. "It's a perfect background for beautiful objects," she stated with pride.[3]

Figure 60. Lizzie Bliss Music Room mural, 1914. Oil on canvas, 54¼ x 68 inches. Museum of Art, Munson-Williams-Proctor Institute, Utica, Gift of Mrs. Bliss Parkinson. Photograph courtesy Peter A. Juley and Son Collection, National Museum of American Art, Smithsonian Institution.

Critical acclaim for the murals was quickly forthcoming. Frederick James Gregg wrote in *Vanity Fair:*

> That the room made for a woman collector of New York by Arthur B. Davies will prove to be of great importance in the development of decoration on this side of the Atlantic seems obvious. It is the first indication of a change of attitude here towards what used to be, in France and Italy, one of the most important of the arts . . . Davies has taken a leading part in the recent movement here to rescue decoration from neglect, commercialism and vulgarity. . . .[4]

Frank Jewett Mather, Jr., said:

> His decorations . . . rest in part upon cubistic devices and are perhaps his most memorable single achievement. . . . The

tour de force involved in the scale of the figures—a proce-
dure which gives the little room an illusion of monumental
scale—is achieved by a novel beauty of color and of spatial
arrangement. . . . As mere pattern and color it is as quietly
ingratiating to the eye as it is in its mood captivating to the
fancy. Since Fragonard laid down his brush nothing so
entrancing has been done in domestic decorations.[5]

Walt Kuhn pointed out that the Bliss commission represented "the
first murals by any modern American."[6]

During the summer of 1914, Virginia left on her first trip
abroad, a vacation in London where she would join her sister and
nieces. Niles and David, now twenty-one and nineteen, were left in
charge of the farm, with both enrolled at Cornell for the fall. Virginia's
timing for the trip could not have been worse. When a state of war
was declared between Britain, France, and Germany in August, ABD
wrote her,

It would not be a bad idea to secure your berth [for the
return home] . . . as there may be a *later* wave of scared
Americans. There are all kinds of calamity howlers
returning . . . while the men have gone to stop the military
Frankenstein.[7]

Virginia quickly followed his advice.

Davies' attitude toward the conflict was contained in another
letter to Virginia:

. . . we all hope for a victory for France. Many of my
friends among the artists in Paris have gone to the front,
we must all say it would be better for the damned crowned
heads to crucify themselves than to bring such horrors into
the world. They are the barbarians of the modern
world . . . The damned fool Americans if they keep on with
their materialism will get left in the big issues of the
future . . .[8]

The state of world affairs prompted ABD to seek some form
of entertainment to buoy his spirits. Never before had he been one

for partying; he despised the watering holes known to be artists' hangouts and for years had avoided their nightly get-togethers. Yet Walt Kuhn, who was a member of a social organization named the Kit Kat Club, persuaded him to attend that year's masked ball. Kuhn produced a poster for the affair from a block print showing five nude female dancers in Daviesesque poses, together with six drummers and a medicine man, some of whom wore masks. Rising to the occasion, Davies created his own primitive mask, a collage of tempera-painted cardboard with the bold colors and shapes that are inherent in much modern art. The mask, made to be worn, would allow him to participate while hiding his identity.

Also that fall, Gertrude Vanderbilt Whitney converted the house adjoining her studio on Eighth Street into a gallery and began scheduling exhibits there. Davies was included in a "fifty-fifty" exhibition in December, 1914, the premise being that half of the proceeds from sales would benefit the American Ambulance Hospital in Paris, with the remainder going to the artists. Davies showed a group of drawings alongside works by Kuhn, Henri, Bellows, Robert Chanler, and others.

Simultaneously, Henri was assisting with plans for an exhibit at the forthcoming Panama-California Exposition in San Diego scheduled to open on January 1, 1915. He provided a list of names and personally invited Sloan, Glackens, Lawson, and Carl Sprinchorn. He requested that the general chairman seek Davies' participation, since Henri expected a negative response. The prediction was borne out when ABD replied with a telegram that read: "Regret I cannot go in the Robert Henri pool with you."[9]

Davies had set his sights on a competing event, the Panama-Pacific International Exposition in San Francisco which, like its San Diego counterpart, was planned to commemorate the recent opening of the Panama Canal. Due to the conservative nature of the San Francisco exhibit, however, Davies' name did not appear among the invited.

In the meantime, the completion of the Lizzie Bliss music room spurred another mural project in which Davies, Kuhn, and Prendergast participated. "None of these four murals [Prendergast produced two] had been commissioned . . . ," Kuhn pointed out, "they were done simply because Davies and myself felt the urge to

do them and hoped that their showing would perhaps stimulate more of the sort by ourselves and others."[10] While the subjects and styles varied, the canvases were each about the same size, measuring between 7 by 11 and 7 by 12½ feet.

Davies arranged for the works to be included in an exhibition at the Montross Gallery from March 23 to April 24, 1915, labeling his contribution *New Numbers, Decoration, Dances.* (It was retitled *Dances* and purchased by the Detroit Institute of Art in 1927 for "the highest price that we have ever paid for an American picture.")[11] A smaller version of the composition called *The Dancers* and later retitled *A Day of Good Fortune* (Plate 11), was bought by Lizzie Bliss. The two paintings represent his most accomplished cubist canvases.

In contrast to the subtle coloration and near-static poses of the Bliss murals, *New Numbers* is a powerful statement which confronts the viewer with dramatic gestures and intense hues. One cubist female figure rushes in from the right, arms arched above her head, a multicolored veil streaming off behind her; another, whose arms and body form a rhythmic curve, is poised as a foil against the first. A third figure, more abstract and anatomically less defined, becomes a visual vertical anchor along the left side of the composition. Gregg praised the Davies painting as "unrestrained . . . exuberant, lavish [and] imaginative,"[12] while Mather characterized it as a panel of "madly dancing figures . . . [which are] brilliant[,] . . . distinguished and interesting . . . the veil was as garish as a tartan, and as stimulating."[13]

The murals remained on display at the Montross Gallery through the next exhibit, titled *Special Exhibition of Modern Art Applied to Decoration by Leading American Artists.* That display also included examples by MacRae, Mowbray-Clarke, Taylor, Glackens, and Frank Nankivell—among the Armory Show's inner circle—plus Charles Sheeler, Morton Schamberg, Man Ray, and six others.

John Quinn purchased all four of the Davies-Kuhn-Prendergast murals and hung them in his apartment on Central Park West. The following winter he loaned them to the Post–Panama Pacific Exposition Exhibit at San Francisco's Palace of Fine Arts, held from January to May, 1916. In an article headlined "Modern Art's Revenge at San Francisco," Gregg explained how the avant-garde had been ignored at the previous year's world's fair there, and how the former

president of the San Francisco Society of Artists had sought to organize a more comprehensive and forward-looking exhibit. As a result, Davies was provided a separate gallery in which forty of his oils and drawings were displayed, the largest group by any artist. By contrast, Prendergast was represented by twenty-two works, Max Weber by fifteen, and Walt Kuhn by four. There were additional examples by Glackens, MacRae, Marin, Demuth and Edwin Dickinson, as well as works by Cézanne, Gauguin, Redon, Matisse, Picasso, Rouault, Duchamp, Dufy, and Gleizes. It resembled a mini Armory Show.

Among Davies' cubist oils were *Mountaineers, Interwoven, Facades,* and *Sacramental Tree,* the latter a painting of the mythological Princess Europa and one of her maidens caressing Jupiter in the guise of a placid bull. According to the classic tale, the princess subsequently mounted the animal, after which it dashed off with her and initiated the rape of Europa. Davies leaves little doubt that the subject is symbolic and perhaps even a personal fantasy of his, for the lovely face of Europa appears to be the likeness of a specific woman. The painting's title is calculated to direct the attention of the viewer to a tree bearing apples, red and ripe for the picking, calling to mind the one in the Garden of Eden.

Interestingly, by depicting Europa enticed but as yet unthreatened, Davies can allude to the impending rape without providing any specific visual reference to it. On the other hand, his female figures in *Dances* and *A Day of Good Fortune,* though suggesting in their nudity and rhythmic movements the sensuality of a disrobing Salome, are stripped of their ultimate sexuality by their cubist, multicolor appearance.

On the occasion of the Montross Gallery show in March, 1915, Davies had exhibited—in addition to the canvas titled *Dances*—two more paintings, a group of drawings, and several sculptures in wood and bronze. This represented his initial display of three-dimensional art. When a photograph of one of the pieces, a statuette of a nude carved in cedar, was illustrated in *Vanity Fair* the following month, the caption read: "The first sculpture by Arthur B. Davies ever to be reproduced."[14] It was a 6-inch-high work, titled *Standing Figure,* of Venus being borne on a wave, her face resembling that of a simplified Cycladic sculpture while her body, arms, and legs are

Figure 61. *Sacramental Tree,* 1915. Oil on canvas, 26 x 42 inches. The Art Institute of Chicago, Mr. and Mrs. Martin A. Ryerson Collection, 1933.1198. Photograph © 1996, The Art Institute of Chicago. All rights reserved.

faceted in the cubist manner. Davies' early bronzes were cast from such carvings, often with the grooved grain of the wood visible in the texture of the metal. Another magazine photo showed his carving of *The Dancer,* which is closely related in pose to the figures in *Dances* and *Day of Good Fortune.* It was at this exhibition that Davies first established himself as the only member of The Eight who had crossed the line by creating both abstract oils and three-dimensional art, a creditable accomplishment.

Davies occasionally developed his wood sculptures while Wreath was posing, but most of them evolved from chalk drawings of her, or from sketches of the Indian model Tahamet. The finished pieces took a variety of forms including sculpture-in-the-round and bas-reliefs of both individual figures, such as one entitled *Athlete* (Plate 12), and group compositions. These cubist carvings were a natural evolution from his whittling days of long ago. To him, experimentation in a three-dimensional medium was akin to his use of abstraction in painting, except that color was eliminated, allowing him to concentrate on the angular break up of shapes without the added complexity of considering hue, value, and intensity. From the outset, ABD thought of his sculpture as a significant component of his creative output. When he helped organize his retrospective exhibition at Macbeth's three years later, the three-dimensional cubist creations were included and the word "sculpture" was part of the title of the show.

Davies continued to create sculpture on an erratic basis over the next decade. When his interest in cubism diminished, he abandoned wood for clay, confronting the basic differences between the two approaches. A wood carver works from a solid block toward the figure, always cutting away, striving to reach the desired form without cutting too far, for once an arm or a leg is diminished in size it cannot be enlarged. In clay, on the other hand, the artist builds up, a process with the added advantage of allowing for continual modification of pose and scale.

Davies was well aware that by producing small sculptures he could cast them in solid bronze without the interior supports required of large pieces. As a result, his classical creations in clay were tiny, as in the case of an idealized head titled *Profile in Relief,* which is a mere $3^3/_4$ inches high. Others, created as bronze plaques rather

than freestanding figures and measuring up to 8 inches, include *Two Nudes; Beauty and Good Fortune; Standing Figure, Right Arm on Shoulder;* and the hauntingly lovely *Bust of Woman with Small Nude.* In the latter example, a pensive, hooded head appears with a dancing nude woman placed on the back of her hand, like a dream image of her aspiration or, as one gazes at the larger face, a possible reverie of lost youth.

Among the most classically inspired of his sculptures is *Mirror of Venus,* a 15-inch-high bronze relief in the shape of a hand-held mirror. It is embellished with five portrait heads, a torso, and two miniature full-length figures of the Roman goddess of love and beauty on its top, sides, and handle. For this work Davies found inspiration in similar women's toilet articles produced in the fourth and third centuries B.C. in Praeneste, south of Rome. The front of such antique mirrors would have been highly polished to create a reflective surface; the backs, like ABD's, were typically engraved with figures from Greek mythology, such as a maiden turning toward Hercules or the marriage of Dionysus. Incised into the rectangular area of his mirror are a nude Venus and her husband, Vulcan, the god of Mount Olympus, though the faces bear a resemblance to those of Wreath and the artist himself.

Davies' insatiable appetite for experimentation even led to his working in glass. He set up a tiny kiln in the kitchen of his studio and produced medallion-like abstractions that he cast himself. "They were small, just a few inches in size and different shapes," Wreath explained, "and he would arrange tiny pieces of colored glass and put them in the kiln. The different shades would melt into each other . . . almost as the moderns paint today."[15] On at least one occasion, he sought to produce a woman's head in the medium, but since the resultant plaque, titled *Full Head,* measures only $1^{1}/_{4}$ by $1^{1}/_{4}$ by $^{3}/_{4}$ inches, attempts at meaningful detail were only marginally successful. Davies even traveled to the Corning Glass Company in upstate New York in order to study various glassmaking techniques and historic patterns of fused glass.

Davies' diverse experiences creating sculpture, together with his organizational skills and reputation as an artist, made him the logical choice to serve as director of the Sculptors' Gallery in New York a few years later. Established in 1917, the gallery (originally

Figure 62. *Bust of Woman with Small Nude* (retitled *Head with Cape*), ca. 1915. Painted bronze, $7^3/_8$ x 4 x $2^1/_4$ inches. Hirshhorn Museum and Sculpture Garden, Smithsonian Institution, Gift of Joseph H. Hirshhorn, 1972.

Figure 63. *Mirror of Venus,* ca. 1915. Bronze, 15 x 5 x 1¼ inches. Hirshhorn Museum and Sculpture Garden, Smithsonian Institution, Gift of Joseph H. Hirshhorn, 1966.

spelled "Sculptor's") was located in Charles Cary Rumsey's studio. When Charles died in 1922, Mary Harriman Rumsey requested that ABD begin arranging the shows. Davies agreed, and may have also volunteered companionship for the forty-year-old widow whom he had known for almost a decade.

His initial exhibit in February, 1922, featured drawings by sculptor Mahonri Young; drawings by Herman Palmer, a sculptor, painter, and illustrator who had studied with Young; together with the sculpture of Amory C. Simons, a one-time student of Rodin's whose work was known to Davies from the 1915 Panama-Pacific Exposition. The themes for several succeeding loan shows included English modernists, contemporary French art, and contemporary American art.

For the French exhibit, Davies amassed 120 sculptures, water-colors, and oils, including works by Bourdelle, Brancusi, Lehmbruck, Maillol, Duchamp-Villon, Degas, Seurat, Matisse, Derain, Rousseau, and Picasso—a mini-Armory Show as the tenth anniversary of that event drew near. The art was loaned by Lizzie Bliss, Gertrude Vanderbilt Whitney, John Quinn, John Kraushaar, Mrs. Rumsey, and Davies himself. These same collectors also contributed a great many of the 200 works for the exhibition of American art. Davies' judicious touch was apparent here, too, for among the selections were Max Weber's *Four Young Women,* a nude study by Walt Kuhn, two paint-ings of women by George Luks, and ABD's long-time favorite by Rockwell Kent, *The Burial of a Young Man.*

While Davies was still exhibiting his dance murals at the Montross Gallery in April, 1915, he showed a group of drawings of dancers at Macbeth's in an exhibit that featured similar subjects by a number of sculptors. "The most successful and gratifying interpre-tation of the dance is not that of the sculptors," wrote the *New York Evening Post* critic, "but it is to be found in the color sketches of Arthur B. Davies. . . . The flashes of pure color are used with thrilling effect to intensify the rhythm. . . ."[16]

Davies continued to create cubist oils throughout 1915, and in one case combined the style with his interest in mythology and erotic thoughts to produce the unusual *Wild He-Goats Dance.* The painting had its origin with a half-dozen snapshots Davies took on a neighbor's farm in Congers. Though the scale of the nude male

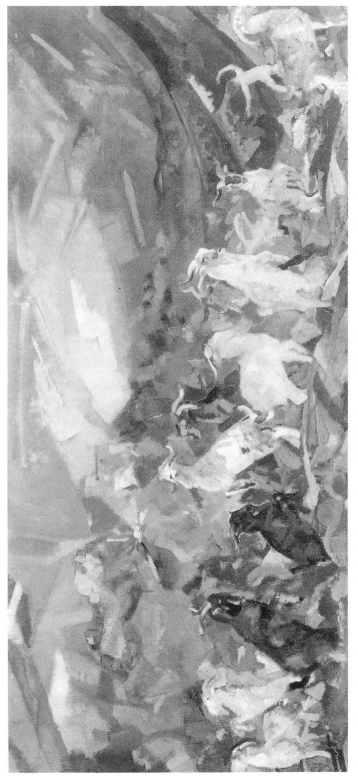

Figure 64. *Wild He-Goats Dance* (retitled *Dance of the Wild He-Goats*), 1915. Oil on canvas, 18 x 40 inches. Maier Museum of Art, Randolph-Macon Woman's College, Lynchburg, Virginia, Gift of Mrs. A. Conger Goodyear, 1952.

Figure 65. One of four studies for *Wild He-Goats Dance,* including Niles (foreground) and David Davies, ca. 1907. Collection of Mr. and Mrs. Niles Meriwether Davies, Jr. Photographer: Arthur B. Davies.

figures among the animals in the oil makes them appear quite child-like, in actuality the photographs were of the artist's twelve- and fifteen-year-old sons playing with a romping, rearing goat. Not one to create a composition solely from nature—at least not at this point in his career—ABD injected the mythology of Ancient Greece, which he knew so well from the pages of Frazer's *The Golden Bough.* Here would be Dionysus, the god of wine, of animal life and vegetation, whose father, Zeus, had saved him from the wrath of Hera by transforming him into a goat.

Yet the two dozen discernible animals in Davies' revel are not limited to multiple images of this god, for the woodland deities of Pan, the satyrs, and the fauns also possessed certain goat-like fea-tures. The sweeping, curving, abstract shapes that unite animals, a middleground hill town, and an explosive sky add to the heightened sense of movement and eroticism. As in a Wagnerian music-drama, the foreground animals move from the darkened lower righthand

corner to a rising crescendo. An orgasmic conclusion is reached on the left, where one of the goats rises up upon another in the act of copulation.

Davies had passed the age of fifty when *Wild He-Goat Dance* was painted. Still considering himself young and virile, he assumes the role of the orgiastic animal just as surely as Picasso, less than two decades later, would depict himself as a participant in the orgy of the Minotaur.

The work drew praise from Elisabeth Luther Cary of the *New York Times* when it was exhibited from March 22 to April 4, 1916, at the Macbeth Gallery:

> The beautiful forms of his [Davies'] goats and the enchanting color with the sweet caprice of the baby riders make the composition—devised with infinite science—a bit of loveliness at which none may cavil. The energy in the rhythmic caperings of the goats is like the energy of Welsh music.[17]

The uniqueness of this painting goes well beyond the subject matter, for the complex composition shows a marked change in ABD's cubist direction as well. Unlike the overall spotting of pure hues and contrasting values that resulted in a pattern of pulsating shapes in many of his earlier abstractions, this canvas displays unified areas of light and dark dominated by subdued hues. In this way the rhythm of the gyrating goats, some barely discernible, others pronounced within a cubist network, encourages the viewer's sustained interest.

At some time during 1916 Davies' cubist canvases turned away from subjects of swirling dancers and leaping goats toward more passive pastorals featuring female nudes. Among his best oils in this mode is *Tartessians* (Plate 13), where nine women are placed in relation to a series of tree trunks, reminiscent of Davies' 1905 California compositions and Cézanne's *Bathers*. The figures are arranged in groups of three with only a trace of overlapping, and their varying height provides a fascinating series of sight lines when the tops of their heads are visually connected. In addition to abandoning the dynamic for the near-static, Davies chose to fragment the figures with pale variations of hue, thereby creating more sensuous and

supple women. Since the Tartessians established one of the earliest settlements at the time of the Phoenicians, perhaps Davies' use of the title is meant to suggest that his painting contains one of the first communities of cubist women in American art.

By 1917, after a four-year love affair with a painting style based upon Cubism, Davies faced a dilemma. Though he saw it as a way of penetrating the realistic facade of nature—a major goal of his earlier style which emphasized mysticism and the symbolic—his intense desire to fuse Cubism, Futurism, and Synchromy had begun to wane.

True, the two-dimensional flattening of pictorial space inherent in such a break up of form had been a concern of his well before the Armory Show, in the days when he painted the shallow space of sylvan settings. There is no doubt that the majority of his cubist examples showed a craving for animated subjects; in this regard his art had come closer to that of Duchamp, Picabia, Delaunay, and Stanton MacDonald-Wright than to the static creations of Picasso and Braque. A letter from ABD to Elmer MacRae attests to his interest in the kinetic:

> I wish I had an article written by Herenshoff on the then new principle of the bow, sails and pressure of wind all working automatically. I recall his first boat in a race . . . I imagine beautiful girls like those yachts. It's all Futuristic in the interplay of motion and changing forms by contact or Cubistic in the static classic balance of line & plane . . .[18]

Yet Davies continued to encounter resistance to the change from his earlier, romantic style to the contemporary. William Macbeth, for one, had expressed strong reservations about some of the avant-garde paintings in the Armory Show. Although he wrote that "the freshness and freedom of the whole show were a real delight," he found "a few score of them to be utterly absurd. . . . For the future, I feel that I can be quite happy if I do not see any of them again."[19]

James Gibbons Huneker had been ABD's strongest advocate among the art critics, but his praise was directed toward Davies' earlier canvases, not his cubist creations. When Huneker's book, *The Pathos of Distance,* appeared in 1913, a thirteen-page segment titled "Arthur B. Davies: A Painter-Visionary" was sandwiched between

shorter chapters on Whistler, Matisse, and Picasso. But that was before Davies' foray into abstraction. By 1916 Huneker was writing to John Quinn, "Don't buy any more pictures. Don't buy crude American art or Cubist junk."[20]

And when Duncan Phillips acquired his first Davies painting in 1916, five years before opening the Phillips Memorial Art Gallery in Washington as the country's first public museum of modern art, the canvas he chose was not a cubist effort but one titled *Visions of Glory* from 1897. While researching a 1916 article about ABD for *Art and Archeology,* Phillips visited his studio and described in another publication that portion of the meeting in which Cubism was the topic:

> He [Davies] took my education in hand and gave me an elementary object lesson. He brought out a framed picture of a young girl playing a violin, one of the exquisite things of his early period. On the [piece of] glass he marked in chalk the contour of the masses and then removed the glass. The diagram was not unlike a Cubist masterpiece. And Mr. Davies said in all seriousness that this skeleton of form contained all the aesthetic emotion suggested by the subject, but now the rhythm was released from all extraneous interest, from all sentimental irrelevance.[21]

Despite Davies' effort, however, for the time being Duncan Phillips' opinion of Cubism remained unchanged. On one occasion Phillips characterized the style as "orgies of unrepresentative form" and "gibberish."[22] Davies lost this battle but in the end won the war, for even though the collector continued to acquire only ABD's pre-cubist works such as *Along the Erie Canal* and *The Flood,* a decade later he finally purchased his first cubist canvases by Picasso, Braque, and Marin.

ABD's creation of cubist paintings came to an end at about this time. Perhaps such negative feelings for the style in general among some influential critics and collectors, or the constant clamoring for his earlier works, finally affected him. Maybe the artist simply tired of the taxing challenge connected with creating cubist canvases, which involved so many decisions about the fragmentation of figures and the creative placement of colors. Davies' productions of paintings diminished in general during the next several years, and

the availability of only inferior oil pigments during the war could have been a factor.

Whatever the reason or reasons, even his model was baffled, for Wreath confessed:

> I do not know why Mr. Davies' interest in Cubism was short-lived. He painted quite a few things the first year I was there [1914], and I wondered why he didn't continue it because it was beautiful. He just laughed. He was ready for any kind of change.[23]

For him the change was one of medium rather than style, for in 1916 Davies initiated his first printmaking in twenty years, producing graphics in a cubist manner. The motivation was an invitation from Walt Kuhn, a member of the New York Society of Etchers, to participate in its annual exhibition at the Montross Gallery from October 31 to November 18, 1916. The society had been established the year after the Armory Show; when its first two annuals appeared undistinguished, members were encouraged to invite certain of their friends to take part.

Davies' initial print, *Mirror of Illusion,* was produced from a photograph of his 1910 painting *Maya, Mirror of Illusions.* Others, such as *Nude Seated* and *Figure Group,* were derived from drawings of Wreath. All three are drypoints. Like etchings, drypoints are sketched with a steel needle on a metal plate. The difference—and the element which gives a drypoint its uniqueness—is that its lines are drawn with a sharp, pointed instrument which deposits metal burrs along its path similar in appearance to the ridges of earth left in a plowed field. The resultant print looks characteristically subtle, suggestive of a soft, somewhat blurred vision.

Davies enjoyed the ease and spontaneity associated with the creation of drypoints, in contrast to the more laborious process of etching. There each immersion of the plate into a nitric acid solution has to be carefully monitored in order to control deeper cuts into the copper, and the richer dark tones that result.

In his drypoints, Davies could concentrate entirely on composition and technique, for in addition to their being small—they range in size from $2^{15}/_{16}$ by $3^7/_8$ to $6^3/_8$ by $8^3/_8$ inches—there were no decisions regarding the choice and placement of colors to contend

Figure 66. *Mirror of Illusion,* 1916. Drypoint, 6³/₈ x 8³/₈ inches. Joslyn Art Museum, Omaha, Nebraska.

with as in his cubist oils. He submitted seven prints to the society exhibit which were hung along with examples by Kuhn, Sloan, Marin, Pach, and others.

Simultaneous with his foray into cubist printmaking he tried his hand at interior design by planning an unorthodox color scheme for the inner walls of a new Fifth Avenue bookstore. The project had its origin following the Armory Show, during which time Davies continued to maintain contact with Mary Mowbray-Clarke. In 1914 he obtained a copy of a new book titled *Art* by the English critic Clive Bell; he shared it with Mary, praising the author's emphasis on works judged to possess significant form, emotion, and emphasis on the spiritual. Bell explains the modern movement's debt to Cézanne and the liberating and revolutionary doctrines of Post-Impressionism, concepts with which Davies already agreed. Mowbray-Clarke and a friend were so taken by the volume that they decided to open a bookshop in Manhattan with the Bell tome as one of the initial offerings. The establishment was called the Sunwise Turn, a name

selected from the pages of *The Golden Bough,* where James Frazer retells many myths associated with the sun.

When the store opened its doors in the fall of 1916 at 2 East Thirty-first Street, it was Davies who provided the interior color scheme. He determined that the walls should be dominated by a bold orange, the "selling color" as it became known, with various other hues interspersed. This was repeated on window moldings, woodwork, and even on the floor. It proved a sensation, and the so-called post-impressionist decorative scheme prompted requests for similar treatments of an apartment on Riverside Drive, a tearoom at Columbia University, and a room in a hotel.

Soon art exhibits were instituted at the Sunwise Turn. On one occasion ABD happened by when Mary Mowbray-Clarke was reviewing a group of watercolors by Charles Burchfield. Davies suggested that the young artist could obtain similar effects by working with a new oil tempera combination with which he was experimenting; Davies then took him to his studio for a demonstration. With an exhibit in the offing, Burchfield was provided with frames by ABD which were paid for by Lizzie Bliss.

During the winter of 1916–17, ABD continued to create black-and-white graphics, producing some of his most intriguing and successful images: *Arms Up, Figure in Glass,* and *Bathing Woman and Servant.* Each addition was quite limited, some to as few as ten prints, and because Davies was more fascinated with the evolving subjects than with printmaking procedures, he never bothered to number them as they were pulled from the press.

For the Corcoran Gallery of Art's *Sixth Biennial Exhibition of Contemporary American Painting* in December, 1916, Davies submitted *Return to the Sea* and *Castalias,* among the few new oils he produced in this period, and both were accepted. The latter oil, painted on burlap, was inspired by his 1910 trip to Greece. It shows four nudes grouped around the fountain of Castalia, one of the two areas of Mount Parnassus believed to have been sacred to the ancients (the oracle of Delphi was the other). According to legend, those who drank from the fountain were enabled to write poetry, and Parnassus was a favored place of Apollo, Dionysus, Pan, the Muses—and ABD.

To Davies' delight, *Castalias* was chosen for the First William A. Clark Prize and the Corcoran Gold Medal, which carried with it a

monetary gift of two thousand dollars. When ABD declined to attend a December 17 reception to receive the honor, the president of the Corcoran sought an explanation of the work. The artist replied:

Figure 67. *Arms Up,* 1916. Drypoint, $4^{13}/_{16}$ x $3^{9}/_{16}$ inches. The Museum of Modern Art, New York, Gift of Abby Aldrich Rockefeller. Photograph © 1997 The Museum of Modern Art.

Figure 68. *Bathing Woman and Servant,* 1917. Drypoint, $6^{1}/_{8}$ x $3^{1}/_{2}$ inches. National Museum of American Art, Smithsonian Institution, Washington, D.C., museum purchase. (1971.62).

Figure 69. *Castalias*, 1916. Oil on burlap mounted on canvas, 20⅛ x 42⅛ inches. Hirshhorn Museum and Sculpture Garden, Smithsonian Institution, Gift of Joseph H. Hirshhorn, 1966. Photographer: Lee Stalsworth.

> The painting is rather the experience of joy than a statement
> of fact, and if I could stimulate in the spectators the emo-
> tion of timeless delight surely it would be a mutual refresh-
> ment by a drink of the Empirean spring of enchantment, at
> the mouth of the Delphic cave, I believe it to be a worthy
> achievement.[24]

Before the Corcoran biennial closed on January 21, 1917, an
exhibit opened at Macbeth's featuring Davies among thirty artists;
then in February, two more exhibitions: the Pennsylvania Academy
annual and a group show at the Montross Gallery. The latter in-
cluded ABD, Kuhn, Pascin, Sheeler, and Weber, with Davies repre-
sented by eleven oils (of which four were sold). In April there was
another exhibit at Montross, and this time Davies borrowed three of
his works for the occasion—*Aspiration,* painted in 1895; *Mother and
Child,* 1893; and *A Lake in the Sierras,* 1905. Also shown in that
exhibition of "Modern American Masters" were paintings by Albert
Pinkham Ryder, who had died the previous month.

Though Davies was not one to attend funerals, he was present
at Ryder's, held on March 30, 1917, two days after Ryder's death at
the age of seventy. There was no pomp or ceremony; museum and
academy officials were noticeably absent. In addition to Davies, Ken-
neth Hayes Miller, and Charles De Kay were on hand, together with
a small group of other friends and disciples. Then ABD and the rest
accompanied the body to Grand Central Station, from where it was
sent on to New Bedford, Massachusetts, for burial in the family plot.

Davies fell heir to the Ryder legacy, or at least that is what
Frederick James Gregg suggested when he wrote:

> Since the death of Albert P. Ryder, Mr. Davies has been rec-
> ognized, by persons abroad who are familiar with art in America,
> as the leading living painter on this side of the Atlantic.[25]

Although Davies had shed the rich burnt umbers and siennas,
the impasto application of paint, and the sometimes haunting subject
matter associated with Ryder, there was one characteristic of the
artist that had become more Ryder-like: The unkempt nature of his
studio. One writer would describe Davies' work space as being

like a very untidy storage warehouse . . . the walls were now covered with pictures and drawings by the modern masters, and fragments of ancient sculpture, ceramics, textiles, Congo idols and Persian pots were on the windowsills, the chairs, the table and piled in out-of-the-way places. There were rare rugs on the floor six or eight deep; an antique Chinese bronze bowl served as an ash-tray. . . . [26]

According to Wreath:

Across the front of the place there were three great windows and those windows were covered in a very interesting manner. The silk drapes had once been very, very beautiful but now they hung in shreds, tied back with a piece of cord and a safety pin. The shades were never down.[27]

The two-foot-tall Matisse bronze, *La Serpentine*—the one on which Wreath had placed her hat during her initial meeting with Davies—still stood in the center of a large, round table, but now, according to her,

the table served as a catch-all. On that table was everything from tubes of paint to bottles of oil to canvas and milk bottles, for he drank a good deal of milk. He had loads of brushes, but not neatly fixed in a bottle or anything like that. They were spread all over that great big table, so that there wasn't a bit of table-top showing.

In the first part of the studio there were scatter rugs—once lovely but old Persian and two or three oriental, quite worn and frayed all around the edges. There was a long hall leading into two large bedrooms filled almost to the top with old paintings and empty frames, all piled any which way, like something forgotten. Further down was his own personal bedroom, and what a mess it was except for his bed. The room was so small it looked like a monk's cell.

Mr. Davies was so neat and dressy himself that I was surprised the way his room really looked. There was a tall, narrow antique dresser covered with hats and coats, and although he only wore bow ties, out of that dresser, with all of the drawers open to their fullest capacity, spilled a lot of ties with some reaching down to the floor.[28]

The ratty appearance of the place even extended to the bathroom, where clippings of uncomplimentary art reviews were affixed haphazardly to the wall. He told Wreath, "Whenever I read a bad notice about myself I hang it up in the bathroom. That's where it belongs."[29] Davies had a cleaning woman come in once a week, but she was advised not to move anything, and her efforts at tidying up the place were not in evidence.

A final element of visual confusion was the slips of paper, varying in size and color, which were spread about the rooms like bits of leftover confetti. Davies was an inveterate note-taker, and he made a habit of jotting down phrases from books, random thoughts, or any idea that had an immediate appeal. His paper consisted of torn corners from a writing pad, backs of envelopes—any scrap, including a druggist's prescription blank. These would be dropped on virtually any flat surface.

None of these notes were dated, so their relevance to a certain period or aspect of his art is impossible to ascertain. However, they do provide some insight into his psyche:

> A work of art contains always a suggestion of a higher or ideal existence as a child suggests a perfect woman. The Venus of Milo suggesting a higher possibility in the idea itself or the ideal that moved the artists.

> Man's soul is the organized totality of his ideas and ideals.

> The tale of cosmic elemental passion thou tellest to a kindred soul.

> Evening, thou that bringest all
> that bright morning scattered;
> thou bringest the sheep the
> goat the child back to her
> mother.

Some of the jottings were goals and words to live by. For example, accompanying a tiny caricature of an artist before a canvas labeled "Monet" is the warning: "Shackles of prior masters." Others state: "Put over your work a spell of suggestion," "Art is nature seen through the prism of an emotion," and "A triumph for the artist is to see that the observer feels a lively pleasure in the exercise of his

senses." And there was this admonition on a remnant of cardboard: "Speak clearly without perplexing preface."[30]

Davies' studio was obviously a workplace, not a showplace, and he remained as secretive as ever about its location on East Fifty-seventh Street between First and Second Avenues. Once he feared discovery of his life with Edna by Virginia's niece, Rostan, who had enrolled for a time at the New York School of Applied Design for Women. As a result, he had advised friends such as Elmer MacRae to keep mum about his address. When Walter Pach provided it to Manierre Dawson, Pach did so with the advice to "please keep it altogether for yourself as he [Davies] does not like to have it in too many people's hands."[31] And when Guy Pène du Bois sought to garner information for his art column by seeing Davies' work in progress, the invitation "was qualified with the condition that the address of his studio must afterwards be forgotten."[32]

Wreath was asked on numerous occasions for the coveted address, but always refused, explaining Davies' wish for privacy. She continued to pose for him four hours a day, three days a week, although at one point in 1916 he nearly lost her to the theater:

> For one glorious winter and the following summer I was at the Amsterdam Theatre with an English Company headed by Sir Herbert Beerbohm Tree. They produced *Henry VIII*, *The Merchant of Venice* and *The Merry Wives of Windsor*, and I was one of the eight Morris Dancers. Mr. Davies was often in the front row busily sketching. He was never without his drawing pad.[33]

She was invited to remain with the company when it left to perform in Canada, but chose to stay in New York and continue with her modeling and voice lessons.

Had Wreath gone off with the acting company, Davies would have had only himself to blame, for it was he who sometimes paid for her studies. One season he financed lessons with Yvette Guilbert, the chanteuse best known as a former model for Toulouse-Lautrec. She and her husband had escaped the war by leaving France and established a school of drama at the Majestic Hotel in New York. "There was not much dramatic work with her," Wreath confessed, "but she used to give little shows in different theaters at the time which were lots of fun. I was in all of them."[34]

Davies also provided the funds for her lessons in exercises and gestures with Paula Pogany, who had moved to the United States from Europe with her brother, Willy, who became a set designer for the Ziegfeld Follies. Of course, these activities were meant to make Wreath a better model. Singing lessons taught her how to breath, allowing the controlled expansion of her high chest; work with Paula Pogany and acting on the stage provided a basis for holding poses and the expressive use of her hands—hands playing an important role in Davies' paintings. "He would often arrange the position of my hands by saying 'They must mean something—as if you're playing a musical instrument with feeling.' "[35]

When Wreath posed, ABD was so focused on the figure that he eliminated from his drawings all nearby objects such as a chair, table, lamp, or even the shape of a picture frame. His fourteen years of sketching Wreath thousands of times was unique, for no other American artist concentrated for so long a period on a single model. "I just felt very close. I loved him very deeply . . . ,"[36] she said, referring to what she described as their Platonic relationship, though it may have actually been something more than that.

Wreath was often helpful in choosing the poses she assumed, having studied all of the positions of the ballet. In addition, ABD saved newspaper photos of dancers and purchased a book about dance containing photographs of Anna Pavlova, Loie Fuller, Ruth St. Denis, and Isadora Duncan, all of it calculated to stimulate his thinking. Isadora Duncan was a particular stimulus, not only for her type of dance but her philosophy as well. "What we are trying to accomplish," she once said,

> [is] to blend together a poem, a melody and a dance, so that you will not listen to the music, see the dance or hear the poem, but will live in the scene and the thought that all are expressing.[37]

Like Davies, Isadora had visited Greece, studied Greek art, and found the "impulsive force" that would start what she referred to as "the motor in the soul."[38] She created her own choreography to Beethoven's Seventh Symphony, the one that Wagner labeled "The

Figure 70. *Venus Attended* [Isadora Duncan Dancers], ca. 1918. Watercolor, Chinese white and pencil on tan paper, 21¼ x 16¼ inches. Collection of Arthur Bowen Davies II and Margaret Davies Marder. Photographer: Duane Suter.

Apotheosis of Dance,"[39] and danced the part of Venus in a scene from *Tannhauser*. Although Davies saw Isadora Duncan dance on a number of occasions, he attended the performances of Ruth St. Denis and her students more often, for St. Denis lived only a block away from him and they met frequently.

Wreath would be invited to accompany him to dance and operatic productions, including one by Sarah Bernhardt on her final United States tour. But experiencing Wagner was still his favorite pastime, and he "never missed a Wagnerian opera if he could help it," according to Wreath:

> He used to take me to the opera about once a month through the years. He would be deep in thought as he listened. Of course, he loved opera because he loved music. He once said, "Certain lovely phrases in a composition bring different colors before my vision." That's how intense he could be.[40]

On the other hand, Davies felt less compelled to treat Wreath to a meal, although he ate virtually all of his lunches and dinners at restaurants. He often simply caught a bite down at Grand Central Station or at one of the establishments in his neighborhood. He still avoided dining out at such artists' haunts as Mouquin's and Petipas'. (When John Quinn learned that one of his law partners was frequenting Petipas', he wrote to Ezra Pound that "A self-respecting artist like Arthur B. Davies . . . wouldn't be caught dead within gunshot of that damned place.")[41] Most of ABD's other needs were met in his immediate vicinity as well; he purchased art supplies at a store around the corner on Second Avenue and for a time had his graphics printed by a man named Clark in the apartment building right next door.

By 1917, when he reached the age of fifty-five, Davies had become vain about his appearance. He began a system of exercises under the direction of Dr. Mensindieg (a well-known female physician from Sweden), which were carried out slowly and deliberately and entirely in the nude. He swore by their beneficial powers and continued them even after the instructor died. His erect posture was still an obvious trait, and his hair remained black without a trace of gray. Vanity caused him to seek repeated assurances from Wreath: "Do I look old?" he would inquire, always expecting a resounding

"No!" in return.[42] Davies did maintain a youthful presence, causing Bryson Burroughs to observe, "Davies appeared the same as he was twenty years before. He looked no older. . . ."[43] Perhaps this explains his only admitting to the age of fifty-one to the 1920 federal census taker when, in actuality, he was fifty-eight.

Because he was such a dapper dresser, Davies looked to be anything but an artist. Marsden Hartley contended that he seemed more professorial than anything else, and he was often mistaken for a businessman. On one occasion, his son Niles recalled, they were together on a ferry boat when his father said: "See that man with a long tie getting aboard? He thinks he's an artist. I try not to dress like an artist, and to be inconspicuous."[44]

However, Davies was not without his idiosyncrasies: Walking along beside someone, he would never turn his head to either the right or left, even during a conversation. A handshake with him was an unusual experience because he cut his fingernails straight across. "That's to protect my fingers," he explained. "I don't want hangnails."[45] Davies' belief in phrenology, the study of the contours of the head as a determination of one's character and mental facilities, caused him to maintain that a bump on his skull revealed his predilection for creativity. (In reality, the area of the bump was labeled one of secretiveness. Little wonder that Davies was a believer.)

And he was still an ardent follower of Theosophy, with its emphasis on Eastern thought and philosophy. For years he had kept the picture of Madame Blavatsky in his vest pocket watch, having been told that by so doing he would never lack for money. One day he said to Wreath, "I found it worked, and now I want you to have it."[46] He fashioned a small silver medallion, a likeness of Wreath on one side and of Tahamet on the other, with the picture pressed into it, and gave it to her (Wreath is shown wearing it in his painting *Eyelids of the Sunset*). From that day on Wreath was seldom without it.

Davies' physical attraction to women was equal to the appeal of his art, and it was undoubtedly a factor in the sale of a goodly number of his works. He was soft-spoken and dignified, and wore English tweeds and kid gloves. It was said that Abby Aldrich Rockefeller had an allowance of two hundred thousand dollars a year for the acquisition of art, and that Davies' share was limited only by the number of paintings he had to sell. Guy Pène du Bois once observed:

"Perhaps it is natural that more women than men were numbered among his admirers. He had an emotional appeal. . . . "[47] Paul Rosenberg explained it in this way: "The woman who fears her own sensuality, and hates the male who appeals directly to it, finds in the art of Davies the man she wants men to be."[48]

Marion Chapman was a case in point. Her husband, stockbroker Henry T. Chapman, had amassed a collection of mostly European art but including nine oils by Davies. Some of these were sold at auction immediately after Henry's death and just prior to the Armory Show. (One newspaper headline announced: "American Artist's Picture Brings Highest Price at Chapman Sale,"[49] a reference to ABD's *Making Her Toilet* which sold for more than twice the amount paid for a Courbet or a Corot.) Mrs. Chapman continued to maintain contact with Davies over the years, sending him sonnets dedicated "To Arthur B. Davies" or "To A.B.D." and containing such sentiments as:

> Your dainty creatures, exquisite in pose,
> Unconscious of their nudity, their charm,
> Make no appeal to lustful thought as those
> Lay figures held responsible for harm
> And art's dethronement . . . [50]

One such verse was accompanied by a letter which read: " . . . yesterday was another day as many have been in cycles,-upward. Heavens' and then again Heavens'-and then and then-!!!! The only thing wanting was yourself . . . "[51] And, of course, the relationship between ABD and Lizzie Bliss was ongoing, she who acquired his *Unicorns, Do Homage,* and *Spring Ecstasy* for seven thousand dollars on July 2, 1917.

Earlier that season, Davies was invited to be among the exhibitors at the Gertrude Vanderbilt Whitney Studio, in a show titled *To Whom Should I Go for My Portrait?* Included among the other seventeen painters, sculptors, and photographers were Sargent, Henri, Luks, Stieglitz, and Steichen. Although the purpose behind the exhibition was to encourage the public to commission portraits, ABD was included through friendship and his reputation as an artist, for he had never painted a bona fide portrait and remarked on more than one occasion that he was not a portraitist.

Davies was issued an invitation to become a charter member of the Whitney Studio Club and during the summer of 1917 Mrs.

Whitney even arranged for him to have a one-man show at the Newport Art Association. Following the exhibition, *Vanity Fair* carried a page of Davies' cubist paintings and an accompanying article under the title "Ever Youthful Work of Arthur B. Davies." The unnamed author, probably Gregg, wrote:

> It is a curious fact that, while many of the new things done by men who are, openly and avowedly, under recent "influences," already look rather old-fashioned, Davies' new things are always fresh and miraculously new.[52]

While ABD's cubist canvases which had been painted a year or two earlier appeared "fresh and miraculously new" to the *Vanity Fair* critic, there were still those same influential voices calling for the abandonment of the style by him and all other American artists. Duncan Phillips launched a vociferous attack against modern art in May, 1917, at the American Federation of Arts Convention in Washington, soon after the United States had entered World War I. His comments appeared the following December and January in the *American Magazine of Art*. Phillips equated modernism's "superstitious fatalistic dogmatism and its unashamed brutality" with the forces of evil in the European conflict. He accused Gauguin of painting "deliberate savageries," Matisse of creating works that were "crude, violent and revolting"; the cubists and futurists were characterized as being "charlatans," producing "atrocities."[53]

Two months before, critic Guy Pène du Bois, who as an artist had never ventured beyond realism, wrote in *Arts and Decoration* of

> . . . a recent [Davies] work, without title, in which the instinctive rhythm of his earlier canvases has given place to one imposed by his will, by extraneous intellectual or, especially, mathematical processes. Mr. Davies has studied the European experimentors and, in the cold complications of their lessons, lost himself.[54]

Even a decade later some conservative writers and collectors were supporting the same position. Frank Jewett Mather, Jr., argued that "These experiments [by Davies] may be taken at best as a mere episode in a varied career, or at worst as an interesting aberration

of a versatile and distinguished mind."[55] Henry McBride continued to prefer ABD's 1905–06 California landscape series: "To this day [1928] I suspect them to be of Davies's best." And Albert Barnes maintained that "The idea of abstract form divorced from a clue, however vague, of its representative equivalent in the real world, is sheer nonsense." He blamed Davies for his part, for Barnes contended that he "preached the doctrine and helped to popularize it by adding angles and cubes to his regular formula for Botticelli-like nudes."

But Davies never gave up hope of broadening the taste of others. In 1922 he wrote to a friend, "Day by day they will like the modern work better and better, it is not to be depreciated by false academic standards or imitations of a photograph."[56]

❧ 18 ❧
New Challenges
(1917–1924)

*I*n the fall of 1917, Arthur and Edna's daughter Ronnie was enrolled in kindergarten at the Friends Seminary on Stuyvesant Square, and the "Owen" family moved from its flat on East Fifty-second Street to one at 155 East Twenty-first Street in order to be closer to the school. Arthur and Edna felt the Quaker institution provided an appropriately quiet atmosphere for a child during wartime, offering spiritual peace in an era of turbulence. Apparently other artists were of the same mind: Another student who had been enrolled there was George Bellows' daughter Anne; her younger sister Jean and William Glackens' daughter Lenna would attend there, too, as would Walt Kuhn's daughter, Brenda, who became a classmate of Ronnie's in the first grade. "Ronnie was frail and a rather shadowy figure," according to Brenda Kuhn, "and she had terrible earaches. I remember sitting with her on the school steps while she held her ear and moaned, waiting for her mother."[1]

Edna and Vera Kuhn often chatted under the trees in the square while their daughters played together, with Vera totally un-aware that the woman seated beside her was Davies' mistress. Davies never appeared on the scene for fear that he would be found out, for the Owens' new apartment was situated in the middle of the Gramercy Park art district. Even his move there had to have been a calculated risk, since both Henri and Bellows lived only three

Figure 71. Second Grade Class, Friends Seminary, New York City, spring, 1920. Ronnie Owen, standing seventh from right; Brenda Kuhn, standing third from right. Photograph courtesy of Friends Seminary, New York.

blocks away and either of them could have blown his cover had they met by chance.

As for the Kuhns, they resided in a two-room apartment at the time, too small for Vera and Brenda to entertain Edna and Ronnie. Of course, the Kuhns' child was never invited to the Owens' household; on the lone occasion when Edna did ask her out, it was to accompany them to a Chinese restaurant.

Within a few months the strain on Davies was lessened when he was forced to move out of his apartment. "Poor Mr. Owen is in such a dither over the fire they had in their building," one of the other mothers told Vera,[2] and so he, Edna, and Ronnie found a new flat further afield.

That same fall of 1917 Davies participated in New York's first auction of modern art, held to benefit the Penguin Club. The organization, an offshoot of the Kit Kat Club, had been brought into existence the previous year by Kuhn who, together with a group of younger artists, rented a floor in an old brownstone at 8 East Fifteenth Street. The auction was scheduled for November 10 and was publicized by the *New York Sun,* whose reporter observed that "Mr. Davies' contribution to the sale shows that his palette is as rich as ever, although the themes are more abstract than ever."[3] There were 110 drawings, paintings, sculptures, and prints available by the likes of Picasso, Vlaminck, Marie Laurencin, Schamberg, Weber, Pascin, and Kuhn. Unfortunately no record exists of the auction results.

The most significant exhibition for Davies held during the 1917–18 season was a major retrospective, his first, held at the Macbeth Gallery during January. Plans were developed for a show to occupy all four of Macbeth's rooms at 450 Fifth Avenue (for several years before the dealer had added two more galleries on the floor below, utilizing one space for his regular stable of artists, the other for temporary exhibits). The event was planned as a benefit, with the proceeds from a fifty-cent admission charge earmarked to help soldiers of the Allied forces who had been blinded in battle. An elegant, fifty-six-page hard-cover catalogue was produced for this *Loan Exhibition of Paintings, Watercolors, Drawings, Etchings and Sculpture by Arthur B. Davies,* with better than one hundred reproductions included.

The source of the works to be shown remained anonymous, and most assumed that they had been culled from among many of the artist's collectors. In fact, the entire exhibit was drawn from the holdings of Lizzie Bliss, who already possessed many of ABD's major oils, among which were *Unicorns, Sleep, Dancing Children,* and *Moral Law—Line of Mountains,* and such notable cubist compositions as *Mountaineers, The Great Mother,* and *The Dancers.* Examples were included from every period, beginning with such early canvases as *Violin Girl, At Her Toilet, The Glade,* and *The Throne,* as well as *A Lake in the Sierras* and *Before Sunrise,* both of which had been inspired by the 1905 California trip. Appropriately, Lizzie Bliss loaned her initial purchase, *After Rain.*

The gallery walls were covered with a new, rich silk fabric as if to simultaneously mark the significance of the show and to celebrate a turn in the fortunes of the war, symbolized by President Wilson's announcement of a Fourteen Point Peace Plan. Yet a pall hung over the exhibition for Davies and others, for the venerable William Macbeth had died just a short time prior to the opening.

Davies felt the loss on both a personal and professional level, since Macbeth had been his friend and confidant, his dealer and skillful promoter for nearly twenty-five years. Though other gallery owners would step forward to exhibit Davies' work, no one else was ever capable of replacing William Macbeth in his life and career.

Macbeth's son Robert assumed leadership of the gallery, taking the initiative to send letters to various museums booming the retrospective and pointing out that "The catalogue will be the finest ever brought out in New York in connection with a one-man exhibition."[4] The catalogue was secretly financed by Lizzie Bliss with all monies from its sale also going to the Lighthouse for the Blind in France.

As one of the major art events of the season, ABD's show was extensively reviewed. Henry McBride wrote enthusiastically that

> It is the best exhibition that has been seen here of the work of Davies, and in view of the modern quality of half of the work it must be regarded as one of the art sensations of the winter.[5]

Gustave Kobbe echoed these sentiments in the *Herald:* "No living artist could ask to be placed more completely or in a better setting

before the public. . . . The exhibition is an unusual, almost a singular, event in the annals of the season. . . . " Gregg was equally laudatory, pointing out that, "It is owing to Davies, more than to any other individual, that the art horizon of America has been greatly extended in the past few years." Guy Pène du Bois concluded that "in expressive power he [Davies] is probably the greatest American artist. . . . "[6]

The *Christian Science Monitor* printed two reviews:

> There is no chronological order in the arrangement of the hundred or so pictures and small sculptures which fill four salons at Macbeth's . . . it is well to know that No. 14 in the first gallery *[The Glade]* . . . was No. 1 in the catalogue of Arthur Davies' first exhibition, held in the old Macbeth Galleries [in 1896]. . . . From this already individual canvas, you may turn and glance directly through the second gallery doorway to the big mural decoration, "The Dawning," . . . the semi-abstraction, with breadth and nobility, of "The Great Mother" . . . and "Freshness of the Wounded."[7]
>
> . . . there is one work, the vast decoration called "Dawning" [measuring 9-by-9 feet] into which he has allied his new knowledge of the geometrical side of art with the old knowledge stored in his vivid, dreamy, inquiring mind. This disturbing, and compeling "Dawning" fresco, which attracts more and more each time it is seen, should be in a public museum . . . [8]

The *Tribune's* conservative critic Royal Cortissoz dwelt on Davies' early work, labeling him "a descendant of Piero di Cosimo," bound to the Italian by "the tie of the imagination." While conceding that "His [Davies'] is a fascinating art, beyond all question," Cortissoz opined that

> as the chronology of the exhibition unfolds . . . we begin to see what has gone wrong with him . . . the old naive scenes, peopled with creatures of faery, give place to . . . "arabesques of form" . . . and the painter's original charm completely disappears. . . . [9]

Writing in *Art in America,* Frederic Fairchild Sherman was similarly less than enthralled by Davies' cubist expressions, referring

to them as having "more the appearance of elaborate exercises in drawing than of anything that can be reasonably described as authentic creation. . . . hardly evidence of an impulse likely to add anything of lasting importance to the art of to-day."[10] Leo Stein, in an article in the *New Republic,* expressed similar criticism of ABD's cubist efforts, though admitting that "His graceful figures . . . have in them a quality of almost equal worth and rareness, which is the ripple of life."[11]

Davies also received letters praising the more recent creations, such as this one from John Quinn:

> I cannot refrain from congratulating you upon the success of the exhibition. It is a veritable feast of beauty. I cannot speak with too much enthusiasm of the perfect taste that characterizes the whole exhibition. . . . Personally, I much prefer the later work. But at the same time the earlier work has great beauty and charm.[12]

As the temporary music critic for the *Times,* James Gibbons Huneker had no New York paper in which to review the exhibit. So he wrote to the editor of the *Philadelphia Press:*

> I met Arthur Davies yesterday afternoon at the Renoir exhibition (Magnificent show—Durand-Ruel) and I promised to go to his studio East 57th St. and see his new work. *There's* a great story for you!—he never gives interviews, but we are fellow-Unicorns, and he is partial to me. This Spring! What? The Sunday Press?[13]

Davies' production of drawings and paintings was minimal during 1918, in part because Wreath became ill and was unable to pose. He visited her on numerous occasions at her mother's apartment near Fordham University in the Bronx, usually keeping her company as she sunned on the rooftop. By the time Wreath resumed modeling, she had gained considerable weight, as is evidenced by Davies' print titled *Pompeian Veil.* In this she appears as a fleshy standing nude beside a thinner, seated figure inspired by an earlier sketch of her.

Davies began producing a few new drypoints, choosing Frank Nankivell as his printer. The two men had known each other since they served together on the board of the Association of American Painters and Sculptors; now Davies discovered that Nankivell's studio, which housed his printing press, was located in the same building as Walt Kuhn's.

The cubist elements embodied in Davies' 1916 graphics had gradually diminished during the following year, and by 1918 they had all but disappeared. For ABD, inspiration continued to be found everywhere: In *Guiding Spirit,* for example, one of his final drypoints, a cluster of seven nudes vaguely resembles those in the Botticelli painting *Primavera,* a reproduction of which hung on the wall behind Ronnie's bed.

Toward the end of 1918 and continuing into the following year, Davies turned to creating large numbers of soft ground etchings. He was drawn to this medium that allowed his lines to appear even more casual that those in his drypoints. After covering a metal plate with a combination of beeswax and tallow, a sheet of paper is placed over this soft base (or "soft ground") and the composition is drawn upon it with a pencil. When the paper is removed the lines in the soft ground are lifted off as well, allowing the plate in those areas to be exposed when it is placed in an acid bath. The resultant print appears grainy, as if it had been drawn with a crayon or piece of chalk. To add to the effect, ABD combined his new medium with aquatint, providing textured tones to the figures and background.

Initially he limited the tonality to minor areas such as the hair of the figures in *Greek Robe* and *Sisters,* but as Davies worked and reworked the metal plates most linear qualities tended to be replaced. Flickering shading in negative spaces was added, emerging as tree trunks, branches, or simply darkened forms.

As he had done with some of his earliest prints, he now searched out elements in a number of his pre-cubist oils: A half-length nude in *Young Muse* was drawn directly from a figure in the oil *Under the Bough* from seven years before, while the five juxtaposed females in *Fountain of Youth* stem from his nine-year-old painting, *Foamless Fountain of Youth.* Some of his sketches of Wreath were recycled as well.

Davies' printer for the majority of the soft ground etching/aquatints was Ernest Haskell, a former magazine illustrator whose

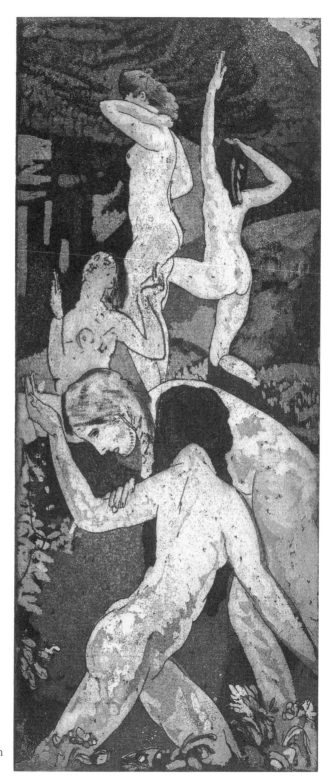

Figure 72. *Fountain of Youth,* 1919. Soft ground etching and aquatint (later state), $10^3/_{16}$ x $4^3/_{16}$ inches. Courtesy Museum of Fine Arts, Boston, Gift of William Emerson, 31.1378.

own graphics Davies had seen at the Berlin Photographic Company and the Montross Gallery.

One of Davies' compositional masterpieces in this combined medium is *Doorway to Illusion,* in which a standing nude has been placed against toned areas of black and gray. The abstract shapes on the right appear to be elements of a painting while a second figure is located on the left. The "doorway to illusion" refers to a full-length mirror that reflects the image of the other woman who stands beyond the picture plane; it is her presence that attracts the gaze of the dominant nude. After a sufficient number of prints were pulled to satisfy him, Davies apparently determined that a smaller portion of the composition was equally intriguing, so the plate was cut down on its sides and bottom and a second version was produced.

Changing media once again, Davies began producing linoleum prints and woodcuts. Davies transformed figures from some of his recently completed intaglios into relief prints. A seated nude with her legs crossed and arms fully extended from his drypoint *Triad* reappears in the woodcut *Balance,* while a kneeling woman in *Triad* shows up again in *Wood Nymphs.* The artist printed his relief prints himself, as evidenced by uneven inking and occasional fingerprints which mark the trial impressions of each one. It is apparent from the meager number of such works that he found this medium unsuitable to his temperament. Prints cut from wood blocks and linoleum are tedious to produce, with no opportunity for redoing areas once they have been gouged out of the surface.

Now the great experimentor changed gears once again and returned to the production of lithographs, a medium he had not touched for over two decades. In February, 1919, ABD received notice that a printer named Bolton Brown would be setting up a press in the gallery at Pratt Institute in conjunction with an exhibition of his own lithographs there. He announced that drawings would be made on lithographic stones by various artists, including Sloan and Bellows, and then printed by him.

The two weeks of demonstrations were free and open to the public, but it is doubtful whether Davies would have stood by gawking while John Sloan, for instance, sketched in his composition for *Tenement Roofs,* shaded it, and then had proofs pulled by Brown. Nevertheless, the activity and subsequent newspaper article about it

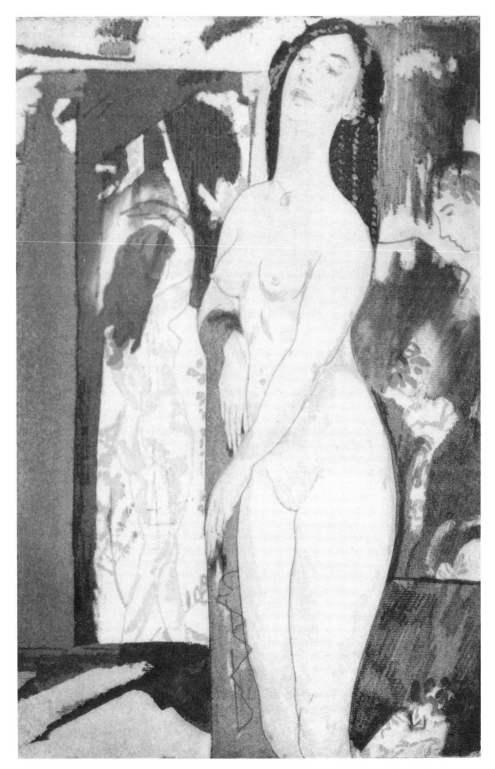

Figure 73. *Doorway to Illusion,* 1919. Soft ground etching and aquatint, 11⁷/₈ x 7⁷/₈ inches. The Saint Louis Art Museum, The Sidney S. and Sadie Cohen Print Purchase Fund.

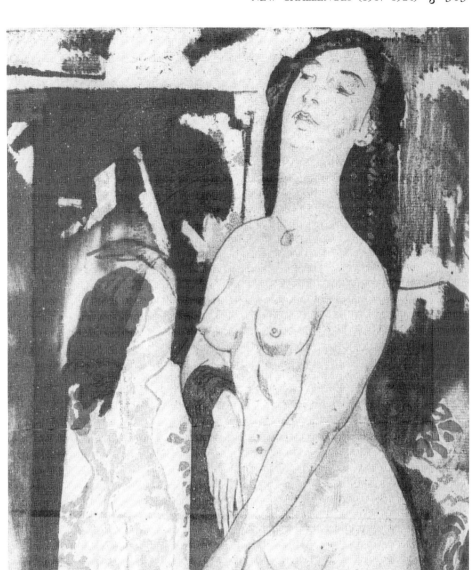

Figure 74. *Doorway to Illusion,* 1922. Soft ground etching and aquatint, 7³/₄ x 6¹/₂ inches. Los Angeles County Museum of Art, Gift of Mr. and Mrs. Dalzell Hatfield.

spurred ABD's return to planographic printmaking, and during the next eighteen months he produced fifty-eight works in the medium.

Most of the initial prints were pulled by Brown (whose credentials included studying in Britain with Whistler's printer), but many were the work of George C. Miller, a former foreman at the American Lithographic Company before he founded his own shop. When Miller's facility was subsequently threatened with closing due

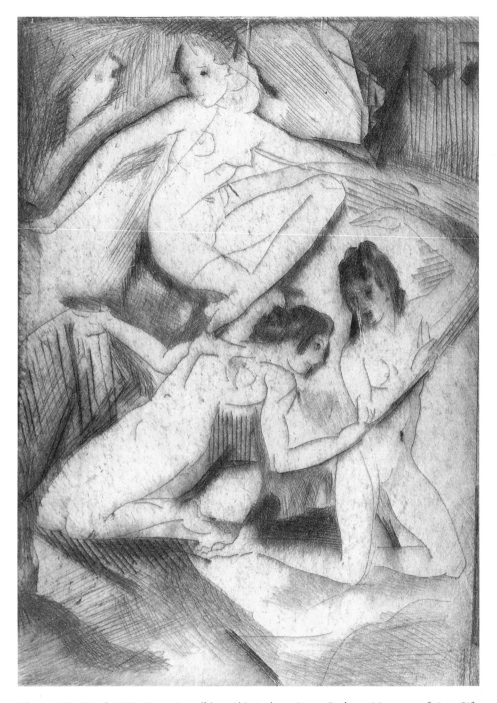

Figure 75. *Triad,* 1917. Drypoint, $4^3/_4$ x $3^1/_2$ inches. Santa Barbara Museum of Art, Gift of Miss Raphaelle Johnson.

Figure 76. *Balance,* ca. 1919. Woodcut, 5$^{1}/_{8}$ x 3$^{3}/_{4}$ inches. Santa Barbara Museum of Art, Gift of Miss Raphaelle Johnson.

to a lack of funds, it was Davies who provided him with a sizable financial advance against work to be done, forestalling his shutting down.

Each of the lithographs ABD produced early in 1919 contain female nudes, usually in simple outline with minor indications of anatomical shading. A good example is the work titled *Nature's Path,* where two figures are visually connected by quick, billowy strokes suggesting terrain and bushes. But Davies then advanced to a bolder use of the medium, in which three-dimensional form is implied by smudges of judiciously placed lithograph crayon, such as in *Flight of Line.* Now the freely drawn female forms take on the appearance of a dry-brush drawing, with long, wonderfully fluid strokes contrasting hard edges with subtle turns of the flesh.

Still experimenting, in 1920 he created fourteen half-length depictions of Wreath where all shading was eliminated. The model was first sketched on paper with long, pencil outlines, each figure contained on a page within a roughly drawn rectangle. This was then traced and transferred onto a lithographic stone or zinc plate and subsequently printed.

The first oil paintings produced by Davies following the end of World War I were not easel size, but of a much larger and novel nature. Within a month after Germany's surrender, he and more than four dozen other artists began working feverishly to produce compositions at the Penguin Club for what was slated to be the Christmas Roll Call of the American Red Cross. The participants represented a virtual Who's Who of American Art. Included besides Davies were such painters, sculptors, and illustrators as James Montgomery Flagg, Charles Dana Gibson, Maxfield Parrish, William Zorach, Randall Davey, Max Weber, Boardman Robinson, Edward Hopper, Louis Bouché, Guy Pène du Bois, and Walt Kuhn (the latter serving as director of the project). The Red Cross provided the paint plus canvases measuring up to 7 by 10 feet.

Bouché, who had worked in the camouflage department of the navy, developed a poster featuring the enormous hull of a ship in drydock; du Bois' contribution showed the flags of all nations with that of the Red Cross flying high above them. Laurence Hague, a writer for the *New York Post,* observed the artists in the act of creating:

Figure 77. *Flight of Line,* ca. 1920. Lithograph, 18 x 12³/₄ inches. The Chrysler Museum of Art, Norfolk, Virginia, Gift of Mrs. Dan Fellows Platt, 50.27.4.

> Arthur B. Davies . . . , perched on a tall ladder, a group of
> tin cups hung on the fingers of one hand, a brush and a
> rag in the other, was joyfully reminded of a time when he
> painted signs for the Bull Durham Company . . .[14]

Du Bois witnessed ABD in action as well:

> I saw Arthur B. Davies at work for the first time, painting
> one of his elongated women in heroic proportions. His own
> mincing figure looked rather ludicrous on a ladder . . . Most
> of us had with the assistance of a small drawing and a
> magic lantern traced or had our pictures traced on the large
> canvas. He was marking his down directly, considering the
> place in which it was to hang, making his proportions
> accord with it. I had expected some emotional fireworks—
> here was cold method. . . .[15]

Davies' painting, for which Wreath had initially posed in the studio, showed five women, the central figure wearing a Red Cross armband and holding a child. Together with a majority of the posters, it was hung along the balustrade in front of the New York Public Library; others were attached to building facades between Twenty-sixth and Fifty-eighth Streets or to four triumphal arches spanning Fifth Avenue which were built for the occasion.

"Mr. Davies has also done some very striking tragic masks for the arches," Gregg reported in the *Herald*,[16] referring to individual, larger-than-life-size heads with eyes expressing fear and bewilderment. Wreath, who posed for them, explained why ABD had chosen the name *Tragic Mask:*

> The word "mask" in the title meant "that which conceals
> temporarily," and since it *is* a war picture he intended it as
> the tragic mask of war, and since wars do not last it was
> a temporary condition that could be *un*masked. . . .[17]

A week prior to Christmas, the Red Cross fund-raiser was held. It consisted of twenty-five block parties spread out along Fifth Avenue, and was attended by some twenty thousand people.

Figure 78. American Red Cross Poster, 1920. Oil on canvas, approximately 10 x 7 feet. Photograph from an unnamed, undated newspaper clipping, Arthur B. Davies scrapbook. Collection of Mr. and Mrs. Niles Meriwether Davies, Jr.

Each spring, the Penguin Club held an annual exhibition to which Davies contributed, as did up to a hundred others. It was a grand combination of the American and European avant-garde, of established artists displaying alongside relative newcomers. The 1918 show included Picasso, Braque, Juan Gris, Weber, Maurer, and Arthur Dove; the following year's version had William Zorach, Gaston Lachaise, Charles Demuth, and Man Ray. In an article in the *Herald* headlined "Sculptors Have the Best of It at the Penguin Show," Gregg wrote that "Arthur B. Davies, as always, steps nobly to the front to back up the youngsters."[18] In a follow-up review, the critic commented on Davies' oil, *On Violence,*

> The wonder is that those responsible for the hanging of the show ever prevailed on M. Davies to allow his canvas to occupy the place of honor. . . . This picture has . . . force and vigor . . .[19]

Early in 1919, ABD had moved to cut his ties with the Macbeth Gallery, writing the management "again to return, *immediately,* the paintings," then adding, "You will do me the kindness to not send any of my paintings to exhibitions."[20] Apparently through an oversight, Macbeth's had failed to deliver four of his oils to the Pennsylvania Academy, as it had been doing for years, in time for the judging of the winter annual. Although Davies had been represented by four works the previous season and been included in each of the shows during the war years, his paintings were noticeably absent when the 114th annual opened in 1919.

Seeking a new dealer, he decided upon Marius de Zayas, who toward the end of the year opened a gallery just a few blocks from Macbeth's. De Zayas had served as director of Walter Arensberg's Modern Gallery before striking out on his own and prior to that had been an illustrator and cartoonist for the *New York World*. He had exhibited his abstract caricatures of Stieglitz, Francis Picabia, Ruth St. Denis, and others at the 291 Gallery.

From January 26 to February 14, 1920, an exhibit of forty-eight Davies oils, watercolors, and aquatints opened at the new gallery and evoked a flurry of reviews. The *New York Times* critic praised the watercolors and prints as "poignant . . . joyous . . . delightful," but

dismissed the oils in the gallery's outer room because "the conditions which permit them to be seen only at very short range . . . give them an aspect of grotesque enlargement. . . . "[21] According to the *Christian Science Monitor:*

> The confirmed idealist in any line, nowadays, is a rare character—a marked, an isolated man. Especially if he be an idealist in art, does he shine like a good deed in a naughty world. In the case of Arthur B. Davies there can be no mistake or ambiguity, for he is the one persistent and unequivocal idealist among our contemporary American painters. What is more, he is a recognized leader among modernists. . . . [22]

Gregg's review in the *Herald* contained more than the usual number of plaudits:

> A dozen water colors, a couple of dozen aquatints and a dozen paintings by Arthur B. Davies at the De Zayas Gallery, No. 549 Fifth Avenue, make up the most striking and significant exhibition of the work of a single contemporary seen in this city in many years . . . The "knowledge and wisdom" which are in these paintings, combined with imagination and strength, are to be found equally in the water colors and the aquatints. In the latter are . . . wonders in detail which show to what an extent the painter has obtained the mastery of what is for him a comparatively new medium.[23]

Not to be outdone, Henry McBride penned another article for the same paper:

> Three of the little water colors were, I thought, the finest water colors I had seen in years . . . they had nymphs in them intent upon some outdoor affairs . . . and all of them fresh as the morning. . . . There are sincere and enthusiastic admirers of Mr. Davies, who . . . would have liked him to remain content with what he was doing. They were disturbed when he entered upon what may be called the "modernist" phase . . . What seemed to some in the last few

years as a deliberate distortion of the surface of his figures by Mr. Davies is now explained so that even those who refused to think seriously of what he might be doing can see for themselves.

The final simplification has come. The synthesis is complete, and there they hang, one noble work after another, without the slightest sign observable as to how the miracle was brought about . . . [24]

De Zayas sent the exhibition to the Art Institute of Chicago for display during the month of March, 1920, adding a group of drawings to accommodate a larger space.

In April, the Montross Gallery brought together four of The Eight to mark the twelfth anniversary of the group's landmark exhibit. It was a nostalgic look back featuring early works by Davies, Henri, Prendergast, and Glackens. Henri included his *Dutch Fisherman* from the 1908 show, and Davies went back even further, being represented by *Along the Erie Canal* and the *Young Harpist,* both painted in the 1890s, plus *Invitation to the Voyage* and *Clust'ring Summer.* All four of them were quickly purchased, two by Duncan Phillips.

During the remainder of 1920, however, few Davies sales were consummated. Only four additional paintings found buyers and those were at Montross', so ABD began to once again seek a new gallery association. The answer appeared in the person of Erhard Weyhe who owned a print gallery on Lexington Avenue.

In 1919 Weyhe had published a portfolio of twelve American artists as printmakers, which group included Davies, Sloan, and Pach. Then, in the summer and fall of 1920, Weyhe published thirty-eight of ABD's lithographs and subsequently displayed them in a one-man show at his gallery. Davies made available a group of unsigned prints as souvenirs of the exhibit, just as he had done on the occasion of his first solo show at Macbeth's. The exhibit was followed by another at the Weyhe Gallery the very next month, heralded as the first comprehensive display of Davies' graphics and comprised of 138 examples. Reviewing it for *The Arts,* Hamilton Easter Field wrote:

Of the versatility of Arthur B. Davies the exhibition at the Weyhe Gallery gives new evidence. He has a feeling for the

beauty of black close in many respects to that of the great Chinese masters. The spotting of the lithographs he is exhibiting is at first sight as beautiful as it is in the work of the great Japanese of the Sixteenth Century. . . . [25]

By now ABD had become intrigued by the effects achieved by printing on colored paper. *Snow Crystals,* for example, first appeared in black ink on a white sheet, then black on tan, and finally black on blue. Davies' concentration on graphics resulted in the virtual cessation of his production of paintings. In February, 1921, the director of the Ferargil Galleries—where the oils of ABD and Albert Pinkham Ryder had just been shown—wrote to Duncan Phillips that

> Mr. Davies is doing but little work (and his things can be obtained now far below what they should bring, and will bring). I have been in his studio recently, and there is, indeed, hardly anything there.[26]

Phillips had already purchased Davies' *Springtime of Delight* through Ferargil's and by mid-year ABD signed on with the gallery to handle his paintings, a union destined to last for the rest of Davies' life. One of the artist's first and most embarrassing tasks was to request of Ferargil payment for a work recently sold:

> I need the money now—my share—and you will do me the kindness to send me your check for the amount. I am sorry the goose uses so much feed to produce the eggs. Even so the eggs are good, and worth "setting."[27]

The Ferargil firm had been established in 1915, originally to produce decorative fireplace screens, ornamental gates, and lanterns at a forge in Hoboken, New Jersey; when it moved to a single-room gallery in Manhattan, paintings, sculpture, and ceramics were added. Frederic Newlin Price, the gallery director, quickly became a Davies admirer and a strong advocate of his work. He commenced sending his oils and watercolors to all of the annual shows, so that during 1921 and 1922 they were exhibited in Washington, Philadelphia,

Pittsburgh, Cincinnati, Chicago, Dallas, and other cities. And within two years, Davies' annual sales through Ferargil climbed to over twenty-five thousand dollars.

Davies was still considered one of America's avant-garde painters, even though his cubist canvases were a thing of the past. As a result, when he was included in a 1921 exhibit such as the Pennsylvania Academy's Exhibition of Paintings and Drawings Showing the Later Tendencies in Art, Davies found it necessary to submit *Facades, On Violence,* and *Three Masks,* all created several years earlier.

In the meantime, the artist's reputation was being strengthened overseas. Thanks to Gertrude Vanderbilt Whitney, he was included in the Venice International in 1920, which she personally financed; his work was also displayed in Paris and London when the exhibit continued on to those cities the following year. In May, 1922, eleven of ABD's lithographs were acquired by London's Victoria and Albert Museum through the efforts of the Weyhe Gallery.

The year 1922 was one of diverse activity for Davies. In March he arranged the initial show at the Sculptors' Gallery, a loan exhibition with works from his own collection and those of Mrs. Charles Rumsey, Mrs. Whitney, Lizzie Bliss, John Quinn, Marius de Zayas, and Walter Arensberg. This exhibit, comprised of the British moderns, was followed by one featuring Brancusi, Duchamp-Villon, and other advanced French sculptors.

Later that year Davies began providing art lessons to John B. Flannagan, who might rightly be called his only student. Flannagan was discovered near starvation in Washington Square. Davies brought him to Congers where he worked on the farm during 1922 and 1923 in exchange for room and board. He began teaching Flannagan on his regular weekend visits, first encaustic painting, then sculpture involving direct carving in wood. The mentor provided critiques and arranged for Flannagan's initial exhibit, a 1923 group show at the Montross Gallery which also included ABD, Kuhn, Prendergast, Glackens, and Sheeler.

Davies devoted considerable time during 1922 to working with Dr. Gustavus A. Eisen, the archeologist credited with identifying what was thought to be the Holy Grail. This chalice had been discovered by Arab workmen in the ruins of Antioch in 1910 and

was purchased by two brothers who sent it to Paris to be restored. With the outbreak of World War I it was taken to New York for safekeeping, where Dr. Eisen began a nine-year study to determine whether the cup was, in fact, the one from which Jesus and His disciples drank at the Last Supper.

Eisen acknowledged ABD's help with his research, stating that "Davies stood by admiring, criticising, advising, as the work of unravelling the mystery progressed."[28] One can well imagine Davies' excitement at being a part of the study, of viewing and handling the goblet about which he had read in Alfred Lord Tennyson's *Idylls of the King* and had heard reference to in Wagner's *Parsifal.*

In the preface to Dr. Eisen's two-volume work, *The Chalice of Antioch: On Which Are Depicted in Sculpture the Earliest Known Portraits of Christ, Apostles and Evangelists,* published in 1923, the archeologist wrote that

> the earliest part of the investigations was benefitted by the interest taken by Mr. Arthur B. Davies, the well-known artist, who carefully followed the chalice work and assisted by providing volume upon volume of books upon art and archaeology from his extensive library. . . . [His] assistance and interest in the chalice investigations have been a real work of love which ought never be forgotten . . . [29]

Some years later, however, Edna revealed what she contended was her role regarding the Antioch Chalice. In a letter to David Davies following ABD's death, she urged that he

> . . . not forget that the exploitation and the consequent price of a million dollars for the "Antioch Chalice" was only made possible through your father's dissemination of my discovery . . . your father submitted the manuscripts, written on the subject by Dr. Eisen, to me for correction . . . [30]

Eisen ultimately concluded that the representations of Christ, the Apostles, four evangelists, and six saints depicted on the elaborate silver cup holder were actual portraits created prior to the year 100 A.D.

Simultaneous with this study was one dealing with the so-called theory of inhalation as initially advanced by Davies, a discovery which he felt explained the supremacy of Ancient Greek art. According to ABD's concept, the excellence of Greek art was based upon the fact that the thorax, rather than the brain, is the center of emotions, and that figures depicted in Greek painting and sculpture were consciously shown at the height of inhaling a breath, rather than when exhaling and relaxed.

Dr. Eisen adopted the idea in his book on the Antioch Chalice, titling chapter 12 "The Lift of Inhalation and the Emotional Centers of the Thorax" and referred to "This heretofore undefined principle of the Greek art [which] constitutes its greatest glory and distinguishes it from the Roman art. . . . "[31] Although the term "Lift of Inhalation" was Eisen's, he pointed out that it was "Davies [who] came to me with the news that the Greek art contained something no one had every seen nor suspected. He showed me the visible effects and asked me to find the cause." The cause, according to the archeologist, "was the . . . intake of air in the human body . . . the designing of the living on the wave crest of the intake of breath, instead of in the vale of exhaust as in most art in our times.[32]

Whether the inhalation theory was discovered by Davies or by Wreath or Edna will probably never be known. Ronnie maintained that her father stole the idea from her mother, for Edna had produced a pamphlet entitled *Dancing* in 1922, under the pseudonym of Helena Garretson, which was supposed to have set forth the analysis. A copy of *Dancing* is recorded as having been placed in the Library of Congress, yet recent efforts to locate it have proven unsuccessful.

Wreath speculated that Edna's role, if any, was merely codifying Davies' thoughts on the subject. Besides, Wreath asserted, having trained as a singer, she illustrated the inhalation theory every time she posed, so if anyone had provided ABD with the idea, it was she.

Of special interest to ABD was Dr. Eisen's conclusion that

> A proper understanding of the lift of Inhalation and of the action of the emotional centers will enable modern artists to apply the essence of the classic art to their own work without fear of slavishly copying that art. . . .[33]

As a result, according to Eisen, Davies "actually set to work and retouched hundreds of his old paintings with comparatively few strokes of his brush, thereby magically as it were infusing new life and new beauty rivalling the best in classic art."[34]

The publicity surrounding Davies' role in the inhalation theory and its relationship to Greek art made it clear that his present concerns were now more in line with those in his former paintings, centering upon classical and romantic themes. No one expressed greater satisfaction at this than Duncan Phillips, who determined by the end of 1922 to publish a monograph about Davies. He wrote of his intentions to Frank Jewett Mather, Jr., one of several authors he hoped would write an essay for the volume:

> My wife and I had a number of fascinating visits at Davies' studio and we were delighted to find that the work he did last summer is not only entirely normal, free from affectations and distortions and confusions of all kinds, but gives promise that at last his genius has been brought to the point where it will bear rich fruitage. I have always lamented his departing from the charming Italianate romancing of his early period . . . But now he has turned back to Greece. . . . On the strength of this encouragement to believe in Davies again, I have decided to make him the subject of our third monograph, for I believe that the variety and charm of his many inventions would make a quite captivating picture book, and that unraveling the tangled skein of his mental processes will give a picture of his pure artist's nature which would be a fascinating subject for our critical effort—yours and mine.[35]

The monograph was published in 1924 and included an essay by Mather. Phillips also approved of the fact that during one of those visits Davies admitted to being a disciple of El Greco, and that "he has an enlarged photograph of a Greco painting at the foot of his bed where he can see and study it the last thing at night and the first thing in the morning."[36]

It was likewise not lost upon Duncan Phillips that he had met his future wife Marjorie at the Century Club in January, 1921, in front of a painting by ABD, when a portion of the Phillips Collection was on view there. As she recalled:

> I remember standing beside a rather plump member [of the club] looking at an Arthur B. Davies and on asking some question about it the collector himself appeared, doing the honors—a man with a gracious, strong, and magnetic personality. . . . I loved the expression he used—looking at the Davies "Springtime of Delight" and the "Along the Erie Canal": "Beauty touched with strangeness."[37]

Duncan Phillips and Marjorie Acker were married the following October.

By the spring of 1923 ABD had still not resumed working in oils full-time, for as he wrote to a friend, "I keep busy with my drawings to sustain the uplift until I get in a painting mood again."[38] Despite this, he had been engaged in one of his busiest exhibition seasons. During the month of December, 1922, his art was featured in three simultaneous one-man shows: Paintings at the Ferargil Galleries, which now occupied larger quarters at 607 Fifth Avenue; prints and watercolors at the E. Weyhe Gallery on Lexington Avenue; and an exhibit of twenty-one oils at the Fine Arts Academy in Buffalo. The following April and May, the Montross Gallery presented a solo exhibit of his paintings, after which *Art News* reported that fifteen had been sold.

Art dealer Charles Daniel, whose own gallery was just two blocks from Montross, wrote to collector Ferdinand Howald in Columbus, Ohio, in June, 1923:

> We have had terrific heat here. . . . Naturally the weather killed the dying Art Season for the time being, although I am doing what I can to resuscitate it.
>
> Davies had an Exhibition of very charming Pictures at Montross' in May, which was a big Financial Success. Fifteen Pictures sold. A few Drawings at 600.00 up to Paintings at 4500.00. He is probably the most successful artist today . . .[39]

As for the buyers, Duncan Phillips purchased *Tissue Parnassian* and *Dewdrops,* Lizzie Bliss bought *From the Heights,* and Stephen C. Clark acquired *Eurydice—A Rendezvous with Death,* while the Cincinnati

Figure 79. *Afterthoughts of Earth*, ca. 1921. Oil on canvas, 26 x 42 inches. Collection of Jane F. Clark. Photograph courtesy Peter A. Juley and Son Collection, National Museum of American Art, Smithsonian Institution.

Museum added *Green Pavilions* to its collection and the St. Paul Art Institute, *Hudson Valley.*

Partial credit for ABD's triumph can be attributed to the announcement, made just prior to the exhibit opening, that one of his paintings had been awarded the gold medal and fifteen-hundred-dollar prize at the Carnegie Institute's twenty-second International. The oil, *Afterthoughts of Earth,* is comprised of six foreground figures and several well in the distance, some nude, others wearing the brightly colored chiton or peplos of Ancient Greece, with each silhouetted against a dark, largely barren landscape.

Writing about the award in the pages of *International Studio,* Guy Pène du Bois lauded Davies as

> one of the American painters about whom the word "important" can not be written in too large letters. He has distinctly expressed the sentimental or spiritual side of American character . . . [40]

And Alan Burroughs, thinking of the legacy of horror and destruction resulting from World War I, as embodied in German expressionism and other European modernism, pointed out that "The World will have to turn farther toward the balanced ideal which Davies holds before his vision is widely appreciated. People will tire of turbulence. Then they will turn to the classical hope again. . . . "[41]

Years later, Frederic Newlin Price told a story about *Afterthoughts of Earth* which ABD would have never revealed:

> The landscape of Nevada mountains and plain belonged to me. Davies asked for it and painted thereon several figures in red and blue and gold. When it was offered at $3,500 to a famous collector he refused it. Shortly afterward Homer Saint-Gaudens [director of the Carnegie Institute] selected it for the Carnegie International. It was sold the first day [to Scott and Fowles, a Fifth Avenue art gallery] at the new price, and won the first prize of $1,500, to be bought from Scott and Fowles months later by the famous collector for $8,000. He needed authority, affirmation.[42]

The purchaser was Stephen C. Clark.

In du Bois' article about Davies' Carnegie prize, the critic made reference to the fact that "No man has been more consistently aloof from public acclaim. . . . "[43] If anything, ABD, soon to celebrate his sixty-first birthday, had become more distant than ever. He was resolute that no one who had not already been taken into his confidence about his decades-old liaison with Edna, or knew of Ronnie (who had recently celebrated her eleventh birthday), should learn of them. He shunned any attempt to place him in the limelight, declined to attend receptions in his honor, and still refused to serve on art juries or to be interviewed by the press.

It is not surprising, then, that when ABD suffered an angina attack in June of 1923, it was kept a well-guarded secret. Strickened while alone in his studio, he lay there for two hours unable to reach the telephone. (With the retelling among his small circle of close friends, he was said to have been unconscious for a full day.) As far as Virginia and Edna knew, this was his first experience with acute chest pains. Yet Wreath had witnessed just such an attack three years earlier. On that occasion it occurred while she was posing; he rolled onto the floor from his low bamboo stool and asked for bottle number 66 from the large collection of Humphrey homeopathic remedies located nearby. The bottle contained digitalis, widely used at the time as a powerful cardiac stimulant. Wreath was startled when, upon handing it to him, she noticed the words "For the heart." He recovered within minutes. Shortly prior to that attack ABD had said to her, "You know, I went to the doctor today and he told me to be a little careful of my heart, and not to think so much, to settle down a little bit."[44] Wreath attributed the condition to his own overly strenuous practice of inhalation, concluding that such continuous deep breathing had permanently strained his heart.

With the doctor prescribing rest and relaxation, Davies left for Europe at the end of July. His itinerary called for a three-month stay in Paris, Southern France, and Sicily. It was his first visit overseas since the hurried trip to Paris and London in 1912 to aid in selecting the Armory Show. Unwilling to tote an easel, canvases and a paint box, Davies limited himself to producing watercolors. He drew on-the-spot sketches of ever-changing skies as seen from Paris' bridges and parks; as he traveled south, he engaged in more ambitious compositions such as one of the medieval walled city of Carcassonne.

As was his custom, he carried a half-dozen pencils in the top pocket of his vest, sharpening them by hand with the skill of a long-time whittler. He drew his subject on white or gray paper, then applied generally pale tones of watercolor.

Davies allowed for a carefully screened trickle of visitors while in Europe, one of whom was John Quinn. Quinn afterward wrote him the following note:

> I am leaving for Italy tomorrow . . . I shall be back in Paris next Thursday morning, [October] 11th . . . I have seen Braque since I have been here, at his studio, and Picasso . . . also Brancusi . . . You would like Braque very much . . . [45]

Despite Quinn's suggestion regarding Braque, Davies maintained his long-standing practice of avoiding such visits to the studios of the famous, shunning the notion of greatness by association.

Upon returning to Manhattan on November 1, 1923, ABD, apparently pleased with his change of media and subject matter, arranged for an exhibition of his new watercolors at the Weyhe Gallery beginning just prior to Christmas. A review in the *New York World* lauded both the artist and his art:

> . . . One of the secrets of Davies's powerful position in the art world is that he never has been known to grow perfunctory . . . has not spent all these years of passionate devotion to work without gaining an equipment which enables him to do anything he chooses and to do it, not with the effect of experiment, but with authority. . . . Mr. Davies uses water color like no one else—as he does everything. In a number of the present group he has used body color on an absorbent gray paper which gives a peculiar texture not unlike pastel.[46]

Another article pointed out that the watercolors

> . . . mark Mr. Davies' return to an earlier interest, landscape. It has been at least ten years since he has essayed pure landscape and the results shown here are in his happiest

vein: lovely, sensitive renderings of mountain, sky and water. There is one mountain subject which for the purity of its wash and its assurance and simplicity of brush stroke bears more than a casual resemblance to the Chinese.[47]

The success of the exhibit was immediate, as announced in the headline of Henry McBride's write-up in the *Herald:* "14 of His Water Colors Bought in First 24 Hours of Display."[48]

On the same day as McBride's review, another notice appeared in the same paper concerning an exhibition by Picasso's long-time friend, Max Jacob, who had turned from poetry to painting. Davies had already viewed the show at Brummer's, just around the corner from Weyhe's, and purchased two watercolors, one a view of Paris from the Seine, the other of the Pont Neuf with Notre Dame in the background. The subjects struck a responsive chord, for they were identical to the spots where Davies had painted just months before.

Davies' show became a complete sellout before it closed in January, 1924. Good for Davies, this was also good for Alfred Maurer, who, after "languishing in obscurity for over ten years,"[49] had the entire contents of his studio purchased by art dealer Erhard Weyhe, who used his commissions from the Davies sales to finance the large acquisition. It was variously estimated that between 255 and 400 works by Maurer were involved. Davies, who had provided Maurer with a big, brotherly boost when he bought one of his oils from Stieglitz in 1909, must have felt a sense of satisfaction that he was once again aiding the younger artist, even though indirectly.

Davies' exhibition also served as his inaugural show at Weyhe's new location, the gallery having moved further north on Lexington Avenue to number 794, between Sixtieth and Sixty-first Streets. The new structure's facade was eye-catching with ironwork and the outdoor sign created by Rockwell Kent (the artist having probably been suggested to Weyhe by Davies). Now Mr. Weyhe and his assistant, Carl Zigrosser, established the art gallery on the second floor with a bookshop occupying the street level. Davies became a regular purchaser at both. He bought books on Greek and Roman sculpture, Buddhist art, Peruvian ceramics, Greek vases, embroidery, and tapestry weaving, and monographs on such artists as Raphael and

Ingres. Many of the volumes had texts in French or German; Davies
must have either enjoyed them solely for their illustrations or have
Edna or others do the translating. His art acquisitions included a
bronze and three lithographs by Maillol, and from time to time
Davies sold some of his own collection through the gallery; these
included a Picasso drawing of a standing nude, a Vlaminck woodcut
and Redon's etching/drypoint *Cain and Abel*.

The early months of 1924 brought with them a rapid succes-
sion of exhibits: Hard on the heels of his show at Weyhe's, one of
his paintings was shipped to Italy in January for inclusion in the first
American exhibition at the Venice Biennale. Several weeks later *An
Exhibition of Paintings, Drawings and Watercolors by Arthur B. Davies*
opened at the Carnegie Institute. In an introduction to the catalogue,
Virgil Barker referred to ABD as

> one of the most personal artists, certainly the most inventive
> poet in paint, this country has yet produced.... [His art]
> constitutes this time's most explicit appeal to the imagina-
> tion. Therein lies their measure of greatness. For the imagi-
> nation is man's most precious possession.... Each work
> from Davies' hands is a reaffirmation in paint of what Keats
> affirmed in words: "What the Imagination seizes as Beauty
> Must be Truth."[50]

The one-man show was comprised of forty-five works, a dozen of
which were loaned by Lizzie Bliss, Stephen C. Clark, and Mary
Harriman Rumsey.

Before that exhibition closed on the last day of March, there
were five other solo shows, consisting of paintings and lithographs
at the Memorial Art Gallery in Rochester, oils at the Dayton Art
Institute, paintings and prints at the Art Institute of Chicago, figure
drawings at a commercial gallery in Chicago, and an exhibit of
etchings and lithographs in Minneapolis. In addition, several of his
graphics were included in a selection of prints by American and
French artists held at the Whitney Studio Club.

During this time, Davies was busy producing fifteen large
lithographs which would be printed through Weyhe in June. These
prints, like his watercolors from the previous summer, were all

Figure 80. *Grassy Point, Hudson River,* 1924. Lithograph, 5 x 17½ inches. The Detroit Institute of Arts, Gift of the Ferargil Galleries, 51.206. Photograph © 1997 The Detroit Institute of Arts.

essentially landscapes. Yet on this occasion the scenes were American rather than European, with titles such as *Shore of Rockland Lake; Grassy Point, Hudson River;* and *Mohawk River Bank.* Davies' lithos received a warm reception, due in part to Frank Weitenkampf's book, *American Graphic Art,* which appeared in a revised edition in 1924. The author heralded ABD as "this insatiable trier of processes" whose earlier experiments in lithography were

> delightful in their spirit of adventurous discovery, no two alike in method of production.... This tireless experimenter..., who will pull different proofs of the same lithograph in different color combinations, is, of course, attracted by the medium for what it will yield in expression of himself.[51]

Yet now, suddenly, at the very moment of these achievements and virtually on the eve of the appearance of Duncan Phillips' book about him and his art, ABD found it necessary to leave New York for Europe. On this occasion he would absent himself from the land of his triumphs for nearly five months, a forced exodus brought about by the likelihood that his secret life would suddenly be revealed.

❧ 19 ❧
Flight and Freedom
(1924–1928)

*I*n June, 1924, immediately after Ronnie completed the sixth grade at the Friends Seminary and classes had recessed for the summer, ABD prepared for the trip overseas. The reason: In recent weeks his daughter's classmates had begun to ask her too many questions about her family, questions which Ronnie, in turn, posed to her parents. Having turned twelve, Ronnie was no longer satisfied with having such queries summarily dismissed. In order to keep their secret intact, ABD and Edna decided to continue her schooling in Paris.

With Duncan Phillips' monograph on Davies set to appear, this was no time for his double life to be discovered. There was also the growing fear that, through a slip of the tongue or a carelessly left piece of mail, Ronnie would begin to suspect this herself. During the past year or so, her father had made a point of not hanging any of his art in their apartment, afraid that the child would inquire, "Daddy, do you know the artist Arthur B. Davies who painted this picture?"

With Edna and Ronnie in tow, ABD, traveling under the name of David Owen, had to be doubly careful of every move he made. His departure appeared to be a last-minute decision, which was done purposely so that when a friend asked, "What boat are you taking?" his stock reply was always, "Oh, there are four sailings today. I just buy a ticket from the purser."[1] If this seemed impetuous or a sign of

disorganization, so be it; at least it guarded against someone noticing him traveling with persons other than his wife and sons.

Posing as David and Edna Owen, they took up residence at 16 bis rue du St. Gothard, an out-of-the-way address for tourists, located a few blocks from the Parc de Montsouris and the Paris Observatory. Edna was unhappy with the arrangement and its effect on Ronnie, as she indicated some years later:

> Since our hard time in Paris when the little girl [Ronnie] who a few weeks before had been the adored and adoring daughter was passed off as a niece or cousin—any old thing—her poor little soul has been pretty black—and her health has been more than frail.[2]

At about this time Ronnie was given a single art lesson by her father, and she demonstrated a certain degree of talent. "I wish Papa hadn't lost some drawings I made when I was twelve," she would one day reminisce. "I'd give a good deal to have them. They were . . . like those of Marie Laurencin, the famous French artist."[3]

By now the youngster had begun to blossom into young womanhood and ABD would sketch her as an Aegean maiden, her hair braided in long plaits so it would fall down across her shoulders and modestly cover her developing breasts. For one pencil and chalk drawing she posed standing straight as an arrow with both arms outstretched, a static stance of a vertical and horizontal unlike the lively, gesturing, dance positions assumed by Wreath.

In Paris without a full-time model, Davies soon reverted to his subject matter of the previous summer and began producing water-colors of nearby landscapes. They were without a trace of people or animals, real or imagined. "Just think," he wrote in a letter to Wreath, "six lovely landscapes in one day. And all of them in Monet country not far from Paris . . ."[4]

Davies made a habit of travelling alone with his small water-color box tucked neatly into his suitcoat pocket. It contained a por-celain palette and rectangular cakes of color, with a built-in drawer to house a few sable brushes. At one point he toured the chateau country of the Loire Valley, creating watercolors of that Renaissance fantasyland (Plate 14)—from the large, visually complex structures

of Chambord and Chenonceau to their smaller counterparts, such as the Château Azay-le-Rideau on a tributary of the Loire River.

At Azay, Davies found a perfection of scale and line—rounded turrets at each corner of the roof-bracketing, evenly spaced crenels and machicolations—with the entire edifice reflected in the waters of the river below. Such details, when incorporated into the watercolors, call to mind Davies' early training as a draftsman, for the straight-on views contain all of the information and accuracy of an elevation in an architectural drawing.

After arrangements were made for Ronnie to enroll in school and classes had begun, ABD returned to New York in early November, 1924. He was curious to see his first grandchild, who had been born in September to David and his wife of nearly two years. David Davies had graduated from Cornell in 1917; he was declared ineligible for military service because of a bad heart and obtained a job as a county agricultural agent near Utica. He met his future wife, Mildred Dunbar, at a church social; she had hoped to be a physician but lacking the funds to pursue it, studied nursing instead. When the couple had their first child they named him Alan, after ABD and Virginia's son who had died in infancy.

Whenever the new grandfather visited David, Mildred, and the baby, he invariably brought along a gift, a treasure from among the objets d'art he was always collecting. Mildred dutifully expressed appreciation for whatever he gave them, even though what she really needed at the time may have been a baby carriage, not a four-inch-high carved jade mountain or an oriental Buddha.

Davies was eager to view the completed book about him by Duncan Phillips which had come off the presses while he was overseas. The publication had originally been scheduled for May, before his departure, but when Phillips made a final examination of the color plates he felt that two of them could be improved, so they were reprinted. Of course, ABD had been consulted, as Phillips informed the Ferargil Galleries in June: "Mr. Davies, before he went away, gave . . . hearty approval to all of the details entering into the manufacture. . . ."[5]

Although the collector may have once considered being the single author of what he would refer to as "the first comprehensive study of the art of Arthur B. Davies,"[6] he shared the writing with five

others: Dwight Williams, Royal Cortissoz, Frank Jewett Mather, Jr., Edward W. Root, and Gustavus A. Eisen. Each extolled the achievements of the artist and his art in the eight-page text: Root proclaimed that "[Davies'] work is nothing less than the study of the most comprehensive artistic intelligence that has as yet, in America, attempted to express itself in paint,"[7] while Mather labeled him a "man of genius" and "a boon to American painting."[8]

But in the end it is the words of Duncan Phillips himself that carry the most passionate and eloquent praise:

> Arthur B. Davies is already recognized, not only in this country but in Europe, as one of the few men of original and authentic genius among the painters of our contemporary world. . . . Few artists since Leonardo da Vinci . . . have had such culture as Davies controls, such a range of extraordinary knowledge, such an ardent curiosity about beauty and the causes for its effects, such a tireless mind serving such a boundless fancy, and so debonair a facility for varied invention.[9]

He alluded to ABD's "range of extraordinary knowledge" in a passage referring to the

> notorious painters known as "Post-Impressionists and Cubists" [who] were after all rational enough in trying to build upon the foundations laid by two pioneers whom he [Davies] respected, two insatiable searchers and daring innovators, artists who dreamed of a new pictorial language of pure design, Cézanne and Seurat.[10]

While it would be another fifteen years before the collector purchased his initial work by Seurat, it was surely no coincidence that he acquired his first Cézanne, a monumental oil of *Mont Sainte-Victoire,* within months after the Davies volume appeared. Only a few years before, Phillips had labeled Cézanne a unique but overrated painter.

The Davies monograph was enriched by forty-one illustrations, all of which were of paintings in major public and private

collections. Holdings from public collections such as those at the Metropolitan Museum of Art, the Art Institute of Chicago, and the Phillips Memorial Gallery, were included, as well as paintings from the private collections of Lizzie Bliss, Gertrude Vanderbilt Whitney, Martin A. Ryerson, and Stephen C. Clark.

In addition to the regular printing, a deluxe, leather-bound edition of one hundred copies was part of the project, evoking this letter from Bliss to Phillips:

> It is good news to hear that the de luxe edition of your Davies book is so nearly ready to make me the proud possessor of a presentation copy. I was of course only too pleased to further in any way possible so fine a recognition of Mr. Davies commanding position in the art of America, this having been for many years the single aim and purpose of my collection.[11]

Davies provided fifty of his drawings for insertion in the deluxe copies acquired by the first fifty subscribers, and these included collector Sam Lewisohn, art dealers John Kraushaar and M. (Michael) Knoedler, and newspaper publisher Ralph Pulitzer (Joseph's son).

Added to all of the attention and kudos lavished upon ABD that fall and winter of 1924–25, a design he submitted to a World Peace Christmas Card Contest sponsored by the National League of Women Voters was awarded the twenty-five-hundred-dollar first prize. The composition, which he titled *Let Faith Inspire All Mankind to Seek the Greater Victory of Love and Tolerance* (Plate 15), depicts Faith placed on the back of a donkey like a nude figure of Mary entering Jerusalem, with birds gathered in her hands. The origin of the subject harks back to a drawing he made of Edna in 1907; then a dozen years later, Wreath became the model for a lithograph titled *Venus Surrounded by Animals* incorporating the identical pose. (The "animal" upon which she sat was actually a slender Louis XIV divan in Davies' studio.) An oil created from that composition, from which the Christmas card was reproduced, measured 9 by 18 inches and was titled *Love Herself Fulfills.* The appeal of this and ABD's other subjects was particularly strong to a public that had grown weary of war and its aftermath, the focus of so many other paintings and

posters. It was a relief to escape to Davies' classically inspired mythical or mystical figures ensconced in the beauty of a never-never land, where death, devastation, or even old age had no place.

Before the end of 1924 there was another spin-off from the book when ABD was commissioned by Mrs. John D. Rockefeller, Jr., to produce a mural for International House. International House was a residence and program center being built by the Rockefeller family for United States and foreign graduate students studying in New York. The germ of the idea for the Davies decorations was probably planted by Frank Jewett Mather, Jr., when he wrote in the Phillips Gallery monograph:

> The fact that Mr. Davies had to wait for a mural commission
> [the Bliss Music Room murals of 1914] till he was past fifty
> is one of the more discreditable mysteries of the patronage
> of art in America.[12]

Mather pointed out the failure of ABD's "admirable design" being chosen for New York's Appellate Court in the 1890s, which likely prompted Abby Aldrich Rockefeller to provide the artist with his first project for a public space. Davies began preliminary sketches for decorating the large lobby area in the building at 500 Riverside Drive, but it would be more than a year before the paintings were completed and installed.

Meanwhile Davies' interest again focused on his graphics as he considered the prospect of producing color prints from some of the plates previously used for printing black-and-whites. He discussed the idea with Frank Nankivell who was skilled at color printing and the two of them spent hours together pulling proofs. Nankivell recalled:

> Occasionally he made for me a complete color scheme, but
> mostly he would demonstrate his wants by dipping his
> finger in a color on his palette and rubbing it on a sheet
> of paper—then another color. . . . I would feel his wants and
> pull a proof. It was usually what he desired.[13]

One day as he left, Davies said in his typically quiet manner, "I had almost lost all interest in my plates and I thank you for reviving it."[14]

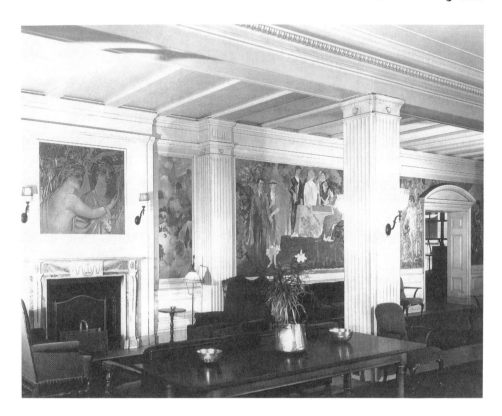

Figure 81. Murals for the Lobby of International House, New York, 1924–26. Oil on canvas. Photograph courtesy Peter A. Juley and Son Collection, National Museum of American Art, Smithsonian Institution.

Davies delivered a total of thirty-three plates to him and subsequently such etchings/aquatints from 1919 as *Moonlight on the Grassy Bank* and *Sea Maidens* were reprinted in new, colorful versions. "His plates cannot be treated in a hasty, commercial manner," Nankivell observed,

> They require time and caressing care in handling. He accumulated a large quantity of fine linen paper: blank pages from old account books of Dutch, French, English, and German origin, dating from 1600 to 1800; all of fine quality, though some would pull a richer print than others. "Use them all," he [Davies] said. "Each has its own quality and will last forever."[15]

The two men worked well together, with Davies occasionally selecting an object such as a gemstone for the desired color and

Nankivell matching it with a mixture of inks. After final approval by the artist, Nankivell would run off a small edition.

The resulting graphics demonstrate the levels of color experimentation attained by ABD and Nankivell on both simple and complex compositions. In *Tragic Figure,* for example, of a single reclining nude, the hues chosen involve the palest of pinks against a background of sap green shaded from light to dark. *Amber Garden* is comprised of two figures, one retaining the white of the paper, the other dominated by a light lavender against a blue-gray background. Warm in tonality by comparison is *Sea Maidens* which is printed on yellow paper; it shows seven female nudes, some standing, others running in a group along the water's edge, their collective bodies forming a mass of yellow-orange topped by flowing locks of burnt umber.

In contrast to these, *Toil of Three* depicts the torsos of a trio of women, each superimposed upon the next. In this case every print was hand-colored with one limited to grays, black, and pale purple, while another contains added areas of cobalt blue on hair and sky and an earth green on one figure's face and body. Such results demonstrate once again Davies' thirst for experimentation and desire for change.

In February and March, 1925, nearly one hundred of Davies' watercolors from the previous summer were shown at the Ferargil Galleries; in June they were displayed at the Corcoran Gallery of Art. Afterward, twenty of them were sent on to a show held at the Carnegie Institute throughout July and August. During the period from February, 1924, to July of the following year, Davies' sales at the Ferargil Galleries amounted to $32,992.67. The total included seventy-seven watercolors priced uniformly at $500 apiece for large compositions and $275 for smaller ones. Four of them were acquired during that time by Abby Rockefeller, three each by Mary Sullivan and Duncan Phillips, six by Stephen C. Clark, and five by the Macbeth Gallery.

In May, 1925, Davies was back in Paris, where one of the attractions was the *Exposition Internationale des Arts Décoratifs* which featured examples of art deco from twenty countries. Among the other shows he visited were an Oriental exhibition at the Bibliothéque National and an exhibit in the Petit Palais of paintings from Poussin

to Corot. "The Claudes [Claude Lorrain] at the 'Petit' are superb . . . ,"
he wrote to Frederic Newlin Price. "All is going well with my work
though I haven't found a good studio other than a hotel room. I
shall have a lot to show you when I get back but *not publicly*—I
want to work most of all—."[16]

The following month saw the opening of the *Exposition
Trinationale* at the Durand-Ruel Galleries displaying the paintings
and sculptures of seventeen Americans, including ABD, plus artists
from Britain and France. Davies viewed the exhibit but his reaction
to it went unrecorded; the show was all but ignored by the French.

One of Davies' agenda items while in Paris that summer was
to have many of his small sculptures cast in bronze. The pieces,
created months or, in some cases, years before, had been produced
in terra cotta and then fired by ABD in his small kiln. After arranging
for a foundry to cast between one and twelve bronzes of each
sculpture, he had several of the works cast in glass as well. As ABD
wrote to his son Niles, "I have about sixty new bronzes for shipment
with a few more to come, also I have been breaking [in] a French-
man to glass paste, 'Pot de Verre' [Pâte de verre] it is called."[17] He
bestowed upon the figurative representations such titles as *Spirit of
Earth; The Three Graces; Isis; Maenad* (a Dionysian dancer); and
Apsaras (in Hindu mythology the mistress of the soul in paradise).

Numbered among Davies' favorite French sculptors was Jean
Goujon, credited with popularizing the Italian Renaissance in France
and often considered the finest sculptor who worked there during
the mid-sixteenth century. Davies viewed his work often in Paris, for
it was Goujon who decorated the facade of the Louvre. Frederic
Newlin Price, who briefly joined him in the French capital, verified
Davies' deep admiration for Goujon: "One day we stood before the
Fountain of the Nymphs, in the Square of the Innocents in Paris, and
Davies said, 'He [Goujon] is the greatest of them all.' "[18]

Davies did not disclose where he resided in Paris, not even
to Price, who gave an example of a typical day:

> Like the sun come up he [Davies] appeared at my little
> hotel. We went forth to the Musée Comparé, and he lec-
> tured [me] on architecture. It was delightful. The Saracens
> sweeping through Italy and Spain building great castles, "to

>stop at the Fourteenth Century in French Gothic, the most
>beautiful of all building." To the Jacquemart André collec-
>tion, to l'Escargot d'Or, near the hall where Jean Goujon . . .
>has a fountain. Then at six to leave me, no address to his
>studio, he went home, retiring early (at seven) to come
>again next day. . . . [19]

After Price returned to New York, Davies again took up watercolor, sometimes pre-painting the skies from his studio window on gloomy days immediately after it rained, or from his imagination. Most watercolorists prefer to depict the heavens using a wet technique, which ABD occasionally employed: Dampening the entire area with water, he would then tilt the paper so that a blue or blue-gray tone placed across the top would run down toward the horizon, becoming lighter as it went. Clouds were often suggested by dabbing a cloth in the appropriate areas, providing a return to the white paper before the sky dried.

But more often than not, Davies would partially outline clouds in pencil, then paint in the sky around them. And while the purist insists that all watercolor washes be transparent and therefore devoid of white, ABD sometimes simply created his clouds through the use of an opaque white tempera. He also made a habit of painting on tinted charcoal paper rather than the heavier white watercolor stock, with the result that the blue, tan, buff, or yellow paper would become the background tone for sky with little modification.

Seeking to experiment further with changing effects, Davies began drawing his subjects with colored pencils, usually employing blue or purple; he also combined certain of his watercolors with pastel, providing tonal unity to areas that may have otherwise appeared disorganized. This combination of unorthodox methods unites to produce watercolors of a fresh, direct, and personalized nature.

In such examples as *Pont Neuf, Paris; From the Quai d'Orleans;* and *Seine Valley—near Paris* the heavens comprise more than half of each composition, with much of the remaining subject matter— the silhouette of the city, a bridge, a cluster of boats or trees— arranged in near-horizontal bands and compressed along the bottom.

Davies worked his way south to Italy as he had done two years before, stopping in Bologna to observe and paint a half-dozen

Figure 82. *From the Quai d'Orleans*, 1925. Watercolor on paper, 11 x 15 inches. The Brooklyn Museum of Art, Gift of the Artist. (26.409).

bell towers, that city's unique architectural characteristic. In Italy he also painted the countryside, focusing on the Apuan mountains near Lucca and the Umbrian hills near Urbino.

Back in Paris by early August, 1925, ABD summarized his recent art activities in a single sentence in a letter to Niles: "I have traveled about more this year getting new and better sketches, though but few chateaux."[20] In the same letter, he revealed another under-taking to his son:

> ...I have made some sketches for tapestry weaving in a new yet old manner not practiced by the Gobelins (a gov-ernment paid factory). Their work is very ordinary and I think I can open up a new venture, which will prove profitable in America, though not here. The French are very hard to get *into*, very conventional. The men employed are on a sort of civil list, get living and garden, *chickens* (yards) and a sort of communal life at the Gobelin works, and are allowed to do outside work.[21]

The phrase "are allowed to do outside work" proved to be the key, for the Gobelin factory had been under government control since the mid-seventeenth century. But thanks to Davies' having met Germaine Montereau, of the Manufactures des Gobelins, an agree-ment was reached whereby the Gobelin weavers at the factory in Beaugency, a village south of Paris, would copy his designs during their off hours.

Davies' grandiose scheme called for the eventual relocation of some French tapestry-makers to the United States in order to pro-mote the art form here. The American muralist Albert Herter had done just that a dozen years before when, under an $850,000 com-mission from the Harriman family, he brought sixty weavers to New York to execute twenty-one tapestries depicting events in the early life of the city. The catalyst for Davies' immediate interest in tapes-tries may very well have been a presentation by the French govern-ment to the Philadelphia Museum of Art the previous year of a Gobelin tapestry showing the departure of American troops in World War I. During the remainder of the summer of 1925, he concentrated on producing designs for his embryonic enterprise, purchasing George

Leland Hunter's just-published volume, *The Practical Book of Tapestries,* which provided technical advice.

Davies' lengthy letter to Niles marked a renewed interest in his family in Congers, prompted in part by increasingly strained relations with Edna. She was unhappy with her plight, what she characterized as the extravagant expenditures for his art collection and library while she and Ronnie existed on a meager subsistence. "Ronnie's schooling in Paris cost, barring her few books, about $25.00 a year," Edna complained.[22] In addition ABD had become increasingly paranoid about taking Edna and Ronnie anywhere in Paris for fear of their being seen together, so it was decided to send Ronnie to Italy to continue her education. According to Edna

> ... There he [ABD] had no bank account and practically all spent passed directly through my hands ... much, much money went for his personal purchases of costly books, stuffs, embroideries, etc., which he conscientiously took away with him when he left.[23]

If anything, Davies' narcissistic behavior had considerably worsened.

As a result, when Edna and Ronnie established residence in Florence, it was largely Edna's own funds that sustained them. Through her brother, Pierpont Potter (a lawyer who still lived in Brooklyn), a real estate agent informed Edna in November, 1925, that he had a buyer for her property holdings, which consisted of a house and four lots located in Ideal Beach, New Jersey. The sale amounted to $1,510, which went a long way at a time when the Italian lira was worth about five cents.

When Davies returned to New York in September, 1925, he did so with a new-found sense of freedom from his second family. Now weekends at the farm became more amiable. Virginia had hired a housekeeper, so the usual disarray of the homestead was less apparent and vexing to him. Arthur's financial contribution to Virginia's well-being, however, remained minimal. Though she was still practicing medicine and the farm was operating in the black, Virginia could never be accused of being an astute businesswoman. Her charge for a house visit to deliver a baby was three dollars, and

more often than not the expectant mother would ask her to bring along five dozen apples. The family would pay for the apples but not the baby's delivery.

A month after his return, ABD had a one-man show of his watercolors at the Baltimore Museum of Art. Only a few of the latest French and Italian landscapes were included, for he anticipated using most of them as the basis for oil paintings during the winter. "The work I did in Paris and Italy this past summer is very important and the best I have ever done," he informed his sister Emma. "I worked in Florence about a month and a half."[24] Art critic John Canaday apparently agreed that this was quality work, for years later he would write: "A case could be made for these [the Umbrian landscapes done in 1925 and 1926] as Davies' finest work. . . . "[25]

By 1926, ABD's reputation had reached new heights. His oils, watercolors, drawings, sculptures, and prints were desired by both fledgling and established collectors. A letter from Duncan Phillips to Frederic Newlin Price dated February 25 of that year attests to his stature:

> I have shipped to you, express prepaid, the colorful and important canvas by Arthur B. Davies entitled "Hill Wind." It distresses me to give it up . . . There are many Davies pictures in captivity which I covet and hope some day to acquire, so please do not think, or permit Mr. Davies to think, that I am weakening on this very good artist. I need funds and Davies is the only artist in our Collection for whom there seems to be a ready market. Two dealers have asked me to send them paintings by Davies which they assure me they can sell. Rehn has a client who wants an important Davies impatiently and I hesitated whether to send "Hill Wind" to him or to you.[26]

Some of the artist's peers praised his work as well. In a letter to Phillips, Alfred Stieglitz wrote that "[Georgia] O'Keeffe tells me how beautiful the two Davies look in your house. She returned from Washington full of rare enthusiasm."[27]

Davies was presently preoccupied with more pressing matters, for he had been informed that the building housing his studio was slated for demolition, a fourteen-story apartment building to

replace it. While conducting a frantic search for a new location he determined to sell off part of his modern French art collection in order to simplify the move into what would inevitably be smaller quarters.

One hundred of these works were offered for sale in a hastily arranged exhibit at the Ferargil Galleries, art which he had lovingly assembled over a period of fifteen years. There were oils, water-colors, pastels, and drawings, including thirteen Picassos, eighteen examples by André Derain, three cubist still lifes by Braque, a nude by Matisse, Daumier's *Parade,* two Henri Rousseaus, a Gauguin, a pair of watercolors by Gleizes, Jacques Villon's *Flowering Trees, Puteaux,* and two compositions by Signac. A smattering of Ameri-cans were displayed as well: A Prendergast watercolor of San Malo, three Preston Dickinsons, a Glackens pastel of Central Park, two oils by Hartley, two Demuths, single works by Burchfield, Schamberg and Patrick Henry Bruce, and eight paintings by Max Weber. Com-menting on the collection, a critic for *Art News* observed:

> It may come as a surprise to many that Davies, the most romantic of the American moderns, should have been inter-ested in cubistic and purely abstract art, and yet there is a very representative showing of paintings in that manner. He is revealed as a man of strong conviction and fearless and catholic taste.[28]

The sale of eleven works resulted:

Ingres	Drawing	$3,000.
Picasso	Trees	400.
Picasso	Figures	350.
Picasso	Vase of Flowers	300.
Picasso	Ceret (France)	350.
Braque	Still life	350.
Derain	Vase	200.
Derain	Green Landscape	1,000.
Derain	Still life	1,500.
Rousseau	Canal	900.
Demuth	Horses	150.
	Total	$8,500.

By contrast, when Duncan Phillips decided to part with not one but four Davies oils (*Hill Wind, Nature's Lyre, Portals of the Night* and *Cressy Wanderer*), they sold for $7,250.

A portion of the funds ABD received from the sale was earmarked for Virginia and Edna. Despite the long-time estrangement from his wife, he sent her $750 on April 16, 1926, as a present for her sixty-fourth birthday; during the two weeks that followed he wrote checks to Edna totaling $850. But such token acts came too little and too late; they could not possibly undo the neglect that both women had experienced for decades.

Davies found new studio space in the Hotel Chelsea at 222 West Twenty-third Street and moved into the tenth floor on April 1. Eager to return to his art, one of his first acts was to send Wreath a telegram that he had settled in, and within the week she resumed her modeling schedule as he sought to complete the murals for International House.

The subject of his decorations was Mother Earth receiving peoples from around the world. It was a seemingly appropriate motif for an international house, yet the pseudo-realistic theme caused Davies to adopt a style unlike any he had previously utilized in painting. Not only are these decorations unrelated to the Lizzie Bliss murals of a decade before—there are no strong cubist or abstract elements—but the imposing figures, slightly larger than life, combine the solidity of Courbet's peasants with contemporary attire. There is also occasional evidence of art deco, an influence traceable to the *Exposition Internationale des Arts Décoratifs* which ABD had viewed in Paris the previous summer. The most Davies-like element in the figures is that of gesturing hands, and they provide a sense of animation otherwise missing.

The murals were painted in oil on canvas, with the two largest measuring 10 by 13 feet. One of these depicts a woman, representing Mother Earth, shepherding three young children before her; the other has her seated at a table with an ingathering of people from various nations. Despite a stylistic departure, there are several subjects reminiscent of his earlier work: A frolicking goat and goatherd recalls the *Wild He-Goats Dance* of 1915; a half-length female figure before a tropical tree resembles the pose of Europa in *Sacramental Tree* from the same year; and the buildings looming up behind a

shepherd boy in a third panel has the familiar ring of a hill town painted in watercolor the summer before.

When the canvases were installed, ABD requested that a text clarifying his intent be placed nearby. This was done. The wording stated in part that his goal was "to present the unity and identity of all peoples through the Maternal Life source with God, to visualize the ideas of perfection and blessings of God is to produce blessing and perfection."[29] It is questionable whether this accomplished the desired effect of clarification.

For her part, Abby Rockefeller felt the murals would "carry a very real message of beauty and hope to the young people from all over the world who live and meet there [in International House]."[30] And *New York Times* critic Edward Alden Jewell referred to them as

> curious [to those] who think murals must be painted in the Blashfield manner, people who suppose that the only reputable murals are the ones to which they have been accustomed by the walls of court houses, capitols and libraries. . . . And yet they [the Davies decorations] are somehow rather wonderful. They grow in wisdom and in power as you gaze, and they have a way of drawing you back again.[31]

Davies was paid ten thousand dollars by Mrs. Rockefeller, who was so taken by his other works that she also purchased a dozen of his watercolors for an additional forty-eight hundred dollars. The check for the International House murals was mailed on June 23, 1926, to the artist in Paris.

Davies had remained in New York until June 12 in order to attend the opening of the *Exhibition of Modern French and American Painters* at the Brooklyn Museum on that day. The exhibitors consisted of Berthe Morisot, Seurat, Gauguin, Cézanne, Redon, Picasso, and Derain, plus three Americans: Davies, and Maurice and Charles Prendergast. There were approximately one hundred paintings, drawings, and prints included in the show, of which sixty were by Davies. All of his were loaned by Lizzie Bliss: Twenty-two oils, a like number of watercolors, five encaustic paintings, and eleven drawings.

Writing of the exhibit in the *New York Times,* Elisabeth Luther Carey remarked that Cézanne's portrait of *Madame Cézanne,* also

loaned by Miss Bliss, was "a representation rivaling that of Davies."[32] Royal Cortissoz applauded ABD in *Scribner's,* stating that his art was

> more poignantly stimulating than anything else with which I am acquainted in modern painting. It makes for a tremendous stirring of the emotions, for a certain spiritual exaltation. The average artist gives you a picture to look at. Davies enlarges your experience and makes a tumult in your imagination.[33]

With Edna and Ronnie in Florence, ABD arranged for Wreath to come to Paris for the summer so that he could continue to work from the figure. Some of the funds Mrs. Rockefeller sent there were used to pay Wreath, but most of it was earmarked for the execution of his tapestries. Davies periodically visited the Gobelin factories in Paris and Beaugency, taking lessons in the art of weaving, studying various pattern possibilities, and refining his designs which Germaine Montereau and nine young women had begun to produce.

Wreath arrived in France chaperoned by a friend, an older woman with whom she also roomed. "I posed for Mr. Davies all that summer," she recalled, adding,

> He lived in Montmartre, in the heart of Paris, and we had to go by cab to his place. He would call for me at my hotel and take me to his studio. Everywhere he went he took a cab. "In that way I can stop at any place that interests me," he said.[34]

He and Wreath also took at least one trip to the seashore, possibly to Trouville on the English Channel, for a photograph taken by him shows her facing the camera at the water's edge, appearing voluptuous in a one-piece bathing suit. It was no coincidence that Davies produced a few watercolors that summer featuring bathers, some lolling on the beach, others bobbing in the surf. They were probably painted on the spot.

The drawings he made of Wreath in his Paris studio found their way into a variety of compositions, some painted in Europe, others back in New York. *Dancers on the Beach,* for instance, has

multiple images of her placed before a turbulent sea, while *Elba* shows her profiled, three-quarter-length figure superimposed over the rugged terrain of an island, with blue waters and a pair of sailboats separating model from mountains.

A fire in his Paris flat led to another painting after he discovered, among the items saved, a blonde-haired doll belonging to Ronnie. She had named it Heliodora after a story her father used to read her written by Heliodorus, the earliest of the Greek romance writers. Davies adopted the doll's name for his painting of Wreath, posing her kneeling before a tree trunk, her hair held in place by an encircling garland. Davies also intended for the composition to be made into a tapestry, but it was never produced.

One of many sketches of Wreath which did become the basis for a tapestry was titled *Galatea,* the name given to a statue sculpted by Pygmalion, the legendary King of Cyprus. The monarch prayed to Aphrodite to bring his creation to life, and when she did they married. George Bernard Shaw updated the tale with his 1914 *Pygmalion,* set in England; ABD transformed Wreath, alive, to art.

After seeing Wreath off in September, 1926, Davies stayed on in Paris in order to attend a public auction of the French works from the John Quinn collection, scheduled to take place in October. Following Quinn's death two years earlier, Davies, Pach, and art dealer Joseph Brummer had been selected to aid and counsel the executors of the estate, but their advice to keep the collection intact was not heeded. Davies refrained from acquiring any of the Quinn works in Paris, since he had disposed of some of his own coveted holdings earlier in the year. However, when the remainder of the collection was auctioned off in New York the following February, the artist chose to repurchase one of over a dozen examples of his owned by Quinn, the 1913 cubist pastel S*hepherd Kings.*

Prior to leaving Paris, Davies viewed a pastel by Degas titled *After the Bath* at the Durand-Ruel Galleries, and was sufficiently impressed by its subject, composition, and technique to contact Lizzie Bliss and recommend she purchase it. Bliss so respected his judgment that she authorized the acquisition sight unseen.

When ABD returned to the United States in October, he learned of the arrival of yet another grandchild born to David and Mildred, the birth having occurred while he was en route home. The infant

was delivered, like the others, by Virginia, and was named Margaret Meriwether. In the months that followed, Davies demonstrated increasingly warm feelings and sensitivity toward his family, especially his wife. In a letter to his sister Emma, he wrote: "[She] is pretty tired with overwork and I am trying to get her away to California for two or three months."[35] And for her next birthday, Arthur bought her some hybrid lilacs, then had them planted near the house on the farm.

Another family event he managed to miss was his oldest son's wedding on April 18, 1927. Niles had met his future bride, Erica Riepe, a librarian from Davenport, Iowa, when she was visiting her aunt near Congers and accompanied her to Dr. Davies' home for medical treatment. Erica first laid eyes on Niles while he was shoveling manure after having milked the cows. Their wedding took place in a Unitarian church in New York City, which probably explains ABD's absence, for there were still those in Manhattan who knew him on sight as David Owen. Such recognition at that time would have proven most embarrassing—so he left for Europe prior to the ceremony.

During the months preceding his departure, Davies had created only a few paintings and prints, though Frederic Newlin Price continued to promote these through exhibitions and sales. Price sent his works to a myriad of exhibits where they were regularly accepted, including the annuals at the Carnegie Institute, Art Institute of Chicago, Pennsylvania Academy, the Palace of the Legion of Honor in San Francisco, the Cincinnati Art Museum, and Cleveland Museum of Art. There was also a one-man show of his watercolors at the John Herron Art Institute in Indianapolis. Davies received a check from his dealer in the amount of eight thousand dollars for the sale of a painting titled *Garden of the Living Infinite,* the highest price paid for one of his oils up to that time.

Davies had been consumed by his tapestries project, working tirelessly on those designs which would be taken to France during the coming summer. Above the door to his studio at the Chelsea he affixed a fragment from a Gobelin tapestry, a sort of talisman announcing his new focus. Inside, actual-size cartoons were spread out across the floor with watercolors and gouache used to suggest the range of colored yarns he desired.

Some of the works created at this time reveal a heightened emphasis on abstract design, where Davies dramatically leads the spectator by the eye around the composition. *Gobelin Poems* is just such an example. Here the figures of three nude females are juxtaposed so that their extended arms become an overall unifying element. Two of the diagonally placed limbs appear as parallel forces anchoring a vertical leg, while it, in turn, it visually extended through a strategically located tree trunk. The use of such continuity of lines recalls the utilization of the device by Degas, and ABD's own employment of it in his earlier paintings such as *Cherokee Pinks.*

Another instance is *Figures of Earth,* in which the nude bodies of five women and a child, seen standing, sitting, and kneeling under a tree, are grouped in such a manner that the gesture of an arm and the curve of a back unite to form a graceful rhythm from the upper left to the lower right.

As in his printmaking and sculpture, Davies sought variety of execution; he would not have been content to allow all of his compositions to be transferred uniformly into textiles. For example, one tapestry depicting a Greek torso was to be produced with a fine warp and a heavy wool weft, the idealized body placed in a mountainous landscape of greens and browns; while another, of Ares, had the weft yarn loosely twisted and the figure in blue drapery above a starry sky. Some of the subjects were embroidered in long-legged cross-stitch in the Spanish manner, others fashioned in a close stem stitch or executed in petit point. These tapestries were bestowed with such titles as *Aphrodite, Eros, Wood Nymph, Pleiades,* and *Bacchanal,* indicating a relationship with the classical nature of many of his earlier works in other media. Davies' textural forays extended to designing rugs as well, including one with a bird motif, another with a pattern of flowers, and a third featuring Chinese scrolls and lotus blossoms.

Upon his arrival in France, he deposited his cartoons with Mademoiselle Montereau. Then, between regular visits to her workshop in order to consider minor changes in his compositions, overseeing the tedious pace of the weaving, and creating additional designs, he once again took up travel and landscape painting. An indication of his activities is contained in a letter written to Virginia from Paris:

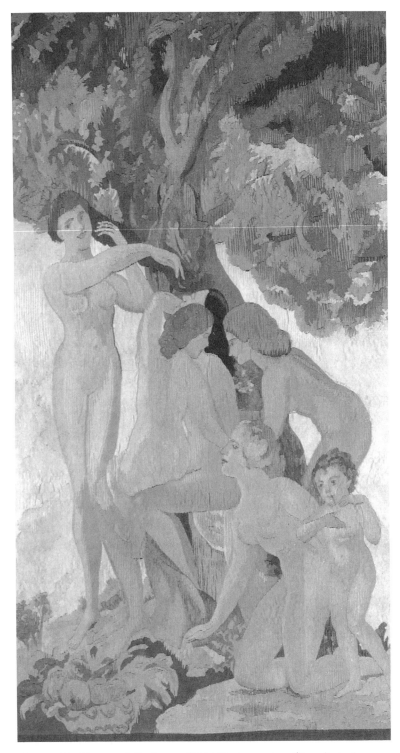

Figure 83. *Figures of Earth,* ca. 1927. Wool tapestry, 62 x 41 inches. Art Museum, Munson-Williams-Proctor Institute, Utica, New York, Gift of Mrs. A. David Davies in memory of her husband Arthur David Davies.

April 27th [1927]

Dearest Mamma

. . . Work has been going very well as I think of nothing else and shall have some of the finest things to bring home, besides leaving good work here for execution in tapestries and carpets, also new kinds of weaving (mosaic) & embroideries—I am rooming in a pension and walk about a block to my studio, which I can keep until Oct. 1st. There are some other things I want to do after I get through with my big things. The new mosaic weaving interests me very much. It seems to be an entirely new method, and I have been after it for a long time. . . .

I went to Italy and visited a number of new old places I have never seen and a month's bathing at Viareggio, which is near the Carrara Mts. Very fine sketching. Got back in Paris with over three hundred watercolors, I showed to Mr. Montross who considers them the best I have ever made. In the studio I have painted some big figure subjects and designs for weaving, looked after the work that is going on beautifully but very slowly . . .

With love to all
from Papa.[36]

Davies' month or more in Italy had naturally involved a reunion with Edna and Ronnie, who in all likelihood accompanied him to the seaside resort of Viareggio near Florence. That summer many of his watercolors were created in and around the area: He depicted two men driving oxen in a work titled *Montignoso near Viareggio,* the sandy beach and blue waters of a fishing village in *Portovenere,* and landscapes containing hillsides dotted with houses or groves of trees in *Near Seravezza, Lucca, Fiesole from Ceceri, Gimignano, Volterra,* and *Near Pistoia.*

Yet in the final analysis it was the mountains of the Apennines, especially in Tuscany and Umbria, which captured his imagination and became the focus for scores of watercolors. Here his art at last came full circle, the stylistically perfected counterparts of those mountain ranges he had painted in the American Southwest during the early 1880s and the towering ridges he rendered of Yosemite National Park in 1905 and 1906. Now, carrying along a collection of prepainted skies with a variety of cloud effects, their watery surfaces

350 ❧

Figure 84. *Italian Landscape*, 1927. Watercolor, Chinese white, and pencil on gray paper, 9⁵/₁₆ x 12 inches. Collection of Arthur Bowen Davies II and Margaret Davies Marder. Photographer: Duane Suter.

long since dried, he superimposed his favorite rugged, lofty subject, painting it sometimes raked by sunlight, at other subdued by shadow, capturing it in a variety of color schemes ranging from harsh browns to subtle blues and purples. These watercolors possess an economy of shapes that transform them into his most abstract compositions.

Davies located one peak near Bologna which was particularly appealing; it intrigued him to such an extent that he repeatedly represented its slopes. That mountain became his equivalent of Cézanne's *Mont Sainte-Victoire*. So attached did he become to that lone, towering shape that one of the watercolors was actually titled *To a Mountain,* as though he were dedicating a piece of poetry—his own visual poetry—to this favorite subject.

When the weather turned rainy and damp for days at a time, with no letup in sight, ABD bid goodbye to Edna and Ronnie and returned to Paris, where he turned to painting in oils from a selection of the watercolors and once again checked on the progress of his tapestries before embarking for home.

Shortly prior to Christmas, 1927, several of Davies' most revered patrons visited him in his studio. First came Duncan and Marjorie Phillips. "There were some lovely new paintings to see for the first time!"[37] Mrs. Phillips would later recall, though she found it difficult to remember exactly which ones they purchased that day. The artist also showed off his deluxe volumes of Raphael drawings as proof that the Renaissance master was aware of the inhalation theory. Then, according to Marjorie Phillips:

> Davies, who was given to consulting astrologers, told us in a matter of fact way that one woman astrologer had predicted that he would die on his contemplated trip to Europe the next summer. Luckily for our peace of mind, we took no stock in it, no more than we did in astrologers. . . .[38]

(Of course, the artist regularly checked his sign of the zodiac, Libra, and appeared to fit at least some of its attributes: Diplomatic, friendly, intelligent, pleasant, companionable, and thoughtful. And a true Libra is supposed to feel incomplete without a partner, so for much of his life Davies should have felt at least doubly complete.)

Another visitor to his Chelsea studio was Abby Aldrich Rockefeller, who brought along her son, Nelson, a freshman at Dartmouth who was home for Christmas. She was determined to expose him to modern art at Davies' and at the Downtown Gallery. When Nelson returned to college he wrote his mother how impressed he had been by the two experiences, and she replied: "If you start to cultivate your taste and eye so young, you ought to be very good at it by the time you can afford to collect. . . . "[39]

Abby Rockefeller was in touch with ABD concerning several other family projects as well. That same month, Frederic Newlin Price informed him that

> Mrs. Rockefeller wanted me to tell you that she was very anxious to have your advice and talk things over . . . This matter is about the church they are building [the Riverside Church, across the street from International House on Riverside Drive] . . . [40]

Some time earlier she had approached Davies on behalf of her husband, who was probing the possibility of restoring an entire colonial town to its original appearance. Mr. Rockefeller sent ABD to Portsmouth, New Hampshire, founded in 1623, to consider the site. Davies reported back that an insufficient number of tourists visited there except for during two months in the summer. After the Rockefellers themselves gave the locale a good look and determined that it was too far from the population centers, a Virginia minister interested the philanthropist in another, more southerly community on the New York–Philadelphia–Baltimore–Washington route to Florida, and Rockefeller funding was directed toward Williamsburg.

During the first few months after his return to New York, Davies resumed the purchase of art and antiquities on a grand scale: From Dikran Kelekian, a Madison Avenue dealer, he acquired seventeen Coptic textiles, an ancient Greek torso and a Picasso drawing; another dealer on Fifth Avenue sold him a large alabaster head of Jupiter, a small bronze, eleven mosaic fragments, ancient gold rings, a beaded bracelet, and a Phoenician cylinder seal, all having been found in Egypt, Palestine, and Syria.

As a result of obtaining these items, plus having brought back some of his completed tapestries and carpets and hundreds of watercolors, Davies decided to take additional space in the Hotel Chelsea. While continuing to occupy Room 1006, he expanded into Room 1002 beginning on January 1, 1928, paying $220 per month for both apartments.

In February, he learned of the death of Frederick James Gregg, his long-time friend and publicist, and determined to pay his last respects by attending the funeral. By chance, Henry McBride encountered ABD on the subway as he, too, headed for the same destination. When McBride sat down beside him, he observed that the artist's eyes "had dwindled to pin-points, as they do often in neurotics who are undergoing strain." Davies was unaware of the critic's presence until he quietly said, "How do," whereupon ABD "gave an effect of being awakened from a dream. A pleased look appeared on his face, he shook hands and began talking so enthusiastically that it became a virtual monologue on his part."[41] The stream of conversation continued unabated at the funeral, even after the priest had begun services, and McBride finally had to shush him. The conduct did not appear typical of ABD at the time.

March, 1928, brought another blessed event to the Davies family: the birth of a second granddaughter. Niles and Erica decided to name her Sylvia in memory of the infant Silvia born to Arthur and Virginia. "As a child, I loved to hear my mother tell the story of my birth," Sylvia said:

> I was born in the Congers farmhouse, delivered—naturally—by my grandmother. When labor first began, she'd telephoned the news to my grandfather—but before she could suggest that he might want to put off his visit that weekend, he said: "Fine! I'll take an earlier train so as not to miss anything!" It must have been a long, hard weekend . . . the ladies were exhausted—but relieved that ABD returned to New York on his usual 4:49 train that Sunday. I was born on Monday.[42]

Though determined to be present for that birth, Arthur missed it nonetheless.

A couple of weeks after Sylvia's arrival, the Davies clan gathered in Congers for a family photograph: Niles held two-week-old Sylvia: Margaret, age six months, was in David's arms; and clustered about them were Arthur, Virginia, Erica, Mildred, and the latter's 3½-year-old son Alan. (Two additional grandchildren were subsequently born, Arthur Bowen Davies II and Niles Meriwether Davies, Jr.)

Shortly thereafter Davies again departed for Europe. Before his departure on April 15, 1928, he discreetly cabled fifteen thousand francs (nearly two thousand dollars) to Germaine Montereau in Beaugency, and twenty-five thousand lira (more than thirteen hundred dollars) to Edna in Florence, funds that had just become available as a result of the sale of his oil *Without Pause—Enters, Passes, Touches* by the Montross Gallery.

Wreath modeled for him the day prior to his sailing and after the session he turned to her and said, "I've never wanted anyone else to pose for me. It's been a wonderful fourteen years."[43] This sounded ominous and strangely prophetic to her, which indeed it was. She may not have fully understood the implications of those words, however. Just days before, ABD had received a letter from a member of the art department at Smith College:

> I found a girl model out in the country last week and can't help thinking you would find her inspiring in certain of your subjects; exotic, a jeune faunesse type, way out of the ordinary.
>
> I know nothing about her except that she has posed and wants to make her living at it . . . and I promised to introduce her to you. Her name is Margie King, and she will probably call on you before long.[44]

Wreath, at age thirty, had begun losing her alluring proportions and the correspondence may have caused Davies to ponder the prospect of taking on a younger model.

The two of them strolled out of the Chelsea together and, as he descended the steps of the subway, Davies raised his hat high above his head in the customary manner and smiled goodbye. Arthur met Virginia for a farewell dinner in Manhattan that evening, after

Figure 85. Davies Family in Congers, New York, April 1928. Top row: Erica (Mrs. Niles) Davies, Mildred (Mrs. A. David) Davies, Alan, and Arthur B. Davies; Middle row: A. David Davies holding Margaret, and Dr. Virginia M. (Mrs. Arthur B.) Davies; Front row: Niles M. Davies holding Sylvia. Photograph. Collection of Mr. and Mrs. Niles Meriwether Davies, Jr.

which she returned to Congers and he prepared to embark on his tenth journey overseas.

That summer ABD expanded the subject matter of his water-colors as a result of his initial visit to Spain. One painting shows a view of Toledo, another depicts the Moors' fort at Lorca. A sketch of a distant town carries the notation "On train from Segovia to Burgos"; a watercolor of Los Rosales features horses and wagons in the foreground and tree-studded foothills beyond.

Davies spent several months capturing such subjects as the Alcazar, castles near Granada, and the harbor at Mallorca, among scores of others. He also devoted time to seeing Madrid and the Prado before moving on to Paris, from where he contacted Frederic Newlin Price on September 18: "Cable seasons prospect forecast please deposit two thousand my bank well busy. ELDAB."[45]

Eight days later ABD wrote a lengthy letter to Virginia:

> The summer has been very good in fair days, and so prolific in good work. I went to the Mallorca Islands and back through Granada, Madrid and the Pyrenees with about two hundred sketches. I made a number of pre-liminary studies for the big decoration [a mural to be based on a series of Spanish scenes], but when I got back here to find the three architects were in disagreement about the building and for the present the decorations have been set aside . . .
>
> I continue with my designs for the weavers & got some rather magnificent things, large hangings & carpets, be-sides many smaller things. At present it is quite cool & frosty in the mornings and as Paris does not agree with me in the dampness of the valley I am going again to the Carrara Mts. & also get a tonic in the sea bathing which did me so much good last year. Maybe I can get over to the Adriatic coast where it will be warm. The only per-sons from N.Y. I have seen were Mr. & Mrs. Montross, who were very cordial . . .
>
> The studio I rented has been very quiet and out of the way of travel, a femme de menage [housekeeper] who cleaned up & gave me my coffee au lait in the morning— a little balcony with flowers on the street which I have enjoyed watering well. With [the exception of] one or two

stomach spells I have been pretty well . . . I expect to be back in N.Y. the first part of Nov. With love & love to all,

From Papa[46]

A month later Arthur B. Davies was dead, and Virginia found herself imagining the story of his demise.

❧ 20 ❧
The Final Cover-Up
(1928–1932)

One chilly morning in November, 1928, Virginia Davies heard
a knock at the farmhouse door and opened it. She was confronted
by a fifty-ish woman and a slightly built teenager. Edna Potter Owen
explained that they had just arrived from Florence, Italy, had been
with Arthur B. Davies when he died, that she had lived with him for
twenty-five years under an assumed name, and that the young girl
standing beside her was his daughter. Virginia was dumbstruck (as
Ronnie had been on the ship coming over when she learned, for the
first time, the true identity of her father). Though probably furious
at Edna, Virginia's stoic nature prevented a scene of unleashed rage—
for whatever her reaction to this woman, she had to feel a sense of
compassion for the child.

Edna told Virginia that Arthur had come to Florence from
Paris by train on October 18, then suffered a heart attack within the
week in their apartment at 8 Borgo San Frediano. Ronnie was sent
to get a doctor but when he arrived it was too late to save ABD,
who died there on October 24. His last words concerned "a great
spiritual light which has come to me this night."[1] Found in his wallet
was a scrap of paper with a verse scribbled on it:

> That light which never wintry blast
> Blows out, nor rain nor snow extinguishes.

That light that shines from loving eyes upon,
Eyes that love back.[2]

The death certificate, written in Italian at the police mortuary in Florence, listed the deceased as "David Owen of New York." Edna, confused about where to ship the body if she could have it removed from Italy, panicked and had it cremated instead. A memorial service was held in Florence, and Edna noted the irony connected with it:

> ...the last page in poor Arthur Davies' trip to his dissolution into the Universal was consecrated by the brother of Alice Kellogg's best friend. He was temporarily in Florence ... and though he knew nothing of our identity, and never saw the body of the man for whom he read the service of the dead, it was simple in the week which followed before our sailing, for me to identify him, as many years ago I had known his sister well.[3]

Upon returning to the United States, a distraught Edna went immediately to Lizzie Bliss. "What should I do?" she reportedly asked. "You'll have to tell his wife," Miss Bliss replied.[4] As soon as Edna departed, Lizzie Bliss phoned Walt Kuhn, whose seventeen-year-old daughter Brenda answered the phone. Brenda recalled:

> A very warm, cultured woman's voice asked: "Is Mr. Kuhn there?" I replied: "No, he isn't, but this is his daughter. Is there a message?" "This is Miss Bliss. I wonder whether you would tell your father I just got word that Arthur B. Davies died in Italy."[5]

That evening Walt told his wife Vera the sad news, revealing for the first time that Davies had also been the man she knew as David Owen, that Edna was his long-time mistress and Ronnie his daughter. According to Brenda:

> When my mother learned who the Owens were, she was shocked. She remembered sitting and chatting with Edna

Owen in Union Square before, while I played with Ronnie
in the park in front of school. My mother's initial comment
was: "Well I'll be!" in a disbelieving tone.[6]

Virginia and Edna must have discussed with one another
various superficial aspects of their lives with Arthur, though it is
unlikely that they would have confided in each other the pain they
both felt at having been abandoned. After all, Virginia's hurt had
occurred a long time ago; for years her union with ABD had been
reduced to a marriage of convenience. For Edna's part, Mrs. Davies
was regarded as the key to obtaining some portion of the estate's
assets for Ronnie and herself, so revealing too much would have
placed that prospect in jeopardy.

When the news settled in, Davies' wife and his mistress worked
together to concoct a story aimed at hiding the awful truth. They
would travel to Italy with Ronnie. Virginia, professing to friends that
she was going alone, planned to explain that her sudden departure
was due to concern for her husband, whom she hadn't heard from
for nearly two months. She arranged to communicate with her son
David as soon as she could verify any "news," and at that point he
would distribute a press release which was to be written before the
women even departed.

Virginia and Edna fashioned details for the newspaper notice,
and prior to sailing, Edna wrote to David from a Manhattan hotel
where she and Ronnie were temporarily quartered:

> Your father's death was caused by a sudden heart attack
> brought on by mountain climbing while sketching . . . This
> was *actually* the cause of the attack—only the mountains
> were the Pistoiese which as we agreed last night should be
> substituted for the northeastern Dolomites.[7]

Virginia, Edna, and Ronnie embarked for Europe, an unusual trio of
traveling companions seeking to learn from each other about the
singular man in their lives. After collecting ABD's belongings from
the apartment in Florence, Virginia left for Paris carrying his ashes
with her. Edna and Ronnie abandoned Italy in favor of the French
Riviera, establishing residence there by the following month.

On December 10, 1928, Virginia wrote to Frederic Newlin Price from the Hotel Felix in the French capital:

> By this time Miss Bliss has probably told you that Arthur B. Davies is dead. I have taken out papers of administration and come to France endeavoring to gather up the work he has left scattered about—and to arrange for the completion of his tapestries . . . Matters seem coming along well with the Gobelin work—I am to bring back one piece and have about arranged for the delivery of three others now on the looms. . . . There are four designs left . . . for which the money must be raised. . . . Arthur and I have both known for three years that death might come this suddenly; it is an old and poignant wound and I will not have the knife turned in it by every casual hand.[8]

Virginia sent a pre-written radiogram to David on December 17, informing him that his father had died in Italy on October 24. This signaled the distribution of the press release which concluded with this account of the artist's demise.

> . . . He was going down from the mountains of Northern Italy to Florence when taken ill in this last attack. He died among persons known to him but who did not know his family or their whereabouts so that there was delay in finding them and making the death known.[9]

The news of Davies' mysterious end appeared in the New York papers the following day, and the story immediately captured the imagination of the press and public alike. "Death of Davies, Artist, Revealed After Seven Weeks" announced the *Herald Tribune;* "Arthur B. Davies, Painter, Dead in Italy, Wife Learns as She Goes There" revealed the *Times*. The former paper's story stated that he "died of heart disease in the mountains of northern Italy on October 24 while completing a landscape painting," and that

> Mrs. Davies is confident she will locate friends of his in Italy who can inform her of the particulars of his death and who

will know the name of the Italian city where his ashes are being held.[10]

When ABD's sister, Emma, received a copy of this article in Chicago from a friend back East, she wrote to the family and inquired: "Was the place where my brother died a village or a country place and has it a name? Were the people with whom he stayed English?"[11] It is doubtful that she ever received the specifics she sought.

Many major newspapers and magazines ran editorials about Davies. The *New York Times* headlined its editorial, "A Lost Mystic," while the *Philadelphia Record* characterized Davies as "an outstanding personality." The *New York Post* labeled its piece simply "Arthur B. Davies."[12] Tributes abounded from many quarters and continued for weeks. Art critic Benjamin de Casseres wrote: "Among painters we have given the world one of the very greatest [is] Arthur B. Davies." Royal Cortissoz referred to him as "one of the salient men in the history of American art." Dr. Gustavus A. Eisen predicted: "He has left the world an inheritance which will be fresher and more glorious as time passes . . . "[13]

Abby Aldrich Rockefeller wrote to David Davies in another vein:

> I have just read with very deep sorrow in the morning paper of the death of your father. I had for him the deepest admiration. . . . I owe to him a very great deal, because he inspired and encouraged me to acquire modern paintings, and without the confidence which his approval gave me I should never have dared venture into the field of modern art.[14]

On Virginia's return to the United States, she stopped off at Beaugency, France, and met Germaine Montereau, who possessed a valise containing all of ABD's tapestry sketches, plus a trunk holding some of his clothing. Mademoiselle Montereau estimated that it would cost five thousand dollars to complete the work from his designs, and once given the go-ahead, she immediately proceeded to do so. According to a letter Virginia wrote to her daughter-in-law Mildred from Paris, Germaine Montereau thought it would take two years to

complete the tapestries, but she agreed to "push it for the Spring of '30" in order to schedule "a big exhibition in New York." Virginia added that "Miss Montereau says Papa planned such an exhibition in Paris . . ."[15]

The widow also visited ABD's Paris studio, where she came upon a cache of the summer's watercolors. When she arrived in New York and entered his rooms at the Chelsea, there were hundreds of works—paintings, drawings, sculptures, and prints—on those premises as well.

Shortly after Virginia returned to Congers, a small ceremony was held on the farm and her husband's ashes were buried alongside the graves of the two Davies children who had died in infancy. The Reverend Charles E. Hamilton of Rockland Village conducted a simple private service for the immediate family and a few close friends.

The mystery of Davies' death continued to play out in the papers, giving rise to rumors that he had not really died but merely disappeared. Some skeptics even suggested that the whole affair was simply a publicity stunt, for the failure of the family to provide any further details left many bothersome questions unanswered:

> Word of his passing comes vaguely over the air many weeks after the event; his ashes are not yet found; no witnesses are known; these things combine to make it seem that he has but vanished into one of his own misty Italian distances . . .[16]

Three years later, disbelievers still remained. One paper carried an article headlined "Kansas Seeress Adds Doubt on Famous Painter's Death," which revealed how a young psychic who claimed to know nothing about art or artists was handed a Davies watercolor and declared:

> This man is still alive. Some people think he is dead, but he isn't. I see him in a foreign country—a peninsula. He is trying to hide, or at any rate he wants to keep away from people he used to know.
>
> She described him in considerable detail and with accuracy. She added that he was not using his own name. . . . [A]

coterie of the painter's friends are in consequence more than ever convinced that he is not dead.[17]

Following the December 18, 1928, newspaper announcements of Davies' death, there were numerous commemorative exhibitions. The first of these involved the Pennsylvania Academy Annual held the next month, where three of his paintings, all loaned by Lizzie Bliss, were hung in the show's traditional place of honor. A wreath was placed beneath the center canvas, appropriately titled *On the Heights*. Beginning on February 2, 1929, the Phillips Collection presented its first retrospective exhibit ever, comprised of twenty of his oils, and that same month the University of Chicago held a memorial exhibition of ABD works from the collection of Mr. and Mrs. Martin A. Ryerson, whose Davies holdings numbered twenty-seven paintings. In the meantime, Virginia was arranging with Frederic Newlin Price to schedule a series of shows. The first one opened on March 25 at the Ferargil Galleries and in it were displayed some of the watercolors Virginia had brought back from Paris.

Interest in the artist's final output was heightened by an article that had appeared in *Vanity Fair* a few months earlier, written by Julius Meier-Graefe, the renowned German art critic who had just arrived in the United States. After stating that "the predilection for watercolor is one of the most essential factors in American art," he continued:

> I found, in America, some exceptional water-colors by Arthur B. Davies. Davies seizes the aspects of landscape which lend themselves to his technique and glorifies them with delicate coloring. . . . Not only the painter's themes but also his manner of seeing belong to Europe, especially his taste . . . There are few Europeans as able in Europe to-day.[18]

A review in the *New York Sun* of the Davies exhibition at Ferargil's labeled it "Quite the most significant American art display," while the *New York Evening Post* called it "a remarkable performance" testifying to "the fecundity of invention, the unflagging interest and the fresh vision of the artist." And *New York Times* critic Edward Alden Jewell stated that "The writer cannot recall having

seen, by any hand, water colors more poignantly beautiful."[19] By the time the one-man show closed on April 8, sixty-eight of the seventy-two watercolors had been sold—twenty-one of them to Lizzie Bliss—for a total of $48,600.

Frederic Newlin Price was also rushing into production the first attempt at a catalogue raisonné of Davies' etchings and lithographs, an impressive, quarto-size publication which would sell for twenty dollars. It immediately established the dealer as the authority on ABD's graphics, usurping the former role of the Weyhe Gallery, and was calculated to stimulate the sale of untold numbers of prints remaining in the estate.

On April 14, 1929, an exhibition of Davies' prints opened at the Carnegie Institute. Two days later his art collection was auctioned off at the American Art Galleries by Hiram H. Parke and Otto Bernet. The sale included Greek and Roman bronzes, Chinese and Japanese objets d'art, Aztec and Peruvian sculptures, French eighteenth-century furniture and modern American and European art—450 items in all. Among works in the latter category were sixteen Picassos, five Cézannes, four Matisses, and fourteen Derains.

Ira Gershwin was the top bidder for a Matisse lithograph and drawings by Braque, Derain, and Luks; John Kraushaar obtained the marble head by Brancusi and Seurat's crayon drawing of *The Rain* for his gallery; and M. Knoedler and Company bought Matisse's fauve *Bather* and Ryder's *Oriental Landscape.* Lizzie Bliss purchased Signac's watercolor *The Harbor: La Rochelle,* and a Picasso drypoint, *Salome,* while Abby Aldrich Rockefeller acquired Odilon Redon's lithograph *Ari* (Boy), Seurat's charcoal drawing *Young Girl with an Umbrella,* and Max Weber's oil *Apples.* She also had the Downtown Gallery successfully bid for her on Matisse's bronze, *La Serpentine.* Other Davies' holdings eventually wound up in the Louise and Walter Arensberg Collection at the Philadelphia Museum of Art and in the Guggenheim Museum, the Art Institute of Chicago, the Hirshhorn Museum, and the Brooklyn Museum. Gross sales for the auction amounted to $33,905.

During the last week in April, Mrs. Rockefeller paid homage to ABD in another way, arranging an exhibition of his works in the private gallery of the Rockefeller mansion at 10 West Fifty-fourth Street. A group of his watercolors cascaded along the wall above a

winding staircase; among her other Davies possessions available for viewing by museum directors, critics, and collectors were oils, drawings, sculptures, and the first of his tapestries to be displayed.

Although some of the art shown was loaned for the occasion by Lizzie Bliss, Abby Rockefeller was particularly proud of her just-acquired wall hanging, *A Thousand Flowers* (Plate 16). As she would shortly write the artist's widow:

> I had so much admiration and affection for Mr. Davies that in buying the tapestry I want everything connected with it to be happy and just as he and you and I would like to have it; therefore I thought I would leave it entirely to you and your sons to name the price that you thought just and right . . . [20]

The tapestry, featuring two rows of six gesturing and cavorting nudes placed against a floral background with a thirteenth figure reaching down to pluck a blossom, is rooted in such double-tiered compositions as *The Last Judgment* by Giovanni di Paolo. According to Virginia:

> The design for this work was really his reaction to the Chinese Art treasures shown him by Mrs. Rockefeller. He came home from seeing them very much exalted in spirit and said: "I shall make something fit to put beside them . . . "[21]

In reporting on the Rockefeller exhibit as a tribute to Davies, the *Herald Tribune* pointed out that it

> was, indeed, momentary and had no public purpose. But that it should have been organized at all was by itself a testimony to the power which Davies exerted through his art. . . . Mrs. Rockefeller's modest gesture is appreciatively to be noted as an indication of the potency of his tradition.[22]

To benefit a larger audience, Abby Rockefeller invited the general public to visit International House in order to view the Davies murals.

During the following month she hosted a luncheon attended by Lizzie Bliss, Mary Quinn Sullivan, and a third guest, A. Conger Goodyear, a banker and the driving force behind the Albright Art Gallery in his native Buffalo. At one point during the meal, Mrs. Rockefeller said, "Shall we ask Mr. Goodyear the question we had in mind?"[23] She proceeded to request that he head a fund-raising committee, on which the women present also would serve, to establish a modern art museum in New York City. Thus was born the Museum of Modern Art, which could rightly be called a memorial to Davies.

All three women had come under ABD's influence either shortly before or after the Armory Show, and each was an avid collector of his work. They recognized the fact that the Metropolitan Museum of Art's acquisitions committee bought cautiously, avoiding twentieth-century European and American moderns. In 1921 Forbes Watson had recommended that Davies and John Quinn be named to a reconstituted purchasing committee at the Metropolitan, but the suggestion was not accepted.

Abby Rockefeller and Lizzie Bliss bemoaned the fact that the Quinn collection had not been kept intact after his death and they were reluctant to bequeath their own holdings to the Metropolitan for fear that such modern examples would be relegated to basement storage racks. Although Miss Bliss and Mrs. Rockefeller had discussed the idea of a new museum before, it jelled when they met by chance while vacationing in the Middle East shortly after Davies' death. As Elizabeth Bliss Cobb recalled:

> My aunt [Lizzie Bliss], my father and I were travelling from Egypt to Jerusalem, and the Rockefeller family was travelling from Jerusalem to Egypt. We all had lunch together in Jerusalem . . . and the story is that they decided it there.[24]

By coincidence, Abby Rockefeller encountered Mary Sullivan on the ship returning home, and they talked over the same plan. Then, when the Davies collection was sold at auction and dispersed only four months after the announcement of his death, the women were spurred into action.

Word of the project spread rapidly. An art dealer named Abel William Bahr, who had been a long-time friend of ABD's and col-

lected his work offered to lend his approximately sixty Davies pastels and several oils to the Museum of Modern Art for a memorial show the following winter. But an ABD memorial exhibition had already been scheduled for the Metropolitan Museum of Art, so the offer was graciously declined.

To mark the first anniversary of Davies' death, the Ferargil Galleries held an exhibit beginning on November 4, 1929, of nearly seventy of the early and late paintings, among which were some of his final, unfinished canvases. The opening was attended by many who sought to pay homage, including Lizzie Bliss, Bryson Burroughs, Royal Cortissoz, Carl Zigrosser, Frank Crowninshield, Forbes Watson, Duncan Phillips, and Walter Damrosch. As usual, Davies' work received rave reviews. "There is not one without the singular beauty which this artist had at his fingertips,"[25] wrote Royal Cortissoz in the *Herald Tribune*. Margaret Breuning opined in the *Post:* " . . . From the whole exhibition there comes the stimulus of creative imagination acting at white heat . . . "[26]

When the show closed, a headline in the *Art Digest* revealed: "$50,000 of Sales Made at Davies Exhibition,"[27] which amount included $12,000 for a single painting titled *I Hear America Singing*. The large canvas had been inspired by Walt Whitman's poem "Song of Myself" from *Leaves of Grass;* ABD had consistently refused to sell the oil during his lifetime.

Bryson Burroughs, the Metropolitan Museum's Curator of Painting, had written to Virginia in September, expressing concern that the Ferargil exhibit would upstage the one scheduled for the Met and asking that it be postponed. But both shows went on as planned, the *Arthur B. Davies Memorial Exhibition* at the Metropolitan on view from February 17 to March 30, 1930. It was only the eighth such commemorative exhibit held there for an American artist, the practice having begun only a decade before.

The Davies display at the Met involved over 200 works, dominated by 126 oils and including 23 watercolors, 10 drawings, 3 encaustics, 14 tapestries, 13 rugs, and an unlisted number of statuettes in wood, bronze, terra-cotta, enamel, and glass. One of the special attractions at the exhibit was the textiles, which were seen by the general public for the first time. "So far as is known," the *Art News* reported, "he is the only American artist whose cartoons have

been executed by workers of the famous Gobelin factory, for more than 300 years a manufactory of the French Government."[28]

Virginia had seen to the completion of those tapestries left unfinished at the time of his death, having them and several designs in cartoon stage carried out by Germaine Montereau and her Gobelin workers. Mademoiselle Montereau devoted over a year to producing ABD's final design, *The Animals of Eden,* and charged 25,000 francs ($1,250) for it. Of that amount, Virginia paid $500, the remainder being underwritten by Lizzie Bliss, who then purchased the work. When Virginia had sought to have this and the other tapestries shipped to New York, she learned that there would be an import duty of between fifty and seventy-five percent on what the United States government considered manufactured woolen goods rather than art. She had petitioned the Tariff Commission concerning the charge: "It has been my function to have the work carried on in France and to bring them back," she wrote, adding:

> I have brought in seven examples completed since the artist's death, and under protest, paid duty on them . . . There remain in France the four made from the cartoons which he left, put on the looms three months after his death; these tapestries made by the same Gobelin artists are now completed in fifteen months labor and ready to be brought to the United States.[29]

A compromise had been reached, the commission permitting Virginia to import six of the works duty-free as part of her husband's effects because he had died abroad.

An indication of the special regard for Davies in American art circles at the time was that when the Metropolitan Museum exhibit closed in New York, it was sent on a three-year tour by the American Federation of Arts. It was seen in twenty-one museums and galleries in seventeen states, including institutions in Washington, Baltimore, Detroit, Milwaukee, and Portland, Oregon. Simultaneously, Frederic Newlin Price organized two additional memorial exhibitions, one consisting of watercolors, the other of prints, which traveled to such cities as Philadelphia, Chicago, Dayton, Denver, and San Francisco. By November, 1930, the *New York World* could report that "museums and

galleries have held more memorial exhibitions of his [Davies'] work than have favored any other artist within living memory."[30]

Meanwhile, the Museum of Modern Art had established its presence on the twelfth floor of the Heckscher Building at 730 Fifth Avenue. Lacking anything in the way of a permanent collection, it filled its five rooms with various loan exhibitions until May, 1931, when it moved into its own home at 11 West Fifty-third Street. The building, donated by the Rockefellers, contained four floors of gallery space and one of offices. Sadly, Lizzie Bliss, who had served as vice-president of the board of trustees, did not live to see the transition to larger quarters. She had died on March 12, at the age of sixty-seven.

The inaugural exhibit at the new location occurred on May 17, with the *Memorial Exhibition of the Collection of Miss Lizzie P. Bliss.* On the walls were many of her icons of nineteenth- and twentieth-century art: Daumier's *The Laundress;* Cézanne's *Self-Portrait, Still-Life with Apples,* and *Landscape: Pines and Rocks;* Monet's *The Cliff at Etretat;* Degas' *After the Bath;* Matisse's *Interior;* Picasso's *Woman in White;* and much more. There were many of Davies' major works as well, including thirty-eight of his oils. In fact, more than one-quarter of the drawings, paintings, and graphics exhibited were by ABD. A writer observed that "One whole room of the present exhibition is devoted almost exclusively to Davies's work and gives a keynote to the exhibition."[31] *Herald Tribune* critic Elisabeth Luther Cary indicated that "They [the ABD paintings] fully ratify our conception of Davies as a creative artist, one of the noblest figures in American painting. . . . "[32] In an earlier article about the collection, she wrote that

> It would be quite impossible to see Davies whole without seeing him in the Bliss collection; and most certainly, it would be impossible to see the Bliss collection fairly represented without its distinguished group of Davies paintings.[33]

The Lizzie Bliss holdings were left to the Museum of Modern Art with the proviso that within three years an endowment fund of six hundred thousand dollars be raised. The goal was difficult to attain because the Great Depression had gripped the country. Yet on the third anniversary of her death the amount was in hand and Lizzie

Bliss' art was presented to the museum. On that occasion, Director Alfred H. Barr, Jr., was quoted as saying:

> With the Bliss collection, New York can now look London, Paris, Berlin, Munich, Moscow and Chicago in the face so far as public collections of modern art are concerned. Without it we would still have had to hang our heads as a backward community.[34]

Two years later, Abby Aldrich Rockefeller gave a sizable segment of her acquisitions to the Museum of Modern Art as well. "What I think," said Elizabeth Bliss Cobb,

> is that these women would never have done this or even maybe made their collections if it hadn't been for Arthur B. Davies . . . I think that his influence on these women is what brought it all about.[35]

The true depth of feeling Arthur B. Davies and Lizzie Bliss had for each other can only be imagined, for any recorded reference to this has long since been destroyed. After she died, a large shoe box packed with correspondence was discovered, on the top of which she had written: "These letters are to be burned without being read." Lizzie's brother and niece dutifully sat before a fireplace and tossed them in, a few at a time. "I've always supposed that most of those letters were from Arthur B. Davies,"[36] Elizabeth Bliss Cobb remarked. "I know that when she [Lizzie Bliss] told me she was going to leave me the Davies [music] room [murals] she said 'I wish I could leave you the letter that he wrote me when he painted it.' But she didn't . . . I'm sure it was a very intimate and a very warm correspondence."[37]

What may have become a treasure-trove or a Pandora's Box—one from which Davies' litany of vices could have escaped into the world—remains instead merely fodder for one's fertile imagination. The loss of any secret thoughts or amorous outpourings of poetry or prose contained on those pages serve now only to further fuel the mystique surrounding the lives, loves, and art of Arthur B. Davies.

❦ *Epilogue* ❧

*I*n Congers, New York, the name "The Golden Bough" is no longer associated with the land that continues to nurture acres of apple trees, and where a narrow lane named Dr. Davies Road comes to an end at the entrance to a farmhouse. The house in which Arthur B. Davies and Virginia Meriwether Davis were wed over a century ago still stands in well-preserved condition, occupied by their grandson, Niles Meriwether Davies, Jr., and his wife Jan. Somewhere beyond the two-story structure is a plot of ground which received the artist's ashes and those of Virginia and their infant children. There, too, are Ronnie's and Niles, Sr.'s cremated remains, intermingled as those of a half-sister and half-brother should rightfully be.

When Edna and Ronnie moved from Florence to Cannes, their sense of a new beginning was tempered by bitterness. In April, 1929, Ronnie wrote to David Davies:

> Put yourself in my place, Dave, having no money, no *name,* honest the world is hard! . . . The little money mother has was none that father gave her. Father did *not* do the right thing toward either mother or me. We both have gotten a rotten deal.[1]

Ronnie obtained a job as an apprentice in an antique shop and in the fall of 1929 she and her mother opened an antique business of their own and lived above the store. But when the worldwide Depression hit, their funds were quickly exhausted.

Edna's brother in Brooklyn could not help but be attracted to newspaper accounts lauding the financial success of Davies' exhibits

and the sale of his art collection. Once he informed Edna, she and Ronnie began a letter-writing campaign from France to solicit funds from the Davies family, monies they considered rightfully theirs. Unlike the long-time mistress of Charles Dickens, who was the first person named in his will, Edna Potter Owen had been entirely omitted from ABD's. Pierpont Potter, still practicing law, proposed that an estate fund be set up for the three Davies children, with one-third of it designated for Ronnie. This was agreed to by a conciliatory Virginia.

The further activities of Edna and Ronnie are sketchy at best. In 1939, Ronnie, then twenty-seven, was engaged to be married, but when the prospective bridegroom was called to French military service the wedding plans were canceled. With Europe already at war, Edna saw to it that her daughter left for the United States in 1940, though Edna stayed on in France. She is said to have spent 1943 and 1944 in a German concentration camp. She survived the ordeal but died of cancer in Cannes in 1947 at the age of seventy.

Ronnie gained employment at a variety of jobs in New York City, first as a practical nurse, then as housekeeper and cook for actress Cornelia Otis Skinner, and finally as a receptionist for the Kennedy Galleries and Sotheby's. She eventually married, but when she developed cancer of the spine and died at the age of sixty-six on October 29, 1978, her body was abandoned at a hospital in Brooklyn and her belongings put out on the street. Ronnie was cremated. The ashes were interred in a potter's field at the Greenwood Cemetery in Brooklyn until her half-niece Dr. Sylvia Davies saw to it that they were brought to the farm in Congers.

Dr. Virginia Meriwether Davies lived the rest of her days on the farm, continuing to promote Arthur's art as best she could, enjoying her sons, daughters-in-law and grandchildren, and maintaining a practice until three weeks before her death. Dr. Davies' role in delivering more than six thousand babies is surely a record, as well as her fifty-seven-year career as a country doctor. Virginia died at the farm on April 21, 1949, just three days after celebrating her eighty-seventh birthday.

During the two decades between the death of ABD and that of his wife, the artist's reputation experienced a steady decline. This was brought about by a combination of factors, including the deep-

ening Depression of the 1930s, changing tastes in art, and a some-times nonprofessional handling of the remaining art in the estate. Despite the efforts of Virginia and Frederic Newlin Price, it soon became apparent that Arthur had been his own best salesman, the individual whose mere presence was responsible for initiating nu-merous purchases.

Virginia Davies was overwhelmed by her continuing duties. In January, 1930, less than two months after the close of an ABD exhibit at Ferargil's, she gathered together sixty-one of his unfinished paintings that had been found in the Chelsea Hotel studio and made a bonfire of them on the farm. She committed the act, according to *Time* magazine, "because she did not consider them 'representa-tive.' " The article concluded, "Undoubtedly Widow Davies built an expensive bonfire."[2] Virginia had not thought to seek professional advice from a museum curator or art critic but relied solely on her own judgment and that of her son David. The most unfortunate aspect of the bonfire incident was that, without this professional input, Virginia hadn't considered the ramifications of her action. Since a number of the sales in the Ferargil show had likewise involved unfinished canvases, this mass destruction cast doubt on the value of those already sold. In addition, she was quoted in the press as saying that another 140 incomplete oils had been saved for future sale. Their value, too, became questionable.

In 1931 a monograph about Davies—a picture book with a short text by Royal Cortissoz—was published as part of the Whitney Museum's American Artists Series. Included in it is a list entitled "The Known Paintings by Arthur B. Davies" compiled by Virginia, a well-intentioned act but one bound to be replete with errors. After all, ABD seldom dated his canvases, kept no extensive records, and most of his work had been created and stored in Manhattan where it was unseen by his wife. Among the erroneous information she provided: The oil *Arethusa* is dated 1910, though it had been exhib-ited in the First Carnegie International of 1896; 1896 was assigned to *Parting at Evening,* although it was shown at Macbeth's two years before; *Little lamb, who made thee?* was exhibited in 1894 but dated by Virginia as 1911; she indicated *L'Allegro* belonged to 1911 though it had been shown at the National Arts Club in 1904; and the *Wild He-Goats Dance,* from 1915, was assigned to 1920, long after

ABD had ceased painting cubistically. Documentation of the proper evolution of Davies' stylistic development suffered as a result.

When Lizzie Bliss died in 1931, no well-to-do socialite stepped forward to fill the void in promoting Davies' work. Nevertheless Bliss had sought to enhance his reputation through her will by showering museums throughout the country with bequests of his art. Two additional oils, *Sleep* and *Moral Law—Line of Mountains,* were left to the Tate Gallery in London, an appropriate gesture in view of Davies' early attraction to the Pre-Raphaelites and his lifelong love of William Blake. Yet later that year, newspapers on this side of the Atlantic revealed the Tate's refusal of the gift. "London Rejects Bliss Bequest of Davies's Art" announced the headline in the *Herald Tribune* on December 31, 1931. The board of the Tate had taken the unexpected action at its November meeting, then reaffirmed the decision in January. No reason was given for the rebuff, allowing critics in the United States to cite such possible explanations as the low regard of American art by the British and the lack of American paintings in the Tate. (Only Copley, West, Whistler, and Sargent were represented there and they were considered English artists in Britain.)

Regardless of the rationalization, this was less than complimentary to Davies. The *New York Times* opined that "it casts an implied aspersion on one of the best loved of modern American painters."[3] *Art News* reported a cable from London indicating that "there were differences of opinion among the trustees concerning the quality of these works."[4]

Adding to a declining interest in Davies' art was the feeling that during the 1930s his dream paintings appeared more and more out of sync with the mood of America. Reveries had limited appeal in a land awash with the urban unemployed and rural families made homeless by the Dust Bowl. Throughout the decade following ABD's death, when American art became successively dominated by social realism and regionalism, many would have agreed with critic Guy Pène du Bois' assessment that "Perhaps Davies cannot be given his due in this materialistic machine age, be understood by it."[5]

In 1940 another setback befell ABD's reputation and art: A fire caused by an electrical short circuit burned through a barn on the farm in which Davies' work was stored. An estimated fifteen-thousand-dollars worth of drawings, paintings, tapestries, and prints

were lost, with many others singed by the flames. "Not long before the fire, Mrs. John D. Rockefeller, Jr. had paid $9,000 for a Davies tapestry and $1,000 for a design cartoon," reported the *Times,* "so the dollar estimate of the art loss may have been somewhat low."[6] It was a calamity, destroying or noticeably damaging works from all periods of the artist's oeuvre with a lasting effect.

Following the conclusion of World War II, Virginia, then in her mid-eighties, sought to divest the estate of its remaining art holdings. She entered into an agreement with a new dealer to "Sell the unfinished works [by ABD] at what you can get, the drawings $5 and $10 to students, the unfinished canvases $450 to $750, holding the finished ones at $1500–$4500 . . . "[7] Thus the bottom dropped out of the one-time pricey market for the art of Arthur B. Davies.

A final blow to ABD's reputation occurred in August, 1949, when the seven murals he had executed for the lobby of the Rockefellers' International House were removed just a quarter-century after their installation. At the time of Davies' death, Abby Rockefeller had written to his son David about the murals:

> The last time I saw your father in his studio, he showed me a small sketch which he said was for one of the two additional decorations that he was planning to make for International House. I very much hope that he was able to finish these pictures, because as far as I know, these are the only decorations in a public place that he has done, and they will be a very lasting and fitting memorial to him and will carry a very real message of beauty and hope to the young people from all over the world who live and meet there.[8]

The decision to take down the murals was made by unanimous vote of the trustees. The murals apparently had never been popular with the graduate students who were housed there due to their inability to understand the symbolism. Additionally, some of the trustees were reported to be offended by the partial nudity of a few of the figures; these trustees had even sought to have them painted out. Once Davies' canvases were withdrawn, the walls were covered by wallpaper containing a unicorn pattern, reproductions of the group of tapestries the Rockefellers had presented to the Cloisters.

It must have appeared to some an appropriate substitute for the work of this painter of unicorns.

Despite such setbacks as these to a once highly held reputation, many of Davies' long-time supporters remained loyal. In 1939 Mrs. Cornelius J. Sullivan displayed nearly one hundred of his works in her Park Avenue gallery, prompting the *Herald Tribune*'s art critic to label it " . . . a remarkable show filled with landscapes and figure subjects of rich feeling and imagination. . . . "[9] A review appearing in the *Art Digest* suggested that

> . . . with art fashions once more in a state of flux, Davies' poetic landscapes and his figure-strewn canvases will appeal to many who are growing weary of artists who can see nothing but misery and ugliness in the world. Davies saw beauty where it must still exist, in the mind and imagination of man . . . [10]

When Knoedler's held a one-man show of his watercolors in September, 1941, the *New York Sun* pointed out that

> unless tastes have utterly changed in the last decade or two, anything that bears the impress of the hand of Arthur B. Davies is bound to be of interest to a fairly wide circle.[11]

The Whitney Museum of American Art, which had included Davies in its inaugural exhibit in 1931 and shown *Textiles and Sculpture by Arthur B. Davies* in 1935, was among seven museums to display *A Centennial Exhibition,* marking the anniversary of his birth, during 1962. Curator John Gordon of the Whitney wrote that

> . . . At a time when we are bombarded by the bold and noisy experiments of contemporary art, this exhibition provides us with an opportunity to enjoy the work of a rare and gentle romantic visionary. His tranquil and nostalgic statements depicting moments of quiet enjoyment, are indeed an oasis in 20th-century American art.[12]

Leslie Katz stated in his review of the exhibition in *Arts Magazine:*

> . . . The art of Davies is a triumphant epochal achievement. . . .
> We shall, among American painters, see the like of Davies
> again some day—the tradition he represents is not dead but
> somnolent—and when we do, his merit as a painter, and
> our debt to him for holding to his way, will be more
> apparent. The power of his art challenges the confines of
> our aesthetic notions more than we can question his.[13]

Still in the forefront of American art on certain occasions,
ABD was included on a list of the twenty-two "most wanted" artists
chosen by a committee for the Preservation of the White House, a
group hoping "to build a collection that reflects the best in history
and art."[14] His name appeared along with those of Copley, Peale,
Bingham, Ryder, Twachtman, and Sloan.

Perhaps, were ABD's final resting place on the farm graced
by a grave marker or a headstone, it would carry an appropriate
epitaph, such as *Magazine of Art* editor Forbes Watson's statement
characterizing him as "that remarkable phenomenon, an artist who
enjoyed an immense success and at the same time was respected by
other artists." Equally poignant is another thought of Watson's: "had
it not been for Arthur B. Davies, modern art in America might not
yet be the official art of the schools and the museums."

The most succinct and fitting tribute could well be the same
editor's words that "He beat his own path, and it led up the moun-
tain" or, better still, "He gained an eminence that few artists reach
in their lifetime."[15] While all of these sentiments ring true, they
merely serve as reminders that the real remembrance of Arthur B.
Davies, as with any artist, is not embodied in an inscription near his
or her mortal remains but is rather evoked by viewing and appre-
ciating examples of the living art in combination with recalling the
positive, unselfish deeds accomplished over a lifetime.

❧ *Appendix* I ❧
One-Man Shows by Arthur B. Davies

1895 — April
Frederick Keppel and Company, Chicago. Paintings.

1896 — March 9–21
Macbeth Gallery, New York. Paintings.

April
Frederick Keppel and Company, Chicago. Paintings.

1897 — April 24–May 8
Macbeth Gallery, New York. Paintings.

1898 — Winter (March?)
Macbeth Gallery, New York. Drawings.

December
Macbeth Gallery, New York.

1901 — May 9–31
Macbeth Gallery, New York. Paintings.

November 4–30
Pratt Institute, Brooklyn. Paintings and drawings.

1902 — February 28–March
Veltin School, New York.

April
Macbeth Gallery, New York. Paintings.

1903 — April
Macbeth Gallery, New York.

1905 — February 23–March 8
Doll and Richards Gallery, Boston. Paintings.

April 1–15
Macbeth Gallery, New York. Paintings.

1909 — February 19–March 4
Macbeth Gallery, New York. Paintings.

March 16–30
Worcester Art Museum, Worcester, Massachusetts. Paintings.

1910 — November 10–January 13, 1911
Portland Art Museum, Portland, Oregon. Figure drawings.

1911 — January 3–22
Art Institute of Chicago. Paintings.

December 15–January 1, 1912
Women's Cosmopolitan Club, New York. Loan exhibition
of paintings from the collections of Gertrude Vanderbilt
Whitney, Col. Henry Thomas Chapman, Gertrude
Käsebier, and Lizzie Bliss.

1912 — March 18–30
Macbeth Gallery, New York. Paintings.

April 5–12
Doll and Richards Gallery, Boston. Paintings.

1913 — March
Macbeth Gallery, New York. Drawings.

1914 — January
Carroll Galleries, New York. Figure studies.

December
Gamut Club, New York. Paintings.

1916 — January–April
Post-Panama-Pacific Exhibition, San Francisco. Paintings
and drawings.

1917 — Summer
Newport Art Association, Newport, Rhode Island. Paintings.

1918 — January 2–31
Macbeth Gallery, New York. Loan exhibition of paintings, watercolors, drawings, sculpture, and prints, loaned anonymously by Lizzie Bliss.

May
Chicago Arts Club. Works in various media.

1920 — January 26–February 14
M. de Zayas, New York. Paintings, watercolors, and prints.

March 9–April 1
Art Institute of Chicago. Paintings, watercolors, prints, and drawings.

December 14–31
E. Weyhe, New York. Lithographs, aquatints, and drypoints.

1921 — January
E. Weyhe, New York. Etchings, aquatints, and lithographs.

February 21–March 7
Albert Roullier Art Galleries, Chicago. Prints and watercolors.

April 16–30
M. de Zayas, New York. Paintings and watercolors.

December 17–January 17, 1922
E. Weyhe, New York. Watercolors, lithographs, and etchings.

1922 — January
Ferargil Galleries, New York. Paintings.

March
Ferargil Galleries, New York. Watercolors and pastels.

December 1–January 2, 1923
Buffalo Fine Arts Academy, Buffalo, New York. Paintings.

December
E. Weyhe, New York. Color lithographs, aquatints, and watercolors.

December
Ferargil Galleries, New York. Paintings.

1923 — April 23–May 19
Montross Gallery, New York. Paintings.

November
John Herron Art Institute, Indianapolis. Paintings and lithographs.

December 1–January 2, 1924
Albright Art Gallery, Buffalo Fine Arts Academy, Buffalo, New York. Paintings.

December–January, 1924
E. Weyhe, New York. Watercolors and drawings.

1924 — January
Memorial Art Gallery, Rochester, New York. Paintings and lithographs.

January
Albert Roullier Art Galleries, Chicago. Drawings.

January
Mabel Ulrich Book Shop, Minneapolis. Etchings and lithographs.

February 18–March 31
Carnegie Institute, Pittsburgh. Paintings, watercolors, and drawings.

March
Dayton Art Institute, Dayton, Ohio. Paintings.

March 20–April 22
Art Institute of Chicago. Paintings and lithographs.

May
Worcester Art Museum, Worcester, Massachusetts. Paintings.

1925 — February–March
Ferargil Galleries, New York. Watercolors.

June 9–30
Corcoran Gallery of Art, Washington. Watercolors.

July–August 31
Carnegie Institute, Pittsburgh. Watercolors.

October
Baltimore Museum of Art. Watercolors and pastels.

1927 — April
John Herron Art Institute, Indianapolis. Watercolors.

1928 — February 1–12
Philadelphia Art Alliance. Prints.

April–May
Ferargil Galleries, New York. Paintings, watercolors, and lithographs.

June–July
Ferargil Galleries, New York. Aquatints.

July 25–October 1
Art Institute of Chicago. Paintings.

September
E. Weyhe, New York. Lithographs, etchings, and engravings.

1929 — February
University of Chicago. Loan exhibition from the collection of Mr. and Mrs. Martin A. Ryerson. Paintings.

February
S. and G. Gump, San Francisco. Lithographs, etchings, and aquatints.

February–June
Phillips Collection, Washington. Paintings.

March
Brooks Memorial Art Gallery, Memphis, Tennessee. Prints and pastels.

March 25–April 8
Ferargil Galleries, New York. Watercolors and sculpture.

April
Private galleries in the home of Mrs. John D. Rockefeller, Jr., New York. Paintings, watercolors, sculpture, and prints.

April 14–30
Carnegie Institute, Pittsburgh. Prints.

April 29–May 11
E. Weyhe, New York. Etchings and lithographs.

June
McClees Gallery, Philadelphia. Prints.

August
St. Louis Museum. Paintings, watercolors, prints, and drawings.

November 4–25
Ferargil Galleries, New York. Paintings.

December 5–23
Philadelphia Art Alliance. Paintings, drawings, and prints.

1930 — February
Gordon Galleries, Detroit. Watercolors.

February 17–March 30
Metropolitan Museum of Art, New York. Paintings, watercolors, sculpture, drawings, and textiles.

March 12–April 30
Art Institute of Chicago. Prints.

April
Kennedy and Company, New York. Etchings and lithographs.

May 1–25
Corcoran Gallery of Art, Washington. Paintings, watercolors, sculpture, drawings, and textiles.

May
Kansas City Art Institute. Watercolors.

June
Dayton Art Institute, Dayton, Ohio. Watercolors.

October
Denver Art Museum. Watercolors..

October–November
Baltimore Museum of Art. Paintings, watercolors, sculpture, drawings, and textiles.

November
S. and G. Gump Company, San Francisco. Watercolors.

December
Milwaukee Art Institute. Paintings, watercolors, sculpture, drawings, and textiles.

1931 — January 6–30
Utica Public Library Art Gallery, Utica, New York. Paintings.

February 12–March 8
Memorial Art Gallery, Rochester, New York. Paintings, watercolors, sculpture, drawings, and textiles.

March
New York Public Library. Prints.

April
Columbus Gallery of Fine Arts, Columbus, Ohio. Paintings, watercolors, drawings, prints, and textiles.

April 14–May 17
Detroit Institute of Arts. Paintings.

June
John Herron Art Institute, Indianapolis. Paintings, watercolors, sculpture, drawings, and textiles.

December 7–25
Ferargil Galleries, New York. Paintings, drawings, and sculpture.

1932 — February
Portland Art Museum, Portland, Oregon. Paintings.

November 28–December 10
Cronyn and Lowndes Gallery, New York. Paintings.

1933 — February 6–25
Ferargil Galleries, New York. Paintings.

April 27–May 22
Williams College, Williamstown, Massachusetts. Paintings, watercolors, drawings, prints, and textiles.

1934 — October 30–December 10
Cleveland Museum of Art. Prints and drawings.

December
Ferargil Galleries, New York. Watercolors and drawings.

1935 — January 15–February 8
Whitney Museum of American Art, New York. Textiles and sculpture.

June
Ferargil Galleries, New York. Watercolors, pastels, and drawings.

1936 — October 1–31
Kleeman Galleries, New York. Paintings.

October 2–28
Brooks Memorial Art Gallery, Memphis, Tennessee. Watercolors and textiles.

1939 — February 7–28
Mrs. Cornelius J. Sullivan Gallery, New York. Paintings.

April 17–May 6
Ferargil Galleries, New York. Paintings.

1940 — January–February
Ferargil Galleries, New York. Paintings and watercolors.

1941 — September
M. Knoedler and Company, New York. Watercolors.

1945 — May 21–June 8
Ferargil Galleries, New York. Paintings, drawings, and prints.

1956 — June 28–September 30
Munson-Williams-Proctor Institute, Utica, New York. Paintings, drawings, and prints.

1958 — February 1–28
James Graham and Sons, New York. Paintings and watercolors.

February 3–March 1
Zabriskie Gallery, New York. Paintings, watercolors, and prints.

1960 — February 2–March 5
James Graham and Sons, New York. Paintings, watercolors, and drawings.

1962 — July 8–August 26
Munson-Williams-Proctor Institute, Utica, New York. Paintings, watercolors, sculpture, and textiles.

September 18–October 17
Whitney Museum of American Art, New York. Paintings, watercolors, sculpture, and textiles.

September 25–October 27
James Graham and Sons, New York. Paintings and drawings.

November 30–December 26
Memorial Art Gallery, University of Rochester, Rochester, New York. Paintings, watercolors, sculpture, and textiles.

1963 — January 11–February 10
Virginia Museum of Fine Arts, Richmond. Paintings, watercolors, sculpture, and textiles.

February 25–March 25
Cincinnati Art Museum. Paintings, watercolors, sculpture, and textiles.

April 3–May 5
City Art Museum of St. Louis. Paintings, watercolors, sculpture, and textiles.

May 23–June 23
Museum of Fine Arts, Boston. Paintings, watercolors, sculpture, and textiles.

1965 — October 19–November 13
Jack Tanzer Gallery, New York. Paintings, drawings, and prints.

November 6–December 4
Noah Goldowsky Gallery, New York. Watercolors and pastels.

1966 — February 28–April 2
American Masters Gallery, Los Angeles. Paintings.

November 1–26
Associated American Artists, New York. Etchings, dry-points, and lithographs.

1967 — March 4–26
Tucson Art Center, Tucson, Arizona. Paintings, watercolors, and prints.

April 5–May 7
La Jolla Museum of Art, La Jolla, California. Paintings, watercolors, and prints.

May 21–June 18
Utah Museum of Art, University of Utah, Salt Lake City, Utah. Paintings, watercolors, and prints.

1972 — July 9–August 6
Harbor Gallery, Cold Spring Harbor, New York. Etchings, aquatints, woodcuts, and lithographs.

September 11–26
Hirschl and Adler Galleries, New York. Etchings and lithographs.

October 17–November 7
Elizabeth Ives Bartholet, New York. Paintings and drawings.

1973 — May 18–June 2
Shore Galleries, Boston. Paintings.

1974 — December 15–January 5, 1975
Munson-Williams-Proctor Institute, Utica, New York. Paintings, watercolors, drawings, prints, and textiles.

1975 — March 11–April 15
M. Knoedler and Company, New York. Paintings, water-colors, drawings, and prints.

1976 — September 12–October 8
Lehigh University, Bethlehem, Pennsylvania. Drawings.

1977 — October 15–November 20
Rockland Center for the Arts, West Nyack, New York. Paintings, watercolors, and textiles.

1978 — April 7–29
Tomlinson Collection gallery, Baltimore. Prints.

1979 — June 24–September 9
Museum of Art, Pennsylvania State University, State College, Pennsylvania. Paintings from the collection of Mr. and Mrs. Herbert Brill.

1981 — September 8–October 30
Munson-Williams-Proctor Institute, Utica, New York. Paintings, sculpture, drawings, and prints.

December 5–February 7, 1982
Phillips Collection, Washington. Paintings, sculpture, drawings, and prints.

1982 — March 17–May 10
Institute of Contemporary Arts, Boston. Paintings, sculpture, drawings, and prints.

June 1–July 15
Marion Koogler McNay Art Institute, San Antonio, Texas. Paintings, sculpture, drawings, and prints.

1983 — September 9–30
Hickory Museum of Art, Hickory, North Carolina. Paintings, drawings, and prints.

December 2–January 25, 1984
St. John's Museum of Art, Wilmington, North Carolina. Paintings, drawings, and prints.

1984 — February 5–26
Weatherspoon Art Gallery, University of North Carolina, Greensboro. Paintings, drawings, and prints.

March 2–April 8
Duke University Museum of Art, Durham, North Carolina. Paintings, drawings, and prints.

April 21–May
Waterworks Gallery, Salisbury, North Carolina. Paintings, drawings, and prints.

June
Wilkes Art Gallery, North Wilkesboro, North Carolina. Paintings, drawings, and prints.

July 1–29
Jailhouse Gallery, Morganton, North Carolina. Paintings, drawings, and prints.

September 5–26
Farthing Gallery, Appalachian State University, Boone, North Carolina. Paintings, drawings, and prints.

1987 — May 19–July 12
Baltimore Museum of Art. Watercolors and drawings.

August 12–September 20
Walt Kuhn Gallery, Cape Neddick, Maine. Watercolors and drawings.

1993 — March 9–September 5
Metropolitan Museum of Art, New York. Pastels.

1995 — May 3–July 31
Corcoran Gallery of Art, Washington. Drawings, paintings, and prints.

1996 — August 17–October 13
Munson-Williams-Proctor Institute, Utica, New York. The museum's collection, including paintings, drawings, prints, sculpture, and tapestry.

❧ *Appendix* II ❧
New York City Residence/Studio Addresses
of Arthur B. Davies/David A. Owen

Arthur B. Davies

1888–1889	116 E. 28th St. and Newtown, Long Island
1889–1890	270 W. 12th St.
1890	147 Forsyth St.
1891–1893	19 W. 22nd St.
1893	116 E. 28th St.
1894	Room 16, 152 W. 55th St.
1894–1895	116 E. 28th St.
1896	Windermere Apts., 404 W. 57th St.
1898	1140 Broadway
1898–1906	237 Fifth Ave.
1907	25 W. 34th St.
1907–1911	53 W. 39th St.
1912–1926	337 E. 57th St.
1926–1928	Chelsea Hotel, 222 W. 23rd St.

David A. Owen

1905–1917	314 E. 52nd St.
1917–1918	155 E. 21st St. and 56 Ocean Ave., Ideal Beach, Keansburg, N.J.

1918–1920	348 E. 18th St.
1920	58 E. 18th St.
1920–1922	348 E. 18th St.
1922–1923	337 E. 67th St. and 310 E. 18th St.
1923–1926	130 E. 24th St.
1926	53 W. 39th St.
1927–1928	100 E. 45th St.

❧ *Appendix III* ❧
Chronology

1862 *September 26.* Arthur Bowen Davies born in Utica, New York, the fourth of five children of David Thomas and Phoebe Loakes Davies.

1872 Demonstrates an aptitude for art; produces his first oil painting, a copy of a magazine illustration.

1876 Begins taking private art lessons with Dwight Williams.

1878 Attends an art exhibit comprised of 250 works by contemporary American artists; attracted to paintings by George Inness.

1879 His father's financial plight prompts a family move to Chicago.

1880–
1881 Enrolls in a class at the Chicago Academy of Fine Arts.

1881–
1883 Serves as a draftsman for the Santa Fe Railroad in New Mexico Territory and Mexico.

1883–
1884 Paints Bull Durham Tobacco advertisements on barns around Chicago and beyond.

1885 Produces landscape drawings while possibly working for the B&O Railroad in West Virginia.

1886 *October.* Enrolls at the School of the Art Institute of Chicago, a student of Charles Corwin and Alice Kellogg. Davies and Kellogg fall in love.

1887 Helps paint a Civil War scene on a Chicago cyclorama with John Twachtman and others.

1888 In New York. Begins producing magazine illustrations for *Century* and *Saint Nicholas* magazines.

His first exhibited work, titled *Strawberry Time*, is included in the twenty-first American Water Color Society annual.

Fall. Enrolls in a class at the Art Students League taught by Kenyon Cox.

1889 *August.* Alice Kellogg returns from two years of art training and triumphs in Paris; she visits Arthur in New York but he rejects the idea of marriage.

1890 *Summer.* Meets Lucille Virginia Meriwether Davis, chief resident physician at the New York Infant Asylum.

Fall. Paints first large oil, *Along the Erie Canal.*

1891 *September.* Creates his last illustrations for *Century Magazine.* Davies and Virginia Davis become engaged.

1892 *July.* Marries Virginia.

October. Enrolls at the Art Students League to study sculpture under Augustus Saint-Gaudens.

1893 *March.* Son Niles is born.

October. First exhibition of his lithographs at Frederick A. Keppel and Son, New York.

1894 *February.* Sells his first painting, *Ducks and Turkeys,* at the American Water Color Club annual held at the National Academy of Design. Exhibits oils and pastels with the short-lived Society of Independents.

March. Initial exhibit in a group show at the Macbeth Gallery, New York.

1895 *March.* Second son, Arthur David, is born.

April. First one-man show, at Frederick Keppel and Company, Chicago.

July–September. Embarks on trip to Europe, including visits to Amsterdam, Paris, and London.

1896 *March.* First one-man show at the Macbeth Gallery.

 April. Second exhibit at Frederick Keppel and Company, Chicago.

 November. Included in *First Annual Exhibition* at the Carnegie Institute, Pittsburgh.

 December. Four paintings accepted for the Pennsylvania Academy's sixty-sixth annual exhibit, Philadelphia.

1897 *April.* One-man show at the Macbeth Gallery.

 July. Birth of daughter Silvia.

 August–November. Trip to Europe, including Ireland, Belgium, Germany, Italy, and Spain.

 December. Arranges for William Macbeth to exhibit the work of Robert Henri.

1898 *Winter.* Exhibits 150 drawings at Macbeth's.

 April. Enters mural competition for new New York State Supreme Court building; his design is not chosen.

 June. Daughter Silvia dies at age eleven months.

 August. To Jonathan, North Carolina.

 November. Moves his studio to 237 Fifth Ave., in the same building as the Macbeth Gallery.

1899 *Summer.* Exhibits in the *Second Exhibition of the International Society of Sculptors, Painters and Gravers* in London.

1900 *March.* Exhibits with Maurice Prendergast at the Macbeth Gallery.

 Summer. Birth of son Alan.

 August. To Newport, Rhode Island.

 September. Aids Robert Henri in obtaining his first teaching position in New York.

1901 *March.* One-man show at the Macbeth Gallery.

 July–August. To London.

 August. Death of year-old son Alan.

September. Wins silver medal for *Full-Orbed Moon* at the Pan-American Exposition in Buffalo.

November. One-man show at the Pratt Institute, Brooklyn.

1902 *April.* One-man show at Macbeth's.
Edna Potter becomes his model, later his mistress.

October. To South Ashfield, Massachusetts.

Fall. Gives one of his paintings to Henri, who finds it useful for classroom discussions.

1903 *April.* One-man show at the Macbeth Gallery.

September. Fire at 237 Fifth Ave. threatens his paintings, damages the Macbeth Gallery on the ground floor.

1904 *January.* Participates in the National Arts Club gallery exhibit with Henri, Sloan, Glackens, Luks, and Prendergast.

Fall. To Utica, where he visits his former teacher Dwight Williams.

1905 *February–March.* One-man show at Doll and Richards Gallery, Boston.

March. One-man show at the Macbeth Gallery.

June–October. To Colorado, California, Oregon, Washington, and Canada.

October. Davies and Edna Potter begin living together as husband and wife under the assumed name of Mr. and Mrs. David A. Owen.

1906 *January.* Exhibits in the Pennsylvania Academy's 101st annual.

Summer. Represented in the Worcester (Massachusetts) Art Museum's 9th annual.

November. Included in the 18th *American Exhibition of Oils and Sculpture* at the Philadelphia Art Club.

1907 *March.* Moves to new studio at 25 West Thirty-fourth Street.

March. represented in the Corcoran Gallery of Art's initial Biennial *Exhibition of Contemporary American Painting.*

April. Exhibits at the New York School of Art Gallery with Sloan, Luks, and Lawson, in a show arranged by Henri.

April. Included in exhibit organized by Gertrude Vanderbilt Whitney at the Colony Club; shows with Whistler, Sargent, ten others.

April. Rejected for membership as an associate of the National Academy of Design, one of thirty-three out of thirty-six artists denied admission.

April. Attends meetings with other artists who will become known as The Eight; writes Prendergast, inviting him to participate.

Fall. Included in the *Exhibition of Works by Living Artists* in Amsterdam.

August. Evicted from his studio of five months; relocates to 53 West Thirty-ninth Street.

December. Designs the exhibition catalogue for the show of The Eight at the Macbeth Gallery.

1908 *January.* Works with Sloan on details for The Eight exhibition.

February. Show of The Eight at Macbeth's.

March. Exhibits his painting *Unicorns* in the National Academy of Design annual.

March. The Eight show opens at the Pennsylvania Academy.

September. The Eight Travelling Exhibit opens at the Art Institute of Chicago; it is seen in seven other cities through May, 1909.

1909 *February.* One-man show at the Macbeth Gallery, from which Lizzie Bliss purchases her first work by Davies.

March. Solo exhibit at the Worcester (Massachusetts) Art Museum.

April. Purchases four frames for Marsden Hartley's first one-man show at Alfred Stieglitz's 291 Gallery.

April. Buys three Paris paintings by Alfred Maurer from his initial exhibit at the 291 Gallery.

December. Represented in the National Academy of Design and Corcoran Gallery annuals.

1910 *February.* Included in an exhibit of American art in Berlin and Munich.

March. Helps organize and finance the *Exhibition of Independent Artists.*

April. Participates in the *Exhibition of Independent Artists.*

November. One-man show of figure drawings at the Portland (Oregon) Art Museum.

November–January, 1911. Trip overseas with Edna to Italy and Greece.

1911 *January.* One-man show at the Art Institute of Chicago; *Maya—Mirror of Illusions* purchased for its permanent collection.

January. Two Davies paintings are removed from a scaled-down version of the 1910 Independent held in Columbus, Ohio, due to the prominent inclusion of female nudes.

March. Exhibits in the 1911 Independent, aiding Rockwell Kent with organization and financing.

April. Participates in a show at the Union League with The Eight, Kent, Kuhn, Weber, and others.

December–January, 1912. Loan show of his paintings at the Women's Cosmopolitan Club, comprised of works owned by Lizzie Bliss, Gertrude Vanderbilt Whitney, Gertrude Käsebier, and Col. Henry Thomas Chapman.

1912 *January.* Elected president of the Association of American Painters and Sculptors, which group will sponsor the 1913 Armory Show.

March. One-man show at Macbeth's.

April. Solo exhibit at Doll and Richards Gallery, Boston.

April. Birth of Helen Ronven Owen, his illegitimate daughter.

June. Moves his studio to 337 East Fifty-seventh Street.

November. To Paris and London to direct selection of works for the Armory Show.

1913 *February.* Opening of the Armory Show, in which he exhibits four oils and three drawings.

March. One-man show of drawings at the Macbeth Gallery.

April. Wins honorable mention for *Sleep* at the Carnegie Institute annual.

May. Armory Show closes at the Copley Society in Boston, after also having been exhibited at the Art Institute of Chicago.

May. Organizes an exhibit of cubist works shown during June, July, and August in Cleveland, Pittsburgh, and Philadelphia.

September. Meets Mary Haskell and Kahlil Gibran; she poses for him. Davies arranges for Macbeth to review Gibran's drawings and paintings.

Fall. Plans exhibit of contemporary art for the Carroll Gallery, which activity continues during the 1913–14 season.

November. Organizes the first museum show of modern American art for the Carnegie Institute; it travels to the Montross Gallery.

November. First exhibition of one of his cubist canvases at Macbeth's.

1914 *By April.* Begins applying the Maratta System of Composition to his art.

May. Wreath McIntyre begins posing for him; will become his only female model for the next fourteen years.

Summer. Begins painting music room murals for Lizzie Bliss.

Fall. Attends Kit Kat Club masked ball.

December. Participates in an exhibit at Gertrude Vanderbilt Whitney's gallery to benefit an American hospital in Paris.

1915 *March.* Davies, Kuhn, and Prendergast exhibit murals at the Montross Galleries; he also shows sculpture there for the first time.

May. His drawings of dance are displayed with sculptures by other artists at Macbeth's.

1916 *January.* Exhibits forty paintings at the Post–Panama Pacific Exposition show at San Francisco's Palace of Fine Arts.

October. Exhibits the first prints he has produced in twenty years with the New York Society of Etchers.

December. Wins the Corcoran Gallery of Art gold medal for his painting *Castalias.*

1917 *Summer.* One-man show organized by Gertrude Vanderbilt Whitney for the Newport (Rhode Island) Art Association.

Fall. Enrolls daughter Ronnie in kindergarten at the Friends Seminary on Stuyvesant Square.

November. Participates in the first auction of modern art held in New York.

1918 *January.* Retrospective exhibition at the Macbeth Gallery.

Spring. Exhibits prints in the Penguin Club annual.

May. One-man show at the Chicago Arts Club.

1919 *January.* Cuts ties with the Macbeth Gallery after a twenty-five-year association.

March. Begins producing lithographs, his first works in this print medium in over two decades.

April. Shows with the Penguin Club in its annual exhibit.

December. Participates with other artists in the Christmas Roll Call of the American Red Cross by producing a poster, in oils, which is hung on the balustrade of the New York Public Library.

1920 *January.* One-man show of oils, watercolors, and aquatints at the de Zayas Gallery.

March. One-man show at the Art Institute of Chicago.

Fall. Represented in the *Venice International Exhibition.*

Fall. Thirty-eight of his lithographs are published by Erhard Weyhe and shown in his gallery in December.

1921 *January.* First comprehensive show of his prints at the Weyhe Gallery.

January. Exhibits at the Century Club.

Summer. Selects Ferargil's as his new gallery.

1922 *February*. Becomes director of the Sculptors' Gallery in New York.

Throughout. Works with Dr. Gustavus A. Eisen in verifying the authenticity of the Holy Grail. Davies' theory of inhalation is also developed at this time.

May. Eleven of his lithographs are acquired by the Victoria and Albert Museum in London.

December. One-man shows at the Ferargil Galleries, E. Weyhe Gallery, and the Fine Arts Academy in Buffalo.

1923 *April*. Awarded the gold medal for *Afterthoughts of Earth* at the Carnegie Institute's International.

April. Solo show at the Montross Gallery.

June. Suffers an attack of angina.

July. Leaves on a three-month European trip; initiates his first landscapes in watercolor.

December. Exhibits the European watercolors at the Weyhe Gallery; show is a complete sellout.

1924 *January*. Represented in the first American exhibition at the Venice Biennale.

January. One-man show of paintings and lithographs at the Memorial Art Gallery in Rochester.

January. One-man show of drawings at the Albert Roullier Galleries in Chicago.

January. Solo exhibition of etchings and lithographs at the Mabel Ulrich Book Shop in Minneapolis.

February. One-man show of paintings, watercolors, and drawings at the Carnegie Institute.

March. One-man show of paintings at the Dayton Art Institute.

March–April. One-man show of paintings and lithographs at the Art Institute of Chicago.

May. Solo exhibit at the Worcester Art Museum.

June. Leaves with Edna on a five-month trip to Paris; enrolls Ronnie in school there.

Summer. Publication of a Davies monograph by Duncan Phillips.

November. Wins $2,500 first prize in a Christmas card contest sponsored by the National League of Women Voters.

December. Commissioned by Abby Aldrich Rockefeller to execute lobby murals for International House in New York.

1925 *February–March.* One-man show of Paris watercolors at the Ferargil Galleries.

May. To Paris; views the *Exposition Internationale des Arts Décoratifs* and other shows.

June. Included in the *Exposition Trinationale* at the Durand-Ruel Galleries in Paris.

June. One-man show at the Corcoran Gallery of Art.

July–August. One-man show at the Carnegie Institute.

Summer. Has sixty of his sculptures cast in bronze by a Paris foundry.

Summer. Produces watercolors in Paris and Italy.

August. Begins creating designs for tapestries, to be woven by Gobelin factory workers.

September. Returns to the United States, leaving Edna and Ronnie in Italy, where the latter is enrolled in school.

October. One-man show of watercolors at the Baltimore Museum of Art.

1926 *February.* With his studio building slated for demolition, he exhibits one hundred examples from his collection of modern art, hoping their sale will lessen the burden of moving and help defray the cost.

April. Takes up residence in the Hotel Chelsea at 222 West Twenty-third Street.

June. One of three Americans included in the *Exhibition of Modern French and American Painters* at the Brooklyn Museum.

June. Leaves for Paris; arranges for Wreath McIntyre to join him and serve as a model there for his tapestry designs.

October. Returns to the United States; learns of birth of a grandchild, Margaret Meriwether Davies, during his absence.

1927 *April.* One-man show at the John Herron Art Institute in Indianapolis.

April. Son Niles is married; Davies departs for Europe prior to the event.

Summer. Produces three hundred watercolors in Paris and Italy, where he is reunited with Edna and Ronnie.

October. Returns to the United States alone.

1928 *March.* Birth of granddaughter Sylvia to Niles and his wife Erica.

April. Departs for Europe; paints watercolors in Spain.

October 24. Dies in Florence in the company of Edna and Ronnie.

November. Edna and Ronnie embark for the United States and meet Virginia for the first time; reveal the tragedy and their relationship to Davies.

November. After conceiving a cover-up story, Virginia, Edna, and Ronnie embark for Europe.

1929 *February.* Memorial exhibitions held at the Phillips Collection in Washington and the University of Chicago.

March. One-man show of his last watercolors at the Ferargil Galleries; sixty-eight of seventy-two are sold.

April. One-man show of prints at the Carnegie Institute.

April. A two-day sale of his art collection, comprised of 450 items, takes place at the American Art Galleries.

April. Abby Aldrich Rockefeller exhibits his oils, watercolors, drawings, sculpture, and tapestries in her private gallery.

May. Abby Rockefeller, Lizzie Bliss, and Mary Quinn Sullivan meet to establish the Museum of Modern Art.

November. Ferargil Galleries exhibition of early and late paintings.

1930 *February–March.* Arthur B. Davies Memorial Exhibition held at the Metropolitan Museum of Art.

❦ Notes ❧

Chapter 1. Youthful Years in Utica (1862–1879)

1. "Former Utica Boy Is Being Honored," *Utica Daily Press,* Feb. 19, 1930, 7.

2. Margaret Marder Davies Family Archives.

3. Note written by Lizzie Davies. Niles M. Davies, Jr., Family Archives.

4. Edward B. Clark, "Start of Career of Arthur B. Davies," *Chicago Evening Post,* July 12, 1925.

5. Ibid.

6. Edward Alden Jewell, "America's Painter of Magical Beauty," *New York Times Magazine,* Feb. 9, 1930, p. 14.

7. Niles M. Davies, Jr., Family Archives.

8. Ibid.

9. Letter from Wreath McIntyre to the author, April 9, 1986.

10. Dwight Williams, "Arthur B. Davies: A Biographical Sketch," in *Arthur B. Davies: Essays on the Man and His Art,* ed. Phillips et al. (Cambridge, MA, 1924), p. 25.

11. Ibid., p. 26.

12. Ibid.

13. George Inness, "A Painter on Painting," *Harper's New Monthly Magazine* 56 (Feb. 1878).

14. Letter from Lizzie Davies to Thomas and David Davies, Feb. 6, 1879. Margaret Davies Marder Family Archives.

15. Niles M. Davies, Jr., Family Archives.

Chapter 2. Chicago and the Southwest (1880–1885)

1. Davies letter to his family, undated [1882]. Margaret Davies Marder Family Archives.

2. Margaret Davies Marder Family Archives.

3. Marsden Hartley Papers, reel 1369, frame 1507, Archives of American Art.

4. "What Makes an Artist," *Art Union,* Oct.–Nov. 1884.

Chapter 3. First Love (1886–1889)

1. Letter from Alice Kellogg to her sister Peggy, 1887; Alice Kellogg letter, 1889. Alice Kellogg Tyler Papers, Archives of American Art.

2. F. Newlin Price, "Davies the Absolute," *International Studio* 75 (June 1922), 215.

3. Letter from Alice Kellogg to her sister Peggy, 1887. Collection of JoAnne Bowie.

4. Letters from Alice Kellogg to her family, winter 1887–88; Dec. 15, 1888; Dec. 26, 1888, and May 21, 1889. Alice Kellogg Tyler Papers, Archives of American Art.

5. Alice Kellogg letter to her sister Kate, Aug. 12, 1888. Alice Kellogg Tyler Papers, Archives of American Art.

6. Carole Klein, *Gramercy Park: An American Bloomsbury.* Boston, 1987, p. 179.

7. Letter from Alice Kellogg to her sister Kate, Feb. 28, 1889; letter from Alice Kellogg to her family, winter 1887–88. Alice Kellogg Tyler Papers, Archives of American Art.

8. Letter from Alice Kellogg to her sister Kate, Feb. 11, 1889. Collection of Jo Anne Bowie.

9. Letter from ABD to his sister Lizzie, undated [April, 1889]. Margaret Davies Marder Family Archives.

10. Edward Alden Jewell, "America's Painter of Magical Beauty," *New York Times Magazine,* Feb. 9, 1930, p. 22.

11. Alice Kellogg letter to her sister Mary, May 16, 1889. Collection of JoAnne Bowie.

Chapter 4. Marriage and Murder (1890–1892)

1. Letter from ABD to Virginia, Dec. 19, 1890. Niles M. Davies, Jr., Family Archives.

2. Note from Virginia Davies to her daughter-in-law Erica Davies, undated. Niles M. Davies, Jr., Family Archives.

3. Letter from ABD to Virginia, "Monday." Niles M. Davies, Jr., Family Archives.

4. Letter from ABD to Virginia, "Saturday A.M.," undated. Niles M. Davies, Jr., Family Archives.

5. Letter from ABD to Virginia, Nov. 25, 1890. Niles M. Davies, Jr., Family Archives.

6. Letter from ABD to Virginia, Dec. 19, 1890. Niles M. Davies, Jr., Family Archives.

7. Ibid.

8. Letter from ABD to Virginia, Nov. 25, 1890. Niles M. Davies, Jr., Family Archives.

9. Letter from ABD to Virginia, undated. Niles M. Davies, Jr., Family Archives.

10. Letter from ABD to Virginia, Nov. 25, 1890. Niles M. Davies, Jr., Family Archives.

11. Letter from ABD to Virginia, "Monday A.M.," undated. Niles M. Davies, Jr., Family Archives.

12. Letter from ABD to Virginia, undated. Niles M. Davies, Jr., Family Archives.

13. Letter from ABD to Virginia, Nov. 25, 1890. Niles M. Davies, Jr., Family Archives.

14. Letter from ABD to Virginia, undated. Niles M. Davies, Jr., Family Archives.

15. Letter from ABD to Virginia, undated. Niles M. Davies, Jr., Family Archives.

16. Letter from ABD to Virginia, "Monday," undated. Niles M. Davies, Jr., Family Archives.

17. Letter from ABD to Virginia, undated. Niles M. Davies, Jr., Family Archives.

18. Letter from Lucile du Pré to Virginia, undated. Niles M. Davies, Jr., Family Archives.

19. Letters from Lucile du Pré to Virginia, undated. Niles M. Davies, Jr., Family Archives.

20. Letter from ABD to Virginia, undated. Niles M. Davies, Jr., Family Archives.

21. Letter from ABD to Virginia, Sept. 21, 1891. Niles M. Davies, Jr., Family Archives.

22. Letter from ABD to Virginia, undated. Niles M. Davies, Jr., Family Archives.

23. Letter from ABD to Virginia, undated. Niles M. Davies, Jr., Family Archives.

24. Letter from ABD to Virginia, undated. Niles M. Davies, Jr., Family Archives.

25. Letter from ABD to Virginia, undated. Niles M. Davies, Jr., Family Archives.

26. Niles M. Davies, Jr., Family Archives.

27. "Hamlet, Prince of Denmark," Act IV, Scene V, *The Complete Works of William Shakespeare.* (New York, 1975), p. 1101.

28. "Killed by His Bride," the *(Chattanooga) Daily Times,* Sept. 14, 1882, p. 1.

29. "Killed by His Wife," *Huntsville (Alabama) Gazette,* Sept. 16, 1882, p. 3.

Chapter 5. The Golden Bough (1893)

1. Sir James G. Frazer, *The Golden Bough: A Study in Magic and Religion.* (New York, 1981), p. 1.

2. Letter from ABD to John P. Davis, May 15, 1896. Niles M. Davies, Jr., Family Archives.

3. Alice Kellogg diary, Oct. 26, 1892. Alice Kellogg Tyler Papers, Archives of American Art.

4. Letter from ABD to Virginia, undated. Margaret Davies Marder Family Archives.

5. Pennsylvania Academy of the Fine Arts Archives.

6. Alice Boughton, *Photographing the Famous.* (New York, 1928), p. 94.

7. "Art Notes," *New York Times,* Oct. 9, 1893, p. 2.

8. Letter from Virginia to ABD, Oct. 22, 1893. Niles M. Davies, Jr., Family Archives.

9. Dr. Virginia M. Davies, reminiscences. Niles M. Davies, Jr., Family Archives.

10. Dr. Virginia M. Davies journal entry, Nov. 13, 1893. Niles M. Davies, Jr., Family Archives.

11. Ibid., Dec. 25, 1893.

12. Letter from Lucile du Pré, undated. Niles M. Davies, Jr., Family Archives.

13. Ibid.

14. H. P. Blavatsky, *The Collected Writings,* vol. 10, p. 246, as quoted in H. P. Blavatsky, *Dynamics of the Psychic World.* (Wheaton, Ill. 1972), p. 76.

15. Elliott Daingerfield, "Albert Pinkham Ryder, Artist and Dreamer," *Scribner's Magazine* 63 (March 1918), p. 380.

16. *Albert Pinkham Ryder, Arthur B. Davies Exhibition,* March 4–23, 1946. New York, Ferargil Gallery, unpaginated.

17. Henry Eckford, "A Modern Colorist: Albert Pinkham Ryder," *Century Magazine* 40 (June 1890), p. 250.

18. Letter from ABD to Virginia, undated [1891]. Niles M. Davies, Jr., Family Archives.

19. George Moore, *Modern Painting.* (New York, 1893), p. 78.

20. Sophia Antoinette Walker, "Fine Arts. An Artist Whom I Know," *Independent* 47 (Aug. 1, 1895), p. 13.

21. Eckford, "A Modern Colorist," p. 254.

22. Ibid., p. 250.

Chapter 6. A Call to Art (1894–1895)

1. [Sadakichi Hartmann] Unsigned, "American Art Gossip. Arthur B. Davies," *Art Critic* 1 (Jan., 1894), p. 40.

2. Sadakichi Hartmann, "Hours of Midnight." Unpublished manuscript, 1890. Special Collections, Fales Library, New York University.

3. Sadakichi Hartmann, "En Courant," *Art Critic* 1 (March 1894), p. 41.

4. Sadakichi Hartmann, "The Independents," *Art Critic* 1 (March 1894), p. x.

5. "Announcement," Macbeth Gallery Scrapbooks, Macbeth Gallery Papers, Archives of American Art.

6. *New York Sun,* March 24, 1894.

7. *New York Tribune,* March 18, 1894.

8. Macbeth Gallery catalogue, May 1915. New York Public Library.

9. Bennard B. Perlman, *Robert Henri: His Art and Life.* (New York, 1991), p. 31.

10. Walker, "Fine Arts," *Independent* 47 (Aug. 1, 1895), p. 13.

11. Royal Cortissoz, "The Water-Color Exhibition," *Harper's Weekly* 9 (Feb. 9, 1895), 127.

12. *Springfield (Massachusetts) Republican,* undated [Jan., 1895].

13. "The Fine Arts," *Boston Evening Transcript,* Jan. 25, 1895, p. 5.

14. "Of Interest," *Elite* 13 (April 20, 1895).

15. Letter from ABD to William Macbeth, May 15, 1895. Macbeth Papers, reel NMc6, frame 259, Archives of American Art.

16. Letter from ABD to William Macbeth, July 10, 1895. Macbeth Papers, reel NMc6, frame 260, Archives of American Art.

17. As quoted in Henri Dorra, *The American Muse.* (New York, 1961), p. 72.

18. Letter from ABD to Virginia, Aug. 4, 1895. Niles M. Davies, Jr., Family Archives.

19. Ibid.

20. Letter from ABD to William Macbeth, Aug. 5, 1895. Macbeth Papers, reel NMc6, frame 262, Archives of American Art.

21. Ibid.

22. Letter from ABD to Virginia, Aug. 8, 1895. Niles M. Davies, Jr., Family Archives.

23. Letter from ABD to Sadakichi Hartmann, Feb. 18, 1896. Special Collections, University of California, Riverside.

24. Letters from ABD to Virginia, Aug. 18, 17, and 18, 1895. Niles M. Davies, Jr., Family Archives.

25. Letter from ABD to Virginia, Sept. 4, 1895. Niles M. Davies, Jr., Family Archives.

26. Ibid.

27. Letter from ABD to William Macbeth, Jan. 10, 1896. Macbeth Papers, reel NMc6, frame 278, Archives of American Art.

28. Letter from ABD to Sadakichi Hartmann, Feb. 18, 1896. Special Collections, University of California, Riverside.

Chapter 7. The Dealer and the Double-Dealer (1896–1898)

1. I am indebted to Brooks Wright for sharing the contents of this letter to him from Wreath McIntyre, dated Oct. 10, 1967.

2. William Macbeth, "Introduction," *Exhibition of Paintings by Arthur B. Davies.* (New York: Macbeth Gallery, 1896), p. 2.

3. "Pictures by Arthur B. Davies," *New York Times,* March 14, 1896.

4. *New York Post,* March 14, 1896.

5. *New York Sun,* undated [March, 1896]. ABD scrapbook, Niles M. Davies, Jr., Family Archives.

6. Ibid.

7. *New York Mail and Express,* undated [March 1896]. ABD scrapbook, Niles M. Davies, Jr., Family Archives.

8. Sadakichi Hartmann, *Daily Tatler,* Nov. 18, 1896, reproduced in Jane Calhoun Weaver, *Sadakichi Hartmann: Critical Modernist.* (Berkeley, Calif., 1991), p. 244.

9. Ibid.

10. I am indebted to Gwendolyn Owens for providing me with a printout of Davies' Macbeth Gallery sales from 1894 to 1913.

11. *Chicago Tribune,* April 26, 1896.

12. *Chicago Times Herald,* April 26, 1896.

13. Unnamed newspaper, April 19, 1896. ABD scrapbook, Niles M. Davies, Jr., Family Archives.

14. Macbeth Gallery *Art Notes* 2 (Nov. and Dec. 1896), p. 28. Macbeth Papers, reel 3091, frame 489, Archives of American Art.

15. Macbeth Gallery *Art Notes* 4 (April 1897), p. 50. Macbeth Papers, reel 3091, frame 500, Archives of American Art.

16. *Exhibition of Paintings by Arthur B. Davies.* (New York: Macbeth Gallery, 1897). Exhibition catalogue.

17. "The Fine Arts: Paintings by Mr. Arthur B. Davies," *Critic* 27 (May 8, 1897), p. 328.

18. Letters from ABD to William Macbeth, July 1, 1897. Macbeth Papers, reel NMc6, frame 285, and reel D23, frame 70, Archives of American Art.

19. [Sadakichi Hartmann] Unsigned, "The Echo," *American Art News* 1 (June 1897), pp. 4, 5.

20. Letter from ABD to William Macbeth, Aug. 11, 1897. Macbeth Papers, reel NMc6, frame 288, Archives of American Art.

21. Letters from ABD to William Macbeth, Aug. 11–Oct. 10, 1897. Macbeth Papers, reel NMc6, frames 287–303, Archives of American Art.

22. As told to Wreath McIntyre and subsequently related to the author in an interview, May 25, 1985.

23. Letter from ABD to Virginia, Oct. 18, 1897. Niles M. Davies, Jr., Family Archives.

24. Macbeth Gallery *Art Notes* 1 (Oct. 1897), p. 6.

25. Letter from William Glackens to Robert Henri, undated [fall 1897]. Robert Henri Papers, The Beinecke Rare Book and Manuscript Library, Yale University.

26. Perlman, *Robert Henri: His Art and Life.* (New York, 1991), p. 37.

27. The Town Traveler, "Arthur B. Davies," *Art Collector* 9 (Dec. 15, 1898), p. 54.

28. Frank Jewett Mather, Jr., "The Art of Arthur B. Davies," in *Arthur B. Davies: Essays on the Man and His Art,* ed. Phillips et al. (Washington, D.C., 1924), p. 53.

29. Elisabeth Luther Cary, "Arthur B. Davies Memorial," *New York Times,* Feb. 16, 1930.

30. Virginia Davies' journal, Nov. 25, 1898. Niles M. Davies, Jr., Family Archives.

31. As related to the author by Wreath McIntyre, May 25, 1985.

Chapter 8. Forging Friendships (1898–1900)

1. Letters from ABD to William Macbeth, August, 1898. Macbeth Papers, reel NMc6, frames 305, 251, Archives of American Art.

2. Ibid.

3. Macbeth Gallery *Art Notes* 8 (Nov. 1898), p. 123.

4. The Town Traveler, "Arthur B. Davies," *Art Collector,* p. 54.

5. Macbeth Gallery *Art Notes* 10 (April, 1899), p. 147.

6. Ibid., Nov., 1899.

7. Letter from ABD to Robert Henri, March 28, 1898. Robert Henri Papers, The Beinecke Rare Book and Manuscript Library, Yale University.

8. Ibid., Sept. 27, 1900.

9. Letter from ABD to William Macbeth, Aug. 20, 1900. Macbeth Papers, reel NMc6, frame 307, Archives of American Art.

10. *Brooklyn Standard Union,* Oct. 14, 1900.

11. Samuel Swift, *New York Mail and Express,* Dec. 8, 1900.

12. Letter from Lucile du Pré to Virginia Davies, undated. Niles M. Davies, Jr., Family Papers.

13. *Poems of Lucile du Pré.* Boston, 1923, p. 12.

14. Letter from Lucile du Pré to Virginia Davies, undated. Niles M. Davies, Jr., Family Archives.

15. Ibid.

16. Letter from ABD to his brother David, undated. Margaret Davies Marder Family Archives.

17. Samuel Swift, Dec. 8, 1900.

Chapter 9. A Model Liaison (1901–1902)

1. Letter from ABD to the Pennsylvania Academy, Jan. 14, 1901. Pennsylvania Academy of the Fine Arts Archives.

2. Perlman, *Robert Henri: His Life and Art,* p. 47.

3. Unidentified newspaper, May 1901. ABD scrapbook.

4. Bryson Burroughs, "Arthur B. Davies," *Arts* 15 (Feb. 1929), p. 81.

5. "Art Notes. The Work of Mr. A. B. Davies," unidentified newspaper, undated [May 1901]. Ferargil Galleries Scrapbooks, reel 1028, frame 764, Archives of American Art.

6. "Art Notes: Arthur B. Davies, in an Exhibition of Recent Work at the Macbeth Gallery, Discloses New and Remarkable Powers," *New York Mail and Express,* May 1901. Ferargil Galleries Scrapbooks, reel 1028, frame 764, Archives of American Art.

7. Robert Henri diary, May 20, 1901.

8. Letter from ABD to Virginia, summer 1901. Niles M. Davies, Jr., Family Archives.

9. Robert Henri diary, Aug. 21, 1901.

10. Elizabeth Broun, *Albert Pinkham Ryder.* (Washington, D.C., 1990), p. 315.

11. Henri diary, April 4, 1902.

12. Letter to the author from Dudley Crafts Watson, June 25, 1957.

13. Letter from Edna Potter to David Davies, June 2, 1929. Margaret Davies Marder Family Archives.

Chapter 10. New Alliances (1902–1905)

1. Letter from ABD to Robert Henri, Oct. 29, 1900. Robert Henri Papers, The Beinecke Rare Book and Manuscript Library, Yale University.

2. "W. L. Lathrop and A. B. Davies," unidentified newspaper, May 3, 1902. Ferargil Galleries Scrapbooks, reel 1028, frame 763, Archives of American Art.

3. Letter from ABD to Macbeth, Oct. 10, 1902. Macbeth Papers, reel NMc6, frame 310, Archives of American Art.

4. Letter from Robert Henri to John Sloan, Oct. 22, 1902. John Sloan Collection, Delaware Art Museum.

5. Author's interview with Carl Sprinchorn, July 14, 1956.

6. Walter Tittle diary, April 9, 1903. Wittenberg University Library.

7. "The Oldest Thing in Art," *Town Topics* 49 (April 2, 1903), p. 19.

8. Samuel Swift, *New York Mail and Express,* April 25, 1903.

9. Burroughs, "Arthur B. Davies," *Arts,* p. 81.

10. "Six in Peril in Fifth Ave. Fire," *New York Evening Journal,* Sept. 29, 1903.

11. *New York Evening Post,* Nov. 11, 1903.

12. Arthur Hoeber, "Art and Artists. A Most Lugubrious Show at the National Arts Club," *New York Commercial Advertiser,* Jan. 20, 1904.

13. Charles De Kay, "Six Impressionists. Startling Works By Red-Hot American Painters," *New York Times,* Jan. 20, 1904.

14. Samuel Swift, "Six Painters in a Club Show, Vigorous Work on View at the National Arts Gallery," *New York Mail and Express,* Jan. 25, 1904.

15. Letter from ABD to Macbeth, Sept. 18, 1904. Macbeth Papers, reel NMc6, frame 311, Archives of American Art.

16. "Art and Artists: Exhibition of Oil Paintings by Arthur B. Davies," *Boston Sunday Globe,* Feb. 26, 1905, p. 35.

17. *Boston Herald,* Feb. 25, 1905.

18. Letter from Maurice B. Prendergast to Esther Williams, March 6, 1905. Esther Williams Papers, Archives of American Art.

19. Charles FitzGerald, "The Art of Arthur B. Davies," *New York Evening Sun,* April 6, 1905.

20. Charles De Kay, "Paintings by Davies," *New York Times,* April 12, 1905, p. 10.

21. Samuel Swift, "New Paintings by Arthur B. Davies," *New York Mail and Express,* April 3, 1905.

22. De Kay, "Paintings by Davies," p. 10.

23. *Chicago Record Herald,* June 2, 1901.

24. "Picture That Gave Offense," unidentified newspaper, undated [Feb. 1905]. Macbeth Gallery Papers, Archives of American Art.

25. *New York Mail and Express,* undated [Feb. 1905]. Macbeth Gallery Papers, Archives of American Art.

Chapter 11. Reaching the Heights (1905–1907)

1. Mather, "The Art of Arthur B. Davies," in *Arthur B. Davies: Essays on the Man and His Art,* p. 49.

2. Marsden Hartley, "The Poetry of Arthur B. Davies' Art," *Touchstone* 6 (Feb. 1920), p. 278.

3. ABD statement to Wood Gaylor, as quoted in *The Illustrated Biographical Encyclopedia of Artists of the American West* by Peggy and Harold Samuels. (Garden City, N.Y., 1976), p. 125.

4. Letter from ABD to William Macbeth, July 18, 1905. Macbeth Papers, reel NMc6, frame 315, Archives of American Art.

5. Frederic Newlin Price, "The Etchings and Lithographs of Arthur B. Davies," *Print* 1 (Nov. 1930), p. 8.

6. Letter from ABD to William Macbeth, July 18, 1905. Macbeth Papers, reel NMc6, frame 317, Archives of American Art.

7. James Gibbons Huneker, "Arthur B. Davies," *New York Sun,* June 4, 1908, p. 6.

8. Letter from ABD to William Macbeth, Sept. 21, 1905. Macbeth Papers, reel NMc6, frame 319. Archives of American Art.

9. Samuel Isham, *The History of American Painting.* (New York, 1905), p. 487.

10. Robert Henri diary, Dec. 5, 1904.

11. Ibid.

12. "National Academy's Scope," *New York Evening Post,* March 9, 1907.

13. Letter from ABD to Robert Henri, March 9, 1907. Robert Henri Papers, The Beinecke Rare Book and Manuscript Library, Yale University.

14. Ibid., April 5, 1907.

15. James Gibbons Huneker, *New York Sun,* April 2, 1907.

16. Guy Pène du Bois, *New York American,* April, 1907.

17. Letter from ABD to Gertrude Vanderbilt Whitney, April 10, 1907. Gertrude Vanderbilt Whitney Papers, reel 2358, frame 173, Archives of American Art.

18. Eliot Clark, *History of the National Academy of Design 1825–1952.* (New York, 1954), p. 162.

19. *New York Times,* April 12, 1907.

20. "Eight Independent Painters to Give an Exhibition of Their Own Next Winter," *New York Sun,* May 15, 1907.

21. Letter from ABD to Hamilton Easter Field, Sept. 18, 1907. Hamilton Easter Field Papers, reel N68-2, frame 18, Archives of American Art.

22. Letter from Robert Henri to John Sloan, Jan. 29, 1908. John Sloan Collection, Delaware Art Museum.

23. John Sloan diary, Jan. 31, 1908, John Sloan Collection, Delaware Art Museum.

Chapter 12. The Eight (1908–1909)

1. Bennard B. Perlman, *The Immortal Eight: American Painting from Eakins to the Armory Show.* (Cincinnati, 1979), p. 178.

2. "Eight Painters," *Philadelphia Press,* undated [Feb. 1908]. Macbeth Gallery Scrapbook, p. 179, Archives of American Art; Bruce St. John, ed., *John Sloan's New York Scene.* (New York, 1965), p. 192; C. de K. [Charles de Kay], "Eight-Man Show at Macbeth's," *New York Evening Post,* Feb. 7, 1908.

3. Giles Edgerton [Mary Fanton Roberts], "The Younger American Painters: Are They Creating a National Art?" *Craftsman* 13 (Feb. 1908), p. 656; *New York Sun,* June 4, 1908, p. 6.

4. John B. Townsend, "The Eight Arrive," *Art News* 6 (Feb. 8, 1908), p. 6; "The Month's Exhibitions," *Independent* 64 (Feb. 27, 1908), p. 464; James Gibbons Huneker, "Eight Painters. First Article," *New York Sun,* Feb. 9, 1908.

5. *New York Sun,* June 4, 1908.

6. Macbeth Gallery *Art Notes* (March 1908), p. 545. John Sloan Collection, Delaware Art Museum.

7. Ibid.

8. As recorded in the John Sloan diary, Feb. 3, 1908. John Sloan Collection, Delaware Art Museum; Ibid., Feb. 17, 1908; Ibid., Feb. 5, 1908.

9. Ibid., April 21, 1908.

10. Perlman, *The Immortal Eight,* p. 184.

11. Chicago newspaper, unidentified, undated [Sept. 1908]. ABD scrapbook.

12. Perlman, *Robert Henri: His Life and Art,* p. 77.

13. Ibid., p. 91.

14. John Sloan diary, March 23, 1909.

15. Letter from Marsden Hartley to Alfred Stieglitz, Feb. 1913. Alfred Stieglitz Papers, The Beinecke Rare Book and Manuscript Library, Yale University.

16. Barbara Haskell, *Marsden Hartley.* (New York, 1980), p. 18.

17. Maurice Tuchman, *The Spiritual in Art: Abstract Painting 1890–1985.* (New York, 1986), p. 21.

18. "American Pictures Admired in Paris," *New York Times,* April 19, 1908, Sec. C, p. 1.

19. Dorothy Norman, *Alfred Stieglitz: An American Seer.* (New York, 1973), p. 97.

20. Letter from ABD to Alfred Stieglitz, April 7, 1909. Alfred Stieglitz Papers, The Beinecke Rare Book and Manuscript Library, Yale University.

21. Perlman, *The Immortal Eight,* p. 189.

22. Robert Henri diary, Dec. 13, 1908.

23. James Gibbons Huneker, "A Painter Visionary," *New York Sun,* Feb. 28, 1909.

24. Phyllis B. Bartlett, ed., "A Face on Trial," *The Poems of George Meredith.* New Haven, CT, 1978, p. 436.

25. There has been, and continues to be, confusion over the names "Lizzie" and "Lillie" Bliss, and whether they are one and the same person. Miss Bliss was given the name "Lizzie" at birth and that name appears on her will. When the Museum of Modern Art, which she helped found, held a Memorial Exhibition of her extensive art holdings in 1931, it was officially labeled the Lizzie P. Bliss Collection. However, her brother had always disliked the name, purportedly because of the contemporary use of the term "Tin Lizzie" to refer to an inferior automobile. On August 8, 1934, the *New York Herald Tribune* headlined an article "Lizzie P. Bliss Becomes Lillie on Art at Museum," explaining that

> The legal name of the late Lizzie P. Bliss has been removed from
> her famous collection of modern pictures at the Museum of Modern

Art . . . and for it has been substituted the name Lillie P. Bliss . . . Her sister-in-law, Mrs. Cornelius N. Bliss, explained last night that the change had been made not only because Miss Bliss was called Lillie by everyone who knew her well enough to call her by her first name, but also because she so much preferred the name of Lillie to her own that she had planned to make it legally hers for some time before her death.

However, the Metropolitan Museum of Art, which also received a bequest of paintings from her estate, continues to refer to these gifts as coming from Lizzie P. Bliss. She is referred to as "Lizzie" throughout this volume.

26. Author's conversation with Eliza Bliss Parkinson Cobb, Sept. 11, 1992.

27. E. B. [Eleanor (Mrs. August) Belmont], "Lizzie P. Bliss," *Memorial Exhibition: The Collection of Miss Lizzie P. Bliss.* (New York: Museum of Modern Art, 1931), p. 7.

28. Macbeth Gallery Papers, reel NMc27, frame 0018, Archives of American Art.

29. Author's conversation with Eliza Bliss Parkinson Cobb, Sept. 19, 1992.

Chapter 13. Two Independents (1910–1911)

1. "Eight Independent Painters to Give an Exhibition of Their Own Next Winter," *New York Sun,* May 15, 1907.

2. "Notes and Reviews," *Craftsman* 14 (June 1908), p. 341.

3. Letter from Maurice Prendergast to Walter Pach, Dec. 6, 1909. Walter Pach Papers, reel 4216, frame 821, Archives of American Art.

4. *New York Evening Sun,* March 16, 1910.

5. Guy Pène du Bois, "Great Modern Art Display Here April 1," *New York American,* March 17, 1910.

6. Letter from William Macbeth to Robert McIntyre, Nov. 5, 1909. Macbeth Gallery Papers, Archives of American Art.

7. Macbeth Gallery *Art Notes,* 41 (Dec. 1910), p. 650.

8. Letter from ABD to William Macbeth, Dec. 6, 1910. Macbeth Papers, reel NMc6, frame 327, Archives of American Art.

9. Letter from ABD to Macbeth, Jan. 5, 1911. William Macbeth Papers, reel NMc6 37, frame 1121, Archives of American Art.

10 Letter from ABD to Virginia Davies, Jan. 1911. Niles M. Davies, Jr., Family Archives.

11. Letter from ABD to William Macbeth, Jan. 26, 1911. Macbeth Papers, reel NMc6 37, frame 1128, Archives of American Art.

12. Frederick James Gregg, "The Arthur B. Davies Exhibition," *Vanity Fair* 9 (Dec. 1917), p. 130.

13. Macbeth Gallery *Art Notes* 42 (Feb. 1911), p. 664.

14. "Vivid Examples of Modern School Shown at Exhibit," *Columbus Evening Dispatch,* Jan. 18, 1911, p. 7.

15. Rockwell Kent, *It's Me, O Lord.* (New York, 1955), p. 233.

16. John Sloan diary, Jan. 12, 1911. John Sloan Collection, Delaware Art Museum.

17. Kent, *It's Me, O Lord,* p. 227.

18. Ibid.

19. Letter from Robert Henri to John Sloan, undated [Feb. 1911]. John Sloan Collection, Delaware Art Museum.

20. Letter from ABD to Rockwell Kent, March 6, 1911. Rockwell Kent Papers, Archives of American Art.

21. Letter from Rockwell Kent to the author, Sept. 22, 1956.

22. *New York Sun,* April 2, 1911.

23. Ibid.

24. "Paintings Shown by "Insurgents,' " unidentified publication, April 2, 1911. Homer Boss scrapbook.

25. Letter from ABD to Rockwell Kent, March 28, 1911. Rockwell Kent Papers, Archives of American Art.

26. John Sloan diary, April 17, 1911.

27. "Rap Independents' Art Works," *New York Press,* April 14, 1911.

28. Robert Henri diary, April 7, 1911.

29. "Insurgent Art Shown at the Union League," *New York Herald,* April 14, 1911.

30. Letter from Rockwell Kent to Brooks Wright, Sept. 1, 1967.

31. "Around the Galleries," *New York Sun,* April 18, 1911.

32. Letter from ABD to Alfred Stieglitz, April 3, 1911. Stieglitz Collection, The Beinecke Rare Book and Manuscript Library, Yale University.

33. Norman, *Alfred Stieglitz: An American Seer,* p. 106.

34. Dorothy Norman, "Alfred Stieglitz," *Wings* (Dec. 1934), p. 9.

Chapter 14. Assuming the Presidency (1911–1912)

1. *New York World,* June 10, 1906; *Independent* 64 (June 25, 1908), pp. 1427–32; *American Art News* 5 (March 23, 1907), p. 4.

2. Dikran Khan Kelekian, "Introduction," *Exhibition of Early and Middle Periods of the Work of Arthur B. Davies.* (New York: Mrs. Cornelius J. Sullivan Gallery, 1939).

3. Manierre Dawson Papers, Reel 64, frame 949. Archives of American Art.

4. Ibid., frame 950, Dec. 15, 1910 and Jan. 2, 1911.

5. William Zorach, Oral History Project, Columbia University, p. 109.

6. John Sloan diary, March 16, 1910.

7. F. J. G. [Frederick James Gregg], "Letter to the Editor," *New York Evening Sun,* March 23, 1911.

8. John Sloan diary, Mary 26, 1911.

9. Letter from Walt Kuhn to his wife Vera, Dec. 12, 1911. Walt Kuhn Papers, Archives of American Art.

10. Ibid., Dec. 15, 1911.

11. Letter from Wreath McIntyre to the author, March 15, 1986.

12. Letter from Walt Kuhn to his wife Vera, Oct. 18, 1911. Walt Kuhn Papers, Archives of American Art.

13. Minutes of the Association of American Painters and Sculptors meeting of Jan. 2, 1912. Walt Kuhn Papers, Archives of American Art.

14. Meeting of the Association of American Painters and Sculptors. Armory Show Papers, Archives of American Art.

15. Robert Henri diary, Jan. 4, 1912.

16. Ibid., Jan. 23, 1912.

17. William J. Glackens, "The American Section, The National Art: An Interview with the Chairman of the Domestic Committee," *Arts and Decoration* 3 (March 1913), p. 164.

18. Macbeth Gallery *Art Notes* 44 (Dec. 1911), p. 695.

19. Macbeth Gallery *Art Notes* 45 (March 1912), p. 708.

20. Letter from ABD to Virginia, Dec. 19, 1890. Niles M. Davies, Jr., Family Archives.

21. Letter from Edna Owen to David Davies, June 2, 1929. Margaret Davies Marder Family Archives.

22. Letter from ABD to Walt Kuhn, undated [April, 1912]. Walt Kuhn Papers, Archives of American Art.

23. Letter from Robert Henri to John Sloan, Dec. 29, 1911. John Sloan Collection, Delaware Art Museum.

24. Armory Show Papers. Archives of American Art.

25. Letter from ABD to Alfred Stieglitz, April 18, 1912. Stieglitz Collection, The Beinecke Rare Book and Manuscript Library, Yale University.

26. "Progressives in Art Counted Out by Reactionaries," *New York American,* June 27, 1912.

27. Ibid.

Chapter 15. The Armory Assault (1912–1913)

1. "Progressives in Art Counted Out by Reactionaries." *New York American,* June 27, 1912.

2. Letter from Walter Pach to Alice Klauber, Aug. 31, 1909. Alice Klauber Papers, Archives of American Art.

3. Letter from ABD to Walter Pach, July 9, 1909. Walter Pach Papers, reel 4216, frame 817, Archives of American Art.

4. Letter from Martin Birnbaum to John Quinn, July, 1912, as quoted in Judith Zilczer, *The Noble Buyer: John Quinn, Patron of the Avant-Garde.* (Washington, 1978), p. 26.

5. Letter from ABD to Walt Kuhn, Sept. 2, 1912. Walt Kuhn Papers, Archives of American Art.

6. Letter from ABD to Walter Pach, Sept. 2, 1912. Walter Pach Papers, Archives of American Art.

7. Letter from ABD to Walt Kuhn, undated [Oct., 1912]. Walt Kuhn Papers, Archives of American Art.

8. Letter from ABD to Walt Kuhn, Oct. 1, 1912. Walt Kuhn Papers, Archives of American Art.

9. Ibid., Oct. 10, 1912.

10. Author's conversation with Brenda Kuhn, March 16, 1991.

11. Ibid., Sept. 21, 1989.

12. "A Recollection by Walter Pach," *Arthur B. Davies 1862–1928: A Centennial Exhibition.* (Utica, N.Y.: Munson-Williams-Proctor Institute, 1962), p. 7.

13. Walter Pach, *Queer Thing, Painting.* (New York, 1938), p. 178.

14. Ibid.

15. Milton Brown, *The Story of the Armory Show.* (New York, 1988), p. 50.

16. Barbara Haskell, *Marsden Hartley,* p. 27.

17. Walt Kuhn, *The Story of the Armory Show.* (New York, 1938), p. 11.

18. Denys Sutton, *Letters of Roger Fry.* (New York, 1922), p. 311.

19. Guy Pène du Bois, *Artists Say the Silliest Things.* (New York, 1940), p. 174.

20. Letter from ABD to Walt Kuhn, undated [Oct., 1912]. Walt Kuhn Papers, Archives of American Art.

21. Mabel Dodge Luhan, *Movers and Shakers,* p. 36.

22. Ibid., p. 37.

23. Letter from ABD to Mabel Dodge, Jan. 25, 1913, as quoted in Luhan, *Movers and Shakers,* p. 37.

24. *New York Evening Journal,* March 29, 1912.

25. Carlo Carrà Archives, Milan, in a letter to the author from Ester Coen, Rome, May 2, 1989.

26. From a private archive in Padua, courtesy Ester Coen, Rome. May 2, 1989.

27. Glackens, "The American Section," p. 164.

28. Manierre Dawson journal, Dec. 16, 1912. Manierre Dawson Papers, reel 64, frame 954, Archives of American Art.

29. Letter from Wreath McIntyre to the author, July 24, 1986.

30. Letter from Walt Kuhn to his wife Vera. Walt Kuhn Papers, reel D240, frame 653, Archives of American Art.

31. *Camera Work: A Photographic Quarterly* 31 (July, 1910), p. 25.

32. Newspaper clipping, untitled and undated. Niles M. Davies, Jr., Family Archives.

33. Letter from ABD to Max Weber, Jan. 1, 1913. Max Weber Papers, reel N69-83, frame 60, Archives of American Art.

34. Max Weber Oral History Project, Columbia University, p. 268.

35. Letter from ABD to Max Weber, Jan. 27, 1913. Max Weber Papers, reel N69-83, frame 63, Archives of American Art.

36. *New York Sun,* Dec. 14, 1912; *New York Press,* Jan. 1, 1913; *New York Globe and Commercial Advertiser,* Jan. 15, 1913.

37. *New York Sunday American,* Jan. 26, 1913.

38. Author's conversation with Manuel Komroff, Jan. 25, 1957.

39. Author's conversation with Walter Pach, Sept. 5, 1952.

40. Letter from ABD to Max Weber, Jan. 7, 1913. Max Weber Papers, reel N69–83, frame 62, Archives of American Art.

41. "Letter to the Editor" from Arthur Farwell, *New York Sun,* Aug. 30, 1948.

42. Pach, *Queer Thing, Painting,* p. 157.

43. Rudi Blesh, *Modern Art USA,* p. 51.

44. Frank Crowninshield, "The Scandalous Armory Show of 1913," unidentified publication, undated. Walt Kuhn Papers, reel D72, frame 819, Archives of American Art.

45. Charles H. Caffin, "International Exhibition and Modern Art Opens Tuesday," *New York American,* Feb. 16, 1913.

46. Pach, *Queer Thing, Painting,* p. 261.

47. Arthur B. Davies, "Explanatory Statement: The Aim of the Association of American Painters and Sculptors," *Arts and Decoration* 3 (March 1913), p. 149.

48. Pach, *Queer Thing, Painting,* p. 199.

49. Theodore Roosevelt, "Roosevelt on Cubism: A Layman's View of an Art Exhibition," *Outlook* 103 (March 29, 1913), p. 719.

50. Glackens, "The American Section," p. 159.

51. Letter from Alfred Stieglitz to ABD, Feb. 18, 1913. Stieglitz Collection, The Beinecke Rare Book and Manuscript Library, Yale University.

52. Jerome Myers, *Artist in Manhattan.* (New York, 1940), p. 36.

53. Ibid.

Chapter 16. Modernism and Models (1913–1914)

1. Letter from William M. R. French to ABD, March 6, 1913. The William M. R. French Papers, Art Institute of Chicago Archives.

2. Letter from Arthur Jerome Eddy to ABD, March 15, 1913. Walt Kuhn Papers, reel D 72, frame 1523, Archives of American Art.

3. *New York Sun,* Jan. 29, 1914.

4. *New York Sun,* Feb. 8, 1914.

5. Hardesty G. Maratta, "A Rediscovery of the Principles of Form Measurement," *Arts and Decoration* 4 (April 1914), p. 230.

6. Ibid., p. 231.

7. *(Baltimore) Evening Sun,* April 15, 1914.

8. Letter from ABD to Virginia, Aug. 25, 1913. Niles M. Davies, Jr., Family Archives.

9. Virginia Hilu, ed., *Beloved Prophet.* (New York, 1992), p. 142.

10. Ibid., p. 146.

11. H. P. Blavatsky, *The Collected Writings,* p. 249.

12. *New York Sun,* Nov. 16, 1913.

13. Letter from Duncan Phillips to Frank Jewett Mather, Jr., Nov. 29, 1922. Phillips Collection Archives.

14. Leo Stein, "The Painting of Arthur B. Davies," *New Republic* 13 (Jan. 19, 1918), p. 338.

15. Frederic Fairchild Sherman, "The Earlier and Later Work of Arthur B. Davies," *Art in America* 6 (Oct. 1918), p. 296.

16. Guy Pène du Bois, "Mistresses of Famous American Collections: The Collection of Mrs. Charles Cary Ramsey," *Arts and Decoration* 7 (Oct. 1917), p. 558.

17. Marsden Hartley, "The Poetry of Arthur B. Davies' Art," *Touchstone* 6 (Feb. 1920), p. 283.

18. Henry McBride's review of ABD's one-man show at the Macbeth Gallery, publication unknown, undated [1918]. Ferargil Galleries Scrapbooks, reel 1028, frame 763, Archives of American Art.

19. Author's interview with Wreath McIntyre, May 25, 1985.

20. Ibid., Oct. 18, 1986.

21. Ibid.

22. Letter from Walt Kuhn to his wife Vera, Feb. 19, 1914. Walt Kuhn Papers, reel D240, frame 732, Archives of American Art.

23. Letter from Wreath McIntyre to the author, Oct. 30, 1986.

24. Author's interview with Wreath McIntyre, May 25, 1985.

25. Ibid., Oct. 21, 1986.

26. Ibid., May 25, 1985.

Chapter 17. Murals, Sculptures, and Prints (1914–1917)

1. "Artists at Odds," *New York Evening Sun,* June 5, 1914.

2. Elmer MacRae Papers, Hirshhorn Museum and Sculpture Garden Archives.

3. Forbes Watson, "Arthur Bowen Davies," *Magazine of Art* 45 (Dec. 1952), p. 367.

4. Frederick James Gregg, "A Room Made by Arthur B. Davies," *Vanity Fair* 5 (Jan. 1916), p. 71.

5. Mather, "The Art of Arthur B. Davies," in *Arthur B. Davies: Essays on the Man and His Art,* p. 53.

6. Walt Kuhn Papers, reel D242B, frame 0014, Archives of American Art.

7. Letter from ABD to Virginia, Aug. 25, 1914. Niles M. Davies, Jr., Family Archives.

8. Ibid., Aug. 21, 1914.

9. Jean Stern, "Robert Henri and the 1915 San Diego Exposition," *American Art Review* 2 (Sept.–Oct. 1975), p. 112.

10. Letter from Walt Kuhn to John D. Morse, April 8, 1939. Walt Kuhn Papers, reel D242B, frame 0014, Archives of American Art.

11. Letter from Clyde H. Burroughs to Frederic Newlin Price, Feb. 5, 1927. The Detroit Institute of Art Archives.

12. Frederick James Gregg, "What the New Art Has Done," *Vanity Fair* 4 (April 1915), p. 31.

13. Mather, "The Art of Arthur B. Davies," in *Arthur B. Davies: Essays on the Man and His Art,* p. 52.

14. Gregg, "What the New Art Has Done," p. 31.

15. Author's conversation with Wreath McIntyre, May 25, 1985.

16. As reported in *Current Opinion* 58 (May 1915), pp. 354–5.

17. Elisabeth Luther Cary, "Art Notes: Pictures by Pascin, Arthur Davies and Walt Kuhn," *New York Times,* March 25, 1916, p. 12.

18. Letter from ABD to Elmer MacRae, undated. Elmer MacRae Papers, Hirshhorn Museum and Sculpture Garden Archives.

19. Macbeth Gallery *Art Notes* 48 (April 1913), p. 753.

20. Letter from James Gibbons Huneker to John Quinn, March 26, 1916, in Josephine Huneker, *Letters of James Gibbons Huneker.* (New York, 1922), p. 206.

21. Duncan Phillips, "Fallacies of the New Dogmatism in Art," *American Magazine of Art* 9 (Dec. 1917), p. 45.

22. Ibid.

23. Author's conversation with Wreath McIntyre, May 25, 1985.

24. Letter from ABD to Charles C. Glover, Dec. 9, 1916. Corcoran Gallery of Art Archives.

25. Frederick James Gregg, "The Earlier Work of Arthur B. Davies," *Vanity Fair* 12 (April 1919), p. 100.

26. Bryson Burroughs, "Arthur B. Davies," *Arts* 15 (Feb. 1929), p. 90.

27. Author's interview with Wreath McIntyre, May 25, 1985.

28. Ibid.

29. Ibid., March 4, 1983.

30. Niles M. Davies, Jr., Family Archives.

31. Letter from Walter Pach to Manierre Dawson, Dec. 10, 1913. Manierre Dawson Papers, reel 64, frame 878, Archives of American Art.

32. du Bois, *Artists Say the Silliest Things,* p. 174.

33. Letter from Wreath McIntyre to the author, July 9, 1985.

34. Author's conversation with Wreath McIntyre, May 25, 1985.

35. Letter from Wreath McIntyre to the author, Oct. 21, 1986.

36. Author's conversation with Wreath McIntyre, May 25, 1985.

37. Franklin Rosemont, ed., *"Isadora Speaks" by Isadora Duncan.* (San Francisco, 1981), p. 50.

38. Tobi Tobias, "Remembering the Matriarch of Modern Dance," *New York Times,* May 22, 1977.

39. Irma Duncan, *Duncan Dancer: An Autobiography by Irma Duncan.* (Middletown, Connecticut), 1965, p. 20.

40. Letter from Wreath McIntyre to the author, March 22, 1987.

41. Philip Rhys Adams, *Walt Kuhn, Painter: His Life and Work.* (Columbus, Ohio, 1978), p. 74.

42. Author's conversation with Wreath McIntyre, May 25, 1985.

43. Bryson Burroughs, "Arthur B. Davies," p. 90.

44. Author's conversation with Niles M. Davies, Sr., Feb. 16, 1963.

45. Author's conversation with Wreath McIntyre, May 25, 1985.

46. Letter from Wreath McIntyre to the author, Nov. 24, 1986.

47. Guy Pène du Bois, "The Lizzie P. Bliss Collection," *Arts* 17 (June 1931), p. 606.

48. Paul Rosenberg, "American Painting," *Dial* 71 (Dec. 1921), p. 655.

49. Unidentified newspaper clipping, Jan. 28, 1913. Arthur B. Davies scrapbook, Niles M. Davies, Jr., Family Archives.

50. Letter from Marion Chapman to ABD, Nov. 1921. Margaret Davies Marder Family Archives.

51. Ibid., March 9, 1921.

52. "Ever Youthful Work by Arthur B. Davies," *Vanity Fair* 9 (Sept. 1917), p. 60.

53. Phillips, "Fallacies of the New Dogmatism in Art," *American Magazine of Art* 9 (Dec., 1917), p. 45; (Jan. 1918), p. 105; (Dec. 1917), p. 46.

54. du Bois, "Mistresses of Famous American Collections," p. 558.

55. Frank Jewett Mather, Jr., "Arthur B. Davies," *Dictionary of American Biography,* vol. 5 (New York, 1958), p. 100.

56. H. M'B. [Henry McBride], "Arthur B. Davies's Mysterious End Great Shock to Art World," *New York Sun,* Dec. 22, 1928; Albert C. Barnes, *The Art in Painting.* (New York, 1928), p. 377; Letter from ABD to Sally Lewis, 1922, as quoted in *Dream Vision: The Work of Arthur B. Davies.* (Boston: Institute of Contemporary Arts, 1981), unpaginated.

Chapter 18. New Challenges (1917–1924)

1. Author's conversation with Brenda Kuhn, Aug. 21, 1992.

2. Ibid.

3. "Cubistic Art To Be offered at Auction," *New York Sun,* Nov. 5, 1917.

4. Letter from the Macbeth Gallery to the Pennsylvania Academy of the Fine Arts, Dec. 12, 1917. Pennsylvania Academy of the Fine Arts Library.

5. Henry McBride, unidentified newspaper clipping, undated [Jan., 1918]. Ferargil Galleries Scrapbooks, reel 1028, frame 763, Archives of American Art; Gustav Kobbe, *New York Herald,* undated. ABD scrapbook, Niles M. Davies, Jr., Family Archives; Frederick James Gregg, "The Arthur B. Davies Exhibition," *Vanity Fair* 9 (Dec. 1917), p. 130.

6. G. P. B. [Guy Pène du Bois], "The Arthur B. Davies Loan Exhibition," *Arts and Decoration* 8 (Jan. 1918), p. 112.

7. "Arthur B. Davies Past and Present," *Christian Science Monitor,* Jan. 9, 1918.

8. "Some Adventures in Freedom," *Christian Science Monitor,* Jan. 11, 1918.

9. Royal Cortissoz, "Beauty for the Profit of the Blind," *Literary Digest* 56 (Jan. 26, 1918), p. 24.

10. Sherman, "The Earlier and Later Work of Arthur B. Davies," p. 296.

11. Stein, "The Painting of Arthur B. Davies," p. 338.

12. Letter from John Quinn to ABD, Jan. 6, 1918. John Quinn Papers, Archives of American Art.

13. Huneker, *Letters of James Gibbons Huneker,* p. 243.

14. Laurence Hague, "In a Red Cross Art Factory," *New York Post,* Dec. 21, 1918.

15. du Bois, *Artists Say the Silliest Things,* p. 192.

16. Frederick James Gregg, "Arthur B. Davies Becomes Sign Painter for the Red Cross, As Do Other Artists," *New York Herald,* Dec. 8, 1918.

17. Wreath McIntyre Mason talk concerning an exhibition at the Zabriskie Gallery, Feb. 16, 1958. Whitney Museum of American Art Papers, reel N 651, frame 429, Archives of American Art.

18. Frederick James Gregg, "Sculptors Have the Best of It at the Penguin Show," *New York Herald,* April 13, 1919.

19. *New York Herald,* April 20, 1919.

20. Letter from ABD to William Macbeth, Inc., Jan. 16, 1919. Macbeth Gallery Papers, reel NMc37, frame 1167, Archives of American Art.

21. *New York Times,* Feb. 1, 1920.

22. "Arthur B. Davies, A Modern Idealist," *Christian Science Monitor,* Feb. 9, 1920.

23. Frederick James Gregg, "A. B. Davies' Art in Striking Show," *New York Herald,* Jan. 29, 1920.

24. Henry McBride, "Arthur B. Davies Exhibition," *New York Herald,* undated [Jan. 1920].

25. Hamilton Easter Field, "The Forum," *Arts* 1 (Jan., 1921), p. 32.

26. Letter from Thomas H. Russell to Duncan Phillips, Feb. 2, 1921. Phillips Collection Archives.

27. Letter from ABD to Frederic Newlin Price, June 9, 1921. Ferargil Galleries Papers, reel N68, frame 15, Archives of American Art.

28. Gustavus A. Eisen and F. Newlin Price, "Obituary: Arthur B. Davies," *Art News* 27 (Dec. 22, 1928), p. 12.

29. Gustavus A. Eisen, *The Great Chalice of Antioch.* (New York, 1923), vol. 1, p. vii.

30. Letter from Edna Potter to David Davies, undated [ca. 1929]. Margaret Davies Marder Family Archives.

31. Eisen, *The Great Chalice of Antioch.* Vol. 1, p. 75.

32. Eisen and Price, "Obituary," p. 12.

33. Eisen, *The Great Chalice of Antioch.* Vol. 1, p. 76.

34. Eisen and Price, "Obituary," p. 12.

35. Letter from Duncan Phillips to Frank Jewett Mather, Jr., Nov. 29, 1922. Phillips Collection Archives.

36. Ibid.

37. Marjorie Phillips, *Duncan Phillips and His Collection.* (New York, 1970), p. 4.

38. Letter from ABD to Sally Lewis, March 27, 1923. Harris K. Prior Papers, Archives of American Art.

39. Letter from Charles Daniel to Ferdinand Howald, June 22, 1923. Columbus Museum of Art Archives.

40. Guy Pène du Bois, "Art by the Way," *International Studio* 77 (June 1923), p. 254.

41. Alan Burroughs, "The Art of Arthur B. Davies," *Print Connoisseur* 3 (July 1923), p. 195.

42. Frederic Newlin Price, "The Etchings and Lithographs of Arthur B. Davies," *Print* 1 (Nov. 1930), p. 3.

43. du Bois, "Art by the Way," p. 254.

44. Author's conversation with Wreath McIntyre, May 25, 1985.

45. Letter from John Quinn to ABD, Oct. 2, 1923, as quoted in Zilczer, *The Noble Buyer,* p. 49.

46. "Davies Shows Recent Work," *New York World,* Dec. 23, 1923.

47. "Recent Drawings by Davies," unidentified newspaper clipping, undated [Dec., 1923]. E. Weyhe scrapbook, Weyhe Gallery.

48. *New York Herald,* Dec. 23, 1923.

49. *New York Sun,* Nov. 15, 1924.

50. Virgil Barker, "Introduction," *Arthur B. Davies: Paintings, Drawings, Water Colors.* (Pittsburgh: Carnegie Institute, 1924).

51. Frank Weitenkampf, *American Graphic Art.* (New York, 1924), p. 175.

Chapter 19. Flight and Freedom (1924–1928)

1. Edward Alden Jewell, "America's Painter of Magical Beauty," *New York Times Magazine,* Feb. 9, 1930, p. 22.

2. Letter from Edna Owen to David Davies, undated [ca. 1929]. Margaret Davies Marder Family Archives.

3. Letter from Ronnie Owen to David Davies, June 2, 1930. Margaret Davies Marder Family Archives.

4. Letter from Wreath McIntyre to the author, Oct. 21, 1986.

5. Letter from Duncan Phillips to Thomas H. Russell, June 22, 1925. Phillips Collection Archives.

6. Duncan Phillips, et al., *Arthur B. Davies: Essays on the Man and His Art,* p. vii.

7. Ibid., p. 64.

8. Ibid., p. 43.

9. Ibid., pp. 3, 5.

10. Ibid., p. 16.

11. Letter from Lizzie Bliss to Duncan Phillips, undated [1929]. Phillips Collection Papers, reel 1932, frame 326, Archives of American Art.

12. Phillips, et al., *Arthur B. Davies: Essays on the Man and His Art,* p. 53.

13. Frank A. Nankivell, "A Bowl of Rice and Other Grains." Unpublished autobiography, p. 255.

14. Ibid.

15. Ibid.

16. Letter from ABD to Frederic Newlin Price, May 22, 1925. Frederic Newlin Price Collection, reel D-42, frame 35, Archives of American Art.

17. Letter from ABD to Niles M. Davies, Sr., Aug. 10, 1925. Niles M. Davies, Jr., Family Archives.

18. Frederic Newlin Price, "The Miniature Sculpture of Arthur B. Davies," *Parnassus* 5 (Dec. 1933), p. 13.

19. Price, "The Etchings and Lithographs of Arthur B. Davies," p. 12.

20. Letter from ABD to Niles M. Davies, Sr., Aug. 10, 1925. Niles M. Davies, Jr., Family Archives.

21. Ibid.

22. Letter from Edna Owen to David Davies, June 2, 1929. Margaret Davies Marder Family Archives.

23. Ibid.

24. Letter from ABD to Emma Davies, undated [1925–26]. Niles M. Davies, Jr., Family Archives.

25. John Canaday, "Arthur B. Davies and Modern Prints," *New York Times,* Sept. 23, 1962.

26. Letter from Duncan Phillips to Frederic Newlin Price, Feb. 25, 1926. Phillips Collection Archives.

27. Letter from Alfred Stieglitz to Duncan Phillips, March 6, 1926. Phillips Collection Archives.

28. "Davies Collection of Modern French Paintings Shown," *Art News* 24 (Feb. 20, 1926), p. 1.

29. "International House to Remove Murals That Aren't Understood," *New York Herald Tribune,* Aug. 3, 1949.

30. Rockefeller Family Papers, Box 10, Rockefeller Archive Center.

31. Edward Alden Jewell, "Mural Artists Find Adventure in Large Wall Spaces: Karoly Fulop's Murals, Mural Art of Davies," *New York Times,* undated [ca. 1930]. International House Archives.

32. *New York Times,* July 4, 1926, as quoted in *Brooklyn Museum Quarterly* 13 (Oct. 1926), p. 134.

33. Royal Cortissoz, "The Field of Art: Arthur B. Davies," *Scribner's Magazine* 80 (Sept. 1926), p. 344.

34. Letter from Wreath McIntyre to the author, Nov. 30, 1986.

35. Letter from ABD to Emma Davies, undated [1926]. Niles M. Davies, Jr., Family Archives.

36. Letter from ABD to Virginia, Aug. 27, 1927. Niles M. Davies, Jr., Family Archives.

37. Phillips, *Duncan Phillips,* p. 68.

38. Ibid., p. 69.

39. James R. Mellow, "Rocky [Nelson Rockefeller] as a Collector," *New York Times Magazine,* May 18, 1929, p. 48.

40. Letter from Frederic Newlin Price to ABD, Dec. 19, 1927. Margaret Davies Marder Family Archives.

41. McBride, "Arthur B. Davies's Mysterious End," p. 21.

42. Notes for a talk by Dr. Sylvia Davies Diehl, Feb. 19, 1978. Collection of Dr. Sylvia Davies Diehl.

43. Author's conversation with Wreath McIntyre, Oct. 18. 1986.

44. Letter from Alyce N. Churchill to ABD, March 30, 1928. Margaret Davies Marder Family Archives.

45. Frederic Newlin Price Letters, reel N68-15, frame 69, Archives of American Art.

46. Letter from ABD to Virginia, Sept. 26, 1928. Niles M. Davies, Jr., Family Archives.

Chapter 20. The Final Cover-Up (1928–1932)

1. Letter from Edna Owen to Virginia, undated [ca. 1930]. Niles M. Davies, Jr., Family Archives.

2. Niles M. Davies, Jr., Family Archives.

3. Letter from Edna Owen to Virginia, June 19, 1929. Margaret Davies Marder Family Archives.

4. Author's conversation with Eliza Bliss Parkinson Cobb, Sept. 11, 1992.

5. Author's conversation with Brenda Kuhn, July 3, 1985.

6. Ibid., Aug. 8, 1985.

7. Letter from Edna Owen to David Davies, undated [Nov., 1928]. Margaret Davies Marder Family Archives.

8. Letter from Virginia to Frederic Newlin Price, Dec. 10, 1928. Frederic Newlin Price Papers, reel N68-15, frame 50, Archives of American Art.

9. Ibid., frame 52.

10. "Death of Davies, Artist, Revealed After Seven Weeks," *New York Herald Tribune,* Dec. 18, 1928.

11. Letter from Emma Davies to David Davies, Jan. 13, 1929. Margaret Davies Marder Family Archives.

12. Dec. 30, 1928; Jan. 13, 1929; and undated.

13. *New York World,* Aug. 23, 1929; Royal Cortissoz, *Arthur B. Davies.* (New York, 1931), p. 10; Eisen and Price, "Obituary," p. 12.

14. Letter from Abby Aldrich Rockefeller to David Davies, Dec. 18, 1928. Rockefeller Family Papers, Box 10, Rockefeller Archive Center.

15. Letter from Virginia to Mildred (Mrs. David) Davies, Dec. 17, 1928. Margaret Marder Family Archives.

16. "Arthur B. Davies," *New York Evening Post,* Dec. 18, 1928.

17. "Kansas Seeress Adds Doubt on Famous Painter's Death," *New York Evening Post,* . . . r [Sept., Oct., Nov. or Dec.] 21, 1931.

18. As quoted in "Our Water-Color Mindedness," *Literary Digest,* 99 (Nov. 24, 1928).

19. "Davies' Last Water Colors Shown," *New York Sun,* March 26, 1929; *New York Evening Post,* March 30, 1929; Edward Alden Jewell, "Arthur B. Davies's Watercolors," *New York Times,* March 31, 1929.

20. Letter from Abby Aldrich Rockefeller to Virginia Davies, June 24, 1929. Niles M. Davies, Jr., Family Archives.

21. Letter from Virginia Davies to the Museum of Modern Art, Oct. 5, 1931, as published in *Selected Paintings and Sculpture from the Hirshhorn Museum and Sculpture Garden.* (New York, 1974), p. 678.

22. *New York Herald Tribune,* April 28, 1929.

23. Geoffrey T. Hellman, "Profile of a Museum" [the Museum of Modern Art], *Art in America* 52 (Feb. 1964), p. 29.

24. Author's conversation with Elizabeth Bliss Parkinson Cobb, Jan. 5, 1986.

25. *New York Herald Tribune,* Nov. 10, 1929.

26. As reported in *Art Digest* 4 (Nov. 15, 1929).

27. Dec. 1, 1929, p. 9.

28. "Davies Tapestries to Be Included in Memorial Showing," *Art News* 28 (Feb. 15, 1930), p. 8.

29. Letter from Virginia Davies to the United States Tariff Commission, May 12, 1930. Margaret Davies Marder Family Archives.

30. "Studio Effects Enliven Davies Memorials," *New York World,* Nov. 29, 1930.

31. Frederic Thompson, "The American Luxembourg" [the Museum of Modern Art], *Commonweal* 14 (July 29, 1931), p. 319.

32. Elisabeth Luther Cary, "Arthur B. Davies," *New York Herald Tribune,* May 17, 1931.

33. Elisabeth Luther Cary, "A Personal Collection" [of Lizzie Bliss], *New York Herald Tribune,* March 29, 1931.

34. "Modern Museum Receives Bliss Art," *New York Times,* March 13, 1934.

35. Author's conversation with Elizabeth Bliss Parkinson Cobb, Jan. 5, 1986.

36. Ibid., Jan. 20, 1987.

37. Elizabeth Bliss Parkinson Oral History, p. 21, frame 1174, Archives of American Art.

Epilogue

1. Letter from Ronnie Owen to David Davies, April 28, 1928. Margaret Davies Marder Family Archives.

2. "Bonfire," *Time* 15 (Jan. 27, 1930), p. 40.

3. "The Mystery at Millbank," *New York Times,* Dec. 27, 1931, p. 12.

4. "Tate Refusal of Davies Canvases Stuns New York," *Art News 30* (Dec. 19, 1931), p. 5.

5. du Bois, "The Lizzie P. Bliss Collection," p. 608.

6. "Art Works of the Late A. B. Davies Burn in a $75,000 Fire in Barn on His Son's Farm," *New York Times,* Dec. 11, 1940.

7. Letter from Virginia Davies to an unnamed art dealer, Nov. 15, 1946. Niles M. Davies, Jr., Family Archives.

8. Letter from Abby Aldrich Rockefeller to David Davies, Dec. 18, 1928. Rockefeller Family Papers, Box 10, Rockefeller Archive Center.

9. "Arthur B. Davies," *New York Herald Tribune,* Feb. 12, 1939.

10. "Davies Saw Beauty in the World of Man," *Art Digest* 13 (Feb. 15, 1939), p. 9.

11. Melville Upton, "Arthur B. Davies Again," *New York Sun,* Sept. 12, 1941.

12. John Gordon preface in *Arthur B. Davies 1862–1928: A Centennial Exhibition,* p. 3.

13. Leslie Katz, "The Originality of Arthur B. Davies," *Arts Magazine* 37 (Nov. 1962), p. 16.

14. Howard Taubman, "More Art Sought for White House," *New York Times,* July 19, 1967.

15. Forbes Watson, "Arthur Bowen Davies," *Magazine of Art* 45 (Dec. 1952), p. 367.

✤ Bibliography ✤

Unpublished Material

Archives of American Art. Oral History interview of Elizabeth [Eliza] Bliss Parkinson [Cobb] by Paul Cummings. Jan. 3, 1978, reel 3198, 51 pp.

Betts, Rostan [Virginia Davies' niece]. Four letters to Niles M. Davies, Jr. Davies Family Archives.

Bliss, Lizzie P. Scrapbook. Collection Eliza Bliss Parkinson Cobb.

Columbia University. Oral History Project transcripts of interviews with Holger Cahill, Leon Kroll, Max Weber, and William Zorach.

Davies, Arthur B. Scrapbook, undated. Davies Family Archives.

Davies, Arthur B. Scrapbook containing sketches, 1878–1883. Davies Family Archives.

Davies, Arthur B. "The Greek Center of Movement," ca. 1923, unpaged. Davies Family Archives.

Davies, Erica. "Gotham Girl Makes Good," undated manuscript. Davies Family Archives.

"Davies Paintings Sold by the Ferargil Galleries," 15 pp. Davies Family Archives.

"Davies Sold by the Macbeth Galleries," 7 pp. listing 370 works. Davies Family Archives.

Davies, Virginia. Reminiscences, undated. Davies Family Archives.

du Pré, Lucile. Seven letters to Virginia Davies, 1890 ff. Davies Family Archives.

Hartley, Marsden. "The Re-Visioning of Arthur B. Davies," undated essay [ca. 1930]. Marsden Hartley Archives, The Beinecke Rare Book and Manuscript Library, Yale University.

Hartmann, Sadakichi. "Hours of Midnight," manuscript, 1890. Special Collections, Fales Library, New York University.

————. Letters. Special Collections, University of California, Riverside.

Healy, Daty. "A History of the Whitney Museum of American Art, 1930–1954." Doctoral dissertation, New York University, 1960.

"Inventory and Appraisal of the Art and Literary Property Belonging to the Estate of the late Arthur B. Davies Contained in the Warehouse at Day and Meyer, Murray and Young, Inc.," 109 pp. Davies Family Archives.

Journal of Dr. Virginia M. Davies. 1890–1893. Davies Family Archives.

"List of Arthur B. Davies' Works in Museums," 7 pp. Davies Family Archives.

Nankivell, Frank S. "A Bowl of Rice and Other Grains," autobiography, 1945. Nankivell Family Archives.

New York Public Library. "The Century Collection," Manuscript Division.

Owen, Edna Potter. Letters to A. David Davies, undated. Davies Family Archive.

————. Letters to Virginia Davies, undated. Davies Family Archives.

Owen, Ronnie. Letters to A. David Davies, 1930. Davies Family Archives.

Patterson, Paige. "The Theme of Innocence in the Early Works of Arthur Bowen Davies." Thesis paper, Randolph-Macon Woman's College, undated.

Rockefeller Family Papers. Rockefeller Archive Center, North Tarrytown, NY.

Rueppel, Merrill Clement. "The Graphic Art of Arthur Bowen Davies and John Sloan." Doctoral dissertation, University of Wisconsin, 1955.

Sherower, Ronven Owen. "Untitled" [Reminiscences of her father, Arthur B. Davies], 4 pp., spring, 1978. Ronven Owen Sherower Papers, reel 2336, frame 600 ff., Archives of American Art.

Weaver, Jane Ann Calhoun. "Sadakichi Hartmann: Herald of Modernism in American Art," 2 vols. Doctoral dissertation, The University of North Carolina, Chapel Hill, 1986.

Books about Arthur B. Davies

Cortissoz, Royal. *Arthur B. Davies*. New York, 1931.

Czestochowski, Joseph S. *Arthur B. Davies: A Catalogue Raisonné of the Prints*. Newark, DE, 1987.

————. *The Works of Arthur B. Davies*. Chicago, 1979.

Phillips, Duncan, Dwight Williams, Royal Cortissoz, Frank Jewett Mather, Jr., Edward W. Root, and Gustavus A. Eisen. *Arthur B. Davies: Essays on the Man and His Art*. Washington, 1924.

Price, Frederic Newlin. *The Etchings and Lithographs of Arthur B. Davies*. New York, 1929.

The Arthur B. Davies Art Collection: Modern Drawings, Prints, Paintings and Sculpture; Ancient Bronzes, Pottery and Fabrics; French Furniture and Tapestries. New York, 1929.

Wright, Brooks. *The Artist and the Unicorn*. New City, NY, 1978.

Catalogues of One-Man Shows by Arthur B. Davies

Arthur B. Davies. Introduction by Gertrude Dalberg. James Graham & Sons, New York, 1962.

Arthur B. Davies (1862–1928). Foreword by Sylvia Ann Davies. James Graham & Sons, New York, 1958.

Arthur B. Davies 1862–1928. James Graham & Sons, New York, 1960.

Arthur B. Davies 1862–1928. Zabriskie Gallery, New York, 1958.

Arthur B. Davies 1862–1928: A Centennial Exhibition. Preface by John Gordon, recollections by Walter Pach, introduction by Harris K. Prior. Munson-Williams-Proctor Institute, Utica, NY, 1962.

Arthur B. Davies 1862–1928: An Exhibition of Etchings, Aquatints, Woodcuts and Lithographs. Harbor Gallery, Cold Spring Harbor, NY, 1972.

Arthur B. Davies: A Chronological Retrospective. M. Knoedler & Co., New York, 1975.

Arthur B. Davies: A Retrospective Exhibition. Introduction by Joseph S. Czestochowski. Cedar Rapids Museum of Art, IA, 1984.

Arthur B. Davies: An Exhibition of a Collection of Etchings, Drypoints and Lithographs. Associated American Artists, New York, 1966.

Arthur B. Davies: Artist and Collector. Introduction by Andrea Kirsh. Rockland Center for the Arts, West Nyack, NY, 1977.

Arthur B. Davies: Drawings and Watercolors. Foreword by Arnold L. Lehman, essay by Bennard B. Perlman. Baltimore Museum of Art, Baltimore, 1987.

Arthur B. Davies: Paintings and Graphics. Essay by Sheldon Reich. The Tucson Art Center, Tucson, AZ, 1967.

Arthur B. Davies: Paintings, Drawings, Water Colors. Essay by Virgil Barker. Carnegie Institute, Pittsburgh, 1924.

Arthur Bowen Davies 1862–1928. Lehigh University, Bethlehem, PA, 1976.

Catalogue for an Exhibition of Etchings and Lithographs by Arthur B. Davies. Kennedy and Co., New York, 1930.

Catalogue of a Loan Collection of Paintings by Arthur B. Davies. Women's Cosmopolitan Club, New York, 1911.

Catalogue of an Exhibition of Original Etchings, Drypoints, Aquatints, Lithographs and Water Colors by Arthur B. Davies. Albert Roullier Art Galleries, Chicago, 1921.

Catalogue of Paintings by Arthur B. Davies. Macbeth Gallery, New York, 1912.

Dream Vision: The Work of Arthur B. Davies. Foreword by Stephen S. Prokopoff, essays by Linda Wolpert, Garnett McCoy, Elisabeth S. Sussman and Nancy E. Miller. Institute of Contemporary Art, Boston, 1981.

Etchings and Lithographs by Arthur B. Davies. E. Weyhe, New York, 1929.

Exhibition of Early and Middle Periods of the Work of Arthur B. Davies. Mrs. Cornelius J. Sullivan Gallery, New York, 1939.

Exhibition of Paintings by Arthur B. Davies. Macbeth Gallery, New York, 1896.

Exhibition of Paintings, Watercolors and Aquatints by Arthur B. Davies. M. de Zayas, New York, 1920.

Loan Exhibition of Paintings, Watercolors, Drawings, Etchings and Sculpture by Arthur B. Davies. Macbeth Gallery, New York, 1918.

Memorial Exhibition of the Works of Arthur B. Davies. Essay by Bryson Burroughs. Metropolitan Museum of Art, New York, 1930.

Paintings by Arthur B. Davies. Art Institute of Chicago, 1911.

Special Memorial Exhibition of Works by the Late Arthur B. Davies. Corcoran Gallery of Art, Washington, 1930.

The Art of Arthur B. Davies. Essay by Alan Burroughs. E. Weyhe, New York, 1923.

Works by Arthur B. Davies from the Collection of Mr. and Mrs. Herbert Brill. Notes by John Paul Driscoll. Pennsylvania State University, State College, PA, 1979.

Articles About Arthur B. Davies

"A Tearless World," *Time* 80 (Aug. 17, 1962), 56.

"A Tribute to the Late Arthur B. Davies: Arthur B. Davies Memorial Number," *Bulletin of the Columbus Gallery of Fine Arts* 1 (April 1931), 27–29.

"Art," *Society* 1 (Jan. 17, 1913), 7.

"Art and Artists: Exhibition of Oil Paintings by Arthur B. Davies," *Boston Sunday Globe,* Feb. 26, 1905, 35.

"Art Notes," *New York Times,* Oct. 9, 1893, 2.

"Arthur B. Davies," *New York Evening Post,* Dec. 18, 1928.

"Arthur B. Davies," *New York Herald Tribune,* Feb. 12, 1939.

"Arthur B. Davies, A Modern Idealist," *Christian Science Monitor,* Feb. 9, 1920.

"Arthur B. Davies: A Muralist in Prints," *International Studio* 72 (Feb. 1921), cxxviii.

"Arthur B. Davies in Varied Moods: Most Phases of Artist's Career Illustrated at Special Showing of His Work," *New York Sun,* April 27, 1929.

"Arthur B. Davies Past and Present," *Christian Science Monitor,* Jan. 9, 1918.

"Arthur Bowen Davies," *Index of Twentieth Century Artists* 4 (Feb. 1937), 385–400.

"Beauty for the Profit of the Blind," *Literary Digest* 56 (Jan. 26, 1918), 23, 24.

Benezin, Ellen. "Arthur B. Davies: Artist and Connoisseur," *Worcester Art Museum Bulletin* 6 (Nov. 1976), 1–16.

"Bonfire" [concerning the burning of sixty-one uncompleted Davies paintings by his widow], *Time* 15 (Jan. 27, 1930), 40.

Broadd, Dr. Harry A. "Arthur B. Davies," *Arts and Activities* 82 (Dec. 1977), 39–41, 50, 51.

Burroughs, Alan. "The Art of Arthur B. Davies," *Print Connoisseur* 3 (July 1923), 194–213.

Burroughs, Bryson. "Arthur B. Davies," *Arts* 15 (Feb. 1929), 79–93.

———. "Arthur B. Davies, Romanticist," *Creative Art* 8 (Feb. 1931), 98–102.

Burrows, Carlyle. "Letter from New York," *Apollo* 11 (April 1930), 276, 277.

Campbell, Lawrence. "An Idealist Who Changed History: Arthur B. Davies," *Art News* 61 (Oct. 1962), 40–43, 64, 65.

Canaday, John. "Arthur B. Davies and Modern Prints," *New York Times,* Sept. 23, 1962, Sec. 10, 19.

———. "Davies, Others, and Jazz," *New York Times,* Feb. 7, 1960.

Cary, Elisabeth Luther. "A Lost Mystic," *New York Times,* Dec. 30, 1928, Sec. 8, 12.

———. "Art Notes: Pictures by Pascin, Arthur Davies and Walt Kuhn," *New York Times,* March 25, 1916, 12.

———. "Arthur B. Davies," *New York Herald Tribune,* May 17, 1931.

———. "Arthur B. Davies Memorial." *New York Times,* Feb. 16, 1930. Sec. 10, 12.

Clark, Edward B. "Start of Career of Arthur B. Davies," *Chicago Evening Post,* July 12, 1925.

"Color Harmonies by Mr. Arthur Davies," *New York Sun,* March 12, 1896.

Cortissoz, Royal. "A Group of Water Colors and Bronzes," *New York Herald Tribune,* March 31, 1929, Sec. 8, 10.

————. "Arthur B. Davies," *The Painter's Craft.* (New York, 1930), pp. 359–72.

————. "The Character and Art of Arthur B. Davies," *Art News* 27 (April 27, 1929), 63–74.

————. "The Field of Art: Arthur B. Davies," *Scribner's Magazine* 80 (Sept. 1926), 344–52.

————. "The Magical Art of Arthur B. Davies," *New York Herald Tribune,* Dec. 30, 1928, Sec. 8, 10.

Cournos, John. "Arthur B. Davies," *Forum* 51 (May 1914), 770–72.

Czestochowski, Joseph S. "The Graphic Work of Arthur B. Davies," *American Art Review* 3 (July–Aug. 1976), 102–13.

Dahlberg, Gertrude. "Arthur B. Davies: 1862–1928," *Art and Antiques* 4 (July–Aug. 1981), 42–49.

————. "Arthur B. Davies—One of Rockland's Greatest," *(Rockland) County (New York) Citizen,* Sept. 6, 1962, 15.

————. "Davies's Party Revisited," *New Magazine* 1 (Sept. 1964), 14–16.

Davies, Arthur B. "Explanatory Statement: The Aim of the Association of American Painters and Sculptors," *Arts and Decoration* 3 (March 1913), 149.

"Davies Collection of Modern French Paintings Shown," *Art News* 24 (Feb. 20, 1926), 1.

"Davies' Last Water Colors Shown," *New York Sun,* March 26, 1929.

"Davies Shows Recent Work," *New York World,* Dec. 23, 1923.

"Davies Tapestries to Be Included in Memorial Showing," *Art News* 28 (Feb. 15, 1930), 8.

De Kay, Charles. "Paintings by Davies," *New York Times,* April 12, 1905, 10.

"Death of Davies, Artist, Revealed After Seven Weeks," *New York Herald Tribune,* Dec. 18, 1928.

[du Bois, Guy Pène] G. P. B., "The Arthur B. Davies Loan Exhibition," *Arts and Decoration* 8 (Jan. 1918), 112–13.

Eddy, Frederick W. "Arthur B. Davies's Career Reviews in a Loan Exhibition of His Work for War Relief," *New York World,* Jan. 1918.

Eisen, Dr. Gustavus A., and F. Newlin Price. "Obituary: Arthur B. Davies," *Art News* 27 (Dec. 22, 1928), 12.

"Ever Youthful Work of Arthur B. Davies," *Vanity Fair* 9 (Sept. 1917), 60.

Field, Hamilton Easter. "Comments on the Arts," *Arts* 1 (May 1921), 36.

————. "The Art of Arthur B. Davies," *Brooklyn Daily Eagle,* Feb. 15, 1920, 5.

"$50,000 of Sales Made at Davies Exhibition," *Art Digest* 4 (Dec. 1, 1929), 9.

FitzGerald, Charles. "The Art of Arthur B. Davies," *New York Evening Sun,* April 6, 1905.

F. J. M., Jr. [Mather, Jr., Frank Jewett], "Arthur B. Davies," *Dictionary of American Biography* 5 (New York, 1958), 99–101.

"Former Utica Boy Is Being Honored for His Art Work by Metropolitan Museum," *Utica Daily Press,* Feb. 19, 1930, 7.

G. P. B. [Guy Péne du Bois], "The Arthur B. Davies Loan Exhibition," *Arts and Decoration* 8 (Jan. 1918), 112–13.

Gregg, Frederick James. "A. B. Davies' Art in Striking Show," *New York Herald,* Jan. 29, 1920.

———. "A Room Made by Arthur B. Davies," *Vanity Fair* 5 (Jan. 1916), 70–71.

———. "Arthur B. Davies Becomes Sign Painter for the Red Cross, As Do Other Artists," *New York Herald,* Dec. 8, 1918.

———. "Modern Art's Revenge at San Francisco," *Vanity Fair* 5 (March 1916), 51, 134.

———. "The Arthur B. Davies Exhibition," *Vanity Fair* 9 (Dec. 1917), 59, 130.

———. "The Earlier Work of Arthur B. Davies," *Vanity Fair* 12 (April 1919), 55, 98, 100.

———. "What the New Art Has Done," *Vanity Fair* 4 (April 1915), 30–31.

Hartley, Marsden. "The Poetry of Arthur B. Davies' Art," *Touchstone* 6 (Feb. 1920), 277–84.

[Hartmann, Sadakichi] unsigned. "American Art Gossip. Arthur B. Davies," *Art Critic* 1 (Jan. 1894), 40.

———. "The Echo," *American Art News* 1 (June 1897), 4–5.

———. "The Entertaining in Art: The Mansfields Sell Out Again, Mr. Chase Starts a New School, Also a word about Mr. Dodge and Mr. Davies," *Daily Tatler* (Nov. 18, 1896), 7.

H. M'B. [McBride, Henry], "Arthur B. Davies's Mysterious End Great Shock to Art World," *New York Sun,* Dec. 22, 1928, 21.

Huneker, James Gibbons. "A Painter Visionary," *New York Sun,* Feb. 28, 1909.

———. "Arthur B. Davies," *New York Sun,* June 4, 1908, 6.

"International House to Remove Murals That Aren't Understood," *New York Herald Tribune,* Aug. 3, 1949.

Jewell, Edward Alden. "America's Painter of Magical Beauty," *New York Times Magazine,* Feb. 9, 1930, 14, 22.

————. "Arthur B. Davies's Watercolors," *New York Times,* March 31, 1929.

————. "Mural Artists Find Adventure in Large Wall Spaces: Karoly Fulop's Murals, Mural Art of Davies," *New York Times,* undated [ca. 1930]. International House Archives, New York.

Johns, Elizabeth. "Arthur B. Davies and Albert Pinkham Ryder: The 'Fix' of the Art Historian," *Arts* 56 (Jan. 1982), 70–74.

Katz, Leslie. "The Originality of Arthur B. Davies," *Arts* 37 (Nov. 1962), 16–20.

Kirk, Gertrude. "Work of Native Utican, Arthur Davies, Is Cited to Disprove Writer's Charge America Has Produced No Great Artist," *Utica Observer-Dispatch,* Oct. 6, 1929.

Kobbe, Gustave. "Two Floors of Macbeth Galleries Required to Show Work of Artist," *New York Herald,* undated [Jan. 1918].

[Mather, Jr., Frank Jewett], F. J. M., Jr. "Arthur B. Davies," *Dictionary of American Biography* 5 (New York, 1958), 99–101.

[McBride, Henry], H. M'B. "Arthur B. Davies's Mysterious End Great Shock to Art World," *New York Sun,* Dec. 22, 1928, 21.

————. "Fourteen of His Water Colors Bought in First Twenty-four Hours of Display," *New York Herald,* Dec. 23, 1923.

McCauley, Lena M. "Arthur B. Davies," *Chicago Post,* Dec. 31, 1929.

[Milliken, William M.], W. M. M. "Hermes and the Infant Dionysus: Painting by Arthur B. Davies," *Bulletin of the Cleveland Museum of Art* 15 (Nov. 1928), 178–80.

Mumford, John Kimberly. "Who's Who in New York—No. 33: Arthur B. Davies," *New York Tribune,* Oct. 5, 1924.

"Murals a Puzzle, Davies' Art To Go," *New York Times,* Aug. 3, 1949.

Nawrocki, Dennis A. "Prendergast and Davies: Two Approaches to a Mural Project," *Bulletin of the Detroit Institute of Arts,* 56 (1978), 243–52.

"On the Realist and the Idealist: The Fish of William M. Chase and the Figurines of Arthur B. Davies," *Arts and Decoration* 8 (Nov. 1917), 34, 36–37.

Perlman, Bennard B. "A Model's Tale: The Woman Who Posed for One of America's Most Enigmatic Artists Breaks a Sixty Year Silence to Tell Her Story," *Art and Antiques* (May 1987), 84–87, 110.

Phillips, Duncan. "The American Painter, Arthur B. Davies," *Art and Archaeology* 4 (Sept. 1916), 169–77.

"Pictures by Arthur B. Davies," *New York Times,* March 14, 1896.

Porter, Fairfield. "Arthur B. Davies," *ARTnews* 56 (Feb. 1958), 11.

Price, F. Newlin. "Davies the Absolute," *International Studio* 75 (June 1922), 213–19.

———. "The Etchings and Lithographs of Arthur B. Davies," *Print* 1 (Nov. 1930), 1–12.

———. "The Miniature Sculpture of Arthur B. Davies," *Parnassus* 5 (Dec. 1933), 11–13.

" 'Rebel in Art' Now Is Master," *Chicago Post,* Oct. 14, 1924.

Reich, Sheldon. "The Paradoxes of Arthur B. Davies," *Apollo* 92 (Nov. 1970), 366–71.

"Ryder and Davies Side by Side," *Christian Science Monitor,* Jan. 24, 1921, 12.

Sherman, Frederic Fairchild. "The Earlier and Later Work of Arthur B. Davies," *Art in America* 6 (Oct. 1918), 295–99.

"Some Adventures in Freedom," *Christian Science Monitor,* Jan. 11, 1918.

Stein, Leo. "The Painting of Arthur B. Davies," *New Republic* 13 (Jan. 19, 1918), 338.

"Studio Effects Enliven Davies Memorials," *New York World,* Nov. 29, 1930.

Swift, Samuel. "Art Notes: New Paintings by Arthur Davies at the Macbeth Gallery," *New York Mail and Express,* Dec. 8, 1900.

———. "New Paintings by Arthur B. Davies: Striking and Unforgettable Work by This Imaginative Genius at the Macbeth Gallery," *New York Mail and Express,* April 3, 1905.

"Tate Refusal of Davies Canvases Stuns New York," *Art News* 30 (Dec. 19, 1931), 5, 6.

"The Art of Arthur B. Davies," *New York Evening Sun,* April 6, 1905.

"The Ascendancy of Arthur B. Davies in Contemporary Art," *Vanity Fair* 22 (May 1924), 66.

"The Fine Arts: Arthur B. Davies," *Critic* 28 (July 31, 1897), 63.

"The Fine Arts: Paintings by Arthur B. Davies," *Critic* 27 (May 8, 1897), 328.

"The Mystery at Millbank," *New York Times,* Dec. 27, 1931, 12.

"The 'New Art' Applied to Decoration," *Vanity Fair* 4 (May 1915), 40.

"The Town Traveler. Arthur B. Davies," *Art Collector* 9 (Dec. 15, 1898), 54–55.

"These Are Daviesian (Not Freudian) Dreams," *Art Digest* 13 (April 15, 1939), 15.

Tyrrell, Henry. "Arthur B. Davies: A Muralist in Prints," *International Studio,* Feb. 1921, cxxvii-cxxx.

Upton, Melville. "Arthur B. Davies Again," *New York Sun,* Sept. 12, 1941.

V. B., "A. B. Davies and K. H. Miller," *Arts* 13 (April 1928), 260–61.

Walker, Sophia Antoinette. "Fine Arts. An Artist Whom I Know," *Independent* 47 (Aug. 1, 1895), 13.

"Water Colors Last Work of Davies," *New York World,* March 31, 1929.

Watson, Forbes. "Arthur Bowen Davies," *Magazine of Art* 45 (Dec. 1952), 362–69.

"Widow Burns Sixty-one Unfinished Davies Paintings: Holds Them Unrepresentative of His Work," *New York Times,* Jan. 17. 1930.

W. M. M. [Milliken, William M.], "Hermes and the Infant Dionysus: Painting by Arthur B. Davies," *Bulletin of the Cleveland Museum of Art* 15 (Nov. 1928), 178–80.

Zilczer, Judith. "Arthur B. Davies: The Artist as Patron," *American Art Journal* 19 (1987), 54–83.

———. "The Eight on Tour, 1908–1909," *American Art Journal* 16 (summer 1984), 20–48.

Books, General

Adams, Clinton. *American Lithographers 1900–1960: The Artists and Their Printers.* Albuquerque, NM, 1983.

Adams, Philip Rhys. *Walt Kuhn, Painter: His Life and Work.* Columbus, OH, 1978.

Bell, Clive. *Art.* London, 1949.

Berkman, Pamela, ed. *The History of the Atchison, Topeka and Santa Fe.* Greenwich, CT, 1988.

Berman, Avis. *Rebels on Eighth Street: Juliana Force and the Whitney Museum of American Art.* New York, 1990.

Bindman, David. *William Blake: His Art and Times.* New York, 1982.

Blavatsky, H. P. *Dynamics of the Psychic World.* Wheaton, IL, 1972.

Blesh, Rudi. *Modern Art USA: Men, Rebellion, Conquest 1900–1956.* New York, 1956.

Boughton, Alice. *Photographing the Famous.* New York, 1928.

Brooks, Van Wyck. *John Sloan, A Painter's Life.* New York, 1955.

Brown, Milton. *The Story of the Armory Show.* New York, 1988.

Clark, Eliot. *History of the National Academy of Design 1825–1952.* New York, 1954.

Coastsworth, John H. *Growth Against Development: The Economic Impact of Railroads in Mexico.* DeKalb, IL, 1981.

Cranston, Sylvia. *H. P. B.: The Extraordinary Life and Influence of Helena Blavatsky, Founder of the Modern Theosophical Movement.* New York, 1994.

Davidson, Abraham A. *The Eccentrics and Other American Visionary Painters.* New York, 1978.

Downes, William Howe. *The Life and Works of Winslow Homer.* New York, 1974.

du Bois, Guy Pène. *Artists Say the Silliest Things.* New York, 1940.

du Pré, Lucile. *Poems of Lucile du Pré.* Boston, 1923.

Dunlap, Ian. *The Shock of the New.* New York, 1972.

Eisen, Gustavus A. *The Great Chalice of Antioch: On Which Are Depicted in Sculpture the Earliest Known Portraits of Christ, Apostles and Evangelists.* 2 vols. New York, 1923.

Hartley, Marsden. *Adventures in the Arts: Informal Chapters on Painters, Vaudeville and Poets.* New York, 1921.

Hartmann, Sadakichi. *A History of American Art.* 2 vols. Boston, 1901.

Hilu, Virginia, ed. *Beloved Prophet: The Love Letters of Kahlil Gibran and Mary Haskell and Her Private Journal.* New York, 1972.

Huneker, James. *The Pathos of Distance.* New York, 1913.

Huneker, Josephine. *Letters of James Gibbons Huneker.* New York, 1922.

Isham, Samuel. *The History of American Painting.* New York, 1905.

Jenison, Madge. *Sunwise Turn: A Human Comedy of Bookselling.* New York, 1923.

Kent, Rockwell. *It's Me, O Lord.* New York, 1955.

Kert, Bernice. *Abby Aldrich Rockefeller: The Woman in the Family.* New York, 1993.

Kuhn, Walt. *The Story of the Armory Show.* New York, 1938.

Lowe, Sue Davidson. *Stieglitz: A Memoir Biography.* London, 1983.

Luhan, Mabel Dodge. *Movers and Shakers.* Albuquerque, NM, 1985.

Mather, Jr., Frank Jewett. *Estimates in Art: Sixteen Essays on American Painters of the Nineteenth Century.* New York, 1931.

Meriwether, Lee. *My Yesteryears.* St. Louis, 1942.

Meriwether, Minor. *Lineage of the Meriwethers and the Minors.* St. Louis, 1895.

Meriwether, Nelson Heath. *The Meriwethers and Their Connections.* Columbia, MO, 1964.

Myers, Jerome. *Artist in Manhattan.* New York, 1940.

Norman, Dorothy. *Alfred Stieglitz: An American Seer.* New York, 1973.

Olson, Arlene R. *Art Critics and the Avant-Garde: New York, 1900–1913.* Ann Arbor, MI, 1980.

Pach, Walter. *Queer Thing, Painting.* New York, 1938.

Perlman, Bennard B. *The Immortal Eight: American Painting from Eakins to the Armory Show.* Cincinnati, 1979.

———. *Robert Henri: His Life and Art.* New York, 1991.

Phillips, Marjorie. *Duncan Phillips and His Collection.* New York, 1970.

Porter, Eliot, and Ellen Auerbach. *Mexican Churches.* Albuquerque, NM, 1987.

Price, Frederic Newlin. *Goodbye Ferargil.* New Hope, PA, 1958.

Quinn, John 1870–1925: Collection of Paintings, Water Colors, Drawings and Sculpture. Huntington, NY, 1926.

Rich, Daniel Catton, ed. *The Flow of Art: Essays and Criticisms of Henry McBride.* New York, 1975.

Rose, Andrea. *The Pre-Raphaelites.* Oxford, UK, 1984.

St. John, Bruce, ed. *John Sloan's New York Scene.* New York, 1965.

Schwab, Arnold T. *James Gibbons Huneker: Critic of the Seven Arts.* Stanford, CA, 1963.

Sutton, Denys. *Letters of Roger Fry.* New York, 1972.

Traxel, David. *An American Saga: The Life and Times of Rockwell Kent.* New York, 1980.

Tuchman, Maurice. *The Spiritual in Art: Abstract Painting 1890–1985.* New York, 1986.

Watrous, James. *A Century of American Printmaking 1880–1980.* Madison, WI, 1984.

Weaver, Jane Calhoun. *Sadakichi Hartmann: Critical Modernist.* Berkeley, CA, 1991.

Weitenkampf, Frank. *American Graphic Art.* New York, 1924.

Zilczer, Judith. *The Noble Buyer: John Quinn, Patron of the Avant-Garde.* Washington, 1978.

Catalogues, General

"An Unkindled Eye": The Paintings of Rockwell Kent. Santa Barbara Museum, CA, 1985.

Arthur B. Davies/Everett Shinn: Commemorating the Fiftieth Anniversary of the Original "The Eight" Show. James Graham and Sons, New York, 1958.

Avant-Garde Painting and Sculpture in America 1910–25. Delaware Art Museum, 1975.

[Belmont, Eleanor (Mrs. August)], E. B. "Lizzie P. Bliss," *Memorial Exhibition: The Collection of the Late Miss Lizzie P. Bliss, Vice-President of the Museum.* Museum of Modern Art, NY, 1931.

Bolger, Doreen. "Modern Mural Decoration: Prendergast and His Circle," *The Prendergasts and The Arts and Crafts Movement.* Williams College Museum of Art, Williamstown, MA, 1988.

Broun, Elizabeth. *Albert Pinkham Ryder.* National Museum of American Art, Washington, 1990.

Brown, Milton. *The Modern Spirit: American Painting 1908–1935.* London, 1977.

Cikovsky, Jr., Nicholai, and Michael Quick. *George Inness.* Los Angeles County Museum of Art, CA, 1985.

Dabrowski, Magdalena. *The Symbolist Aesthetic.* Museum of Modern Art, NY, 1980.

Epstein, Sarah G. *The Prints of Edvard Munch: Mirror of His Life.* Allen Memorial Art Museum, Oberlin College, OH, 1983.

Haskell, Barbara. *Marsden Hartley.* Whitney Museum of American Art, New York, 1980.

Kushner, Marilyn S. *George Inness: The Spiritual Landscape.* Borghi and Co., NY, 1991.

Mathews, Nancy Mowll. *Maurice Prendergast.* Williams College Museum of Art, Williamstown, MA, 1990.

Milroy, Elizabeth. *Painters of a New Century: The Eight and American Art.* Milwaukee Art Museum, MN, 1991.

1913 Armory Show: Fiftieth Anniversary Exhibition. Munson-Williams-Proctor Institute, NY, 1963.

The American Eight. Tacoma Art Museum, WA, 1979.

The Eight. Owen Gallery, NY, 1993.

The Entire Collection of Mrs. Cornelius J. Sullivan. Parke-Bernet Galleries, New York, 1939.

The Fiftieth Anniversary of the Exhibition of Independent Artists in 1910. Delaware Art Center, 1960.

Williams, Melissa Pierce. *Alice Kellogg Tyler 1866–1900.* Williams and McCormick, Columbia, MO, 1986.

Articles, General

"Art: 53rd Street Patron" [Abby Aldrich Rockefeller], *Time* 27 (Jan. 27, 1936), 28, 29.

Belejack, Barbara. "Zacatecas: Workhorse of the Spanish Empire," *New York Times,* Dec. 17, 1989, Sec. 5, 14, 16.

Blaugrund, Annette. "Alice D. Kellogg: Letters from Paris, 1887–1889," *Archives of American Art Journal* 28 (1988), 11–19.

Cary, Elisabeth Luther. "A Personal Collection" [of Lizzie Bliss], *New York Herald Tribune,* March 29, 1931.

Daingerfield, Elliott. "Albert Pinkham Ryder, Artist and Dreamer," *Scribner's Magazine* 63 (March 1918), 380–84.

Davies, Erica. "Dockie—A Memoir," *South of the Mountains, The Historical Society of Rockland County* 29 (April–June 1985), 5–9.

"Dr. Virginia M. Davies Dies at Her Home in Congers," *(Nyack, New York) Journal-News,* April 21, 1949, 1.

du Bois, Guy Pène. "Mistresses of Famous American Collections: The Collection of Mrs. Charles Cary Rumsey," *Arts and Decoration* 7 (Oct. 1917), 557–62.

———. "The Lizzie P. Bliss Collection," *Arts* 17 (June 1931), 601–09.

Eckford, Henry [Charles de Kay]. "A Modern Colorist: Albert Pinkham Ryder," *Century Magazine* 40 (June 1890), 250–59.

Glackens, William J. "The American Section, the National Art," *Arts and Decoration* 3 (March 1913), 159–64.

Hague, Laurence. "In a Red Cross Art Factory," *New York Post,* Dec. 21, 1918.

Harris, Neil. "Lizzie Plummer Bliss," in *Notable American Women 1607–1950,* vol. I. Cambridge, MA, 1971, 178, 179.

Hellman, Geoffrey T. "Profile of a Museum" [Museum of Modern Art], *Art in America* 52 (Feb. 1964), 27–30.

Louchheim, Aline B. "Macbeth Celebrates Sixtieth Birthday," *New York Times,* April 6, 1952, xii.

Magee, Joyce, and Phyllis Morena, eds. *Imprints on Rockland County History: Biographies of Twelve Women.* New City, NY, 1984.

Martinez, Andrew. "A Mixed Reception for Modernism: The 1913 Armory Show at the Art Institute of Chicago," Art Institute of Chicago *Modern Studies* 9 (1993), 30–57, 102–05.

Phillips, Duncan. "Fallacies of the New Dogmatism in Art," *American Magazine of Art* 9 (Dec. 1917), 43–48; (Jan. 1918), 101–06.

Pincus-Witten, Robert. "On Target: Symbolist Roots of American Abstraction," *Arts* 50 (April 1976), 84–91.

Savelle, Isabelle K. "Lucy Virginia Meriwether Davies," *South of the Mountains, The Historical Society of Rockland County* 29 (April–June, 1985), 3, 4.

Schuyler, Montgomery. "George Inness: The Man and His Work," *Forum* 18 (Nov. 1894), 301–13.

Sheon, Aaron. "1913: Pittsburgh in the Cubist Avant-Garde," *Carnegie Magazine* 56 (July/Aug. 1982), 12–17, 38, 39.

Taubman, Howard. "More Art Sought for White House," *New York Times,* July 19, 1967.

"The Armory Show: A Selection of Primary Documents," *Archives of American Art Journal* 27, no. 2 (1987), 12–33.

"The Glorious Affair" [The Armory Show Re-Created], *Time* 81 (April 5, 1963), 58–67.

"The Month's Exhibitions," *Independence* 64 (Feb. 27, 1908), 464, 465.

Thompson, Frederic. "The American Luxembourg" [The Museum of Modern Art], *Commonweal* 14 (July 29, 1931), 318–20.

"Vivid Examples of Modern School Shown at Exhibit," *Columbus Evening Dispatch,* Jan. 18, 1911, 7.

"Where Artists Are Made," *Daily Graphic,* Dec. 4. 1886.

Zilczer, Judith K. "The Armory Show and the American Avant-Garde: A Reevaluation," *Arts* 53 (Sept. 1978), 126–30.

❦ Index ❧

Baltimore Museum of Art, 340
Barker, Robert, 84
Barker, Virgil, 324
Barnes, Dr. Albert C., 205, 233, 241, 292
Barr, Jr., Alfred H., 372
Barrymore, Ethel, 178
Beecher, Henry Ward, 7
Beethoven, Ludwig van, 286
Bell, Clive, 277
Bellini, Giovanni, 55, 96
Bellows, Anne, 293
Bellows, George, 166, 168, 191, 193, 195, 233, 240, 258, 262, 293
Bellows, Jean, 293
Belmont, Eleanor, 178
Benda, W. T. (Wladyslaw Theodor), 166
Benedict, H. H. (Henry Harper), 144
Berlin Photographic Company gallery, New York, 212, 301
Bernet, Otto, 366
Bernhardt, Sarah, 288
Besnard, Albert, 211
Betts, Col. Rostan (Virginia Davies' brother-in-law), 45
Betts, Lucy (Virginia Davies' niece), 44, 52, 106, 107, 133
Betts, Mattie (Virginia Davies' niece), 44, 52, 59
Betts, Mattie (Virginia Davies' sister), 44, 45, 49
Betts, Rostan (Virginia Davies' niece), 44, 52, 59, 85, 86, 106, *107,* 285, *Plate 3*
Bibliothéque National, Paris, 334
Bierstadt, Albert, 7
Billy the Kid, 11
Bingham, George Caleb, 379
Birnbaum, Martin, 212
Birren, Joseph P., 24
Blackwell, Dr. Elizabeth, 35
Blackwell, Dr. Emily, 35
Blake, William, 52, 70, 118, 171, 193, 233, 376
Blashfield, Edwin, 27, 343
Blavatsky, Helena P., 64, 243, 289
Bliss, Cornelius, 176
Bliss, Lillie (see Lizzie Bliss)
Bliss, Lizzie Plummer, *177,* 178, 209, 314, 324, 331, 360, 362, 267, 276
 Armory Show, sponsor of, 216

Davies' art collected by, *134,* 176, 178–80, 203, 206, 223, *224,* 237, 240, 263, 290, 296, 318, 376, *Plates 6, 7, 11*
Davies confidant, 206
Davies' Music Room mural for, 258–62, 332, 342
Museum of Modern Art co-founder, xx, 368
Other artists' art collected by, 200, 214, 220, 233, 270, 278, 343–45, 366
Bliss, Sr., Cornelius, 176
Bliss, Sr., Mrs. Cornelius, 258
Boccioni, Umberto, 219
Böcklin, Arnold, 97, 118, 119, 167, 215
Borglum, Gutzon, 186, 215, 216
Boss, Homer, 194
Boston Art Club, 78, 93
Boston Evening Transcript, 78
Boston Herald, 142
Boston Public Library, 102
Boston Sunday Globe, 141
Boston Symphony, 124
Botticelli, Sandro, 84, 85, 96, 97, 102, 118, 137, 197, 299
Bouché, Louis, 306
Boughton, Alice, 56, 58
Bourdelle, Émile-Antoine, 270
Bowen, David (Davies' step-grandfather), 129
Brancusi, Constantin, xx, 214, 270, 314, 322, 366
Brandegee, Robert, 154
Braque, Georges, xx, 219, 221, 233, 246, 310, 322, 341, 366
Breckenridge, Hugh, 154
Breuning, Margaret, 369
British Museum, 97
Bronzino, Agnolo, 110
Brooklyn Museum, 343, 366
Brown, Bolton, 301
Bruce, Patrick Henry, 233, 242, 341
Brummer Gallery, New York, 323
Brummer, Joseph, 345
Buddha, 189
Buffalo Museum (see Albright Art Gallery, Buffalo)
Bulfinch, Thomas, 94, 122